denim
people

30 Designs
from **ROWAN**
for men & women

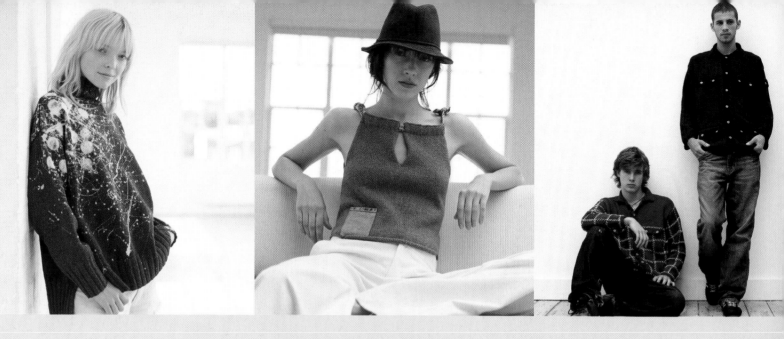

credits

Designs
Kim Hargreaves
Martin Storey
Louisa Harding
Leah Sutton
Erika Knight
Carol Meldrum

Photographer Joey Toller

Stylist Lucie Dodds

Hair & Make up artist Annabel Hobbs

Models
Francesca, Launa, Victoria, Patricia, Mebrak, Natalia, Charlotte, Gemma, Alistair, Eddie, Luke and Matthew

Design layout Simon Wagstaff

Internet: www.knitrown.com
Email:denimpeople@knitrowan.com

British library Cataloguing in Publication Data
Rowan Yarns
Denim People
ISBN 1-904485-12-X

© Copyright Rowan Yarns 2004
First published in Great Britain in 2004 by Rowan Yarns Ltd, Green Lane Mill, Holmfirth, West Yorkshire, England, HD9 2DX

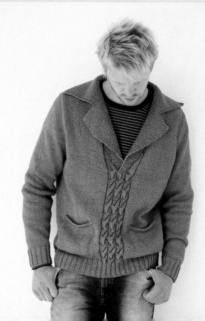

contents

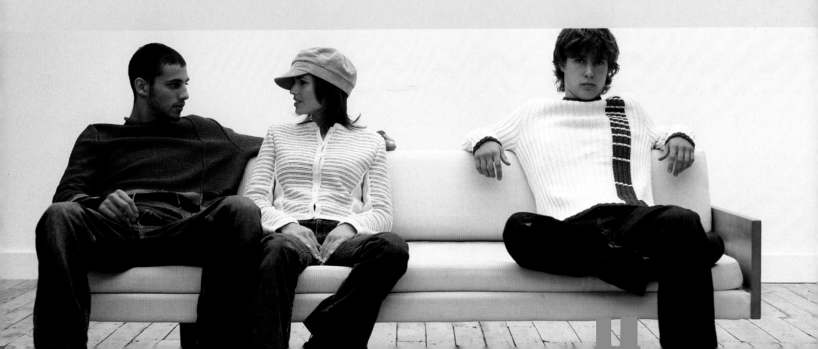

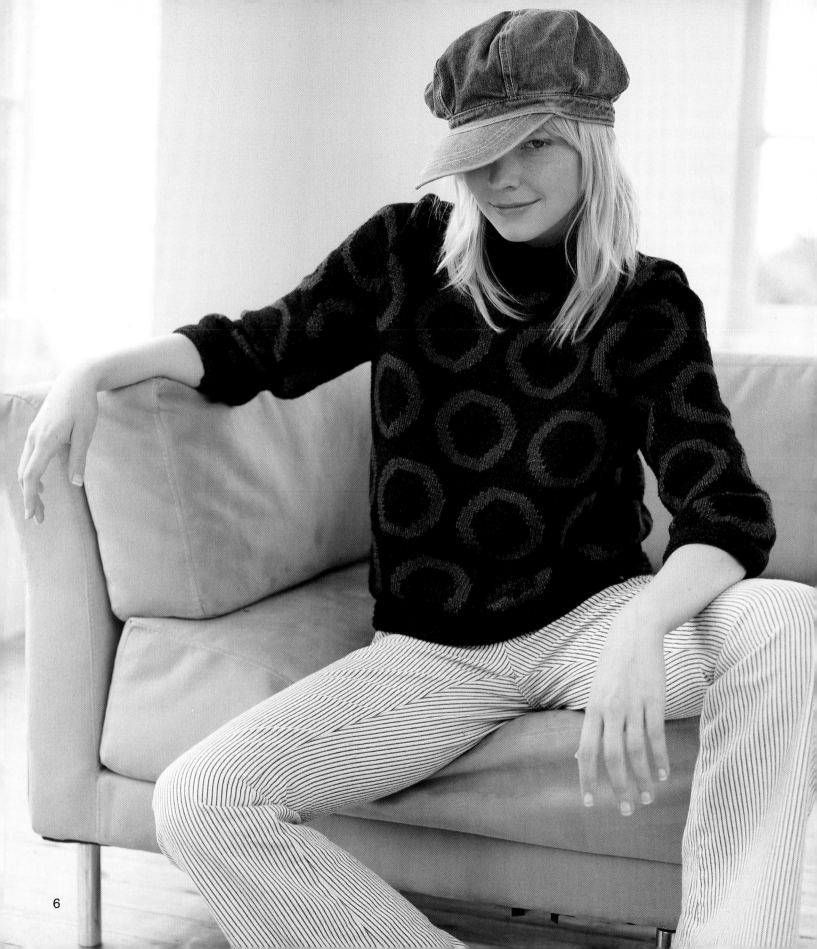

Polo by Louisa Harding

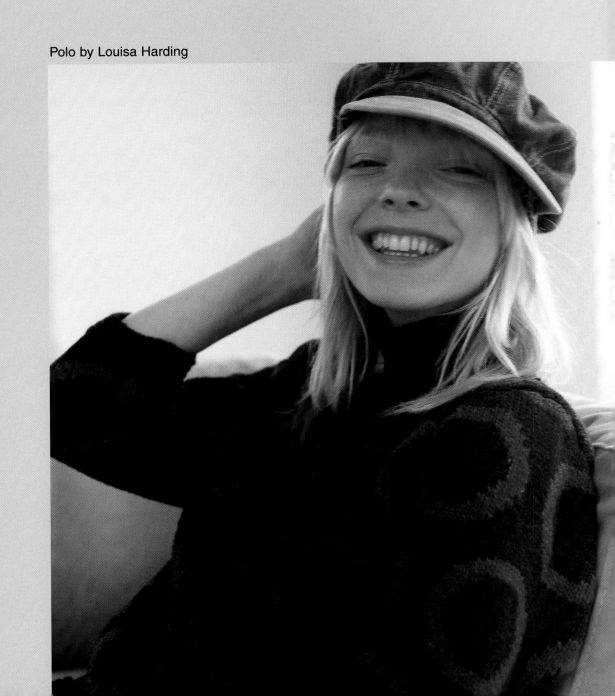

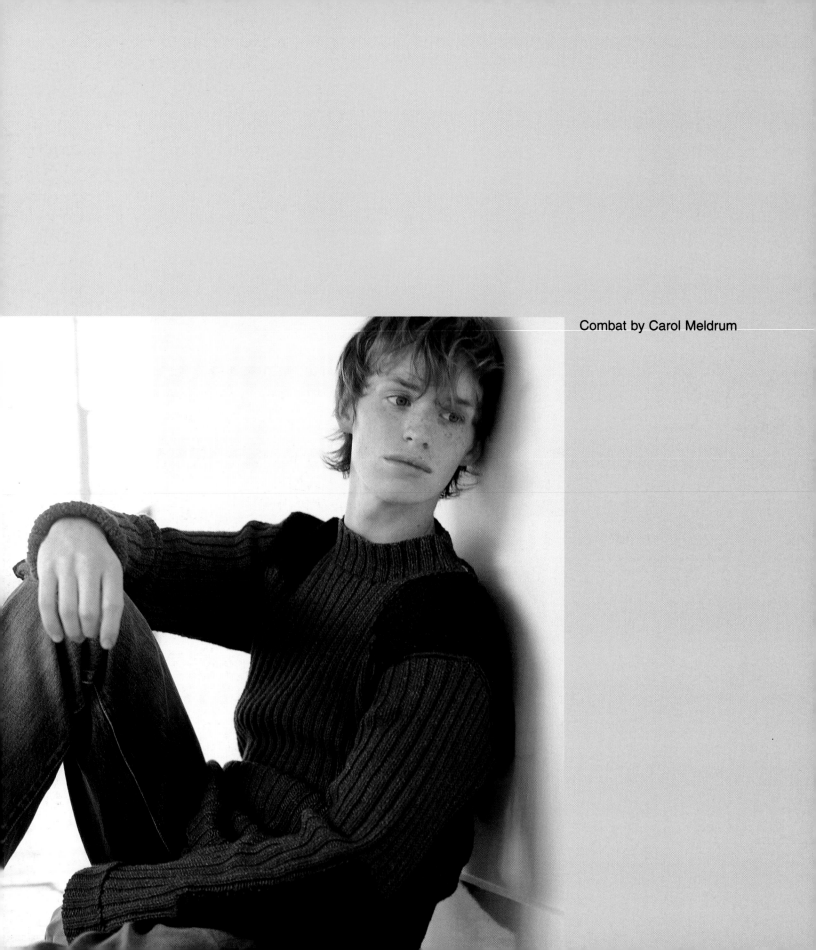

Combat by Carol Meldrum

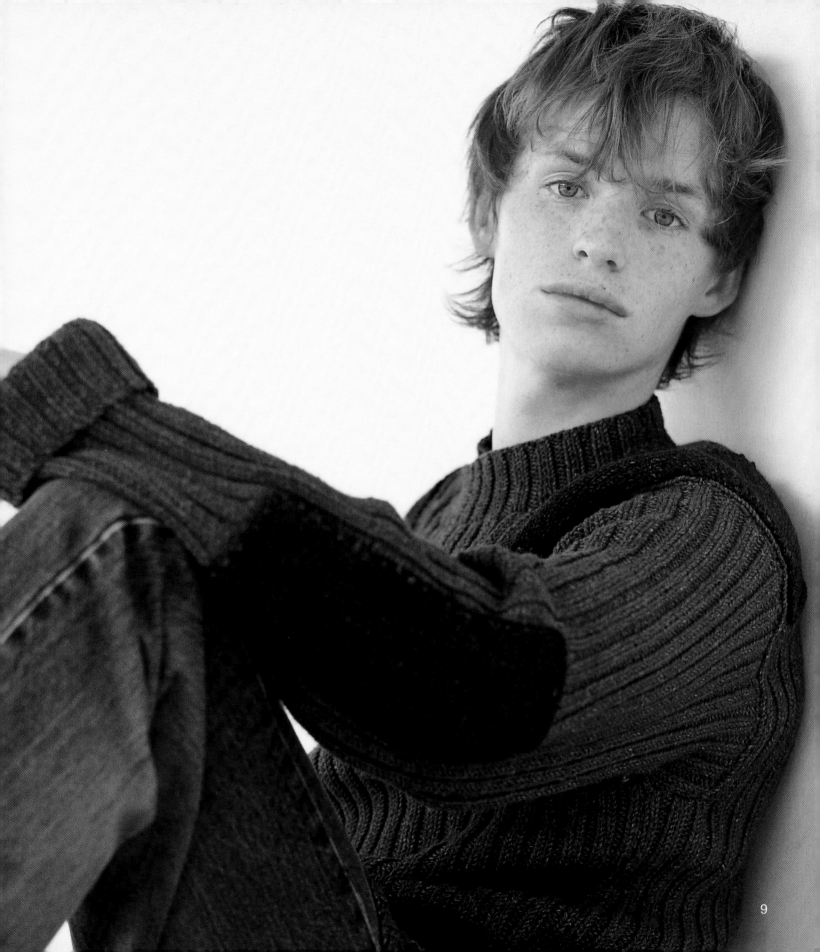

9

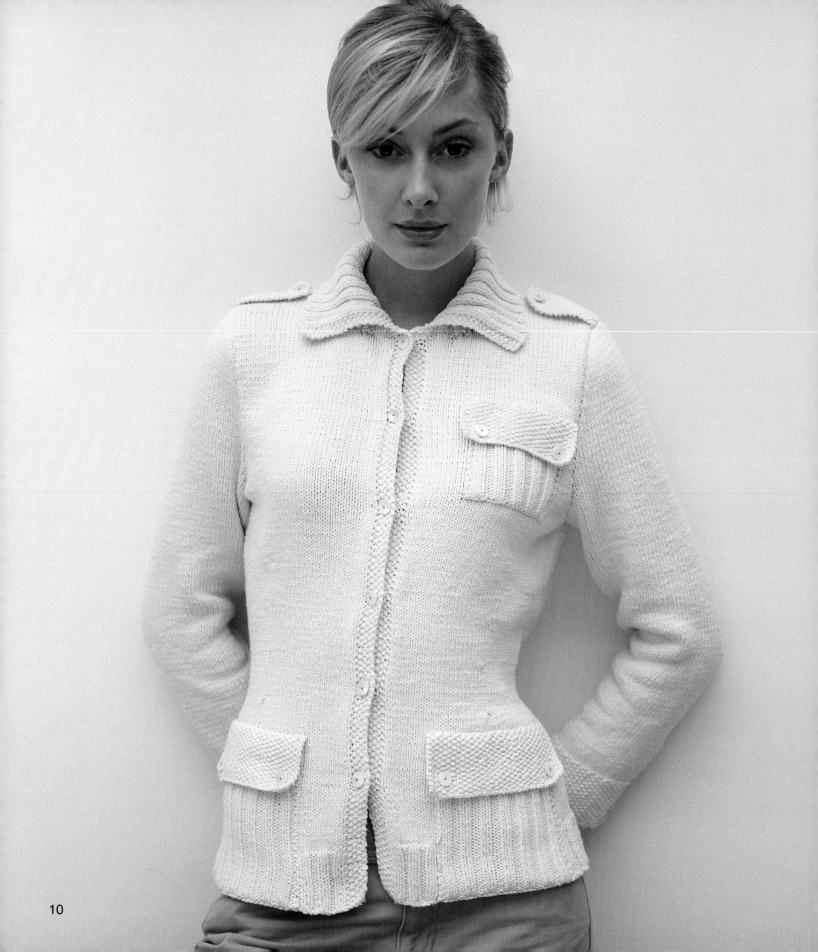

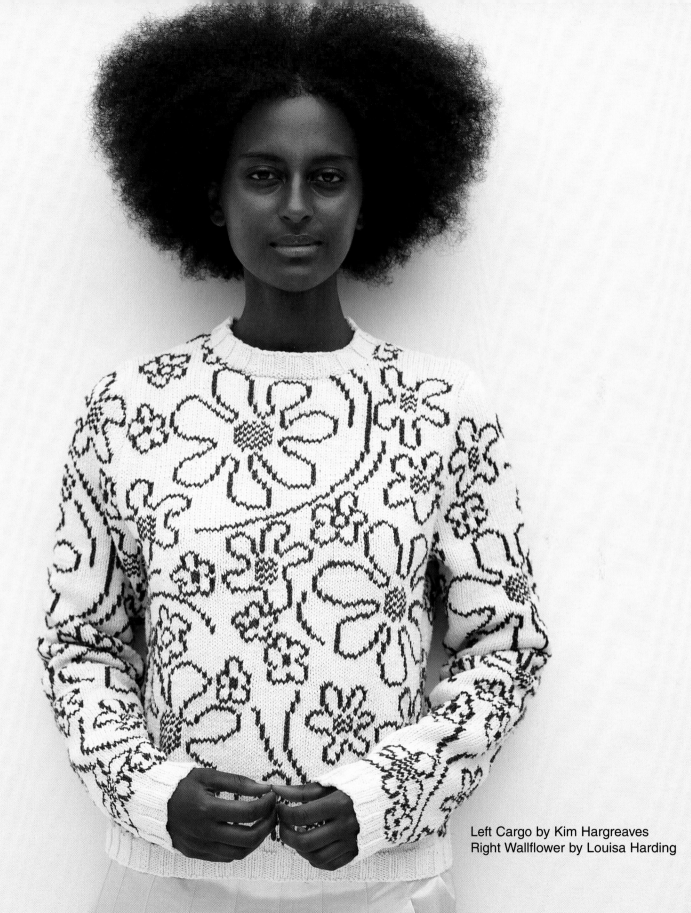

Left Cargo by Kim Hargreaves
Right Wallflower by Louisa Harding

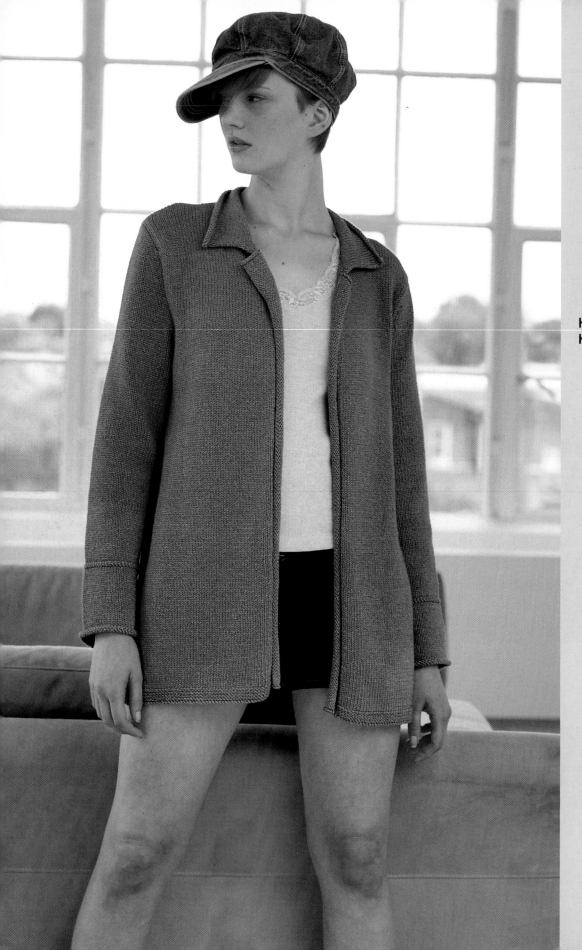

Her Lauren by Kim Hargreaves
Him Denver by Martin Storey

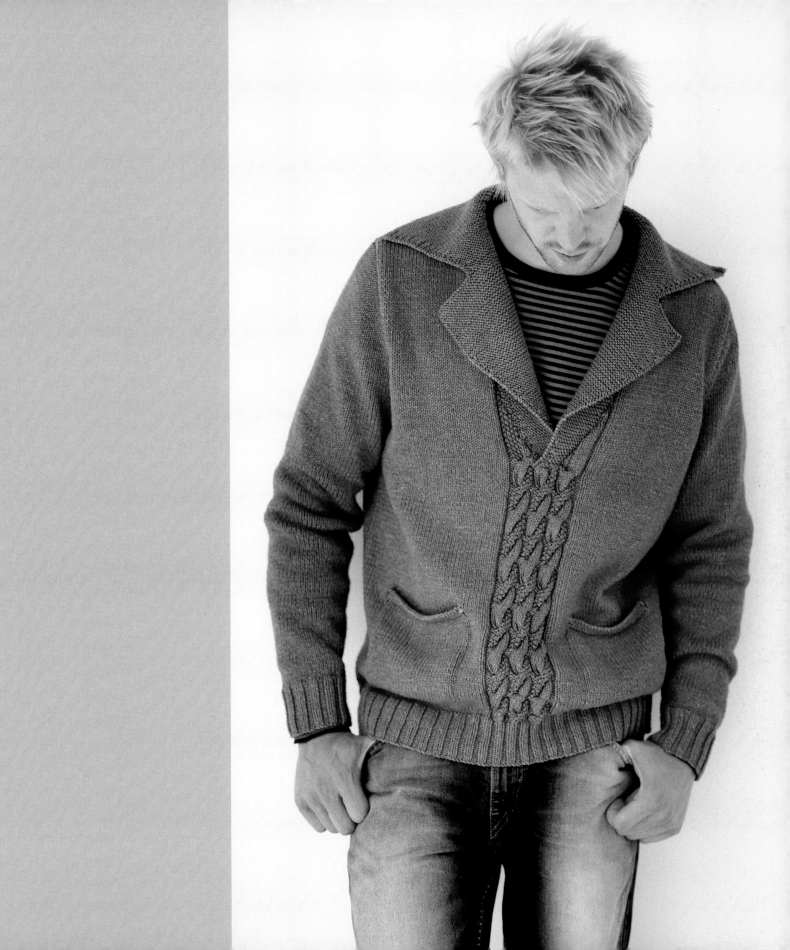

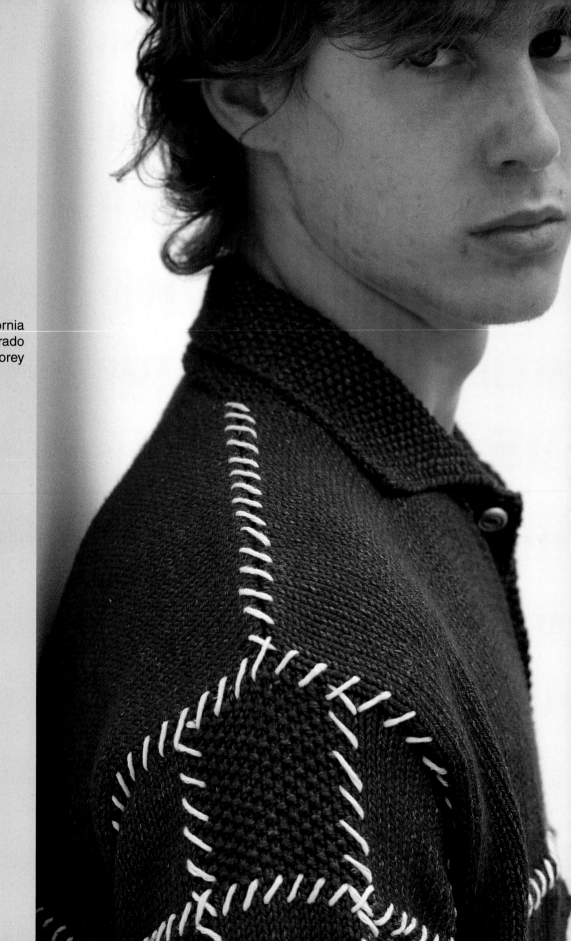

Right California
and far right Colorado
both by Martin Storey

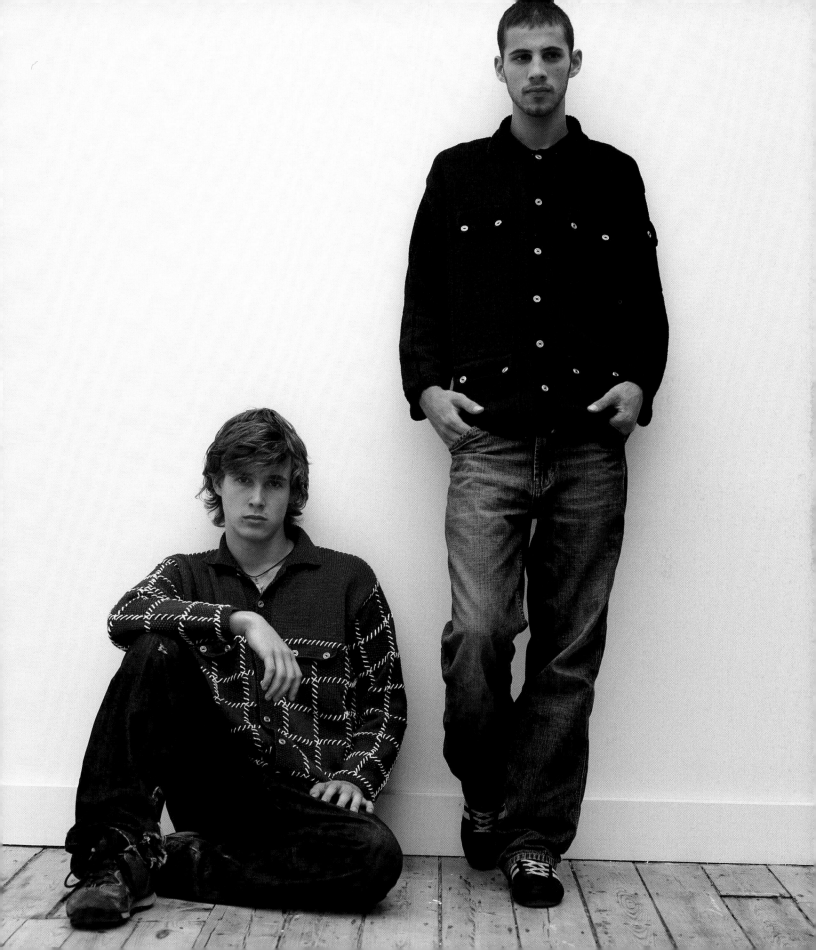

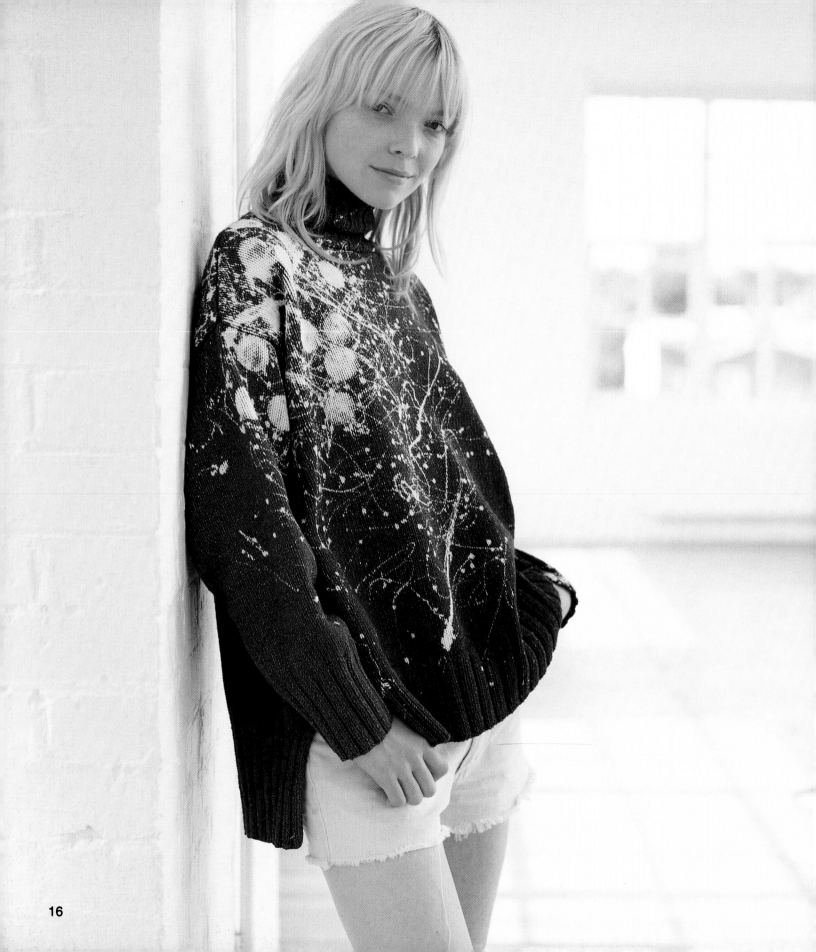

Slouch by Kim Hargreaves

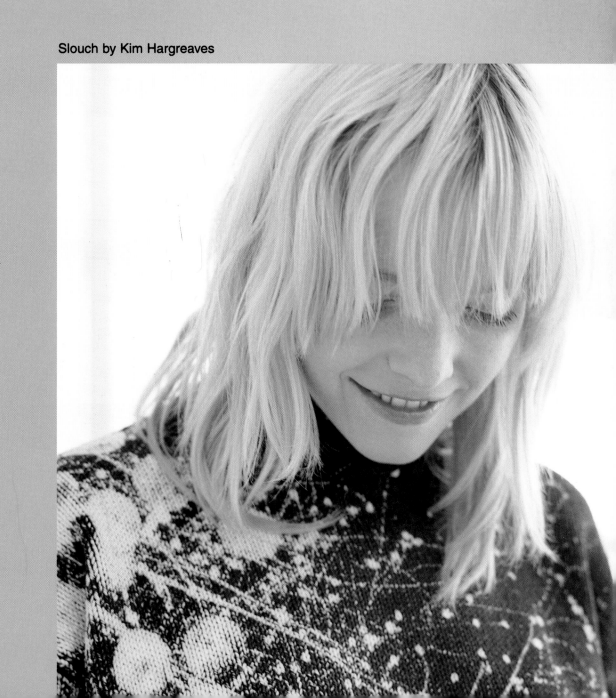

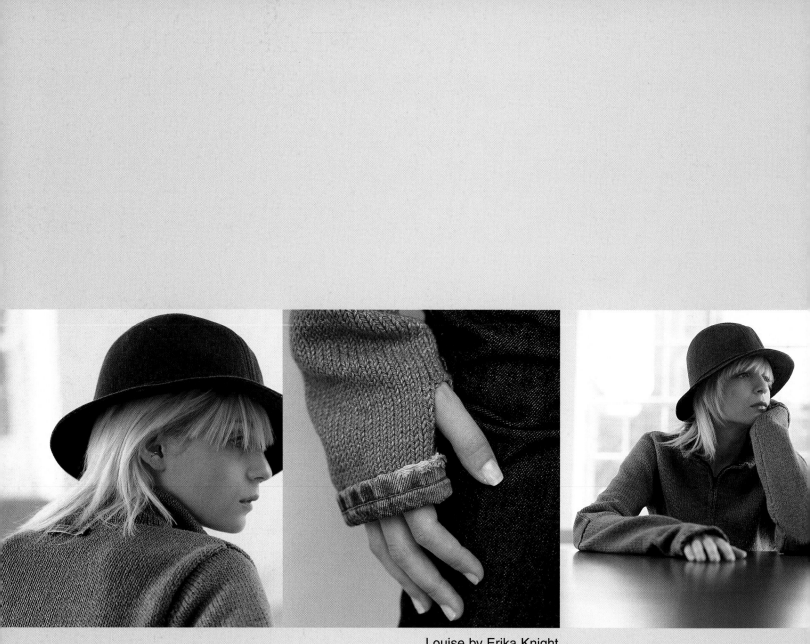

Louise by Erika Knight

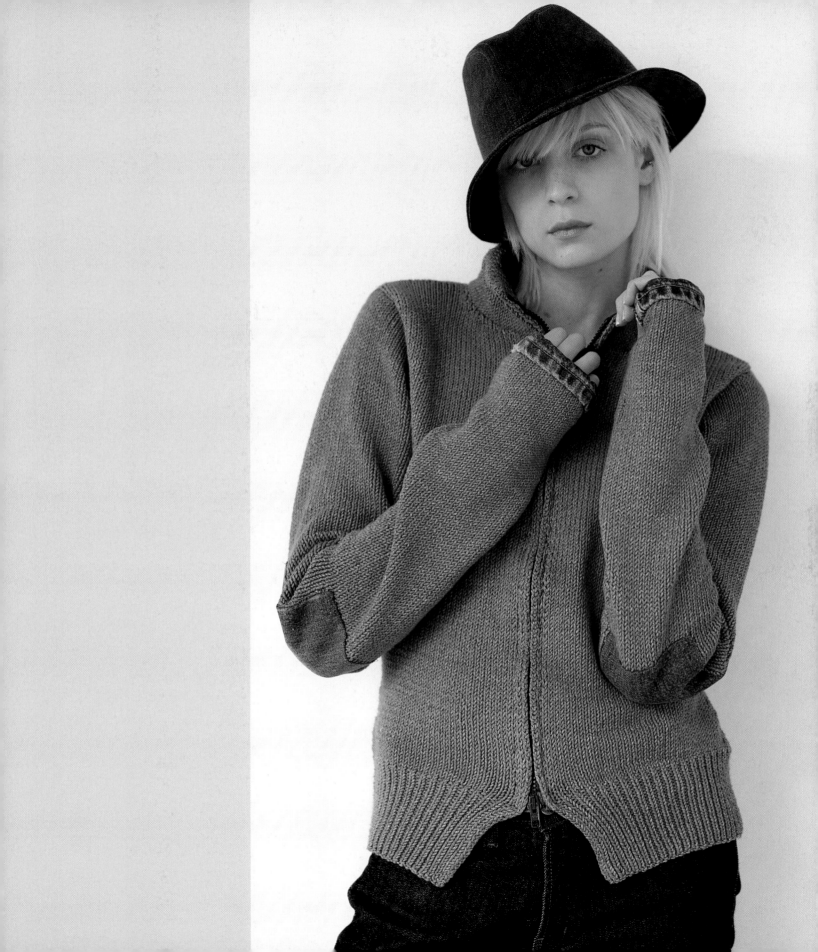

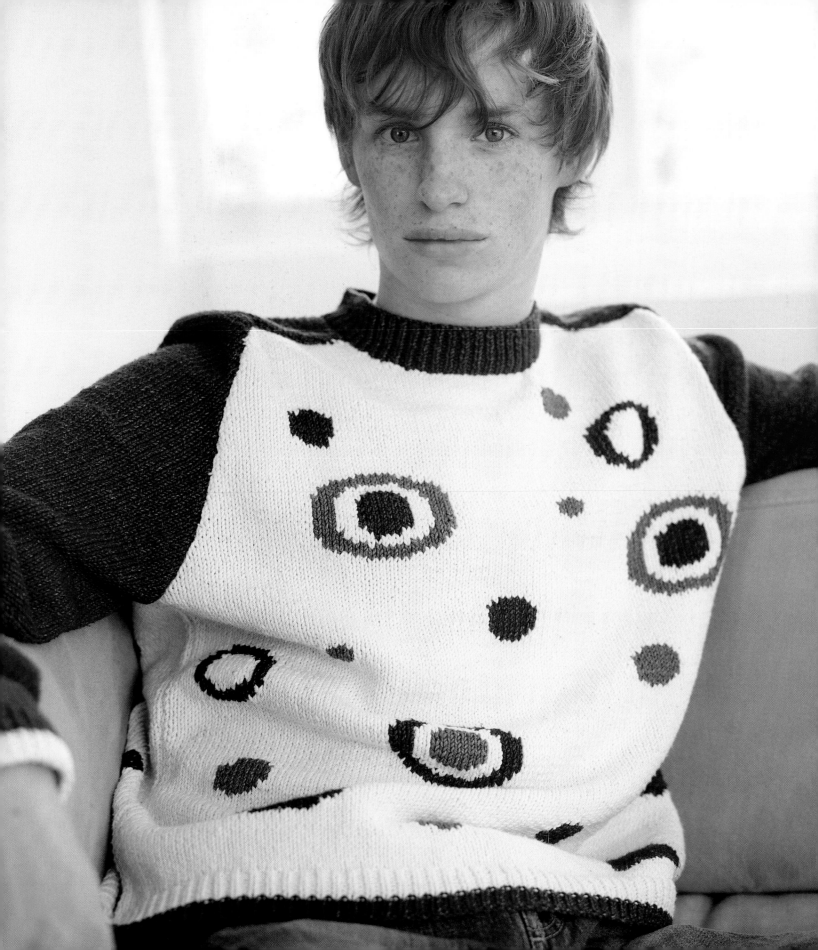

Left Saucer
by Carol Meldrum
Right Action
by Kim Hargreaves

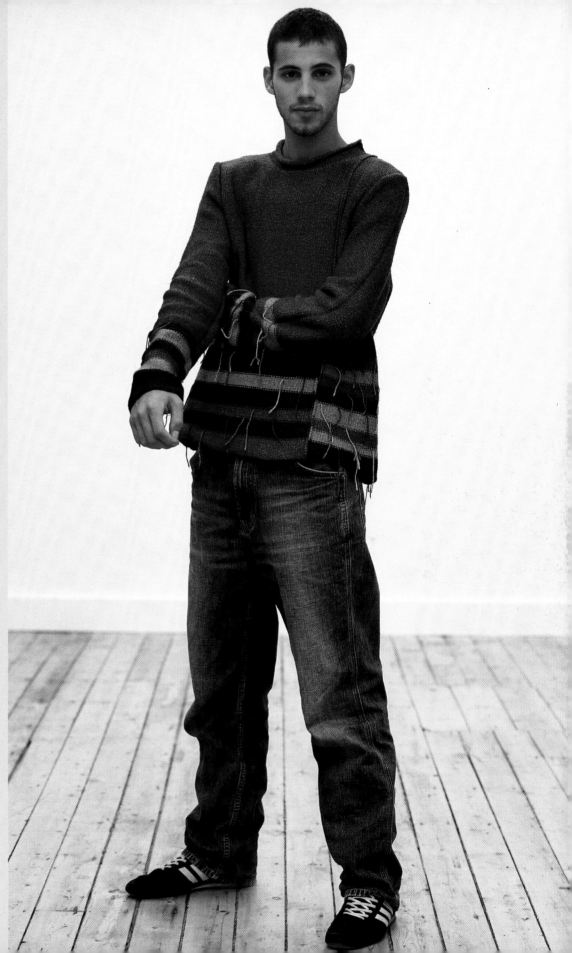

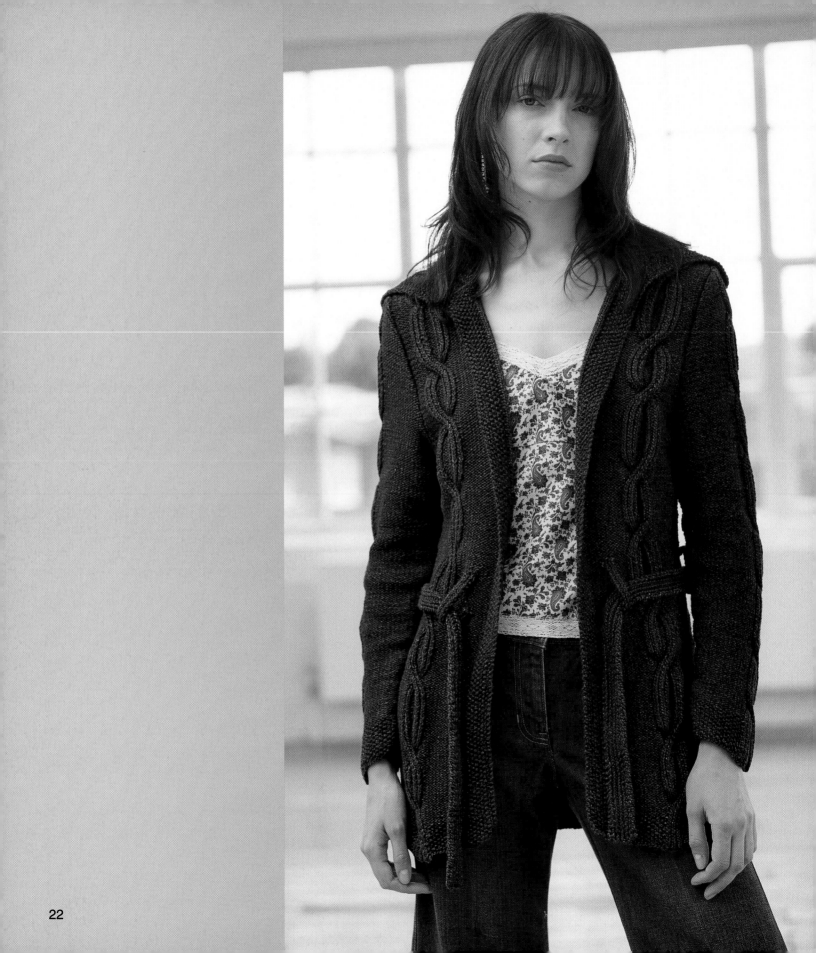

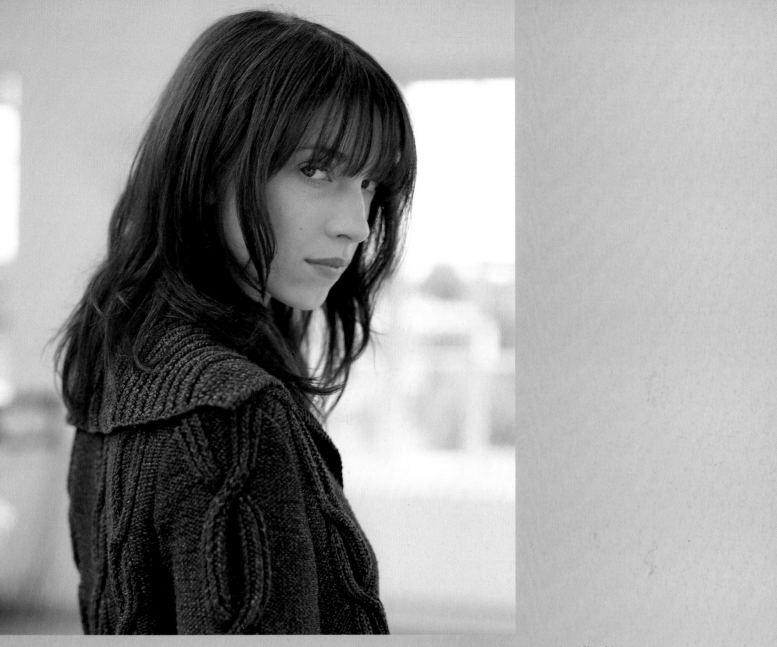

Haven by Kim Hargreaves

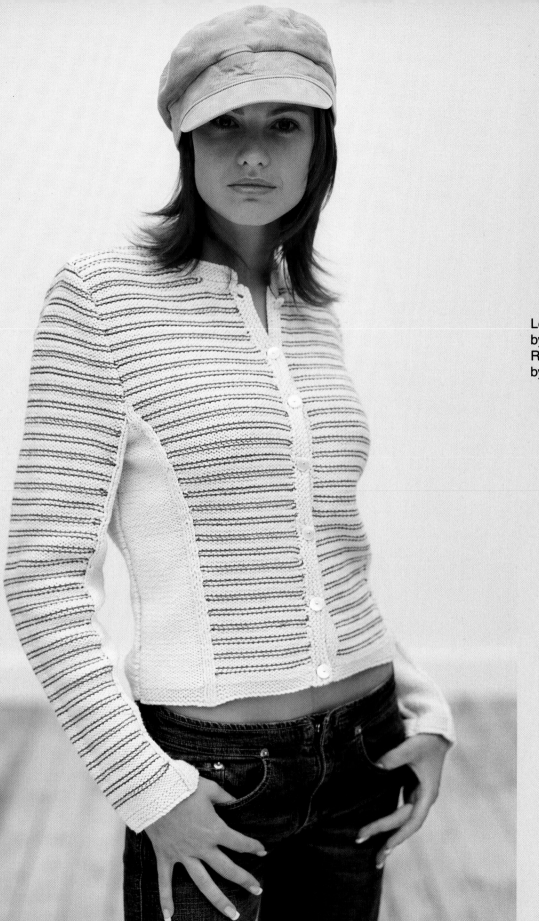

Left Ticking
by Kim Hargreaves
Right Creeper
by Louisa Harding

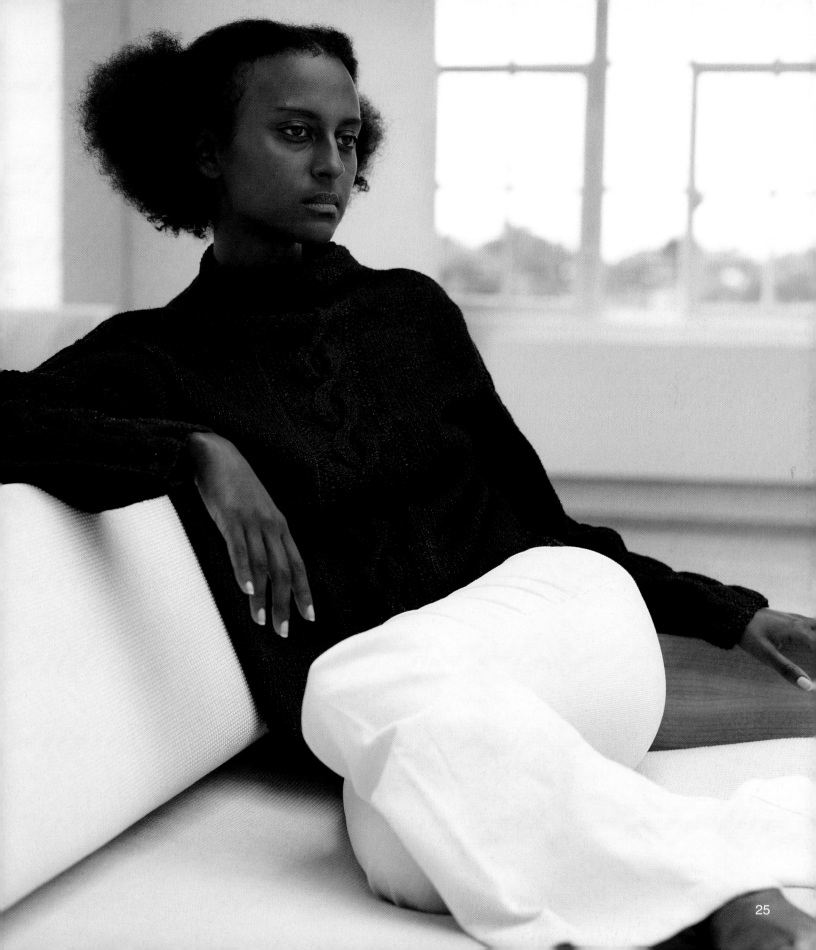

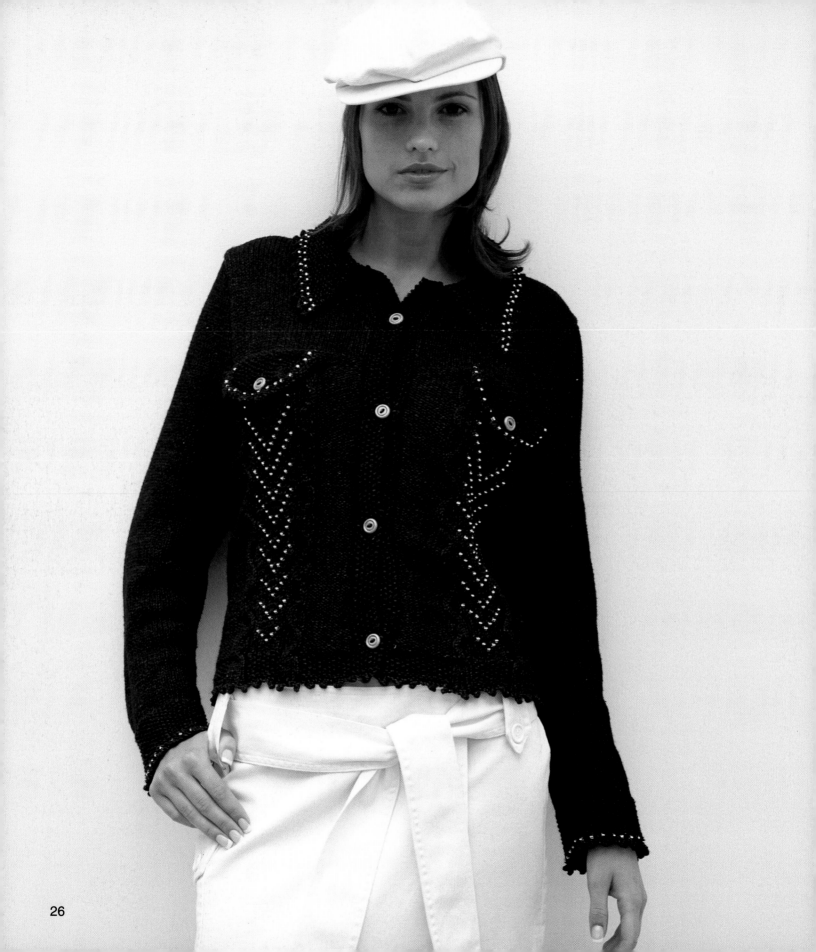

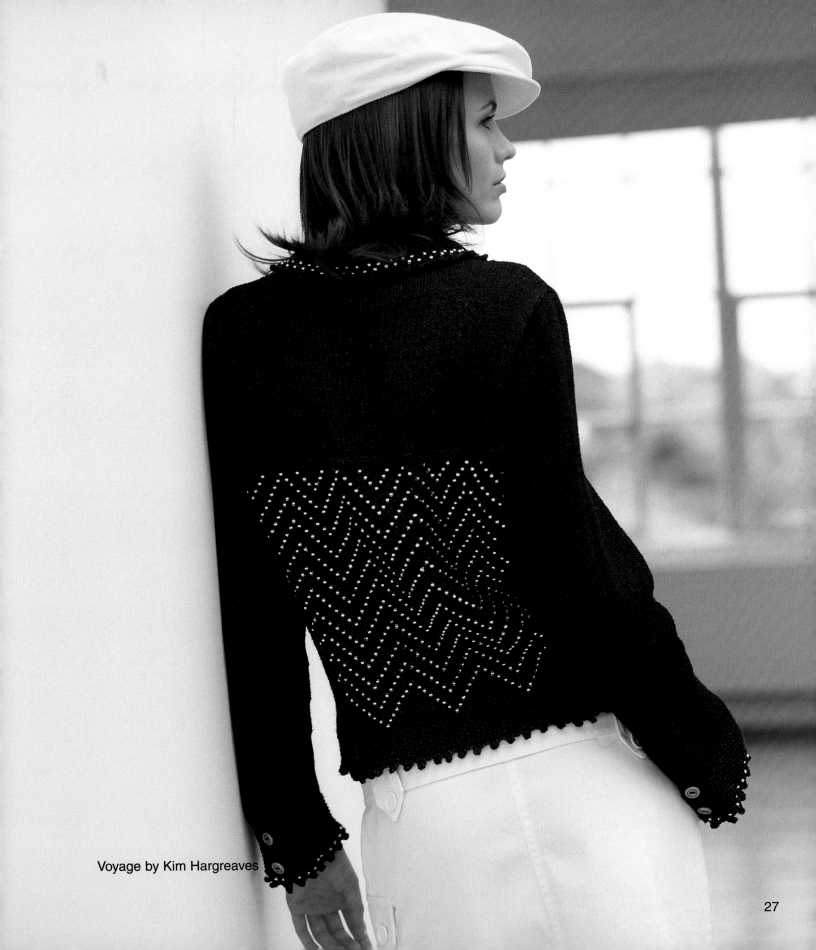

Voyage by Kim Hargreaves

27

Thelma by Erika Knight

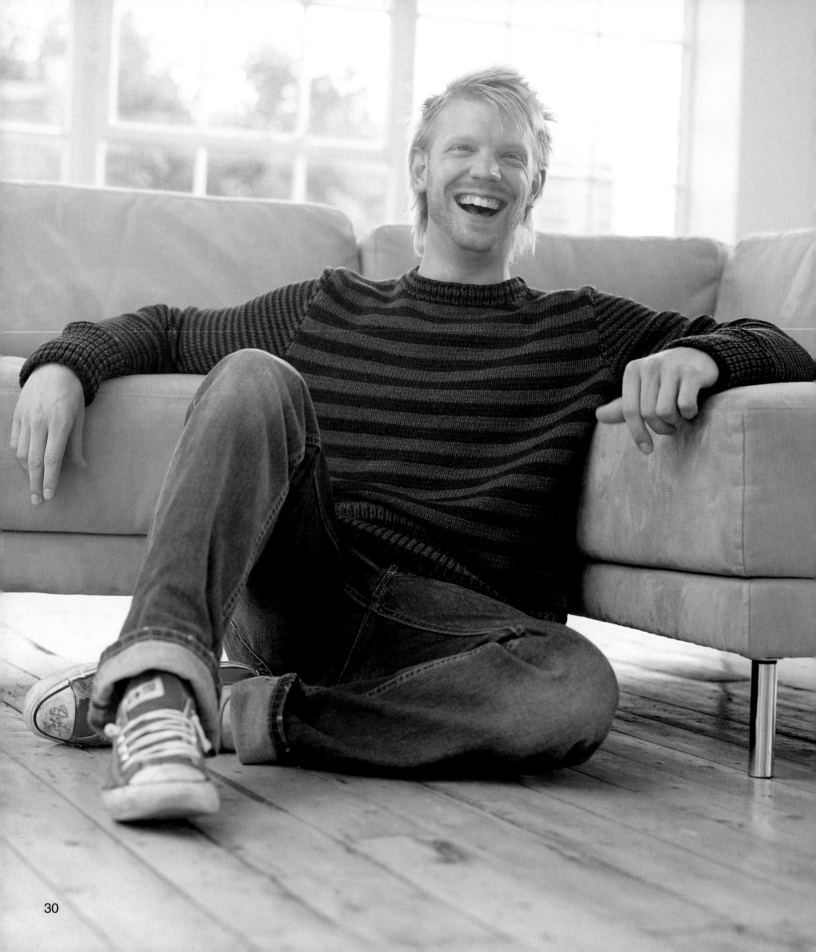

Bret by Kim Hargreaves

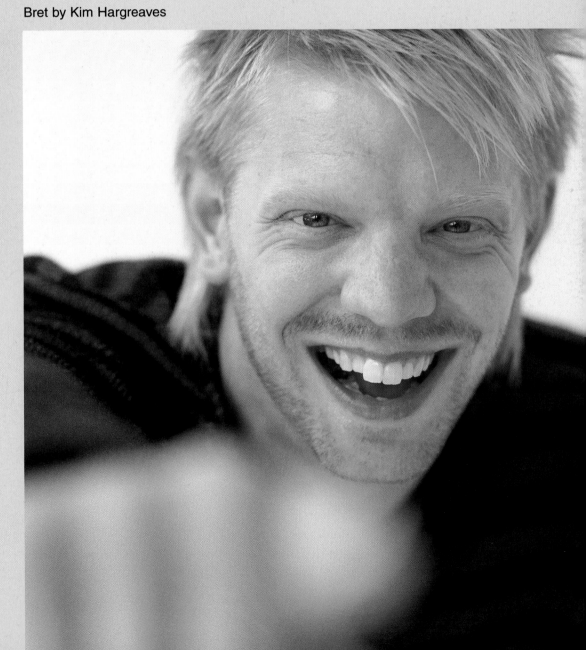

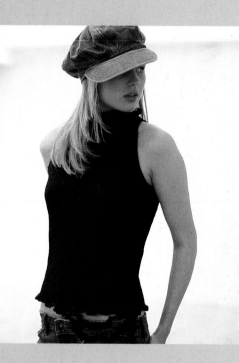

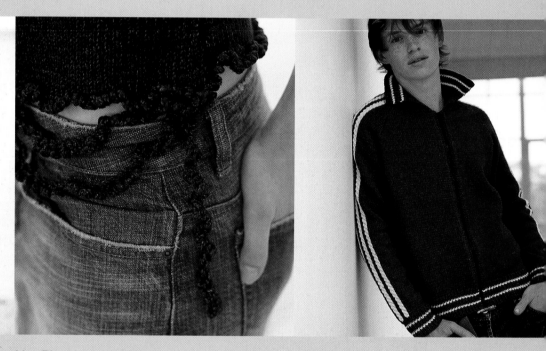

Her Picot by Leah Sutton
and him Brooklyn by Martin Storey

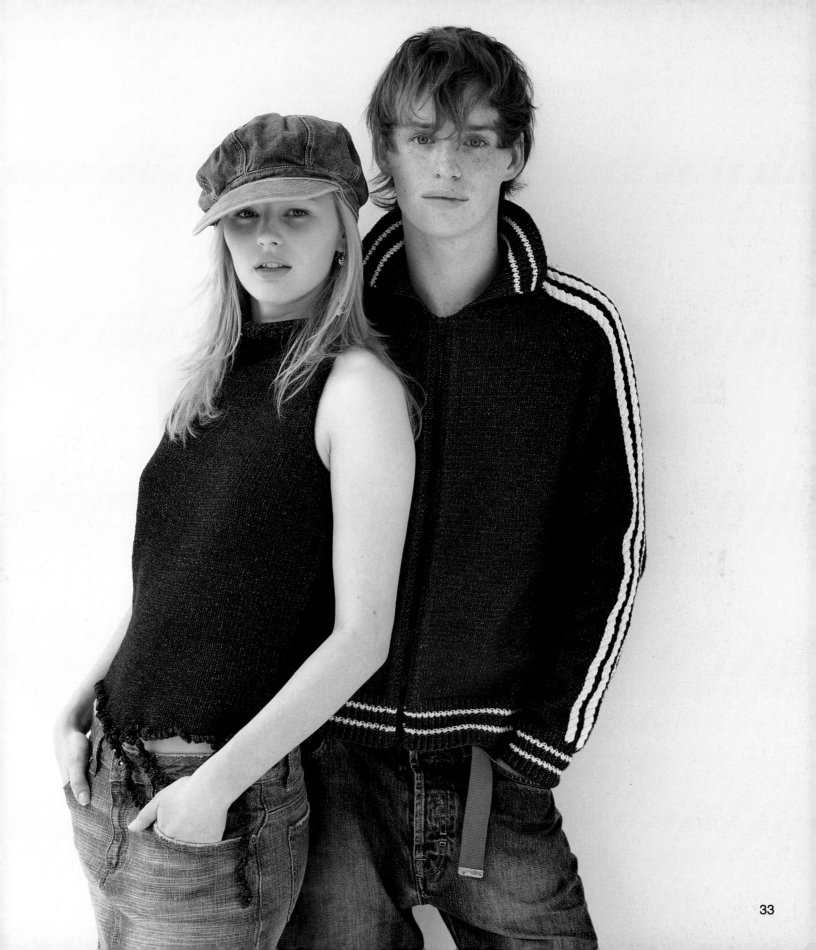

33

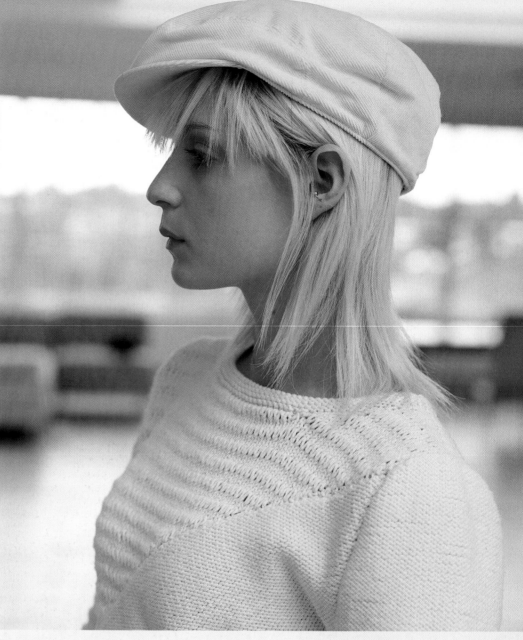

Delta by Leah Sutton

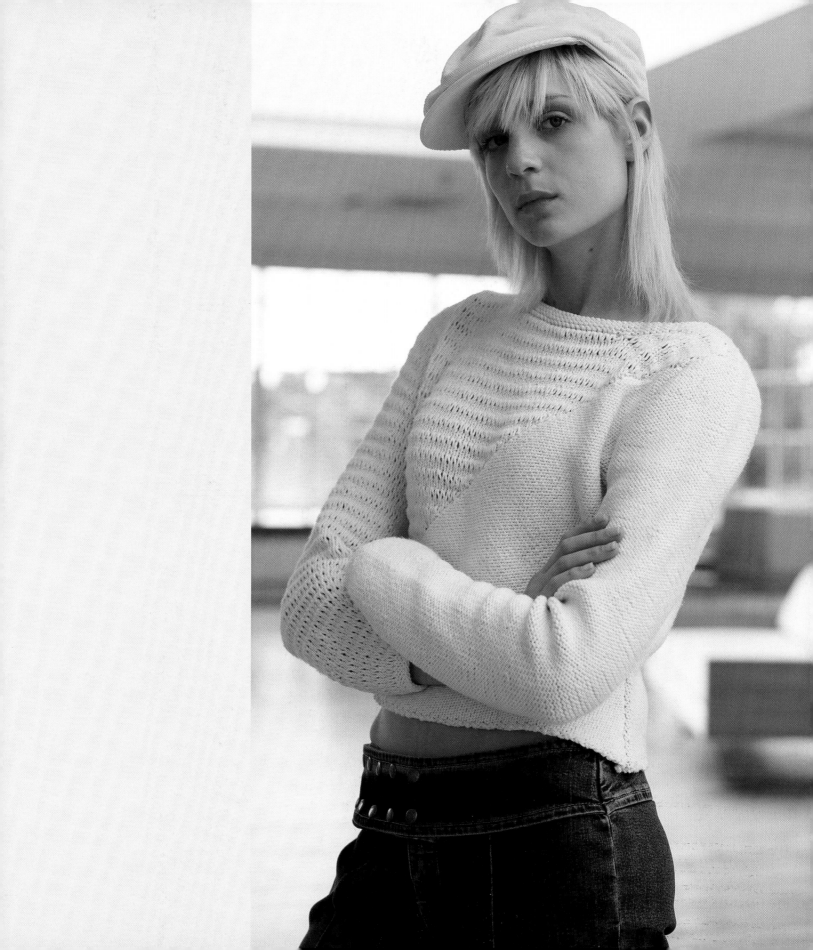

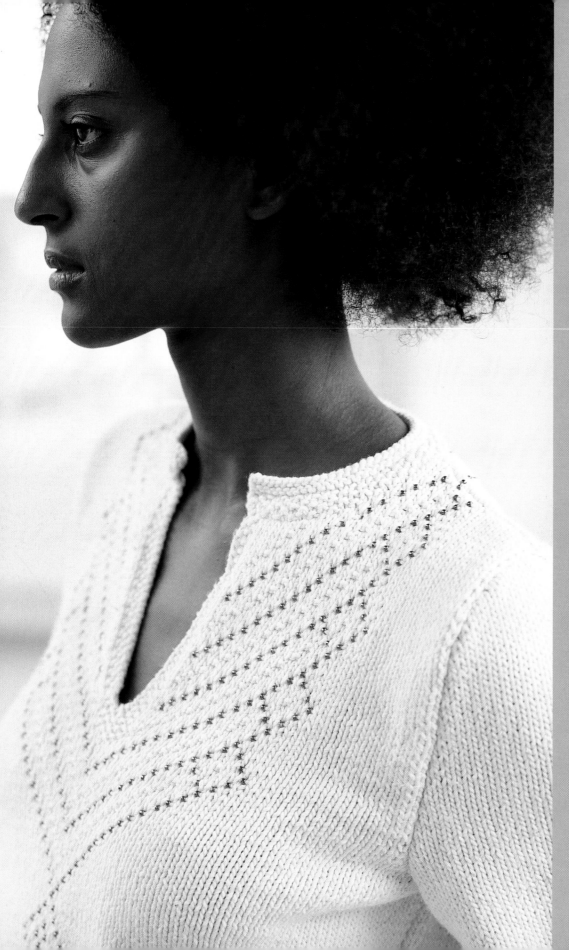

Lush by Kim Hargreaves

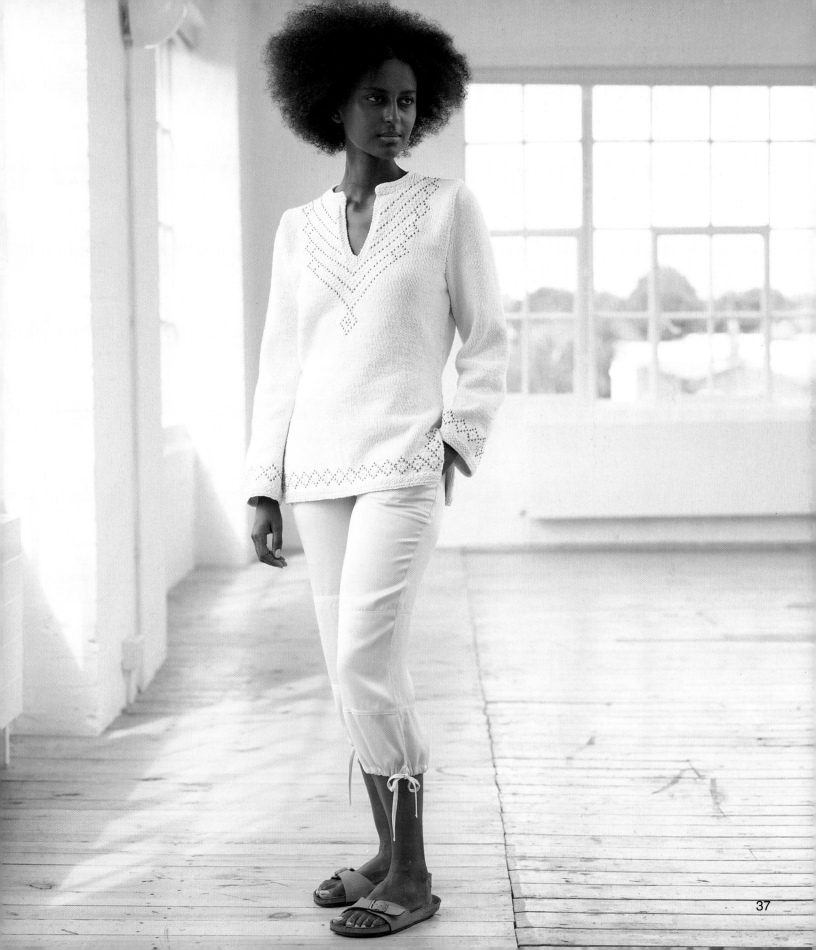

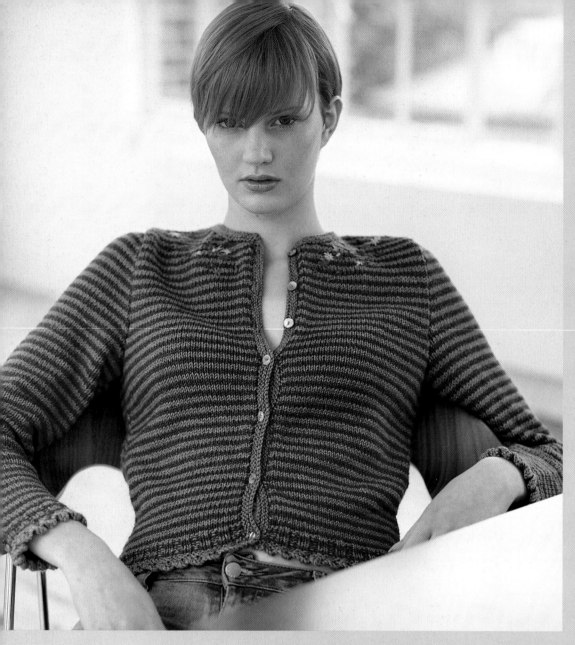

Her Vintage by Kim Hargreaves
Him Pulse by Carol Meldrum

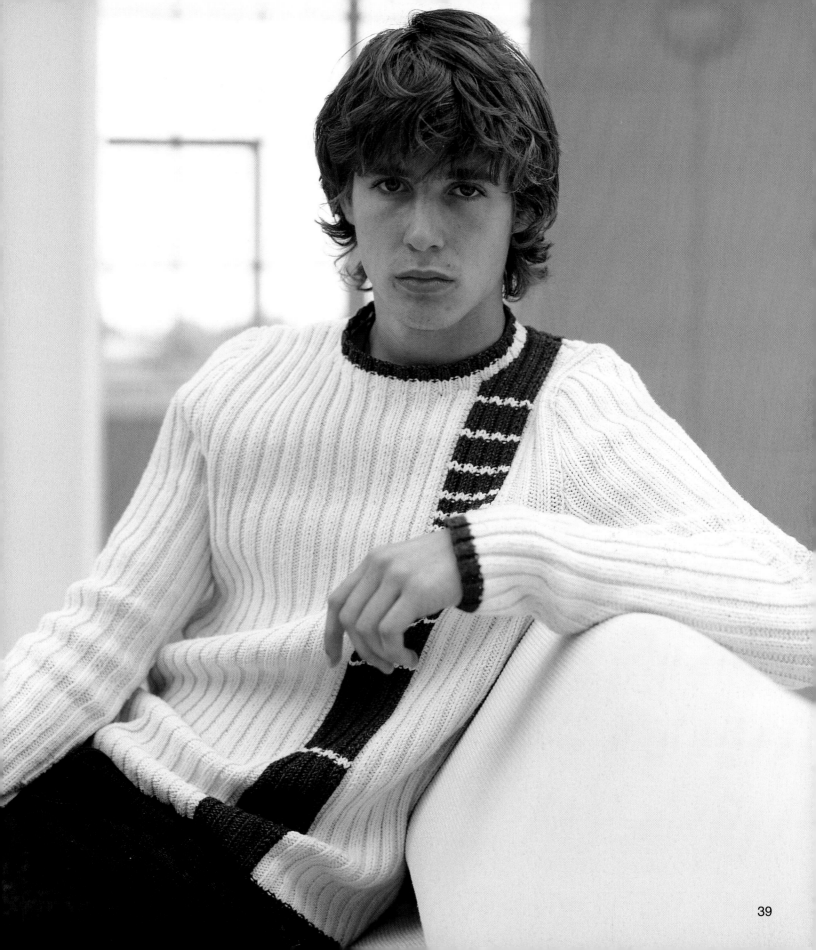

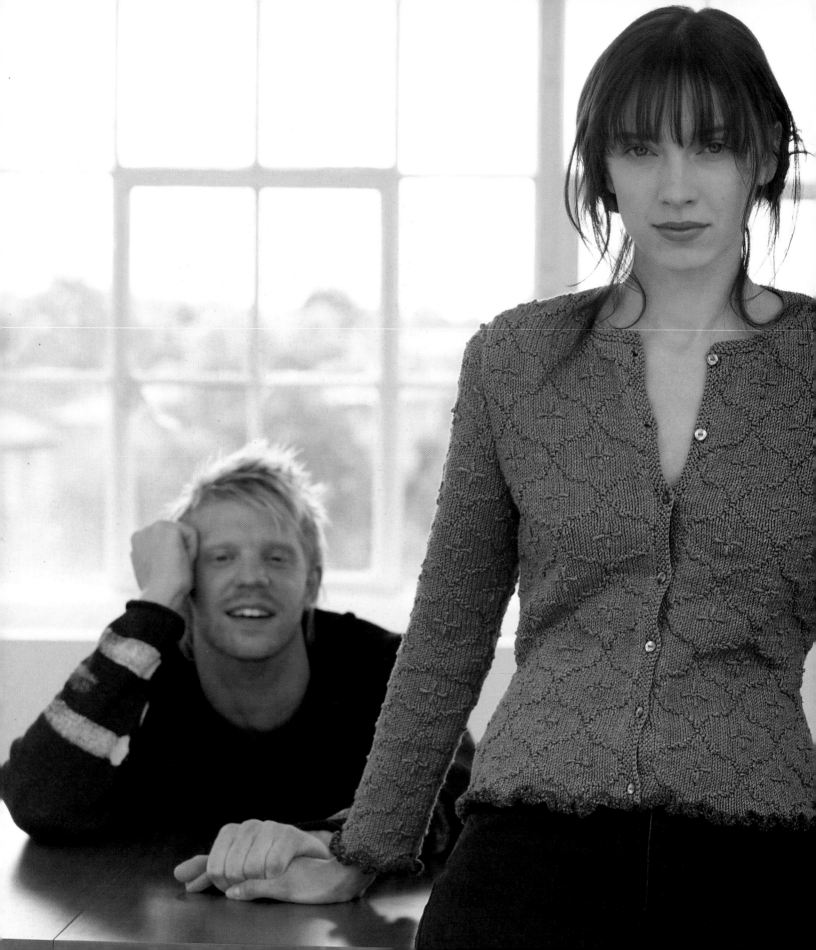

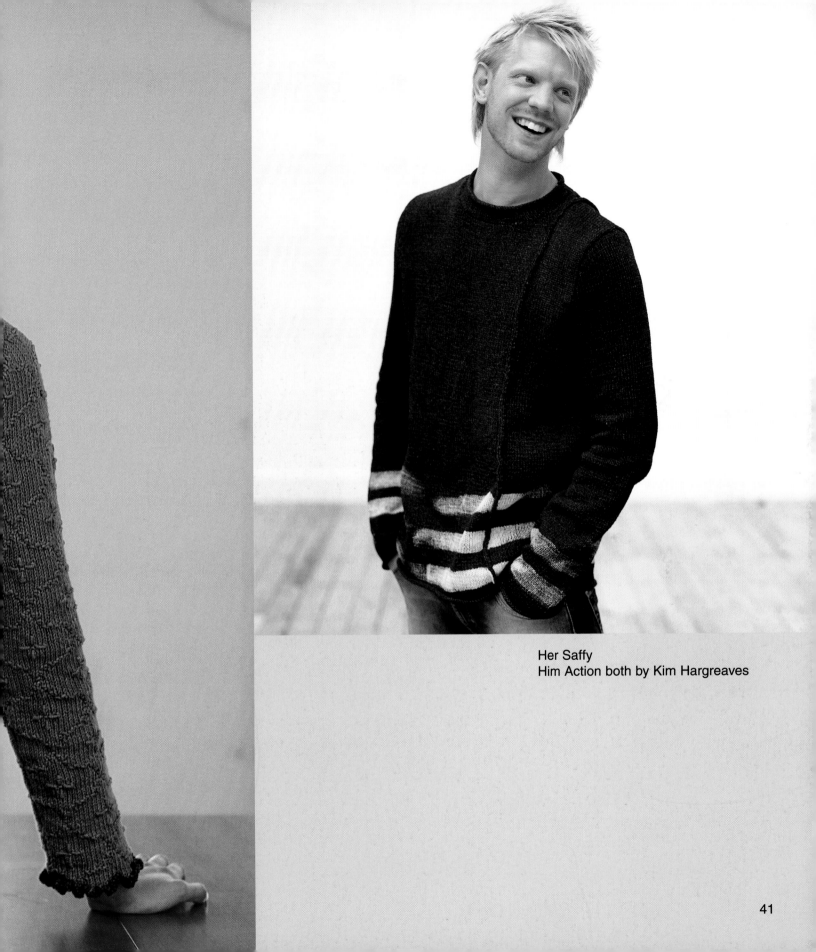

Her Saffy
Him Action both by Kim Hargreaves

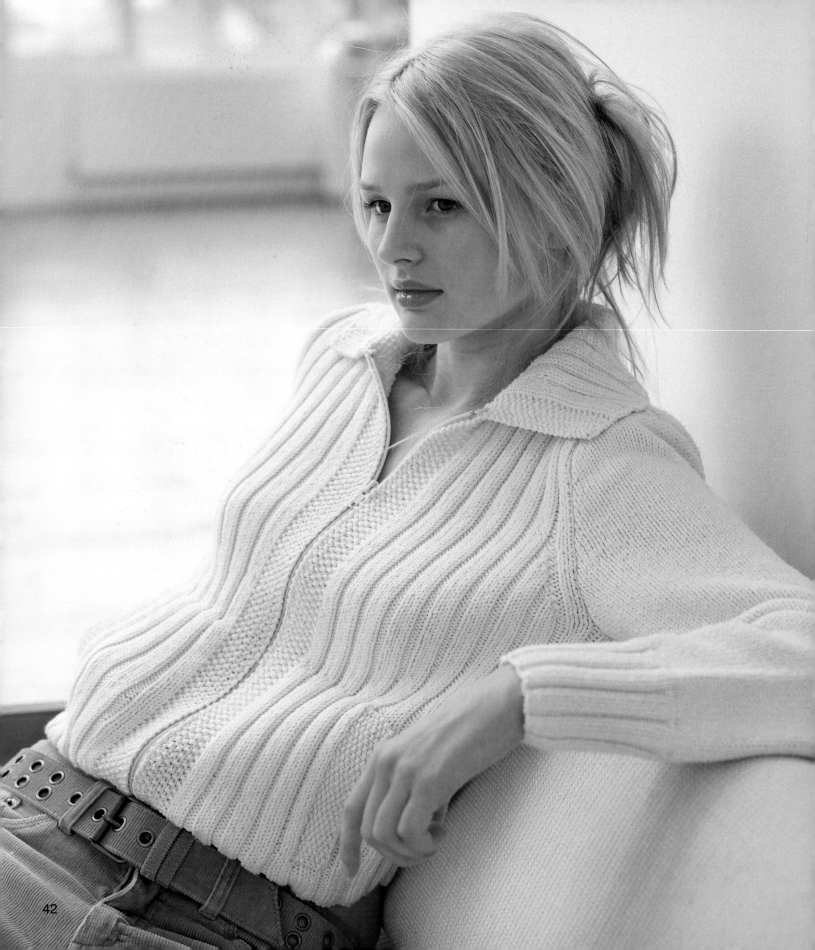

Bomber
ht Paris
h by Kim Hargreaves

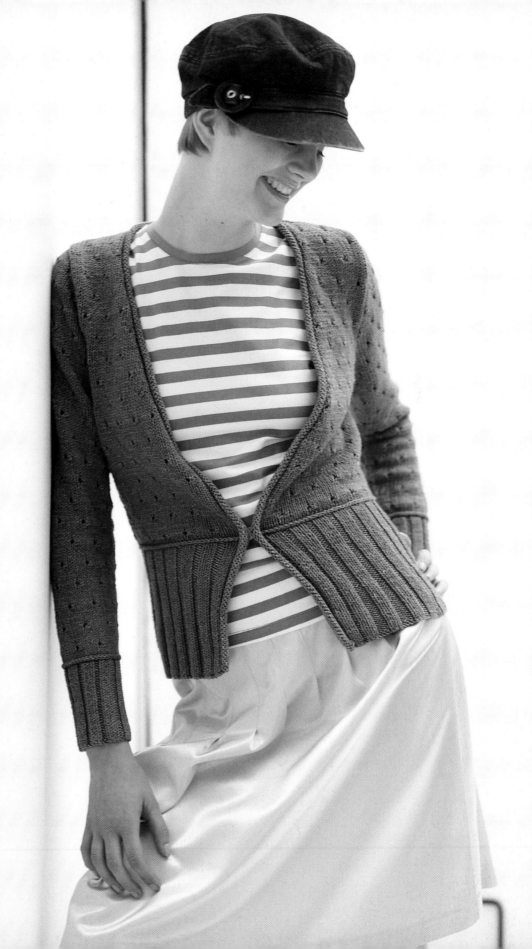

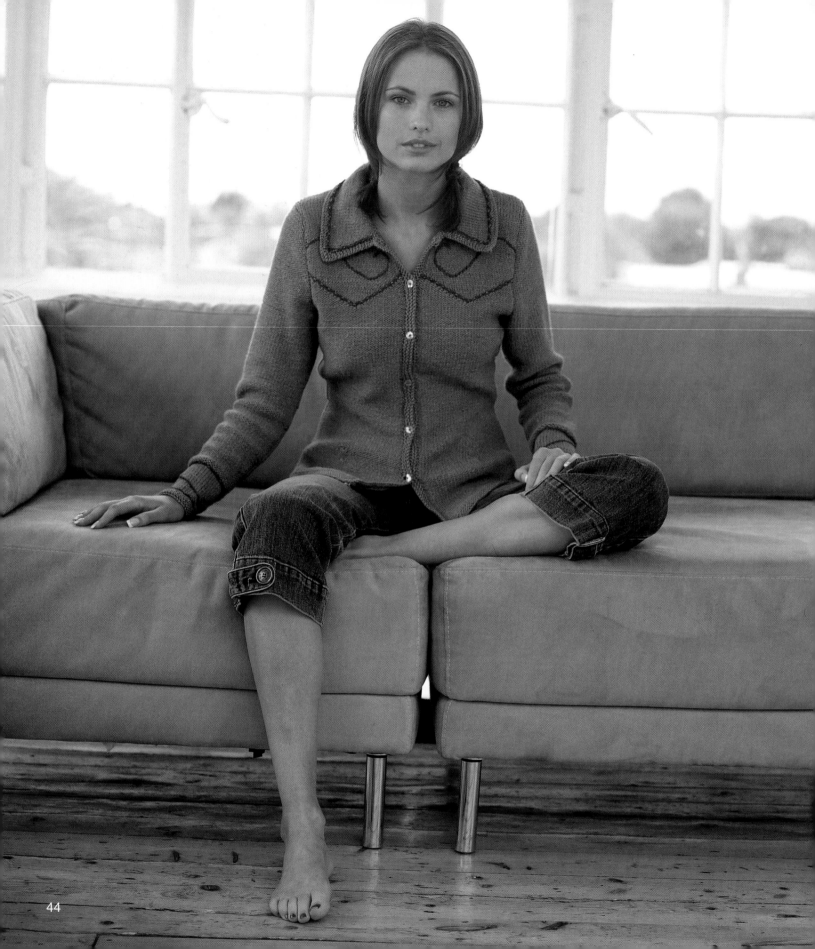

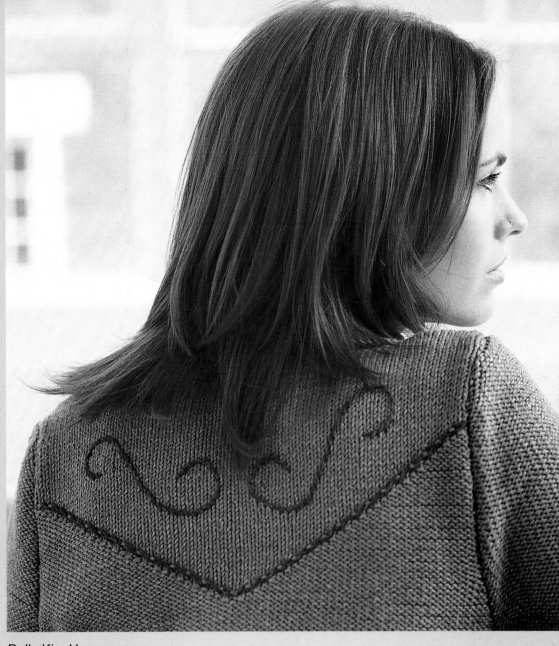

Dolly Kim Hargreaves

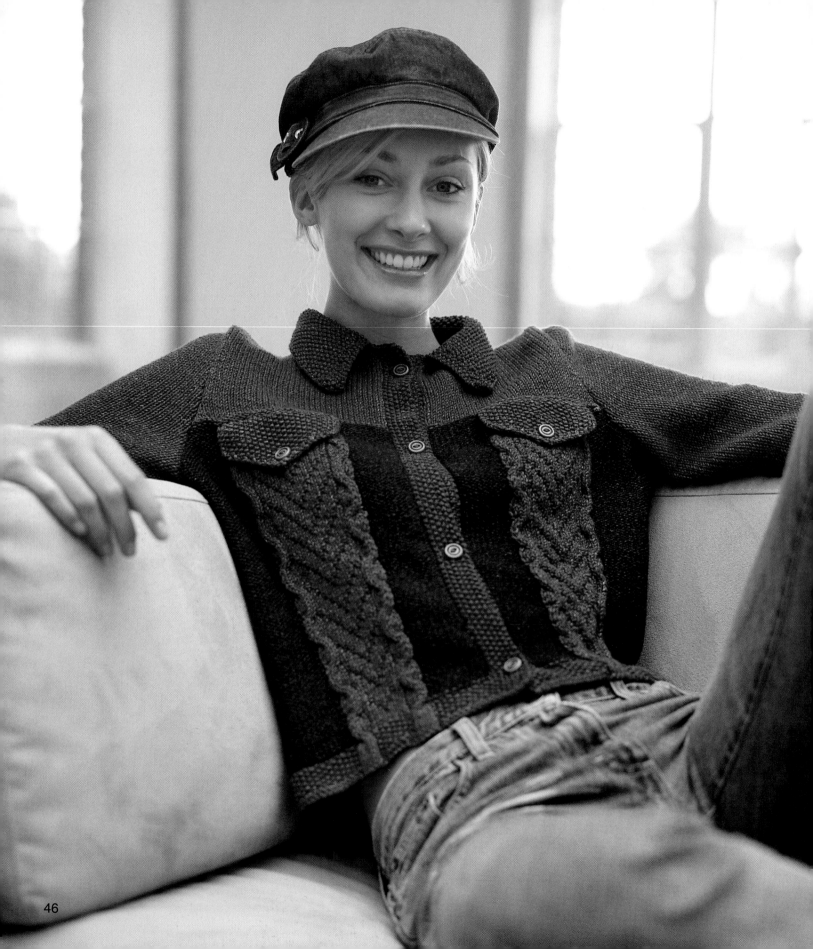

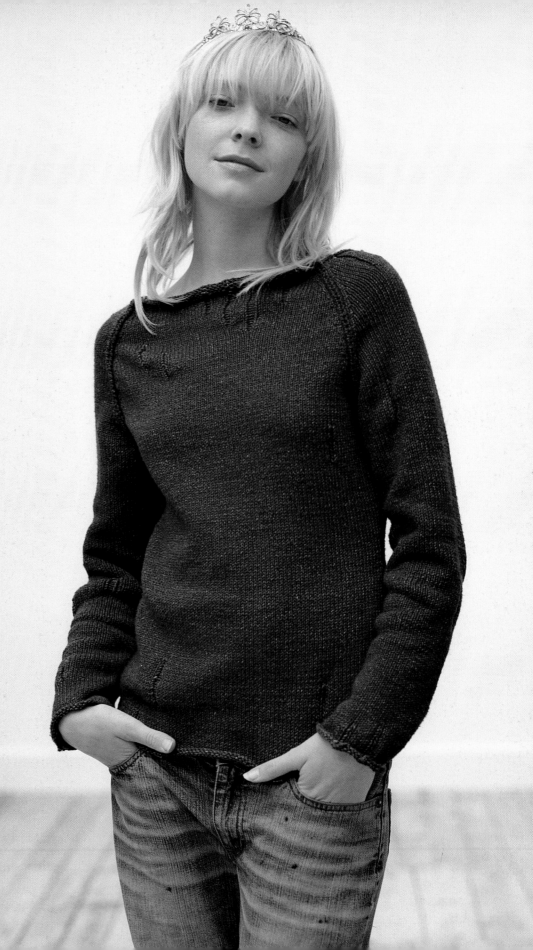

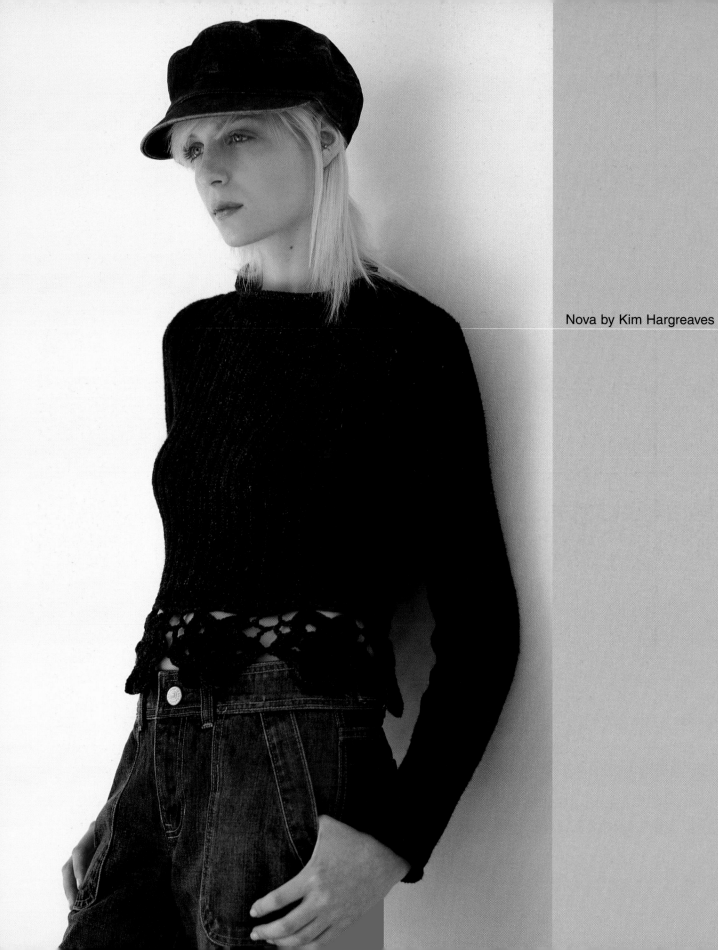

Nova by Kim Hargreaves

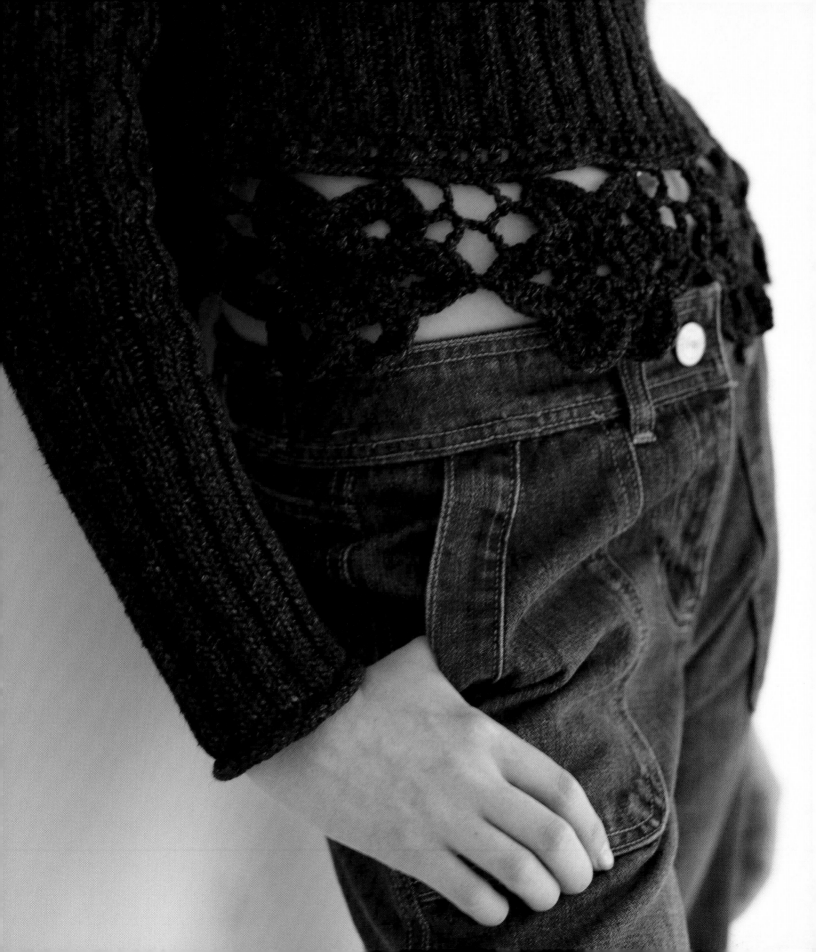

Action

KIM HARGREAVES

YARN

To fit bust/chest

ladies			mens			
S	M	L	**M**	**L**	**XL**	
86	91	97	**102**	**107**	**112**	cm
34	36	38	**40**	**42**	**44**	in

Rowan Denim

Striped sweater

A Memphis 229

11	12	13	**14**	**15**	**15**	x 50gm

B Nashville 225

2	2	2	**3**	**3**	**3**	x 50gm

C Tennessee 231

3	3	4	**4**	**4**	**4**	x 50gm

Plain sweater

15	16	17	**18**	**19**	**20**	x 50gm

(photographed in Nashville 225)

NEEDLES

1 pair 3¼ mm (no 10) (US 3) needles
1 pair 3¾ mm (no 9) (US 5) needles
1 pair 4mm (no 8) (US 6) needles

EXTRAS - Plain sweater only: Bleach and 2.5-3 cm wide paintbrush (to create optional "stripe" effect)

TENSION

Before washing: 20 sts and 28 rows to 10 cm measured over stocking stitch using 4mm (US 6) needles.

Tension note: Denim will shrink in length when washed for the first time. Allowances have been made in the pattern for shrinkage (see size diagram for after washing measurements).

Pattern note: The pattern is written for the 3 ladies sizes, followed by the 3 mens sizes in **bold**. Where only one figure appears this applies to all sizes in that group.

Striped sweater

Special note: When changing colour in middle of rows, leave approx 12-15 cm ends of both colours on RS of work. Knot them tog loosely now - later they will be darned in along row, cut off and left to fray.

RIGHT BACK

Cast on 77 (80: 83: **86: 89: 92**) sts using 3¾ mm (US 5) needles and yarn A.
Beg with a P row, work in rev st st as folls:
Work 10 rows.
Change to 4mm (US 6) needles.
Work a further 5 rows.
Row 16 (WS): Using yarn A K30, break off yarn A and join in yarn B, using yarn B K to end.
Work 10 rows.
Row 27 (RS): Using yarn B P24 (27: 30: **33: 36: 39**), break off yarn B and join in yarn A, using yarn A P to end.
Work 7 rows.
Row 35 (RS): Using yarn A P11 (14: 17: **20: 23: 26**), break off yarn A and join in yarn B, using yarn B P to end.
Work 12 rows.
Row 48 (WS): Using yarn B K16, break off yarn B and join in yarn C, using yarn C K to end.
Work 8 rows.
Row 57 (RS): Using yarn C P4 (6: 8: **10: 12: 14**), break off yarn C and join in yarn B, using yarn B P to end.
Work 14 rows.
Row 72 (WS): Using yarn B K42, break off yarn B and join in yarn C, using yarn C K to end.
Work 12 rows.
Row 85 (RS): Using yarn C P21 (24: 27: **30: 33: 36**), break off yarn C and join in yarn A, using yarn A P to end.**
Cont straight until right back measures 50.5 cm, ending with a WS row.
Shape armhole
Cast off 3 (4: 5: **6: 7: 8**) sts at beg of next row.
74 (76: 78: **80: 82: 84**) sts.
Work 1 row.

Dec 1 st at armhole edge of next 7 rows,
then on foll 3 (3: 4: **4: 5: 5**) alt rows.
64 (66: 67: **69: 70: 72**) sts.
Cont straight until armhole measures 24 (25:
26.5: **27.5: 29: 30**) cm, ending with a WS row.

Shape shoulders and back neck
Cast off 8 sts at beg of next row.
56 (58: 59: **61: 62: 64**) sts.
Work 1 row.

Next row (RS): Cast off 8 sts, P until
there are 11 (11: 12: **12: 13: 13**) sts on
right needle and turn, leaving rem sts
on a holder.
Work each side of neck separately.
Cast off 4 sts at beg of next row.
Cast off rem 7 (7: 8: **8: 9: 9**) sts.
With RS facing, rejoin yarn to rem sts,
cast off centre 28 (30: 30: **32: 32: 34**) sts,
P to end.
Work 1 row.
Cast off 4 sts at beg of next row.
Cast off rem 5 sts.

LEFT BACK
Cast on 33 (34: 37: **38: 41: 42**) sts using
3³/₄ mm (US 5) needles and yarn B.
Beg with a P row, work in rev st st as folls:
Work 10 rows.
Change to 4mm (US 6) needles.
Work a further 4 rows.

Row 15 (RS): Using yarn B P20, break off yarn
B and join in yarn C, using yarn C K to end.
Work 6 rows.

Row 22 (WS): Using yarn C K22 (23: 26: **27:
30: 31**), break off yarn C and join in yarn A,
using yarn A K to end.
Work 8 rows.

Row 31 (RS): Using yarn A P25, break off yarn
A and join in yarn C, using yarn C P to end.
Work 11 rows.

Row 43 (RS): Using yarn C P30, break off yarn
C and join in yarn B, using yarn B P to end.
Work 10 rows.

Row 54 (WS): Using yarn B K3 (5: 7: **8: 11:
12**), break off yarn B and join in yarn A,
using yarn A K to end.
Work 8 rows.

Row 63 (RS): Using yarn A P13, break off yarn
A and join in yarn C, using yarn C P to end.
Work 7 rows.

Row 71 (RS): Using yarn C P27, break off yarn
C and join in yarn A, using yarn A P to end.
Work 10 rows.

Row 82 (WS): Using yarn A K17 (18: 21: **22:
25: 26**), break off yarn A and join in yarn B,
using yarn B K to end.
Work 10 rows.

Row 93 (RS): Using yarn B P26, break
off yarn B and join in yarn A, using yarn
A P to end.**
Cont straight until left back measures
50.5 cm, ending with a RS row.

Shape armhole
Cast off 3 (4: 5: **6: 7: 8**) sts at beg of next row. 30
(30: 32: **32: 34: 34**) sts.
Dec 1 st at armhole edge of next 7 rows,
then on foll 3 (3: 4: **4: 5: 5**) alt rows.
20 (20: 21: **21: 22: 22**) sts.
Cont straight until armhole measures 24 (25:
26.5: **27.5: 29: 30**) cm, ending with a RS row.

Shape shoulder
Cast off 8 sts at beg of next and foll alt row.
Work 1 row.
Cast off rem 4 (4: 5: **5: 6: 6**) sts.

LEFT FRONT
Work as given for left back to **.
Cont straight until left front measures 50.5 cm,
ending with a WS row.

Shape armhole
Cast off 3 (4: 5: **6: 7: 8**) sts at beg
of next row.
30 (30: 32: **32: 34: 34**) sts.
Work 1 row.
Dec 1 st at armhole edge of next 7 rows,
then on foll 3 (3: 4: **4: 5: 5**) alt rows.
20 (20: 21: **21: 22: 22**) sts.
Cont straight until armhole measures 24 (25:
26.5: **27.5: 29: 30**) cm, ending with a WS row.

Shape shoulder
Cast off 8 sts at beg of next and foll alt row.
Work 1 row.
Cast off rem 4 (4: 5: **5: 6: 6**) sts.

RIGHT FRONT
Work as given for right back to **.
Cont straight until right front measures
50.5 cm, ending with a RS row.

Shape armhole
Cast off 3 (4: 5: **6: 7: 8**) sts at beg of next row.
74 (76: 78: **80: 82: 84**) sts.
Dec 1 st at armhole edge of next 7 rows,
then on foll 3 (3: 4: **4: 5: 5**) alt rows.
64 (66: 67: **69: 70: 72**) sts.
Cont straight until 22 (**22: 24: 24**) rows
less have been worked than on left front
to start of shoulder shaping, ending with
a WS row.

Shape neck
Next row (RS): P15 (**15: 16: 16**) and turn,
leaving rem sts on a holder.
Work each side of neck separately.
Dec 1 st at neck edge of next 6 rows,
then on foll 3 (**3: 4: 4**) alt rows, then
on foll 4th row. 5 sts.
Work 9 rows, ending with a WS row.

Shape shoulder
Cast off rem 5 sts.
With RS facing, rejoin yarn to rem sts, cast off
centre 16 (18: 18: **20: 18: 20**) sts, P to end.
33 (33: 34: **34: 36: 36**) sts.
Dec 1 st at neck edge of next 6 rows, then on
foll 3 (**3: 4: 4**) alt rows, then on foll 4th row.
23 (23: 24: **24: 25: 25**) sts.
Work 6 rows, ending with a RS row.

Shape shoulder
Cast off rem 8 sts at beg of next and foll alt row.
Work 1 row.
Cast off rem 7 (7: 8: **8: 9: 9**) sts.

LEFT SLEEVE
Cast on 54 (56: 58: **60: 62: 64**) sts using
3³/₄ mm (US 5) needles and yarn A.
Beg with a P row, work in rev st st as folls:
Work 10 rows.
Change to 4mm (US 6) needles.
Work a further 11 rows.

Row 22 (WS): Using yarn A K35 (36: 37: **38:
39: 40**), break off yarn A and join in yarn B,
using yarn B K to end.

Work 11 rows, inc 1 st at each end of last of these rows.
56 (58: 60: **62: 64: 66**) sts.
Row 34 (WS): Using yarn B K17 (18: 19: **20: 21: 22**), break off yarn B and join in yarn C, using yarn C K to end.
Work 7 rows.
Row 42 (WS): Using yarn C K30 (31: 32: **33: 34: 35**), break off yarn C and join in yarn B, using yarn B K to end.
Work 10 rows, inc 0 (1) st at each end of 0 (**9th: 7th: 7th**) of these rows.
56 (58: 60: **64: 66: 68**) sts.
Row 53 (RS): Using yarn B (inc in first st) 0 (**0: 1: 0**) times, P46 (47: 47: **50: 51: 52**), break off yarn B and join in yarn A, using yarn A P to last 0 (**0: 1: 0**) st, (inc in last st) 0 (0: 1: 0) times.
56 (58: 62: **64: 66: 68**) sts.
Work 10 rows, inc 1 (1: 0: **0: 0: 1**) st at each end of 6th (2nd: 0: **0: 0: 10th**) of these rows.
58 (60: 62: **64: 66: 70**) sts.
Row 64 (WS): Using yarn A K40 (41: 42: **43: 44: 46**), break off yarn A and join in yarn C, using yarn C K to end.
Work 8 rows, inc 0 (1: 1: 0) st at each end of 0 (5th: 1st: 0) of these rows.
58 (60: 62: **64: 68: 70**) sts.
Row 73 (RS): Using yarn C (inc in first st) 0 (0: 1: 0) times, P33 (34: 34: **37: 38: 39**), break off yarn C and join in yarn A, using yarn A P to last 0 (**0: 1: 0**) st, (inc in last st) 0 (0: 1: 0) times.
58 (60: 64: **66: 68: 70**) sts.
Beg with a K row, cont in rev st st, shaping sides by inc 1 st at each end of 12th (4th: 20th: **14th: 8th: 4th**) and every foll 26th (22nd: 20th: **18th: 16th: 14th**) row to 62 (66: 68: **72: 78: 84**) sts, then on every foll 24th (20th: 18th: **16th: 14th: -**) row until there are 64 (68: 72: **76: 80: -**) sts.
Cont straight until sleeve measures 53 (55: 57.5: **60: 61: 62.5**) cm, ending with a WS row.
Shape top
Cast off 3 (4: 5: **6: 7: 8**) sts at beg of next 2 rows.
58 (60: 62: **64: 66: 68**) sts.

Dec 1 st at each end of next 3 rows, then on foll 1 (2) alt rows, then on every foll 4th row until 32 (34: 36: **36: 38: 40**) sts rem.
Work 1 row, ending with a WS row.
Dec 1 st at each end of next and foll 0 (1: 2: **2: 3: 4**) alt rows, then on foll 3 rows, ending with a WS row.
Cast off rem 24 sts.

RIGHT SLEEVE
Cast on 54 (56: 58: **60: 62: 64**) sts using 3¾ mm (US 5) needles and yarn B.
Beg with a P row, work in rev st st as folls:
Work 10 rows.
Change to 4mm (US 6) needles.
Work a further 10 rows.
Row 21 (RS): Using yarn B P29 (30: 31: **32: 33: 34**), break off yarn B and join in yarn C, using yarn C P to end.
Work 11 rows.
Break off yarn C and join in yarn A.
Work 7 rows, inc 1 st at each end of first of these rows.
56 (58: 60: **62: 64: 66**) sts.
Row 40 (WS): Using yarn A K30 (31: 32: **33: 34: 35**), break off yarn A and join in yarn B, using yarn B K to end.
Work 10 rows, inc 0 (**0: 1: 1**) st at each end of 0 (0: 9th: 9th) of these rows.
56 (58: 60: **62: 66: 68**) sts.
Row 51 (RS): Using yarn B (inc in first st) 0 (**1: 0: 0**) times, P46 (47: 48: **48: 51: 52**), break off yarn B and join in yarn C, using yarn C P to last 0 (**1: 0: 0**) st, (inc in last st) 0 (**1: 0: 0**) times.
56 (58: 60: **64: 66: 68**) sts.
Work 10 rows, inc 1 (0) st at each end of 8th (4th: 2nd: 0) of these rows.
58 (60: 62: **64: 66: 68**) sts.
Row 62 (WS): Using yarn C K24 (25: 26: **27: 28: 29**), break off yarn C and join in yarn B, using yarn C B to end.
Work 8 rows, inc 0 (1) st at each end of 0 (7th: 3rd: 1st) of these rows.
58 (60: 62: **66: 68: 70**) sts.
Row 71 (RS): Using yarn B P19 (20: 21: **23:**

24: 25), break off yarn B and join in yarn A, using yarn A P to end.
Beg with a K row, cont in rev st st, shaping sides by inc 1 st at each end of 14th (6th: 2nd: **16th: 10th: 6th**) and every foll 26th (22nd: 20th: **18th: 16th: 14th**) row to 62 (66: 68: **72: 78: 84**) sts, then on every foll 24th (20th: 18th: **16th: 14th: -**) row until there are 64 (68: 72: **76: 80: -**) sts.
Cont straight until sleeve measures 53 (55: 57.5: **60: 61: 62.5**) cm, ending with a WS row.
Complete as given for left sleeve from start of sleeve top shaping.

MAKING UP
PRESS as described on the information page.
Join right shoulder seam using back stitch, or mattress stitch if preferred.
Neckband
With RS facing, using 3¼ mm (US 3) needles and yarn A, pick up and knit 20 (**20: 22: 22**) sts down left side of neck, 16 (18: 18: **20: 18: 20**) sts from front, 20 (**20: 22: 22**) sts up right side of neck, then 36 (38: 38: **40: 40: 42**) sts from back. 92 (96: 96: **100: 102: 106**) sts.
Beg with a P row, work in st st for 5 cm.
Cast off.
Undo knot left when changing colour and darn in ends for approx 3 cm each side of colour change point. Trim yarn ends to 8-10 cm.
Machine wash all pieces before completing sewing together.
Join left front to right front so that seam shows on RS. In same way, join back sections. See information page for finishing instructions, setting in sleeves using the set-in method and reversing neckband seam for roll.

Plain sweater

RIGHT and LEFT BACK, and LEFT and RIGHT FRONT
Work as given for striped sweater, working in st st throughout (beg with a K row) and using same colour throughout.

SLEEVES (both alike)

Cast on 54 (56: 58: **60: 62: 64**) sts using 3³/₄ mm (US 5) needles.

Beg with a K row, work in st st as folls:

Work 10 rows.

Change to 4mm (US 6) needles.

Cont in st st, shaping sides by inc 1 st at each end of 23rd and every foll 26th (22nd: 20th: **18th: 16th: 16th**) row to 62 (66: 68: **72: 78: 68**) sts, then on every foll 24th (20th: 18th: **16th: 14th: 14th**) row until there are 64 (68: 72: **76: 80: 84**) sts.

Cont straight until sleeve measures 53 (55: 57.5: **60: 61: 62.5**) cm, ending with a WS row.

Shape top

Cast off 3 (4: 5: **6: 7: 8**) sts at beg of next 2 rows. 58 (60: 62: **64: 66: 68**) sts.

Dec 1 st at each end of next 3 rows, then on foll 1 (2) alt rows, then on every foll 4th row until 32 (34: 36: **36: 38: 40**) sts rem.

Work 1 row, ending with a WS row.

Dec 1 st at each end of next and foll 0 (1: 2: **2: 3: 4**) alt rows, then on foll 3 rows, ending with a WS row.

Cast off rem 24 sts.

MAKING UP

PRESS as described on the information page.

Join right shoulder seam using back stitch, or mattress stitch if preferred.

Neckband

Work as given for neckband of striped sweater.

Decoration (optional)

Before washing knitted sections for first time and completing sewing up, decorate using bleach as folls: Cover work surface with old newspapers (this will stop bleach soaking through onto work surface) and lay knitted pieces onto this. Pour a little bleach into a saucer. Dip paintbrush into bleach and, using photograph as a guide, paint "stripes" onto knitted sections, starting at row-end edges so that "stripe" fades towards opposite edge. (Note: as bleach will remove colour from virtually everything it comes into contact with, protect your clothes and the surface you are working on) Once bleach has removed dye and you are happy with finished effect, immediately wash knitted sections to remove bleach residue. (Remember to wash it on its own as the bleach than remains in the garment could fade anything else washed with it)

Plain or decorated version

Machine wash all pieces before completing sewing together.

See information page for finishing instructions, setting in sleeves using the set-in method and reversing neckband seam for roll.

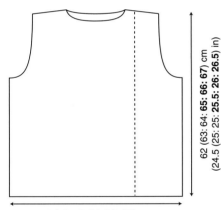

54 (56: 59: **61: 64: 66**) cm
(21.5 (22: 23: **24: 25: 26**) in)

62 (63: 64: **65: 66: 67**) cm
(24.5 (25: 25: **25.5: 26: 26.5**) in)

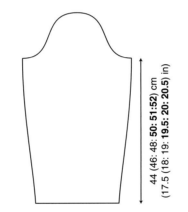

44 (46: 48: **50: 51:52**) cm
(17.5 (18: 19: **19.5: 20: 20.5**) in)

Creeper
LOUISA HARDING

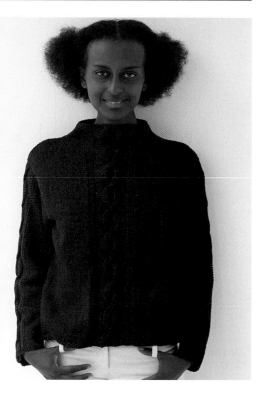

YARN

	XS	S	M	L	XL	
To fit bust	81	86	91	97	102	cm
	32	34	36	38	40	in

Rowan Denim

| 14 | 15 | 16 | 16 | 17 | x50gm |

(photographed in Nashville 225)

NEEDLES

1 pair 3¼ mm (no 10) (US 3) needles
1 pair 4mm (no 8) (US 6) needles
Cable needle

TENSION

Before washing: 20 sts and 28 rows to
10 cm measured over stocking stitch using
4mm (US 6) needles.

Tension note: Denim will shrink in length
when washed for the first time. Allowances
have been made in the pattern for shrinkage
(see size diagram for after washing
measurements).

SPECIAL ABBREVIATIONS

Cr6R = Cross 6 right Slip next st onto cable
needle and leave at back of work, K5, then
P1 from cable needle.
Cr6L = Cross 6 left Slip next 5 sts onto cable
needle and leave at front of work, P1, then
K5 from cable needle.
C10B = Cable 10 back Slip next 5 sts onto
cable needle and leave at back of work, K5,
then K5 from cable needle.

BACK and FRONT (both alike)

Cast on 95 (101: 105: 111: 115) sts using
3¼ mm (US 3) needles.
Row 1 (RS): K1, *P1, K1, rep from * to end.
Row 2: As row 1.
These 2 rows form moss st.
Work in moss st for a further 2 rows, inc 1 st
at end of last row and ending with a WS row.
96 (102: 106: 112: 116) sts.
Change to 4mm (US 6) needles.
Next row (inc) (RS): K36 (39: 41: 44: 46),
moss st 3 sts, P3, K1, M1, K2, M1,
(P2, M1) 3 times, K2, M1, K1, P3, moss st
3 sts, K to end.
102 (108: 112: 118: 122) sts.
Next row: P36 (39: 41: 44: 46), moss st 3 sts,
K3, P5, K8, P5, K3, moss st 3 sts, P to end.
Cont in patt as folls:
Row 1 (RS): K36 (39: 41: 44: 46), moss st
3 sts, work next 24 sts as row 1 of cable
chart, moss st 3 sts, K to end.
Row 2: P36 (39: 41: 44: 46), moss st 3 sts,
work next 24 sts as row 2 of cable chart,
moss st 3 sts, P to end.
These 2 rows set the sts - central cable
panel with 3 sts in moss st at each side, and
rem sts in st st.
Cont as set until work measures 33.5 (35:
35: 36: 36) cm, ending with a WS row.

Shape armholes

Keeping patt correct, cast off 5 sts at beg of
next 2 rows.
92 (98: 102: 108: 112) sts.
Dec 1 st at each end of next and foll 4 alt rows.
82 (88: 92: 98: 102) sts.
Cont straight until armhole measures
26.5 (26.5: 27.5: 27.5: 29) cm, ending with
a WS row.

Shape shoulders and neck

Cast off 4 (5: 6: 6: 7) sts at beg of next 4 rows,
then 5 (5: 5: 7: 7) sts at beg of foll 2 rows.
56 (58: 58: 60: 60) sts.
Dec 1 st at each end of next and foll 3 alt rows.
48 (50: 50: 52: 52) sts.
Work a further 6 rows, ending with a RS row.
Next row (dec) (WS): Patt 15 (16: 16: 17: 17),
(work 2 tog, patt 1 st) 5 times, work 2 tog,
patt to end.
42 (44: 44: 46: 46) sts.
Change to 3¼ mm (US 3) needles.
Keeping moss st correct as set by sts either
side of cable panel, work in moss st for 4 rows.
Cast off in moss st.

SLEEVES (both alike)

Cast on 55 (55: 57: 59: 59) sts using 3¼ mm
(US 3) needles.
Work in moss st as for back and front for 4
rows, inc 1 st at end of last row and ending
with a WS row.
56 (56: 58: 60: 60) sts.
Change to 4mm (US 6) needles.
Next row (inc) (RS): K13 (13: 14: 15: 15),
moss st 3 sts, P3, K1, M1, K2, M1, (P2, M1) 3
times, K2, M1, K1, P3, moss st 3 sts, K to end.
62 (62: 64: 66: 66) sts.
Next row: P13 (13: 14: 15: 15), moss st 3 sts,
K3, P5, K8, P5, K3, moss st 3 sts, P to end.
Cont in patt as folls:
Row 1 (RS): K13 (13: 14: 15: 15), moss st
3 sts, work next 24 sts as row 1 of cable
chart, moss st 3 sts, K to end.
Row 2: P13 (13: 14: 15: 15), moss st 3 sts,
work next 24 sts as row 2 of cable chart,
moss st 3 sts, P to end.

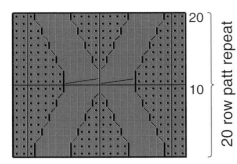

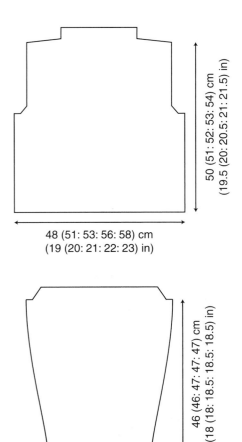

Key

■ K on RS, P on WS

▨ P on RS, K on WS

 Cr6R

◣ Cr6L

━ C10B

These 2 rows set the sts - central cable panel with 3 sts in moss st at each side, and rem sts in st st.

Cont as set, shaping sides by inc 1 st at each end of next and every foll 8th row to 82 (82: 90: 82: 102) sts, then on every foll 10th (10th: 10th: 10th: -) row until there are 94 (94: 98: 98: -) sts.

Cont straight until sleeve measures 55 (55: 56.5: 56.5: 56.5) cm, ending with a WS row.

Shape top

Keeping patt correct, cast off 5 sts at beg of next 2 rows.

84 (84: 88: 88: 92) sts.

Dec 1 st at each end of next and foll 3 alt rows, then on foll row, ending with a WS row.

Cast off rem 74 (74: 78: 78: 82) sts.

MAKING UP

PRESS as described on the information page. Machine wash all pieces before completing sewing together.

Join both shoulder and neck seams using back stitch, or mattress stitch if preferred.

See info page for finishing instructions, setting in sleeves using the shallow set-in method.

California

MARTIN STOREY

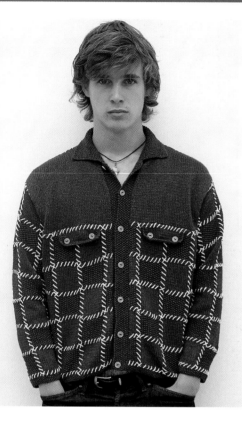

YARN

To fit bust/chest

	ladies			mens			
S	M	L	**M**	**L**	**XL**		
86	91	97	**102**	**107**	**112**	cm	
34	36	38	**40**	**42**	**44**	in	

Rowan Denim

A Memphis 229

15	16	17	**18**	**19**	**20**	x50gm

B Ecru 324

1	1	1	**2**	**2**	**2**	x50gm

NEEDLES

1 pair 3¼ mm (no 10) (US 3) needles
1 pair 4mm (no 8) (US 6) needles

BUTTONS - 11 x 75324

TENSION

Before washing: 20 sts and 28 rows to
10 cm measured over stocking stitch using
4mm (US 6) needles.

Tension note: Denim will shrink in length
when washed for the first time. Allowances
have been made in the pattern for shrinkage
(see size diagram for after washing
measurements).

Pattern note: The pattern is written for the 3
ladies sizes, followed by the 3 mens sizes in
bold. Where only one figure appears this
applies to all sizes in that group.

BACK

Cast on 95 (101: 105: **111: 115: 121**) sts using
3¼ mm (US 3) needles and yarn A.
Row 1 (RS): K0 (1: 1: **0: 0: 1**), *P1, K1, rep from
* to last 1 (0: 0: **1: 1: 0**) st, P1 (0: 0: **1: 1: 0**).
Row 2: As row 1.
These 2 rows form moss st.
Work in moss st for a further 8 rows, inc 1 st
at each end of last row and ending with a
WS row.
97 (103: 107: **113: 117: 123**) sts.
Change to 4mm (US 6) needles.
Starting and ending rows as indicated and
repeating the 48 row repeat throughout, cont
in patt from chart as folls:
Work 20 rows, ending with a WS row.
Inc 1 st at each end of next and every foll
24th row until there are 105 (111: 115: **121:
125: 131**) sts, taking inc sts into patt.
Work a further 23 rows, ending after patt row
20 and with a WS row.
(Back should measure 45 cm.)
Shape armholes
Keeping patt correct, cast off 6 sts at beg of
next 2 rows.
93 (99: 103: **109: 113: 119**) sts.
Dec 1 st at each end of next row.
91 (97: 101: **107: 111: 117**) sts.
Work 1 row, ending after patt row 24 and with
a WS row.

Work in garter st for 4 rows, dec 1 st at each
end of next and foll alt row.
87 (93: 97: **103: 107: 113**) sts.
Beg with a K row, cont in st st, dec 1 st at
each end of next and foll 2 alt rows.
81 (87: 91: **97: 101: 107**) sts.
Cont straight until armhole measures
24 (25.5: 26.5: **28: 29: 30**) cm, ending with
a WS row.
Shape shoulders and back neck
Cast off 9 (9: 10: **11: 11: 12**) sts at beg of
next 2 rows.
63 (69: 71: **75: 79: 83**) sts.
Next row (RS): Cast off 9 (9: 10: **11: 11: 12**) sts,
K until there are 12 (14: 14: **14: 16: 16**) sts on right
needle and turn, leaving rem sts on a holder.
Work each side of neck separately.
Cast off 4 sts at beg of next row.
Cast off rem 8 (10: 10: **10: 12: 12**) sts.
With RS facing, rejoin yarn to rem sts, cast off
centre 21 (23: 23: **25: 25: 27**) sts, K to end.
Complete to match first side, reverse shapings.

POCKET FLAPS (make 2)

Cast on 23 (25) sts using 3¼ mm (US 3)
needles and yarn A.
Work in garter st for 3 rows, ending with a
RS row.
Change to 4mm (US 6) needles.
Row 4 (WS): K3, P to last 3 sts, K3.
Row 5: Knit.
Rep rows 4 and 5, 5 times more, then row 4
again.
Break yarn and leave sts on a holder.

LEFT FRONT

Cast on 55 (58: 60: **63: 65: 68**) sts using
3¼ mm (US 3) needles and yarn A.
Row 1 (RS): K0 (1: 1: 0: 0: 1), *P1, K1, rep
from * to last st, P1.
Row 2: P1, *K1, P1, rep from * to last 0 (1: 1:
0: 0: 1) st, K0 (1: 1: **0: 0: 1**).
These 2 rows form moss st.
Mens sizes only
Work in moss st for a further 2 rows, ending
with a WS row.

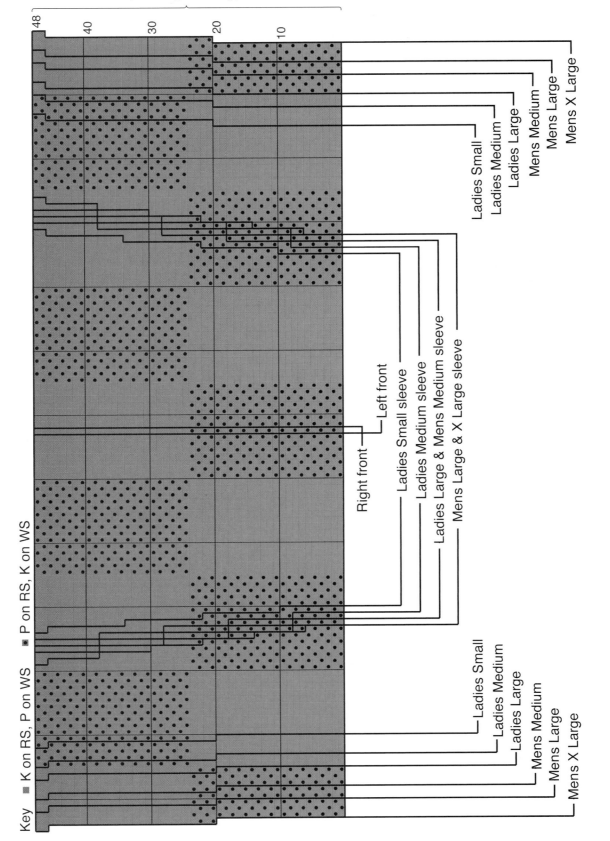

48 row patt repeat

Key ■ K on RS, P on WS ■ P on RS, K on WS

Right front
Left front
Ladies Small sleeve
Ladies Medium sleeve
Ladies Large & Mens Medium sleeve
Mens Large & X Large sleeve

Ladies Small
Ladies Medium
Ladies Large
Mens Medium
Mens Large
Mens X Large

Ladies Small
Ladies Medium
Ladies Large
Mens Medium
Mens Large
Mens X Large

57

Row 5 (buttonhole row) (RS): Moss st
to last 5 sts, work 2 tog, yrn (to make a
buttonhole), moss st 3 sts.

All sizes

Work in moss st for a further 7 (4) rows,
ending with a RS row.

Row 10 (WS): Moss st 8 sts and slip these
sts onto a holder, M1, moss st to last st, inc
in last st.

49 (52: 54: **57: 59: 62**) sts.

Change to 4mm (US 6) needles.

Starting and ending rows as indicated and
repeating the 48 row repeat throughout, cont
in patt from chart as folls:

Work 20 rows, ending with a WS row.

Inc 1 st at beg of next and every foll 24th row
until there are 53 (56: 58: **61: 63: 66**) sts, tak-
ing inc sts into patt.

Work a further 23 rows, ending after patt row
20 and with a WS row. (Left front should
match back to beg of armhole shaping.)

Shape armhole

Keeping patt correct, cast off 6 sts at beg of
next row.

47 (50: 52: **55: 57: 60**) sts.

Work 1 row.

Dec 1 st at armhole edge of next row.

46 (49: 51: **54: 56: 59**) sts.

Work 1 row, ending after patt row 24 and
with a WS row.

Work in garter st for 4 rows, dec 1 st at
armhole edge of next and foll alt row.

44 (47: 49: **52: 54: 57**) sts.

Place pocket flap

Next row (RS): K2tog, K11 (14: 16: **17:
19: 22**), holding WS of pocket flap against
RS of left front K tog first st of pocket flap
with next st of left front, K tog rem 22 (**24**) sts
of pocket flap with next 22 (**24**) sts of left
front in same way, K8.

Beg with a P row, cont in st st, dec 1 st at
armhole edge of 2nd and foll alt row.

41 (44: 46: **49: 51: 54**) sts.

Cont straight until 17 (17: **19: 19**) rows less
have been worked than on back to start of
shoulder shaping, ending with a RS row.

Shape neck

Cast off 3 (4: 4: **5: 4: 5**) sts at beg of next
row, then 5 sts at beg of foll alt row.

33 (35: 37: **39: 42: 44**) sts.

Dec 1 st at neck edge of next 2 rows, then on
foll 4 (4: 5: 5) alt rows, then on foll
4th row, ending with a WS row.

26 (28: 30: **32: 34: 36**) sts.

Shape shoulder

Cast off 9 (9: 10: **11: 11: 12**) sts at beg of
next and foll alt row.

Work 1 row.

Cast off rem 8 (10: 10: **10: 12: 12**) sts.

RIGHT FRONT

Cast on 55 (58: 60: **63: 65: 68**) sts using
3¼ mm (US 3) needles and yarn A.

Row 1 (RS): P1, *K1, P1, rep from * to last 0
(1: 1: **0: 0: 1**) st, K0 (1: 1: **0: 0: 1**).

Row 2: K0 (1: 1: 0: 0: 1), *P1, K1, rep from *
to last st, P1.

These 2 rows form moss st.

Ladies sizes only

Work in moss st for a further 2 rows, ending
with a WS row.

Row 5 (buttonhole row) (RS): Moss st
3 sts, yrn (to make a buttonhole), work 2 tog,
moss st to end.

All sizes

Work in moss st for a further 4 (7) rows,
ending with a RS row.

Row 10 (WS): Inc in first st, moss st to
last 8 sts, M1 and turn, leaving last 8 sts
on a holder.

49 (52: 54: **57: 59: 62**) sts.

Change to 4mm (US 6) needles.

Starting and ending rows as indicated and
repeating the 48 row repeat throughout, cont
in patt from chart and complete to match first
side, reversing shapings.

SLEEVES (both alike)

Cast on 53 (55: 57: **57: 59: 59**) sts using
3¼ mm (US 3) needles and yarn A.

Row 1 (RS): K1 (0: 1: **1: 0: 0**), *P1, K1, rep from
* to last 0 (1: 0: **0: 1: 1**) st, P0 (1: 0: **0: 1: 1**).

Row 2: As row 1.

These 2 rows form moss st.

Work in moss st for a further 8 rows,
inc 1 st at each end of last row and end
with a WS row.

55 (57: 59: **59: 61: 61**) sts.

Change to 4mm (US 6) needles.

Starting and ending rows as indicated and
repeating the 48 row repeat throughout, cont
in patt from chart, shaping sides by inc 1 st
at each end of 11th (9th: 9th: **9th: 9th: 7th**)
and every foll 12th (10th: 10th: **10th: 10th: 8th**)
row to 63 (83: 81: **71: 69: 95**) sts, then on
every foll 10th (-: 8th: **8th: 8th: 6th**) row until
there are 79 (-: 87: **91: 95: 99**) sts, taking inc
sts into patt.

Cont straight until sleeve measures 54 (55:
56.5: **59: 60: 61**) cm, ending with a WS row.

Shape top

Keeping patt correct, cast off 6 sts at beg of
next 2 rows.

67 (71: 75: 7**9: 83: 87**) sts.

Dec 1 st at each end of next and foll 5 alt
rows, then on foll row, ending with a WS row.

Cast off rem 53 (57: 61: **65: 69: 73**) sts.

MAKING UP

PRESS as described on the information page.

Join both shoulder seams using back stitch,
or mattress stitch if preferred.

Ladies sizes only

Button band

Slip 8 sts from left front holder onto
3¼ mm (US 3) needles and rejoin yarn A
with RS facing.

Cont in moss st as set until button band,
when slightly stretched, fits up left front
opening edge to neck shaping, end with a
WS row.

Break yarn and leave sts on a holder.

Slip stitch band in place.

Mark positions for 7 buttons on this band -
first to come level with buttonhole already
worked in right front, last to come just above
neck shaping and rem 5 buttons evenly
spaced between.

Buttonhole band

Slip 8 sts from right front holder onto 3¼ mm (US 3) needles and rejoin yarn A with WS facing. Cont in moss st as set until buttonhole band, when slightly stretched, fits up right front opening edge to neck shaping, ending with a WS row and with the addition of a further 5 buttonholes to correspond with positions marked for buttons worked as folls:

Buttonhole row (RS): Moss st 3 sts, yrn (to make a buttonhole), work 2 tog, moss st to end.

When band in complete, do NOT break yarn. Slip stitch band in place.

Mens sizes only

Button band

Slip 8 sts from right front holder onto 3¼ mm (US 3) needles and rejoin yarn A with WS facing.

Cont in moss st as set until button band, when slightly stretched, fits up right front opening edge to neck shaping, ending with a WS row.

Do NOT break yarn but set this ball of yarn to one side and leave sts on a holder.

Slip stitch band in place.

Mark positions for 7 buttons on this band -

first to come level with buttonhole already worked in left front, last to come just above neck shaping and rem 5 buttons evenly spaced between.

Buttonhole band

Slip 8 sts from left front holder onto 3¼ mm (US 3) needles and rejoin yarn A with RS facing.

Cont in moss st as set until buttonhole band, when slightly stretched, fits up left front opening edge to neck shaping, ending with a WS row and with the addition of a further 5 buttonholes to correspond with positions marked for buttons worked as folls:

Buttonhole row (RS): Moss st 3 sts, work 2 tog, yrn (to make a buttonhole), moss st 3 sts.

When band in complete, break yarn and leave sts on a holder.

Slip stitch band in place.

All sizes

Collar

With RS facing, using 3¼ mm (US 3) needles and yarn A, moss st 8 sts of right front band, pick up and knit 23 (**23: 25: 25**) sts up right side of neck, 29 (31: 31: **33: 33: 35**) sts from back, 23 (**23: 25: 25**) sts down left side of

neck, then moss st 8 sts of left front band. 91 (93: 93: **95: 99: 101**) sts.

Work in moss st as set by front bands for 1 row, ending with a WS row.

Ladies sizes only

Next row (RS): Moss st 3 sts, yrn (to make 7th buttonhole), work 2 tog, moss st to end.

Mens sizes only

Next row (RS): Moss st to last 5 sts, work 2 tog, yrn (to make 7th buttonhole), moss st 3 sts.

All sizes

Work in moss st for a further 4 rows.

Cast off 4 sts at beg of next 2 rows. 83 (85: 85: **87: 91: 93**) sts.

Cont in moss st until collar measures 12 cm from pick-up row.

Cast off in moss st.

Machine wash all pieces before completing sewing together.

See information page for finishing instructions, setting in sleeves using the shallow set-in method. Using yarn B and photograph as a guide, oversew along outline of blocks of patt to outline all patches, along yoke garter st lines, around armhole seams and across shoulder seams. Sew on 2 buttons to each pocket flap to secure flaps to fronts.

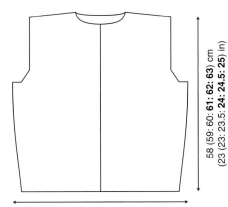

58 (59: 60: **61: 62: 63**) cm
(23 (23: 23.5: **24: 24.5: 25**) in)

52.5 (55.5: 57.5: **60.5: 62.5: 65.5**) cm
(20.5 (22: 22.5: **24: 24.5: 26**) in)

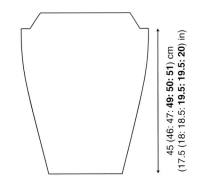

45 (46: 47: **49: 50: 51**) cm
(17.5 (18: 18.5: **19.5: 19.5: 20**) in)

Bomber

KIM HARGREAVES

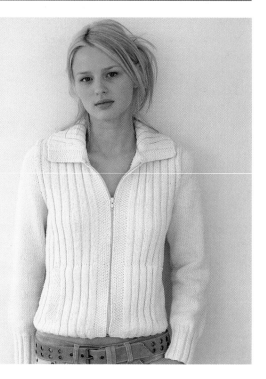

YARN

	XS	S	M	L	XL	
To fit bust	81	86	91	97	102	cm
	32	34	36	38	40	in

Rowan Denim

| | 14 | 14 | 15 | 16 | 17 | x50gm |

(photographed in Ecru 324)

NEEDLES

1 pair 3¼ mm (no 10) (US 3) needles
1 pair 3¾ mm (no 9) (US 5) needles
1 pair 4mm (no 8) (US 6) needles

ZIP - Open-ended zip to fit

TENSION

Before washing: 20 sts and 28 rows to
10 cm measured over stocking stitch using
4mm (US 6) needles.

Tension note: Denim will shrink in length
when washed for the first time. Allowances
have been made in the pattern for shrinkage
(see size diagram for after washing
measurements).

Pattern note: As row end edges of
fronts form actual finished edges of garment
it is important these edges are kept neat.
Therefore all new balls of yarn should
be joined in at side seam or armhole
edges of rows.

BACK

Cast on 86 (92: 96: 102: 106) sts using
3¼ mm (US 5) needles.
Row 1 (RS): K2 (0: 2: 0: 2), P2, *K3, P2, rep
from * to last 2 (0: 2: 0: 2) sts, K2 (0: 2: 0: 2).
Row 2: P2 (0: 2: 0: 2), K2, *P3, K2, rep from
* to last 2 (0: 2: 0: 2) sts, P2 (0: 2: 0: 2).
These 2 rows form rib.
Work in rib for a further 8 rows, ending with a
WS row.
Change to 4mm (US 6) needles.
Cont in rib, shaping side seams by inc 1 st at
each end of 11th and every foll 20th row until
there are 94 (100: 104: 110: 114) sts, taking
inc sts into rib.
Cont straight until back measures 35 (36: 36:
37: 37) cm, ending with a WS row.
Shape armholes
Keeping rib correct, cast off 4 (5: 5: 6: 6) sts
at beg of next 2 rows.
86 (90: 94: 98: 102) sts.
Next row (RS): P2, K3, P1, P2tog, rib to last
8 sts, P2tog tbl, P1, K3, P2.
Next row: K2, P3, K2, rib to last 7 sts, K2,
P3, K2.
Rep last 2 rows 6 (8: 10: 7: 9) times more. 72
(72: 72: 82: 82) sts.
Cont straight until armhole measures
24 (24: 25: 25: 26.5) cm, ending with
a WS row.
Shape shoulders and back neck
Cast off 8 (8: 8: 9: 9) sts at beg of next 2 rows.
56 (56: 56: 64: 64) sts.

Next row (RS): Cast off 8 (8: 8: 9: 9) sts, rib
until there are 12 (11: 11: 13: 13) sts on right
needle and turn, leaving rem sts on a holder.
Work each side of neck separately.
Cast off 4 sts at beg of next row.
Cast off rem 8 (7: 7: 9: 9) sts.
With RS facing, rejoin yarn to rem sts, cast
off centre 16 (18: 18: 20: 20) sts, rib to end.
Complete to match first side, reverse shapings.

POCKET LININGS (make 2)

Cast on 23 sts using 4mm (US 6) needles.
Row 1 (RS): K3, *P2, K3, rep from * to end.
Row 2: P3, *K2, P3, rep from * to end.
Rep last 2 rows once more.
Break yarn and leave sts on a holder.

LEFT FRONT

Cast on 49 (52: 54: 57: 59) sts using 3¾ mm
(US 5) needles.
Row 1 (RS): K2 (0: 2: 0: 2), *P2, K3, rep
from * to last 7 sts, (P1, K1) 3 times, P1.
Row 2: P1, (K1, P1) 3 times, *P3, K2, rep from
* to last 2 (0: 2: 0: 2) sts, P2 (0: 2: 0: 2).
These 2 rows set the sts - front opening
edge 7 sts in moss st with rem sts in rib.
Cont as set for a further 8 rows, end with a WS row.
Change to 4mm (US 6) needles.
Work a further 4 rows, ending with a WS row.
Place pocket
Next row (RS): Rib 19 (22: 24: 27: 29), slip
rem 30 sts onto a second holder and, in their
place, rib across 23 sts of first pocket lining.
42 (45: 47: 50: 52) sts.
Cont in rib, shaping side seam by inc 1 st at beg
of 6th and foll 20th row, taking inc sts into rib.
44 (47: 49: 52: 54) sts.
Work a further 18 rows, ending with a RS row.
Cast off 23 sts at beg of next row.
21 (24: 26: 29: 31) sts.
Break yarn and leave sts on a third holder.
Return to sts left on second holder and rejoin
yarn with RS facing.
Work 46 rows on these 30 sts, end
with a WS row.
Break yarn.

Join sections

Rejoin yarn to sts left on third holder with RS facing, inc in first st, rib to end, then patt across 30 sts left on third holder.

52 (55: 57: 60: 62) sts.

Cont in patt, inc 1 st at beg of 20th row.

53 (56: 58: 61: 63) sts.

Cont straight until left front matches back to beg of armhole shaping, ending with a WS row.

Shape armhole

Keeping rib correct, cast off 4 (5: 5: 6: 6) sts at beg of next row.

49 (51: 53: 55: 57) sts.

Work 1 row.

Working all armhole decreases in same way as for back, dec 1 st at armhole edge of next and foll 6 (8: 10: 7: 9) alt rows.

42 (42: 42: 47: 47) sts.

Cont straight until 19 (19: 19: 21: 21) rows less have been worked than on back to start of shoulder shaping, ending with a RS row.

Shape neck

Next row (WS): Patt 7 (8: 8: 8: 8) sts and slip these sts onto a holder, patt to end.

35 (34: 34: 39: 39) sts.

Dec 1 st at neck edge of next 8 rows, then on foll 2 (2: 2: 3: 3) alt rows, then on foll 4th row.

24 (23: 23: 27: 27) sts.

Work 2 rows, ending with a WS row.

Shape shoulder

Cast off 8 (8: 8: 9: 9) sts at beg of next and foll alt row.

Work 1 row.

Cast off rem 8 (7: 7: 9: 9) sts.

RIGHT FRONT

Cast on 49 (52: 54: 57: 59) sts using 3¾ mm (US 5) needles.

Row 1 (RS): P1, (K1, P1) 3 times, *K3, P2, rep from * to last 2 (0: 2: 0: 2) sts, K2 (0: 2: 0: 2).

Row 2: P2 (0: 2: 0: 2), *K2, P3, rep from * to last 7 sts, (P1, K1) 3 times, P1.

These 2 rows set the sts - front opening edge 7 sts in moss st with rem sts in rib.

Cont as set for a further 8 rows, ending

with a WS row.

Change to 4mm (US 6) needles.

Work a further 4 rows, ending with a WS row.

Place pocket

Next row (RS): Patt 30 sts and turn, leaving rem 19 (22: 24: 27: 29) sts on a holder.

Work a further 45 rows on these 30 sts, ending with a WS row.

Leave these sts on a second holder - **DO NOT** break yarn but set this ball of yarn to one side.

With RS facing and new ball of yarn, rib across 23 sts of second pocket lining, then rib across 19 (22: 24: 27: 29) sts left on holder.

42 (45: 47: 50: 52) sts.

Cont in rib, shaping side seam by inc 1 st at end of 6th and foll 20th row, taking inc sts into rib.

44 (47: 49: 52: 54) sts.

Work a further 18 rows, ending with a RS row.

Next row (WS): Rib 21 (24: 26: 29: 31), cast off rem 23 sts.

21 (24: 26: 29: 31) sts.

Break yarn and leave sts on a third holder.

Join sections

Using ball of yarn set to one side and RS facing, patt across 30 sts left on second holder, then work across sts left on third holder as folls: rib to last st, inc in last st.

52 (55: 57: 60: 62) sts.

Complete to match left front, reversing shapings.

SLEEVES (both alike)

Cast on 52 (52: 54: 56: 56) sts using 3¾ mm (US 5) needles.

Row 1 (RS): K0 (0: 1: 2: 2), P2, *K3, P2, rep from * to last 0 (0: 1: 2: 2) sts, K0 (0: 1: 2: 2).

Row 2: P0 (0: 1: 2: 2), K2, *P3, K2, rep from * to last 0 (0: 1: 2: 2) sts, P0 (0: 1: 2: 2).

These 2 rows form rib.

Work in rib for a further 28 rows, ending with a WS row.

Change to 4mm (US 6) needles.

Beg with a K row, work in st st for 2 rows.

Next row (RS): K2, M1, K to last 2 sts, M1, K2.

Working all increases as set by last row, cont in st st, shaping sides by inc 1 st at

each end of every foll 16th (14th: 14th: 14th: 12th) row to 64 (68: 66: 68: 68) sts, then on every foll 18th (-: 16th: 16th: 14th) row until there are 66 (-: 70: 72: 74) sts.

Cont straight until sleeve measures 51.5 (51.5: 53: 53: 53) cm, end with a WS row.

Shape top

Cast off 4 (5: 5: 6: 6) sts at beg of next 2 rows.

58 (58: 60: 60: 62) sts.

Dec 1 st at each end of next 3 rows, then on foll 3 alt rows, then on every foll 4th row until 32 (32: 34: 34: 36) sts rem.

Work 1 row, ending with a WS row.

Dec 1 st at each end of next and every foll alt row to 28 sts, then on foll 3 rows, ending with a WS row.

Cast off rem 22 sts.

MAKING UP

PRESS as described on the information page. Join shoulder seams using back stitch, or mattress stitch if preferred.

Collar

With RS facing and using 3¾ mm (US 5) needles, slip 7 (8: 8: 8: 8) sts from right front holder onto right needle, rejoin yarn and pick up and knit 26 (26: 26: 28: 28) sts up right side of neck, 26 (29: 29: 30: 30) sts from back, and 26 (26: 26: 28: 28) sts down left side of neck, then patt across 7 (8: 8: 8: 8) sts from left front holder.

92 (97: 97: 102: 102) sts.

Row 1 (RS of collar, WS of body): Moss st 7 sts, K3, *P2, K3; rep from * to last 7 sts, moss st 7 sts.

Row 2: Moss st 7 sts, P3, *K2, P3; rep from * to last 7 sts, moss st 7 sts.

These 2 rows set the sts.

Keeping sts correct as set, work 2 rows.

Row 5 (RS): Moss st 7 sts, K3, M1, rib to last 10 sts, M1, K3, moss st 7 sts.

Row 6: Moss st 7 sts, P3, rib to last 10 sts, P3, moss st 7 sts.

Rep last 4 rows 9 times more.

112 (117: 117: 122: 122) sts.

Cast off in patt.

Pocket borders (both alike)

With RS facing and using 3¼ mm (US 3) needles, pick up and knit 29 sts along row-end edge of pocket opening.

Row 1 (WS): K1, *P1, K1, rep from * to end.

Rep this row 10 times more.

Cast off in moss st.

Machine wash all pieces before completing sewing together.

See information page for finishing instructions, setting in sleeves using the set-in method.

Insert zip, placing top of zip level with collar pick-up row.

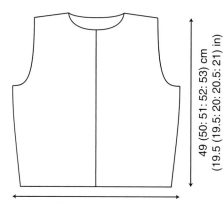

49 (50: 51: 52: 53) cm
(19.5 (19.5: 20: 20.5: 21) in)

47 (50: 52: 55: 57) cm
(18.5 (19.5: 20.5: 21.5: 22.5) in)

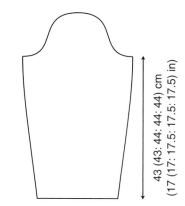

43 (43: 44: 44: 44) cm
(17 (17: 17.5: 17.5: 17.5) in)

Brooklyn
MARTIN STOREY

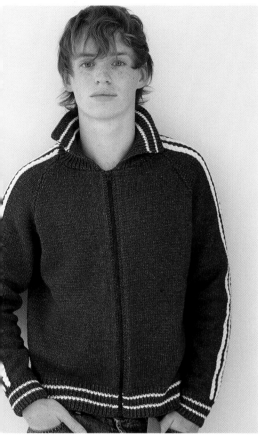

YARN

	S	M	L	XL	XXL	
To fit chest	97	102	107	112	117	cm
	38	40	42	44	46	in

Rowan Denim

A Memphis 229

	16	16	17	18	18	x50gm

B Ecru 324

	3	3	3	3	3	x50gm

NEEDLES

1 pair 3¼ mm mm (no 10) (US 3) needles
1 pair 3¾ mm mm (no 9) (US 5) needles
1 pair 4mm (no 8) (US 6) needles
Cable needle

ZIP - Open-ended zip to fit

TENSION

Before washing: 20 sts and 28 rows to 10cm measured over stocking stitch using 4mm (US 6) needles.

Tension note: Denim will shrink in length when washed for the first time. Allowances have been made in the pattern for shrinkage (see size diagram for after washing measurements).

SPECIAL ABBREVIATION

C4B = Cable 4 back Slip next 2 sts onto cable needle and leave at back of work, K2, then K2 from cable needle.

BACK

Cast on 113 (117: 123: 127: 133) sts using 3¾ mm (US 5) needles and yarn A.
Row 1 (RS): K1, *P1, K1, rep from * to end.
Row 2: P1, *K1, P1, rep from * to end.
These 2 rows form rib.
Using yarn A, work in rib for a further 4 rows.
Join in yarn B.
Using yarn B, work in rib for 2 rows.
Using yarn A, work in rib for 6 rows.
Rep last 8 rows once more, end with a WS row.
Break off yarn B.
Change to 4mm (US 6) needles.
Beg with a K row, cont in st st until back measures 43 cm, ending with a WS row.
Shape raglan armholes
Cast off 2 sts at beg of next 2 rows.
109 (113: 119: 123: 129) sts.
Dec 1 st at each end of next and foll 28 (29: 34: 35: 38) alt rows, then on every foll 4th row until 39 (41: 41: 43: 45) sts rem, end with a RS row.
Shape back neck
Next row (WS): P4 and turn, leaving rem sts on a holder.
Work each side of neck separately.
Dec 1 st at neck edge of next 2 rows.
Next row (RS): K2tog and fasten off.
With WS facing, rejoin yarn to rem sts, cast off centre 31 (33: 33: 35: 37) sts, P to end. 4 sts.
Dec 1 st at neck edge of next 2 rows.
Next row (RS): K2tog and fasten off.

LEFT FRONT

Cast on 57 (59: 61: 63: 67) sts using 3¾ mm (US 5) needles and yarn A.
Row 1 (RS): *K1, P1, rep from * to last 3 sts, K3.
Row 2: K2, P1, *K1, P1, rep from * to end.
These 2 rows set the sts - front opening edge 2 sts in garter st with rem sts in rib.
Using yarn A, work a further 4 rows.
Join in yarn B.
Using yarn B, work 2 rows.
Using yarn A, work 6 rows.
Rep last 8 rows once more, inc 0 (0: 1: 1: 0) st at end of last row and ending with a WS row.
57 (59: 62: 64: 67) sts.
Break off yarn B.
Change to 4mm (US 6) needles.
Next row (RS): Knit.
Next row: K2, P to end.
These 2 rows set the sts - front opening edge 2 sts still in garter st with rem sts now in st st.
Cont as set until left front matches back to beg of raglan armhole shaping, end with a WS row.
Shape raglan armhole
Cast off 2 sts at beg of next row.
55 (57: 60: 62: 65) sts.
Work 1 row.
Dec 1 st at raglan armhole edge of next and every foll alt row to 26 (27: 27: 28: 30) sts, then on every foll 4th (4th: 0: 0: 0) row until 25 (26: -: -: -) sts rem.
Work 2 (2: 0: 0: 0) rows, ending with a RS row.
Shape neck
Cast off 4 (5: 4: 5: 6) sts at beg of next row, then 5 sts at beg of foll 2 alt rows **and at same time** dec 1 st at raglan armhole edge of 2nd and foll 0 (0: 1: 1: 1) alt row.
10 (10: 11: 11: 12) sts.
Dec 1 st at neck edge of next 5 rows, then on foll 1 (1: 2: 2: 2) alt rows **and at same time** dec 1 st at raglan armhole edge of next (next: 3rd: 3rd: next) and foll 0 (0: 0: 0: 1) alt row, then on every foll 4th row. 2 sts.
Work 1 row.
Next row (RS): K2tog and fasten off.

RIGHT FRONT

Cast on 57 (59: 61: 63: 67) sts using 3¾ mm (US 5) needles and yarn A.

Row 1 (RS): K3, *P1, K1, rep from * to end.

Row 2: *P1, K1, rep from * to last 3 sts, P1, K2.

These 2 rows set the sts - front opening edge 2 sts in garter st with rem sts in rib.

Using yarn A, work a further 4 rows.

Join in yarn B.

Using yarn B, work 2 rows.

Using yarn A, work 6 rows.

Rep last 8 rows once more, inc 0 (0: 1: 1: 0) st at beg of last row and ending with a WS row.
57 (59: 62: 64: 67) sts.

Break off yarn B.

Change to 4mm (US 6) needles.

Next row (RS): Knit.

Next row: P to last 2 sts, K2.

These 2 rows set the sts - front opening edge 2 sts still in garter st with rem sts now in st st.

Complete to match left front, reverse shapings.

SLEEVES

Cast on 49 (49: 51: 53: 53) sts using 3¾ mm (US 5) needles and yarn A.

Using yarn A, work in rib as for back for 6 rows.

Join in yarn B.

Using yarn B, work in rib for 2 rows.

Rep last 8 rows once more.

Break off yarn B.

Work in rib for a further 5 rows.

Row 22 (WS): Rib 20 (20: 21: 22: 22), (M1, rib 2) 5 times, M1, rib to last st, inc in last st.
56 (56: 58: 60: 60) sts.

Change to 4mm (US 6) needles.

Using the intarsia technique as described on the information page, patt as folls:

Row 1 (RS): Using yarn A K20 (20: 21: 22: 22), using yarn B K4, (using yarn A K2, using yarn B K4) twice, using yarn A K to end.

Row 2: Using yarn A P20 (20: 21: 22: 22), using yarn B P4, (using yarn A P2, using yarn B P4) twice, using yarn A P to end.

Row 3: Using yarn A K20 (20: 21: 22: 22), using yarn B C4B, (using yarn A K2, using yarn B C4B) twice, using yarn A K to end.

Row 4: As row 2.

These 4 rows form patt.

Cont in patt, shaping sides by inc 1 st at each end of 3rd (3rd: 3rd: 3rd: next) and every foll 8th (8th: 8th: 8th: 6th) row to 80 (88: 90: 88: 64) sts, then on every foll 10th (-: -: 10th: 8th) row until there are 86 (-: -: 92: 94) sts.

Cont straight until sleeve measures 57.5 (59: 59: 60: 60) cm, ending with a WS row.

Shape top

Keeping patt correct, cast off 2 sts at beg of next 2 rows. 82 (84: 86: 88: 90) sts.

Dec 1 st at each end of next and every foll alt row to 36 sts, then on every foll 4th row until 22 sts rem.

Work 3 rows, ending with a WS row.

Left sleeve only

Dec 1 st at each end of next row. 20 sts.

Cast off 3 sts at beg of next row, then 4 sts at beg of foll alt row. 13 sts.

Dec 1 st at beg of next row. 12 sts.

Cast off 4 sts at beg of next and foll alt row, ending with a WS row.

Right sleeve only

Cast off 4 sts at beg and dec 1 st at end of next row. 17 sts.

Work 1 row.

Cast off 4 sts at beg of next row. 13 sts.

Work 1 row, ending with a WS row.

Rep last 4 rows once more.

Both sleeves

Cast off rem 4 sts.

MAKING UP

PRESS as described on the information page.

Join raglan seams using back stitch, or mattress stitch if preferred.

Collar

With RS facing, using 3¼ mm (US 3) needles and yarn A, beg and ending at front opening edges, pick up and knit 22 (23: 24: 25: 26) sts up right side of neck, 13 sts from right sleeve, 39 (41: 41: 43: 45) sts from back, 13 sts from left sleeve, then 22 (23: 24: 25: 26) sts down left side of neck.
109 (113: 115: 119: 123) sts.

Beg with row 2, work in rib as for back for 26 rows, ending with RS of collar (WS of body) facing for next row.

Join in yarn B.

Using yarn B, work in rib for 2 rows.

Using yarn A, work in rib for 6 rows.

Rep last 8 rows once more.

Cast off in rib.

Machine wash all pieces before completing sewing together.

See information page for finishing instructions, inserting zip into front opening so that top of zip is level with collar pick-up row.

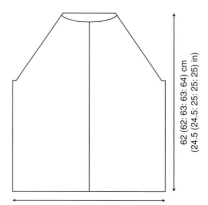

56.5 (58.5: 61.5: 63.5: 66.5) cm
(22 (23: 24: 25: 26) in)

62 (62: 63: 63: 64) cm
(24.5 (24.5: 25: 25: 25) in)

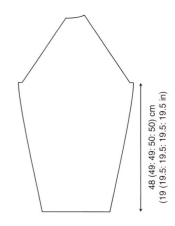

48 (49: 49: 50: 50) cm
(19 (19.5: 19.5: 19.5: 19.5) in)

Delta
LEAH SUTTON

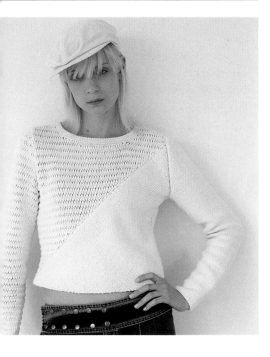

YARN

	XS-M	
One size, to fit bust	81-91	cm
	32-36	in

Rowan Denim

	10	x50gm

(photographed in Ecru 324)

NEEDLES

1 pair 3¼ mm (no 10) (US 3) needles
1 pair 4mm (no 8) (US 6) needles

TENSION

Before washing: 20 sts and 28 rows to
10 cm measured over stocking stitch using
4mm (US 6) needles.

Tension note: Denim will shrink in length
when washed for the first time. Allowances
have been made in the pattern for shrinkage
(see size diagram for after washing
measurements).

BACK

Lower back

This is worked downwards, starting at the
diagonal line across the body and ending at
the left side seam hem point.

Cast on 112 sts using 4mm (US 6) needles.
Beg with a P row, work in rev st st as folls:
Work 1 row.
Place red marker at beg of last row, and blue
marker at end of last row.
Dec 1 st at end of next 6 rows. 106 sts.
Dec 1 st at both ends of next and foll 2 alt
rows. 100 sts.
Work 1 row.
Dec 1 st at beg of next row, then at both
ends of foll row. 97 sts.
Work 1 row.
Dec 1 st at end of next 3 rows. 94 sts.
Work 1 row.
Dec 1 st at both ends of next row. 92 sts.
Dec 1 st at beg of next row. 91 sts.
Work 1 row.
Dec 1 st at both ends of next row. 89 sts.
Work 1 row.
Dec 1 st at beg of next 3 rows. 86 sts.
Dec 1 st at end of next and foll alt row. 84 sts.
Work 1 row.
Dec 1 st at both ends of next row. 82 sts.
Work 1 row.
Dec 1 st at end of next row. 81 sts.
Dec 1 st at beg of next and foll alt row. 79 sts.
Inc 1 st at beg of next row, then dec 1 st at
beg of foll row. 79 sts.
Rep last 2 rows once more.
Place green marker at end of last row - this is
underarm point.
Dec 1 st at both ends of next row, then at
end of foll row. 76 sts.
Rep last 2 rows twice more. 70 sts.
Dec 1 st at both ends of next 2 rows. 66 sts.
Dec 1 st at beg of next row, then at both
ends of foll row. 63 sts.
Rep last 2 rows twice more. 57 sts.

Dec 1 st at both ends of next row, then at
end of foll row. 54 sts.
Rep last 2 rows twice more. 48 sts.
Dec 1 st at both ends of next 2 rows.
44 sts.
Dec 1 st at beg of next row, then at both
ends of foll row. 41 sts.
Rep last 2 rows twice more. 35 sts.
Dec 1 st at both ends of next row, then at
end of foll row. 32 sts.
Dec 1 st at both ends of next and foll 2 alt
rows. 26 sts.
Dec 1 st at beg of next 7 rows. 19 sts.
Dec 1 st at both ends of next and foll 3 alt
rows. 11 sts.
Dec 1 st at beg of next row. 10 sts.
Work 1 row.
Dec 1 st at both ends of next row. 8 sts.
Work 1 row.
Dec 1 st at beg of next 3 rows. 5 sts.
Dec 1 st at end of next 3 rows. 2 sts.
Work 1 row, ending with a WS row.
Next row (RS): P2tog and fasten off.

Upper back

This is worked upwards, starting at base of
right side seam.
Cast on 2 sts using 4mm (US 6) needles.
Row 1 (RS): Winding yarn twice round
needle for each st, K2.
Place blue marker at end of last row.
Row 2: Dropping extra loops of previous row,
inc purlwise in first st, P1. 3 sts.
Row 3: K2, inc in last st. 4 sts.
Row 4: P4.
Row 5: Winding yarn twice round needle for
each st, K to last st, inc in last st. 5 sts.
Row 6: Dropping extra loops of previous row,
inc purlwise in first st, P to end. 6 sts.
Row 7: K2tog, K to last st, inc in last st. 6 sts.
Row 8: Purl.
Last 4 rows form patt and cont shaping.
***Keeping patt correct, cont as folls:
Inc 1 st at end of next row, then at beg of foll
row. 8 sts.
Inc 1 st at end of next row. 9 sts.
Inc 1 st at beg of next row. 10 sts.

Dec 1 st at beg and inc 1 st at end of next row. 10 sts.

Work 1 row.

Inc 1 st at end of next row and at same edge of foll 2 rows. 13 sts.

Rep last 4 rows once more. 16 sts.

*Work 1 row.

Inc 1 st at end of next row, then at beg of foll row. 18 sts.

Inc 1 st at both ends of next row. 20 sts.

Work 1 row.

Inc 1 st at end of next row, then at same edge of foll 2 rows. 23 sts.

Rep from * 4 times more. 51 sts.

Work 1 row.***

Inc 1 st at end of next row, then at beg of foll row, ending with a WS row. 53 sts.

Shape armhole

Cast off 4 sts at beg and inc 1 st at end of next row. 50 sts.

Dec 1 st at end of next row. 49 sts.

Dec 1 st at beg and inc 1 st at end of next row.

Inc 1 st at beg and dec 1 st at end of next row.

Dec 1 st at beg and inc 1 st at end of next row.

Dec 1 st at end of next row. 48 sts.

Inc 1 st at end of next row. 49 sts.

Inc 1 st at beg and dec 1 st at end of next row.

**Inc 1 st at end of next and foll alt row. 51 sts.

Inc 1 st at beg of next row. 52 sts.

Rep from ** 3 times more. 61 sts.

Inc 1 st at end of next row. 62 sts.

Place red marker at end of last row.

Work 9 rows, ending with a WS row.

Shape back neck and shoulders

Next row (RS): Patt 17 sts and turn, leaving rem sts on a holder.

Work each side of neck separately.

Dec 1 st at neck edge of next 3 rows. 14 sts.

Cast off 7 sts at beg and dec 1 st at end of next row.

Work 1 row.

Cast off rem 6 sts.

With RS facing, rejoin yarn to rem sts, cast off centre 28 sts, patt to end.

Dec 1 st at neck edge of next 4 rows, ending with a RS row. 13 sts.

Cast off 7 sts at beg of next row.

Work 1 row.

Cast off rem 6 sts.

FRONT

Lower front

Work as given for lower back, reversing all shaping and positions of markers.

Upper front

This is worked upwards, starting at base of right side seam.

Cast on 2 sts using 4mm (US 6) needles.

Row 1 (RS): Winding yarn twice round needle for each st, K2.

Place blue marker at beg of last row.

Row 2: Dropping extra loops of previous row, P1, inc purlwise in last st. 3 sts.

Row 3: Inc in first st, K2. 4 sts.

Row 4: P4.

Row 5: Winding yarn twice round needle for each st, inc in first st, K to end. 5 sts.

Row 6: Dropping extra loops of previous row, P to last st, inc purlwise in last st. 6 sts.

Row 7: Inc in first st, K to last 2 sts, K2tog. 6 sts.

Row 8: Purl.

Last 4 rows form patt and cont shaping.

Work as given for upper back from *** to ***, reversing all shaping.

Inc 1 st at beg of next row, ending with a RS row. 52 sts.

Shape armhole

Cast off 4 sts at beg and inc 1 st at end of next row. 49 sts.

Inc 1 st at beg and dec 1 st at end of next row.

Dec 1 st at beg of next row. 48 sts.

Inc 1 st at beg and dec 1 st at end of next row.

Dec 1 st at beg and inc 1 st at end of next row.

Inc 1 st at beg and dec 1 st at end of next row.

Work 1 row.

Inc 1 st at beg of next row.

Dec 1 st at beg and inc 1 st at end of next row. 49 sts.

****Inc 1 st at beg of next and foll alt row. 51 sts.

Inc 1 st at end of next row. 52 sts.

Rep from **** 3 times more. 61 sts.

Shape neck

Next row (RS): Inc in first st, patt 17 sts and turn, leaving rem sts on a holder.

Place red marker at beg of last row.

Work each side of neck separately.

Dec 1 st at neck edge of next 5 rows, then on foll 4th row.

13 sts.

Work 4 rows, ending with a WS row.

Shape shoulder

Cast off 7 sts at beg of next row.

Work 1 row.

Cast off rem 6 sts.

With RS facing, rejoin yarn to rem sts, cast off centre 24 sts, patt to end.

Dec 1 st at neck edge of next 5 rows, then on foll 4th row.

13 sts.

Work 5 rows, ending with a RS row.

Shape shoulder

Cast off 7 sts at beg of next row.

Work 1 row.

Cast off rem 6 sts.

LEFT SLEEVE

Cast on 46 sts using 3¼ mm (US 3) needles.

Work in garter st for 6 rows, ending with a WS row.

Change to 4mm (US 6) needles.

Beg with a P row, cont in rev st st, shaping sides by inc 1 st at each end of 13th and every foll 12th row until there are 66 sts.

Work 19 rows, ending with a WS row.

Shape top

Cast off 4 sts at beg of next 2 rows. 58 sts.

Dec 1 st at each end of next 3 rows, then on foll 2 alt rows, then on every foll 4th row until 32 sts rem.

Work 1 row, ending with a WS row.

Dec 1 st at each end of next and foll 2 alt rows, then on foll 3 rows, ending with a WS row.

Cast off rem 20 sts.

RIGHT SLEEVE

Cast on 42 sts using 3¼ mm (US 3) needles.

Work in garter st for 6 rows, ending with a WS row.

Change to 4mm (US 6) needles.

Row 1 (RS): Winding yarn twice round needle for each st, knit.

Row 2: Dropping extra loops of previous row, purl.

Row 3: Knit.

Row 4: Purl.

These 4 rows form patt.

Cont in patt, shaping sides by inc 1 st at each end of 3rd and every foll 10th row to 56 sts, then on every foll 8th row until there are 60 sts.

Work 11 rows, ending with a WS row.

Shape top

Keeping patt correct, cast off 4 sts at beg of next 2 rows. 52 sts.

Dec 1 st at each end of next 5 rows, then on foll alt row, then on every foll 4th row until 34 sts rem.

Work 1 row, ending with a WS row.

Dec 1 st at each end of next and foll alt row, then on foll 6 rows, ending with a RS row.

Cast off rem 18 sts.

MAKING UP

PRESS as described on the information page. Join right shoulder seam using back stitch, or mattress stitch if preferred.

Neckband

With RS facing and using 3¼ mm (US 3) needles, pick up and knit 18 sts down left side of front neck, 24 sts from front, 18 sts up right side of front neck, 6 sts down right side of back neck, 28 sts from back, then 6 sts up left side of back neck. 100 sts.

Work in garter st for 6 rows.

Cast off knitwise (on WS).

Machine wash all pieces before completing sewing together.

See information page for finishing instructions, joining upper and lower backs and fronts matching coloured markers and setting in sleeves using the set-in method.

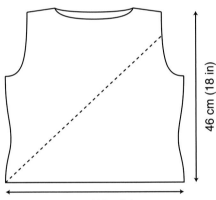

46 cm (18 in)

49 cm (19.5 in)

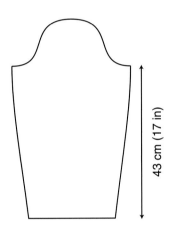

43 cm (17 in)

Haven

KIM HARGREAVES

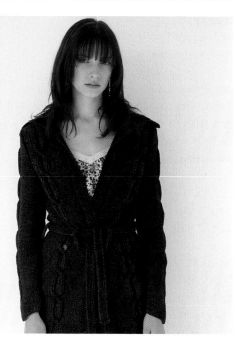

YARN

	XS	S	M	L	XL	
To fit bust	81	86	91	97	102	cm
	32	34	36	38	40	in

Rowan Denim

	19	20	21	22	23	x50gm

(photographed in Nashville 225)

NEEDLES

1 pair 3¾ mm (no 9) (US 5) needles
1 pair 4mm (no 8) (US 6) needles
Cable needle

TENSION

Before washing: 20 sts and 28 rows to
10 cm measured over stocking stitch using
4mm (US 6) needles.

Tension note: Denim will shrink in length
when washed for the first time. Allowances
have been made in the pattern for shrinkage
(see size diagram for after washing
measurements).

Pattern note: As row end edges of fronts
form actual finished edges of garment it is
important these edges are kept neat.
Therefore all new balls of yarn should
be joined in at side seam or armhole
edges of rows.

SPECIAL ABBREVIATIONS

Cr6R = Cross 6 right Slip next st onto
cable needle and leave at back of work,
(K1 tbl, P1) twice, K1 tbl, then P1 from
cable needle.
Cr6L = Cross 6 left Slip next 5 sts onto cable
needle and leave at front of work, P1, then
(K1 tbl, P1) twice, K1 tbl from cable needle.
C11B = Cable 11 back Slip next 6 sts onto
cable needle and leave at back of work, (K1
tbl, P1) twice, K1 tbl, then (P1, K1 tbl) 3 times
from cable needle.
C11F = Cable 11 front Slip next 5 sts onto
cable needle and leave at front of work, (K1
tbl, P1) 3 times, then (K1 tbl, P1), K1 tbl from
cable needle.

BACK

Cast on 107 (113: 117: 123: 127) sts using
3¾ mm(US 5) needles.
Patt as folls:
Row 1 (RS): P0 (1: 1: 0: 0), (K1, P1) 9 (10: 11:
13: 14) times, *(K1 tbl, P1) twice,
K1 tbl, P5, K1 tbl, (P1, K1 tbl) twice,
(P1, K1) 6 times, P1, rep from * once more,
(K1 tbl, P1) twice, K1 tbl, P5, K1 tbl,
(P1, K1 tbl) twice, (P1, K1) 9 (10: 11: 13: 14)
times, P0 (1: 1: 0: 0).
Row 2: P0 (1: 1: 0: 0), (K1, P1) 9 (10: 11: 13:
14) times, *(P1 tbl, K1) twice, P1 tbl,
K5, P1 tbl, (K1, P1 tbl) twice, (P1, K1) 6
times, P1, rep from * once more, (P1 tbl, K1)
twice, P1 tbl, K5, P1 tbl, (K1, P1 tbl) twice,

(P1, K1) 9 (10: 11: 13: 14) times,
P0 (1: 1: 1: 0: 0).
Last 2 rows set the sts - 4 cable panels with
moss st between and at sides.
Cont as set for a further 10 rows, ending with
a WS row.
Change to 4mm (US 6) needles.
Row 13 (RS): P18 (21: 23: 26: 28), *(K1 tbl,
P1) twice, K1 tbl, P5, K1 tbl, (P1, K1 tbl)
twice, P13, rep from * twice more, P to end.
Row 14: K18 (21: 23: 26: 28), *(P1 tbl, K1)
twice, P1 tbl, K5, P1 tbl, (K1, P1 tbl) twice,
K13, rep from * twice more, K to end.
Last 2 rows set position of cable panels now
with rev st st between and at sides.
Rows 15 and 16: As rows 13 and 14.
Row 17: P18 (21: 23: 26: 28), *Cr6L, P3,
Cr6R, P13, rep from * twice more, P to end.
Row 18: K18 (21: 23: 26: 28), *(K1, P1 tbl) 3
times, K3, (P1 tbl, K1) 3 times, K13, rep from
* twice more, K to end.
Row 19: P18 (21: 23: 26: 28), *P1,
Cr6L, P1, Cr6R, P14, rep from * twice
more, P to end.
Row 20: K18 (21: 23: 26: 28), *K2, (P1 tbl,
K1) 5 times, P1 tbl, K15, rep from * twice
more, K to end.
Row 21: P18 (21: 23: 26: 28), *P2, C11F,
P15, rep from * twice more, P to end.
Row 22: As row 20.
Row 23: P18 (21: 23: 26: 28), *P1,
Cr6R, P1, Cr6L, P14, rep from * twice
more, P to end.
Row 24: As row 18.
Row 25: P18 (21: 23: 26: 28), *Cr6R, P3,
Cr6L, P13, rep from * twice more, P to end.
Row 26: As row 14.
Rows 27 to 38: As rows 13 and 14, 6 times.
Rows 39 to 48: As rows 17 to 26.
Rows 49 and 50: As rows 13 and 14.
Last 50 rows form cable panels.
Cont in patt until back measures
19 (20: 20: 21: 21) cm, end with a WS row.
Cont in patt, shaping side seams by dec 1 st
at each end of next and every foll 10th row
until 97 (103: 107: 113: 117) sts rem.

Work 15 rows, ending with a WS row.

Inc 1 st at each end of next and every foll 8th row until there are 107 (113: 117: 123: 127) sts, taking inc sts into rev st st.

Cont straight until back measures 56.5 (57.5: 57.5: 59: 59) cm, ending with a WS row.

Shape armholes

Keeping patt correct, cast off 4 (5: 5: 6: 6) sts at beg of next 2 rows.

99 (103: 107: 111: 115) sts.

Dec 1 st at each end of next 3 (3: 5: 5: 7) rows, then on foll 6 (7: 6: 7: 6) alt rows.

81 (83: 85: 87: 89) sts.

Cont straight until armhole measures 27.5 (27.5: 29: 29: 30) cm, end with a WS row.

Shape shoulders and back neck

Cast off 8 (8: 9: 9: 9) sts at beg of next 2 rows.

65 (67: 67: 69: 71) sts.

Next row (RS): Cast off 8 (8: 9: 9: 9) sts, patt until there are 13 (13: 12: 12: 13) sts on right needle and turn, leaving rem sts on a holder.

Work each side of neck separately.

Cast off 4 sts at beg of next row.

Cast off rem 9 (9: 8: 8: 9) sts.

With RS facing, rejoin yarn to rem sts, cast off centre 23 (25: 25: 27: 27) sts, patt to end.

Complete to match first side, reverse shapings.

LEFT FRONT

Cast on 54 (57: 59: 62: 64) sts using 3¼ mm (US 5) needles.

Patt as folls:

Row 1 (RS): P0 (1: 1: 0: 0), (K1, P1) 9 (10: 11: 13: 14) times, (K1 tbl, P1) twice, K1 tbl, P5, K1 tbl, (P1, K1 tbl) twice, (P1, K1) 10 times, P1.

Row 2: P1, (K1, P1) 10 times, (P1 tbl, K1) twice, P1 tbl, K5, P1 tbl, (K1, P1 tbl) twice, (P1, K1) 9 (10: 11: 13: 14) times, P0 (1: 1: 0: 0).

Last 2 rows set the sts - cable panel with moss st at sides.

Cont as set for a further 10 rows, end with a WS row.

Change to 4mm (US 6) needles.

Row 13 (RS): P18 (21: 23: 26: 28), (K1 tbl, P1) twice, K1 tbl, P5, K1 tbl, (P1, K1 tbl) twice, P to last 8 sts, (K1, P1) 4 times.

Row 14: (P1, K1) 4 times, K13, (P1 tbl, K1) twice, P1 tbl, K5, P1 tbl, (K1, P1 tbl) twice, K to end.

Last 2 rows set position of cable panel and front opening edge in moss st, now with rev st st between.

Rows 15 and 16: As rows 13 and 14.

Row 17: P18 (21: 23: 26: 28), Cr6L, P3, Cr6R, P to last 8 sts, (K1, P1) 4 times.

Row 18: (P1, K1) 4 times, K13, (K1, P1 tbl) 3 times, K3, (P1 tbl, K1) 3 times, K to end.

Row 19: P19 (22: 24: 27: 29), Cr6L, P1, Cr6R, P to last 8 sts, (K1, P1) 4 times.

Row 20: (P1, K1) 4 times, K15, (P1 tbl, K1) 5 times, P1 tbl, K to end.

Row 21: P20 (23: 25: 28: 30), C11B, P to last 8 sts, (K1, P1) 4 times.

Row 22: As row 20.

Row 23: P19 (22: 24: 27: 29), Cr6R, P1, Cr6L, P to last 8 sts, (K1, P1) 4 times.

Row 24: As row 18.

Row 25: P18 (21: 23: 26: 28), Cr6R, P3, Cr6L, P to last 8 sts, (K1, P1) 4 times.

Row 26: As row 14.

Rows 27 to 38: As rows 13 and 14, 6 times.

Rows 39 to 48: As rows 17 to 26.

Rows 49 and 50: As rows 13 and 14.

Last 50 rows form cable panel.

Cont in patt until left front measures 19 (20: 20: 21: 21) cm, ending with a WS row.

Cont in patt, shaping side seams by dec 1 st at beg of next and every foll 10th row until 49 (52: 54: 57: 59) sts rem.

Work 15 rows, ending with a WS row.

Inc 1 st at beg of next and every foll 8th row until there are 54 (57: 59: 62: 64) sts, taking inc sts into rev st st.

Cont straight until left front matches back to beg of armhole shaping, ending with a WS row.

Shape armhole

Keeping patt correct, cast off 4 (5: 5: 6: 6) sts at beg of next row. 50 (52: 54: 56: 58) sts.

Work 1 row.

Dec 1 st at armhole edge of next 3 (3: 5: 5: 7) rows, then on foll 6 (7: 6: 7: 6) alt rows.

41 (42: 43: 44: 45) sts.

Cont straight until 19 (19: 19: 21: 21) rows less have been worked than on back to start of shoulder shaping, ending with a RS row.

Shape neck

Next row (WS): Patt 7 (8: 8: 8: 8) sts and slip these sts onto a holder, patt to end.

34 (34: 35: 36: 37) sts.

Dec 1 st at neck edge of next 4 rows, then on foll 5 (5: 5: 6: 6) alt rows.

25 (25: 26: 26: 27) sts.

Work 4 rows, ending with a WS row.

Shape shoulder

Cast off 8 (8: 9: 9: 9) sts at beg of next and foll alt row.

Work 1 row.

Cast off rem 9 (9: 8: 8: 9) sts.

RIGHT FRONT

Cast on 54 (57: 59: 62: 64) sts using 3¾ mm (US 5) needles.

Patt as folls:

Row 1 (RS): P1, (K1, P1) 10 times, (K1 tbl, P1) twice, K1 tbl, P5, K1 tbl, (P1, K1 tbl) twice, (P1, K1) 9 (10: 11: 13: 14) times, P0 (1: 1: 0: 0).

Row 2: P0 (1: 1: 0: 0), (K1, P1) 9 (10: 11: 13: 14) times, (P1 tbl, K1) twice, P1 tbl, K5, P1 tbl, (K1, P1 tbl) twice, (P1, K1) 10 times, P1.

Last 2 rows set the sts - cable panel with moss st at sides.

Cont as set for a further 10 rows, ending with a WS row.

Change to 4mm (US 6) needles.

Row 13 (RS): (P1, K1) 4 times, P13, (K1 tbl, P1) twice, K1 tbl, P5, K1 tbl, (P1, K1 tbl) twice, P to end.

Row 14: K18 (21: 23: 26: 28), (P1 tbl, K1) twice, P1 tbl, K5, P1 tbl, (K1, P1 tbl) twice, K13, (K1, P1) 4 times.

Last 2 rows set position of cable panel and front opening edge in moss st, now with rev st st between.

Rows 15 and 16: As rows 13 and 14.

69

Row 17: (P1, K1) 4 times, P13, Cr6L, P3, Cr6R, P to end.

Row 18: K18 (21: 23: 26: 28), (K1, P1 tbl) 3 times, K3, (P1 tbl, K1) 3 times, K13, (K1, P1) 4 times.

Row 19: (P1, K1) 4 times, P14, Cr6L, P1, Cr6R, P to end.

Row 20: K20 (23: 25: 28: 30), (P1 tbl, K1) 5 times, P1 tbl, K15, (K1, P1) 4 times.

Row 21: (P1, K1) 4 times, P15, C11F, P to end.

Row 22: As row 20.

Row 23: (P1, K1) 4 times, P14, Cr6R, P1, Cr6L, P to end.

Row 24: As row 18.

Row 25: (P1, K1) 4 times, P13, Cr6R, P3, Cr6L, P to end.

Row 26: As row 14.

Rows 27 to 38: As rows 13 and 14, 6 times.

Rows 39 to 48: As rows 17 to 26.

Rows 49 and 50: As rows 13 and 14.

Last 50 rows form cable panel.

Complete to match left front, reverse shapings.

SLEEVES

Cast on 51 (51: 53: 55: 55) sts using 3¾ mm (US 5) needles.

Patt as folls:

Row 1 (RS): P0 (0: 1: 0: 0), (K1, P1) 9 (9: 9: 10: 10) times, (K1 tbl, P1) twice, K1 tbl, P5, K1 tbl, (P1, K1 tbl) twice, (P1, K1) 9 (9: 9: 10: 10) times, P0 (0: 1: 0: 0).

Row 2: P0 (0: 1: 0: 0), (K1, P1) 9 (9: 9: 10: 10) times, (P1 tbl, K1) twice, P1 tbl, K5, P1 tbl, (K1, P1 tbl) twice, (P1, K1) 9 (9: 9: 10: 10) times, P0 (0: 1: 0: 0).

Last 2 rows set the sts - cable panel with moss st at sides.

Cont as set for a further 14 rows, ending with a WS row.

Change to 4mm (US 6) needles.

Row 17 (RS): P18 (18: 19: 20: 20), (K1 tbl, P1) twice, K1 tbl, P5, K1 tbl, (P1, K1 tbl) twice, P to end.

Row 18: K18 (18: 19: 20: 20), (P1 tbl, K1) twice, P1 tbl, K5, P1 tbl, (K1, P1 tbl) twice, K to end.

Rows 19 and 20: As rows 17 and 18.

Row 21: Inc in first st, P17 (17: 18: 19: 19), Cr6L, P3, Cr6R, P to last st, inc in last st. 53 (53: 55: 57: 57) sts.

Row 22: K19 (19: 20: 21: 21), (K1, P1 tbl) 3 times, K3, (P1 tbl, K1) 3 times, K to end.

Row 23: P20 (20: 21: 22: 22), Cr6L, P1, Cr6R, P to end.

Row 24: K21 (21: 22: 23: 23), (P1 tbl, K1) 5 times, P1 tbl, K to end.

Left sleeve only

Row 25: P21 (21: 22: 23: 23), C11F, P to end.

Right sleeve only

Row 25: P21 (21: 22: 23: 23), C11B, P to end.

Both sleeves

Row 26: As row 24.

Row 27: P20 (20: 21: 22: 22), Cr6R, P1, Cr6L, P to end.

Row 28: As row 22.

Row 29: P19 (19: 20: 21: 21), Cr6R, P3, Cr6L, P to end.

Row 30: K19 (19: 20: 21: 21), (P1 tbl, K1) twice, P1 tbl, K5, P1 tbl, (K1, P1 tbl) twice, K to end.

Row 31: P19 (19: 20: 21: 21), (K1 tbl, P1) twice, K1 tbl, P5, K1 tbl, (P1, K1 tbl) twice, P to end.

Row 32: As row 30.

Row 33: (Inc in first st) 0 (0: 0: 0: 1) times, P19 (19: 20: 21: 20), (K1, P1 tbl) twice, K1 tbl, P5, K1 tbl, (P1, K1 tbl) twice, P to last 0 (0: 0: 0: 1) st, (inc in last st) 0 (0: 0: 0: 1) times. 53 (53: 55: 57: 59) sts.

Row 34: K19 (19: 20: 21: 22), (P1 tbl, K1) twice, P1 tbl, K5, P1 tbl, (K1, P1 tbl) twice, K to end.

Row 35: (Inc in first st) 1 (1: 1: 1: 0) times, P18 (18: 19: 20: 22), (K1 tbl, P1) twice, K1 tbl, P5, K1 tbl, (P1, K1 tbl) twice, P to last 1 (1: 1: 1: 0) st, (inc in last st) 1 (1: 1: 1: 0) times. 55 (55: 57: 59: 59) sts.

Row 36: K20 (20: 21: 22: 22), (P1 tbl, K1) twice, P1 tbl, K5, P1 tbl, (K1, P1 tbl) twice, K to end.

Row 37: P20 (20: 21: 22: 22), (K1 tbl, P1) twice, K1 tbl, P5, K1 tbl, (P1, K1 tbl) twice, P to end.

Row 38: As row 36.

Last 22 rows set position of cable panel on rev st st, and start sleeve shaping.

Keeping sts correct as set and as for back and fronts, cont in patt, shaping sides by inc 1 st at each end of 11th (9th: 11th: 11th: 7th) and every foll 14th (12th: 14th: 14th: 12th) row to 67 (71: 61: 63: 71) sts, then on every foll 12th (-: 12th: 12th: 10th) row until there are 69 (-: 73: 75: 77) sts, taking inc sts into rev st st. Cont straight until sleeve measures 51.5 (51.5: 53: 53: 53) cm, end with a WS row.

Shape top

Keeping patt correct, cast off 4 (5: 5: 6: 6) sts at beg of next 2 rows.

61 (61: 63: 63: 65) sts.

Dec 1 st at each end of next 3 rows, then on foll 2 alt rows, then on every foll 4th row until 35 (35: 37: 37: 39) sts rem.

Work 1 row, ending with a WS row.

Dec 1 st at each end of next and every foll alt row to 29 sts, then on foll 3 rows, ending with a WS row.

Cast off rem 23 sts.

MAKING UP

PRESS as described on the information page.

Join shoulder seams using back stitch, or mattress stitch if preferred.

Collar

With RS facing and using 3¾ mm (US 5) needles, slip 7 (8: 8: 8: 8) sts from right front holder onto right needle, rejoin yarn and pick up and knit 20 (20: 20: 23: 23) sts up right side of neck, 31 (33: 33: 35: 35) sts from back, and 20 (20: 20: 23: 23) sts down left side of neck, then patt across 7 (8: 8: 8: 8) sts from left front holder. 85 (89: 89: 97: 97) sts.

Row 1 (RS of collar, WS of body): (P1, K1) 4 times, (P2, K1 tbl) 7 (7: 7: 8: 8) times, (P1, K1 tbl) 13 (15: 15: 16: 16) times, P1, (K1 tbl, P2) 7 (7: 7: 8: 8) times, (K1, P1) 4 times.

Row 2: (P1, K1) 4 times, (K2, P1 tbl) 7 (7: 7: 8: 8) times, (K1, P1 tbl) 13 (15: 15: 16: 16) times, K1, (P1 tbl, K2) 7 (7: 7: 8: 8) times, (K1, P1) 4 times.

Rows 3 and 4: As rows 1 and 2.

Row 5: (P1, K1) 4 times, (P2, K1 tbl) 7 (7: 7: 8: 8) times, (inc purlwise in next st, K1 tbl) 13 (15: 15: 16: 16) times, inc purlwise in next st, (K1 tbl, P2) 7 (7: 7: 8: 8) times, (K1, P1) 4 times. 99 (105: 105: 114: 114) sts.

Row 6: (P1, K1) 4 times, *K2, P1 tbl, rep from * to last 10 sts, K2, (K1, P1) 4 times.

Row 7: (P1, K1) 4 times, *P2, K1 tbl, rep from * to last 10 sts, P2, (K1, P1) 4 times. Last 2 rows form patt.

Keeping sts correct as set, work 1 row.

Row 9 (RS): (P1, K1) 4 times, P2, K1 tbl, M1, patt to last 11 sts, M1, K1 tbl, P2, (K1, P1) 4 times.

Row 10: (P1, K1) 4 times, K2, P1 tbl, patt to last 11 sts, P1 tbl, K2, (K1, P1) 4 times.

Row 11: (P1, K1) 4 times, P2, K1 tbl, patt to last 11 sts, K1 tbl, P2, (K1, P1) 4 times.

Rows 12 to 15: As rows 10 and 11, twice.

Row 16: As row 10.

Rep rows 9 to 16, 5 times more.

111 (117: 117: 126: 126) sts.

Work a further 4 rows.

Cast off in patt.

Belt

Cast on 11 sts using 3¾ mm (US 5) needles.

Row 1 (RS): K1, (K1 tbl, P1 tbl) 4 times, K1 tbl, K1.

Row 2: K1, (P1 tbl, K1 tbl) 4 times, P1 tbl, K1.

Rep last 2 rows until belt measures 150 cm.

Cast off in patt.

Belt loops (make 6)

Cast on 5 sts using 3¾ mm (US 5) needles.

Row 1 (RS): K1, K1 tbl, P1 tbl, K1 tbl, K1.

Row 2: K1, P1 tbl, K1 tbl, P1 tbl, K1.

Rep last 2 rows 13 times more.

Cast off in patt.

Machine wash all pieces before completing sewing together.

See information page for finishing instructions, setting in sleeves using the set-in method. Using photograph as a guide, attach belt loops and thread belt through loops.

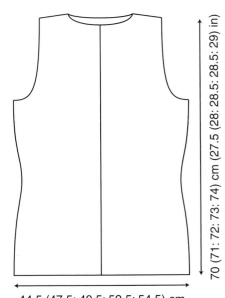

44.5 (47.5: 49.5: 52.5: 54.5) cm
(17.5 (18.5: 19.5: 20.5: 21.5) in)

70 (71: 72: 73: 74) cm (27.5 (28: 28.5: 28.5: 29) in)

43 (43: 44: 44: 44) cm
(17 (17: 17.5: 17.5: 17.5) in)

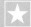

Lauren

KIM HARGREAVES

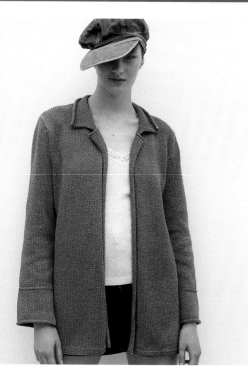

YARN

	XS	S	M	L	XL	
To fit bust	81	86	91	97	102	cm
	32	34	36	38	40	in

Rowan Denim

| | 16 | 17 | 18 | 19 | 19 | x50gm |

(photographed in Tennessee 231)

NEEDLES

1 pair 3¾ mm (no 9) (US 5) needles
1 pair 4mm (no 8) (US 6) needles

TENSION

Before washing: 20 sts and 28 rows to
10 cm measured over stocking stitch using
4mm (US 6) needles.

Tension note: Denim will shrink in length
when washed for the first time. Allowances
have been made in the pattern for shrinkage

(see size diagram for after washing
measurements).

BACK

Cast on 106 (112: 116: 122: 126) sts using
3¾ mm (US 5) needles.
Work in garter st for 8 rows, ending with a
WS row.
Change to 4mm (US 6) needles.
Beg with a K row, cont in st st until back
measures 56.5 (57.5: 57.5: 59: 59) cm,
ending with a WS row.

Shape armholes

Cast off 4 (5: 5: 6: 6) sts at beg of next 2 rows.
98 (102: 106: 110: 114) sts.
Dec 1 st at each end of next 5 (5: 7: 7: 9)
rows, then on every foll alt row until 80 (82:
84: 86: 88) sts rem.
Cont straight until armhole measures
26.5 (26.5: 27.5: 27.5: 29) cm, ending
with a WS row.

Shape shoulders and back neck

Cast off 8 (8: 9: 9: 9) sts at beg of next 2 rows.
64 (66: 66: 68: 70) sts.
Next row (RS): Cast off 8 (8: 9: 9: 9) sts, K
until there are 13 (13: 12: 12: 13) sts on right
needle and turn, leaving rem sts on a holder.
Work each side of neck separately.
Cast off 4 sts at beg of next row.
Cast off rem 9 (9: 8: 8: 9) sts.
With RS facing, rejoin yarn to rem sts, cast
off centre 22 (24: 24: 26: 26) sts, K to end.
Complete to match first side, reverse shapings.

LEFT FRONT

Cast on 53 (56: 58: 61: 63) sts using 3¾ mm
(US 5) needles.
Work in garter st for 8 rows, ending with a
WS row.
Change to 4mm (US 6) needles.
Beg with a K row, cont in st st until left front
matches back to beg of armhole shaping,
ending with a WS row.

Shape armhole

Cast off 4 (5: 5: 6: 6) sts at beg of next row.
49 (51: 53: 55: 57) sts.

Work 1 row.
Dec 1 st at armhole edge of next 5 (5: 7: 7: 9)
rows, then on every foll alt row until 40 (41:
42: 43: 44) sts rem.
Cont straight until 26 (26: 26: 28: 28) rows
less have been worked than on back to start
of shoulder shaping, ending with a WS row.

Shape neck

Dec 1 st at front opening edge of next 9 (11:
11: 11: 11) rows, then on foll 6 (5: 5: 6: 6) alt
rows. 25 (25: 26: 26: 27) sts.
Work 5 rows, ending with a WS row.

Shape shoulder

Cast off 8 (8: 9: 9: 9) sts at beg of next and
foll alt row.
Work 1 row.
Cast off rem 9 (9: 8: 8: 9) sts.

RIGHT FRONT

Work to match left front, reversing shapings.

SLEEVES (both alike)

Main section

Cast on 62 (62: 64: 66: 66) sts using 4mm
(US 6) needles.
Beg with a K row, work in st st for 10 rows,
ending with a WS row.
Next row (RS): K2, M1, K to last 2 sts, M1, K2.
Working all increases as set by last row, inc
1 st at each end of every foll 40th (26th: 28th:
28th: 20th) row to 68 (68: 72: 74: 72) sts,
then on every foll - (28th: -: -: 22nd) row until
there are - (70: -: -: 76) sts.
Cont straight until main section measures
37 (37: 38.5: 38.5: 38.5) cm, end with a WS row.

Shape top

Cast off 4 (5: 5: 6: 6) sts at beg of next 2 rows.
60 (60: 62: 62: 64) sts.
Dec 1 st at each end of next 3 rows, then on
foll 2 alt rows, then on every foll 4th row until
34 (34: 36: 36: 38) sts rem.
Work 1 row, ending with a WS row.
Dec 1 st at each end of next and every foll alt
row to 28 sts, then on foll 3 rows, ending with
a WS row.
Cast off rem 22 sts.

Cuff

With **WS** facing (so that ridge is created on RS of work) and using 4 mm (US 6) needles, pick up and knit 62 (62: 64: 66: 66) sts across cast-on edge of main section.
Beg with a K row, work in st st for 34 rows.
Cast off.

MAKING UP

PRESS as described on the information page.
Join shoulder seams using back stitch, or mattress stitch if preferred.

Front bands (both alike)

With WS facing (so that ridge is created on RS of work) and using 3¾ mm (US 5) needles, pick up and knit 123 (125: 127: 128: 131) sts along front opening edge, between cast-on edge and neck shaping.
Beg with a K row, work in st st for 16 rows.
Cast off.

Collar

With WS facing (so that ridge is created on RS of work) and using 3¾ mm (US 5) needles, starting and ending at pick-up rows for front bands, pick up and knit 29 (30: 30: 33: 33) sts up left side of neck, 30 (32: 32: 34: 34) sts from back, then 29 (30: 30: 33: 33) sts down right side of neck.
88 (92: 92: 100: 100) sts.
Beg with a purl row, work in st st for 28 rows.
Cast off.
Machine wash all pieces before completing sewing together.
See information page for finishing instructions, setting in sleeves using the set-in method.

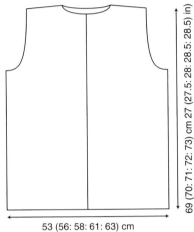

69 (70: 71: 72: 73) cm 27 (27.5: 28: 28.5: 28.5) in

53 (56: 58: 61: 63) cm
(21 (22: 23: 24: 25) in)

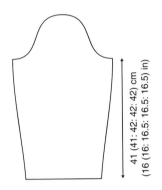

41 (41: 42: 42: 42) cm
(16 (16: 16.5: 16.5: 16.5) in)

Lush
KIM HARGREAVES

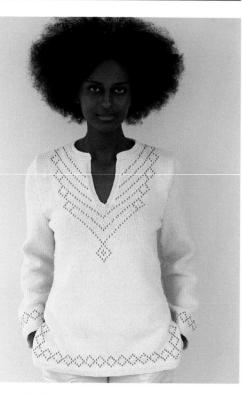

YARN

	XS	S	M	L	XL	
To fit bust	81	86	91	97	102	cm
	32	34	36	38	40	in

Rowan Denim

	14	15	15	16	17	x50gm

(photographed in Ecru 324)

NEEDLES
1 pair 3¼ mm (no 10) (US 3) needles
1 pair 4mm (no 8) (US 6) needles

BEADS - Approx 1,100 (1,100: 1,150: 1,150: 1,200) x J3001009 copper beads

TENSION
Before washing: 20 sts and 28 rows to 10 cm measured over stocking stitch using 4mm (US 6) needles.

Tension note: Denim will shrink in length when washed for the first time. Allowances have been made in the pattern for shrinkage (see size diagram for after washing measurements).

SPECIAL ABBREVIATION
Bead 1 = place a bead (on RS row) by bringing yarn to front (RS) of work and slipping bead up next to st just worked, slip next st purlwise from left needle to right needle and take yarn back to back (WS) of work, leaving bead sitting in front of slipped st on RS. Do not place beads on edge stitches of work as this will interfere with seaming and pick-up rows.

Beading note: Before starting to knit, thread beads onto yarn. To do this, thread a fine sewing needle (one that will easily pass through the beads) with sewing thread. Knot ends of thread and then pass end of yarn through this loop. Thread a bead onto sewing thread and then gently slide it along and onto knitting yarn. Continue in this way until required number of beads are on yarn.

BACK
Cast on 91 (97: 101: 107: 111) sts using 3¼ mm (US 3) needles.
Rows 1 to 3: Knit.
Row 4 (WS): K1, *P1, K1, rep from * to end.
Rows 5 to 8: As row 4.
Change to 4mm (US 6) needles.
Row 9 (RS): (K1, P1) twice, K to last 4 sts, (P1, K1) twice.
Row 10 and every foll alt row: (K1, P1) twice, P to last 4 sts, (P1, K1) twice.
Row 11: (K1, P1) twice, K2 (2: 1: 1: 0), *K3, bead 1, K2, rep from * to last 7 (7: 6: 6: 5) sts, K3 (3: 2: 2: 1), (P1, K1) twice.
Row 13: (K1, P1) twice, K2 (2: 1: 1: 0), *K2, (bead 1, K1) twice, rep from * to last 7 (7: 6: 6: 5) sts, K3 (3: 2: 2: 1), (P1, K1) twice.
Row 15: (K1, P1) twice, K2 (2: 1: 1: 0), *K1, bead 1, K3, bead 1, rep from * to last 7 (7: 6: 6: 5) sts, K3 (3: 2: 2: 1), (P1, K1) twice.

Row 17: (K1, P1) twice, K2 (2: 1: 1: 0), *bead 1, K2, P1, K2, rep from * to last 7 (7: 6: 6: 5) sts, bead 1, K2 (2: 1: 1: 0), (P1, K1) twice.
Row 19: As row 15.
Row 21: As row 13.
Row 23: As row 11.
Row 25: (K1, P1) twice, K4 (4: 3: 3: 2), bead 1, K1, bead 1, K to last 11 (11: 10: 10: 9) sts, bead 1, K1, bead 1, K4 (4: 3: 3: 2), (P1, K1) twice.
Row 27: (K1, P1) twice, K3 (3: 2: 2: 1), bead 1, K3, bead 1, K to last 12 (12: 11: 11: 10) sts, bead 1, K3, bead 1, K3 (3: 2: 2: 1), (P1, K1) twice.
Row 29: (K1, P1) twice, K2 (2: 1: 1: 0), bead 1, K2, P1, K2, bead 1, K to last 13 (13: 12: 12: 11) sts, bead 1, K2, P1, K2, bead 1, K2 (2: 1: 1: 0), (P1, K1) twice.
Row 31: As row 27.
Row 33: As row 25.
Row 35: (K1, P1) twice, K5 (5: 4: 4: 3), bead 1, K to last 10 (10: 9: 9: 8) sts, bead 1, K5 (5: 4: 4: 3), (P1, K1) twice.
Row 37: As row 25.
Row 39: As row 27.
Row 41: As row 29.
Row 43: As row 27.
Row 45: As row 25.
Row 47: As row 35.
These 47 rows complete border patt.
Beg with a P row, cont in st st as folls:
Work 3 rows, ending with a WS row.
Next row (RS): K2, K2tog, K to last 4 sts, K2tog tbl, K2.
Working all decreases as set by last row, dec 1 st at each end of every foll 6th row until 79 (85: 89: 95: 99) sts rem.
Cont straight until back measures 32.5 (33.5: 33.5: 35: 35) cm, ending with a WS row.
Next row (RS): K2, M1, K to last 2 sts, M1, K2. 81 (87: 91: 97: 101) sts.**
Working all increases as set by last row, inc 1 st at each end of every foll 8th row until there are 89 (95: 99: 105: 109) sts.
Work 17 rows, ending with a WS row. (Back should measure 50.5 (51.5: 51.5: 53: 53) cm.)

Shape armholes

Cast off 5 (6: 6: 7: 7) sts at beg of next 2 rows.

79 (83: 87: 91: 95) sts.

Dec 1 st at each end of next 3 (3: 5: 5: 7) rows, then on foll 2 (3: 2: 3: 2) alt rows.

69 (71: 73: 75: 77) sts.

Work 27 (25: 29: 27: 31) rows, ending with a WS row. (Armhole should measure 13 (13: 14: 14: 15.5) cm.)

Place chart

Next row (RS): K14 (15: 16: 17: 18), work next 41 sts as row 1 of chart for back, K to end.

Next row: P14 (15: 16: 17: 18), work next 41 sts as row 2 of chart for back, P to end.

These 2 rows set position of chart for back.

Keeping chart correct, cont straight until chart row 38 has been completed, ending with a WS row. (Armhole should measure 26.5 (26.5: 27.5: 27.5: 29) cm.)

Shape shoulders and back neck

Keeping chart correct, cast off 7 sts at beg of next 2 rows.

55 (57: 59: 61: 63) sts.

Next row (RS): Cast off 7 sts, patt until there are 10 (10: 11: 11: 12) sts on right needle and turn, leaving rem sts on a holder.

Work each side of neck separately.

Cast off 4 sts at beg of next row.

Cast off rem 6 (6: 7: 7: 8) sts.

With RS facing, rejoin yarn to rem sts, cast off centre 21 (23: 23: 25: 25) sts, patt to end.

Complete to match first side, reversing shapings.

FRONT

Work as given for back to **.

Work 7 rows, ending with a WS row.

Place chart

Next row (RS): K2, M1, K9 (12: 14: 17: 19), work next 59 sts as row 1 of chart for front, K to last 2 sts, M1, K1.

Next row: P12 (15: 17: 20: 22), work next 59 sts as row 2 of chart for front, P to end.

These 2 rows set position of chart for front.

Keeping chart correct and working all increases as now set, inc 1 st at each end of 7th and every foll 8th row until there are 89 (95: 99: 105: 109) sts.

Work 17 rows, ending with a WS row. (Front should match back to beg of armhole shaping.)

Shape armholes

Keeping chart correct, cast off 5 (6: 6: 7: 7) sts at beg of next 2 rows.

79 (83: 87: 91: 95) sts.

Dec 1 st at each end of next 3 (3: 5: 5: 7) rows, then on foll 2 (3: 2: 2: 1) alt rows.

69 (71: 73: 77: 79) sts.

Work 3 (1: 1: 1: 1) rows, ending after chart row 54 and a WS row.

Divide for front opening

Next row (RS): (K2tog) 0 (0: 0: 1: 1) times, patt 34 (35: 36: 36: 37) sts and turn, leaving rem sts on a holder.

Work each side of neck separately.

Next row: Inc in first st, patt to end.

35 (36: 37: 38: 39) sts.

Cont straight until chart row 101 (101: 105: 103: 107) has been completed, ending with a RS row.

Shape neck

Next row (WS): Patt 6 (7: 7: 7: 7) sts and slip these sts onto a holder, patt to end.

29 (29: 30: 31: 32) sts.

Dec 1 st at neck edge of next 6 rows, then on foll 3 (3: 3: 4: 4) alt rows.

20 (20: 21: 21: 22) sts.

Work 2 rows, ending with a WS row.

Shape shoulder

Cast off 7 sts at beg of next and foll alt row.

Work 1 row.

Cast off rem 6 (6: 7: 7: 8) sts.

With RS facing, rejoin yarn to rem sts, patt to last 0 (0: 0: 2: 2) sts, (K2tog) 0 (0: 0: 1: 1) times.

35 (36: 37: 38: 39) sts.

Complete to match first side, reversing shapings and noting that centre st of chart is worked for both sides of front.

SLEEVES (both alike)

Cast on 67 (69: 71: 73: 75) sts using 3¼ mm (US 3) needles.

Rows 1 to 3: Knit.

Row 4 (WS): K1, *P1, K1, rep from * to end.

Rows 5 to 8: As row 4.

Change to 4mm (US 6) needles.

Row 9 (RS): Knit.

Row 10 and every foll alt row: Purl.

Row 11: Knit.

Row 13: K3 (1: 2: 0: 1), (bead 1, K2) 0 (1: 1: 0: 0) times, *K3, bead 1, K2, rep from * to last 4 (5: 0: 1: 2) sts, (K3, bead 1) 0 (1: 0: 0: 0) times, K4 (1: 0: 1: 2).

Row 15: K1 (2: 1: 0: 1), (bead 1, K1) 1 (1: 2: 0: 0) times, *K2, (bead 1, K1) twice, rep from * to last 4 (5: 0: 1: 2) sts, (K2, bead 1) 1 (1: 0: 0: 0) times, K1 (2: 0: 1: 2).

Row 17: K3 (3: 4: 0: 1), (bead 1) 0 (1: 1: 0: 0) times, *K1, bead 1, K3, bead 1, rep from * to last 4 (5: 0: 1: 2) sts, (K1, bead 1) 1 (1: 0: 0: 0) times, K2 (3: 0: 1: 2).

Row 19: K0 (1: 2: 3: 0), P1 (1: 1: 1: 0), K2 (2: 2: 2: 1), *bead 1, K2, P1, K2, rep from * to last 4 (5: 0: 1: 2) sts, (bead 1) 1 (1: 0: 0: 1) times, K2 (2: 0: 1: 1), P1 (1: 0: 0: 0), K0 (1: 0: 0: 0).

Row 21: As row 17.

Row 23: As row 15.

Row 25: As row 13.

These 25 rows complete border patt.

Beg with a P row, cont in st st until sleeve measures 51.5 (51.5: 53: 53: 53) cm, ending with a WS row.

Shape top

Cast off 5 (6: 6: 7: 7) sts at beg of next 2 rows.

57 (57: 59: 59: 61) sts.

Dec 1 st at each end of next 3 rows, then on foll 2 alt rows, then on every foll 4th row until 33 (33: 35: 35: 37) sts rem.

Work 1 row, ending with a WS row.

Dec 1 st at each end of next and every foll alt row to 27 sts, then on foll 3 rows, ending with a WS row.

Cast off rem 21 sts.

Front chart

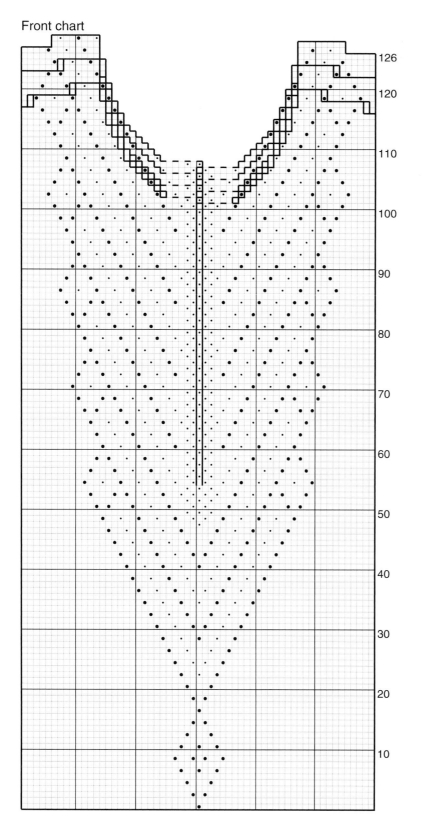

Back

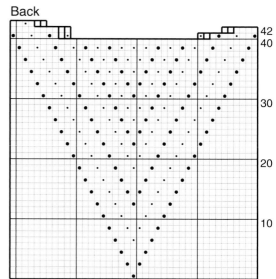

Key

☐ K on RS, P on WS

⊡ P on RS, K on WS

● Place bead

MAKING UP

PRESS as described on the information page. Join both shoulder seams using back stitch, or mattress stitch if preferred.

Neckband

With RS facing and using 3¼ mm (US 3) needles, slip 6 (7: 7: 7: 7) sts from right front holder onto right needle, rejoin yarn and pick up and knit 15 (15: 15: 17: 17) sts up right side of neck, 29 (31: 31: 33: 33) sts from back, 15 (15: 15: 17: 17) sts down left side of neck, then patt across 6 (7: 7: 7: 7) sts from left front holder. 71 (75: 75: 81: 81) sts. Keeping moss st correct as set by front opening edge sts, work in moss st for 5 rows, ending with a WS row.

Knit 3 rows.

Cast off knitwise (on WS).

Machine wash all pieces before completing sewing together.

See information page for finishing instructions, setting in sleeves using the set-in method and leaving side seams open for first 47 rows for side seam openings.

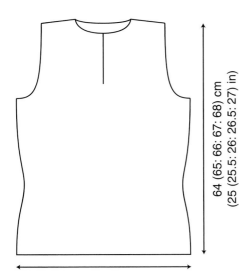

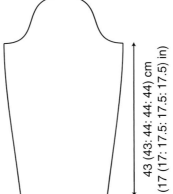

64 (65: 66: 67: 68) cm
(25 (25.5: 26: 26.5: 27) in)

44.5 (47.5: 49.5: 52.5: 54.5) cm
(17.5 (18.5: 19.5: 20.5: 21.5) in)

43 (43: 44: 44: 44) cm
(17 (17: 17.5: 17.5: 17.5) in)

Cargo
KIM HARGREAVES

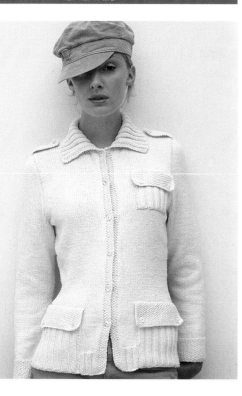

YARN

	XS	S	M	L	XL	
To fit bust	81	86	91	97	102	cm
	32	34	36	38	40	in

Rowan Denim

| | 15 | 16 | 17 | 18 | 18 | x50gm |

(photographed in Ecru 324)

NEEDLES

1 pair 3¼ mm (no 10) (US 3) needles
1 pair 3¾ mm (no 9) (US 5) needles
1 pair 4mm (no 8) (US 6) needles

BUTTONS - 18 x 75318

TENSION

Before washing: 20 sts and 28 rows to
10 cm measured over stocking stitch using
4mm (US 6) needles.

Tension note: Denim will shrink in length
when washed for the first time. Allowances
have been made in the pattern for shrinkage
(see size diagram for after washing
measurements).

Pattern note: As row end edges of fronts form
actual finished edges of garment it is impor-
tant these edges are kept neat. Therefore all
new balls of yarn should be joined in at side
seam or armhole edges of rows.

SPECIAL ABBREVIATIONS

Right dec = Sl 1, K1, psso, slip st now on
right needle back onto left needle, lift 2nd st
on left needle over this st and off left needle,
then slip rem st back onto right needle
– 2 sts decreased.
Left dec = Sl 1, K2tog, psso – 2 sts decreased.

BACK

Cast on 90 (96: 100: 106: 110) sts using
3¼ mm (US 5) needles.
Row 1 (RS): K0 (1: 0: 0: 0), P0 (2: 1: 0: 2),
*K2, P2, rep from * to last 2 (1: 3: 2: 0) sts,
K2 (1: 2: 2: 0), P0 (0: 1: 0: 0).
Row 2: P0 (1: 0: 0: 0), K0 (2: 1: 0: 2), *P2,
K2, rep from * to last 2 (1: 3: 2: 0) sts, P2 (1:
2: 2: 0), K0 (0: 1: 0: 0).
These 2 rows form rib.
Work in rib for a further 18 rows, ending with
a WS row.
Change to 4mm (US 6) needles.
Beg with a K row, work in st st for 24 (26: 26:
28: 28) rows, ending with a WS row.
Shape darts
Place markers on 23rd (25th: 27th: 29th: 31st) st
in from both ends of last row.
Next row (RS): K2, K2tog, K to within 1 st of
first marked st, left dec, K to within 1 st of
second marked st, right dec, K to last 4 sts,
K2tog tbl, K2. 84 (90: 94: 100: 104) sts.
Work 7 rows.
Rep last 8 rows once more, and then the first
of these rows again. 72 (78: 82: 88: 92) sts.
Work 13 rows, ending with a WS row.

Next row (RS): K2, M1, (K to marked st, M1,
K marked st, M1) twice, K to last 2 sts, M1, K2.
Rep last 14 rows twice more.
90 (96: 100: 106: 110) sts.
Cont straight until back measures 44.5 (45.5:
45.5: 47: 47) cm, ending with a WS row.
Shape armholes
Cast off 4 (5: 5: 6: 6) sts at beg of next 2 rows.
82 (86: 90: 94: 98) sts.
Dec 1 st at each end of next 3 (3: 5: 5: 7)
rows, then on foll 4 (5: 4: 5: 4) alt rows.
68 (70: 72: 74: 76) sts.
Cont straight until armhole measures 26.5 (26.5:
27.5: 27.5: 29) cm, ending with a WS row.
Shape shoulders and back neck
Cast off 7 sts at beg of next 2 rows.
54 (56: 58: 60: 62) sts.
Next row (RS): Cast off 7 sts, K until there
are 10 (10: 11: 11: 12) sts on right needle
and turn, leaving rem sts on a holder.
Work each side of neck separately.
Cast off 4 sts at beg of next row.
Cast off rem 6 (6: 7: 7: 8) sts.
With RS facing, rejoin yarn to rem sts, cast off
centre 20 (22: 22: 24: 24) sts, K to end.
Complete to match first side, reversing shapings.

LEFT FRONT
Pocket front
Cast on 30 sts using 3¼ mm (US 5) needles.
Row 1 (RS): K2, *P2, K2, rep from * to end.
Row 2: P2, *K2, P2, rep from * to end.
Rep last 2 rows 23 times more.
Break yarn and leave sts on a holder.
Main section
Cast on 15 sts using 3¾ mm (US 5) needles.
Break yarn.
Slip 30 pocket front sts onto same needle so
that RS will be facing for next row.
Onto same needle, cast on a further 6 (9: 11:
14: 16) sts.
Now work across all 51 (54: 56: 59: 61) sts
as folls:
Row 1 (RS): K0 (1: 0: 0: 0), P0 (2: 1: 0: 2),
*K2, P2, rep from * to last 7 sts, K2, (P1, K1)
twice, P1.

Row 2: (P1, K1) twice, P1, *P2, K2, rep from * to last 2 (1: 3: 2: 0) sts, P2 (1: 2: 2: 0), K0 (0: 1: 0: 0).

These 2 rows set the sts - front opening edge 5 sts in moss st with rem sts in rib.

Cont as set for a further 18 rows, ending with a WS row.

Change to 4mm (US 6) needles.

Next row (RS): K to last 5 sts, (P1, K1) twice, P1.

Next row: (P1, K1) twice, P to end.

These 2 rows set the sts - front opening edge 5 sts still in moss st with rem sts now in st st.

Cont as set for a further 22 (24: 24: 26: 26) rows, ending with a WS row.

Shape dart

Place marker on 23rd (25th: 27th: 29th: 31st) st counting in from end of last row.

Next row (RS): K2, K2tog, K to within 1 st of marked st, left dec, patt to end.

48 (51: 53: 56: 58) sts.

Work 7 rows.

Rep last 8 rows once more, and then the first of these rows again.

42 (45: 47: 50: 52) sts.

Work 13 rows, ending with a WS row.

Next row (RS): K2, M1, K to marked st, M1, K marked st, M1, patt to end.

Rep last 14 rows twice more.

51 (54: 56: 59: 61) sts.

Cont straight until left front matches back to beg of armhole shaping, ending with a WS row.

Shape armhole

Cast off 4 (5: 5: 6: 6) sts at beg of next 2 rows.

47 (49: 51: 53: 55) sts.

Work 1 row.

Dec 1 st at armhole edge of next 3 (3: 5: 5: 7) rows, then on foll 4 (5: 4: 5: 4) alt rows.

40 (41: 42: 43: 44) sts.

Cont straight until 19 (19: 19: 21: 21) rows less have been worked than on back to start of shoulder shaping, ending with a RS row.

Shape neck

Next row (WS): Patt 10 (11: 11: 11: 11) sts and slip these sts onto a holder, patt to end.

30 (30: 31: 32: 33) sts.

Dec 1 st at neck edge of next 6 rows, then on foll 3 (3: 3: 4: 4) alt rows, then on foll 4th row.

20 (20: 21: 21: 22) sts.

Work 2 rows, ending with a WS row.

Shape shoulder

Cast off 7 sts at beg of next and foll alt row.

Work 1 row.

Cast off rem 6 (6: 7: 7: 8) sts.

Mark positions for 6 buttons along left front opening edge - first to come in row 41 of main section, last to come level with neck shaping and rem 4 buttons evenly spaced between.

RIGHT FRONT

Pocket front

Work as for pocket front of left front.

Main section

Cast on 6 (9: 11: 14: 16) sts using 3¼ mm (US 5) needles.

Break yarn.

Slip 30 pocket front sts onto same needle so that RS will be facing for next row.

Onto same needle, cast on a further 15 sts.

Now work across all 51 (54: 56: 59: 61) sts as folls:

Row 1 (RS): P1, (K1, P1) twice, *K2, P2, rep from * to last 2 (1: 3: 2: 0) sts, K2 (1: 2: 2: 0), P0 (0: 1: 0: 0).

Row 2: P0 (1: 0: 0: 0), K0 (2: 1: 0: 2), *P2, K2, rep from * to last 7 sts, P3, (K1, P1) twice.

These 2 rows set the sts - front opening edge 5 sts in moss st with rem sts in rib.

Cont as set for a further 18 rows, end with a WS row.

Change to 4mm (US 6) needles.

Next row (RS): (P1, K1) twice, P1, K to end.

Next row: P to last 4 sts, (K1, P1) twice.

These 2 rows set the sts - front opening edge 5 sts still in moss st with rem sts now in st st.

Cont as set for a further 20 rows, end with a WS row.

Next row (buttonhole row) (RS): P1, K1, P2tog, (yrn) twice (to make a buttonhole - drop extra loop on next row), patt to end.

Cont as set for a further 1 (3: 3: 5: 5) rows, ending with a WS row.

Shape dart

Place marker on 23rd (25th: 27th: 29th: 31st) st counting in from beg of last row.

Next row (RS): Patt to within 1 st of marked st, right dec, K to last 4 sts, K2tog tbl, K2.

48 (51: 53: 56: 58) sts.

Complete to match left front, reversing shapings and making a further 5 buttonholes in same way as first was made to correspond with positions marked for buttons on left front.

LEFT SLEEVE

Cuff

Cast on 53 (53: 55: 57: 57) sts using 3¼ mm (US 5) needles.

Row 1 (RS): K1, *P1, K1, rep from * to end.

Row 2: As row 1.

These 2 rows form moss st.

Work in moss st for a further 6 rows, ending with a WS row.

Row 9 (RS): K1, P1, K2tog, (yfwd) twice (to make a buttonhole - drop extra loop on next row), moss st to end.

Work in moss st for a further 13 rows, ending with a WS row.

Row 23: As row 9.

Work in moss st for 1 more row, end with a WS row.

Change to 4mm (US 6) needles.

Shape front sleeve

Next row (RS): Moss st 4 sts, K33 (33: 34: 35: 35) and turn, leaving rem sts on a holder.

Work each side of sleeve separately.

Next row: P to last 4 sts, moss st 4 sts.

Last 2 rows set the sts - sleeve opening edge 4 sts in moss st with rem sts in st st.

Cont as set for a further 2 (2: 2: 2: 4) rows, ending with a WS row.

Next row (RS): Patt to last 2 sts, M1, K2.

Working all increases as set by last row, inc 1 st at end of foll 10th (10th: 10th: 10th: 8th) row.

39 (39: 40: 41: 41) sts.

Work a further 5 rows, end with a WS row.

Break yarn and leave sts on a second holder.

Shape back sleeve

With RS facing, rejoin yarn to 16 (16: 17: 18: 18) sts left on first holder and cont as folls:

Next row (RS): K to last 4 sts, moss st 4 sts.

Next row: Moss st 4 sts, P to end.

Last 2 rows set the sts - sleeve opening edge 4 sts in moss st with rem sts in st st. Cont as set for a further 2 (2: 2: 2: 4) rows, ending with a WS row.

Next row (RS): K2, M1, patt to end.

Working all increases as set by last row, inc 1 st at beg of foll 10th (10th: 10th: 10th: 8th) row. 18 (18: 19: 20: 20) sts.

Work a further 4 rows, ending with a RS row.

Cast off 4 sts at beg of next row.

14 (14: 15: 16: 16) sts.

Join sections

Next row (RS): K14 (14: 15: 16: 16), then with RS facing K across 39 (39: 40: 41: 41) sts left on second holder.

53 (53: 55: 57: 57) sts.

**Beg with a P row and working all increases as set, cont in st st, shaping sides by inc 1 st at each end of 4th (4th: 4th: 4th: 2nd) and every foll 10th (10th: 10th: 10th: 8th) row to 59 (71: 69: 71: 63) sts, then on every foll 12th (-: 12th: 12th: 10th) row until there are 69 (-: 73: 75: 77) sts.

Cont straight until sleeve measures 51.5 (51.5: 53: 53: 53) cm, ending with a WS row.

Shape top

Cast off 4 (5: 5: 6: 6) sts at beg of next 2 rows. 61 (61: 63: 63: 65) sts.

Dec 1 st at each end of next 3 rows, then on foll 2 alt rows, then on every foll 4th row until 35 (35: 37: 37: 39) sts rem.

Work 1 row, ending with a WS row.

Dec 1 st at each end of next and every foll alt row to 29 sts, then on foll 3 rows, end with a WS row.

Cast off rem 23 sts.

RIGHT SLEEVE

Cuff

Cast on 53 (53: 55: 57: 57) sts using 3³/₄ mm (US 5) needles.

Work in moss st as for cuff of left sleeve for 8 rows, ending with a WS row.

Row 9 (RS): Moss st to last 4 sts, (yfwd) twice (to make a buttonhole - drop extra loop on next row), K2tog, P1, K1.

Work in moss st for a further 13 rows, ending with a WS row.

Row 23: As row 9.

Work in moss st for 1 more row, ending with a WS row.

Change to 4mm (US 6) needles.

Shape back sleeve

Next row (RS): Moss st 4 sts, K12 (12: 13: 14: 14) and turn, leaving rem sts on a holder.

Work each side of sleeve separately.

Next row: P to last 4 sts, moss st 4 sts.

Last 2 rows set the sts - sleeve opening edge 4 sts in moss st with rem sts in st st. Cont as set for a further 2 (2: 2: 2: 4) rows, ending with a WS row.

Next row (RS): Patt to last 2 sts, M1, K2.

Working all increases as set by last row, inc 1 st at end of foll 10th (10th: 10th: 10th: 8th) row.

18 (18: 19: 20: 20) sts.

Work a further 4 rows, ending with a RS row.

Next row (WS): P to last 4 sts, cast off rem 4 sts.

Break yarn and leave rem 14 (14: 15: 16: 16) sts on a second holder.

Shape front sleeve

With RS facing, rejoin yarn to 37 (37: 38: 39: 39) sts left on first holder and cont as folls:

Next row (RS): K to last 4 sts, moss st 4 sts.

Next row: Moss st 4 sts, P to end.

Last 2 rows set the sts - sleeve opening edge 4 sts in moss st with rem sts in st st. Cont as set for a further 2 (2: 2: 2: 4) rows, ending with a WS row.

Next row (RS): K2, M1, patt to end.

Working all increases as set by last row, inc 1 st at beg of foll 10th (10th: 10th: 10th: 8th) row. 39 (39: 40: 41: 41) sts.

Work a further 5 rows, ending with a RS row.

Join sections

Next row (RS): K39 (39: 40: 41: 41), then with RS facing K across 14 (14: 15: 16: 16) sts left on second holder.

53 (53: 55: 57: 57) sts.

Complete to match left sleeve from **.

MAKING UP

PRESS as described on the information page. Join shoulder seams using back stitch, or mattress stitch if preferred.

Collar

With RS facing and using 3³/₄ mm (US 5) needles, slip 10 (11: 11: 11: 11) sts from right front holder onto right needle, rejoin yarn and pick up and knit 22 (22: 22: 25: 25) sts up right side of neck, 28 (30: 30: 32: 32) sts from back, and 22 (22: 22: 25: 25) sts down left side of neck, then patt across 10 (11: 11: 11: 11) sts from left front holder.

92 (96: 96: 104: 104) sts.

Row 1 (RS of collar, WS of body): Moss st 5 sts, K2, *P2, K2; rep from * to last 5 sts, moss st 5 sts.

Row 2: Moss st 5 sts, P2, *K2, P2; rep from * to last 5 sts, moss st 5 sts.

These 2 rows set the sts.

Keeping sts correct as set, cont as folls:

Cast off 2 sts at beg of next 2 rows.

88 (92: 92: 100: 100) sts.

Row 5 (RS): Moss st 3 sts, rib to last 3 sts, moss st 3 sts.

Row 6: Moss st 3 sts, rib to last 3 sts, moss st 3 sts.

Row 7: Moss st 3 sts, K2, M1, rib to last 5 sts, M1, K2, moss st 3 sts.

Row 8: Moss st 3 sts, P2, rib to last 5 sts, P2, moss st 3 sts.

Row 9: Moss st 3 sts, K2, rib to last 5 sts, K2, moss st 3 sts.

Rows 10 to 13: As rows 8 and 9, twice.

Row 14: As row 8.

Rep rows 7 to 14, 3 times more.

96 (100: 100: 108: 108) sts.

Cast off in patt.

Lower pocket flaps (make 2)

Cast on 31 sts using 3¼ mm (US 3) needles.

Work in moss st as for cuffs for 6 rows, ending with a WS row.

Row 7 (RS): K1, P1, K1, P2tog, (yrn) twice (to make a buttonhole - drop extra loop on next row), moss st to last 5 sts, (yrn) twice (to make a buttonhole - drop extra loop on next row), P2tog, K1, P1, K1.

Work in moss st for a further 19 rows, ending with a WS row.

Cast off in moss st.

Breast pocket

Cast on 22 sts using 3¾ mm (US 5) needles.

Row 1 (RS): P2, (K2, P2) 5 times.

Row 2: K2, (P2, K2) 5 times.

Rep last 2 rows 14 times more.

Cast off in rib.

Breast pocket flap

Cast on 27 sts using 3¼ mm (US 3) needles.

Work in moss st as for cuffs for 4 rows, ending with a WS row.

Row 5 (RS): K1, P1, K1, P2tog, (yrn) twice (to make a buttonhole - drop extra loop on next row), moss st to last 5 sts, (yrn) twice (to make a buttonhole - drop extra loop on next row), P2tog, K1, P1, K1.

Work in moss st for a further 21 rows, ending with a WS row.

Cast off in moss st.

Epaulettes (make 2)

Cast on 11 sts using 3¼ mm (US 3) needles.

Work in moss st as for cuffs for 30 rows, ending with a WS row.

Cast off in moss st.

Machine wash all pieces before completing sewing together.

See information page for finishing instructions, setting in sleeves using the set-in method and enclosing one end of epaulette in armhole seam so that epaulette will lay along shoulder seam. Fold pocket front up onto fronts, folding level with cast-on edges of sections at either side, and sew in place. Attach cast-off edge of lower pocket flaps above upper edges of pockets. Using photo as a guide, attach breast pocket to left front and attach breast pocket flap above pocket. Sew cast-off edge of back sleeve in place behind front sleeve. Sew on buttons, attaching buttons to left front, cuffs, pockets and to shoulders to secure epaulettes.

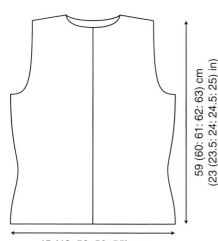

45 (48: 50: 53: 55) cm
(17.5 (19: 19.5: 21: 21.5) in)

59 (60: 61: 62: 63) cm
(23 (23.5: 24: 24.5: 25) in)

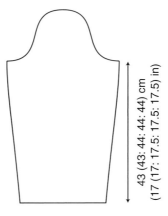

43 (43: 44: 44: 44) cm
(17 (17: 17.5: 17.5: 17.5) in)

Combat

CAROL MELDRUM

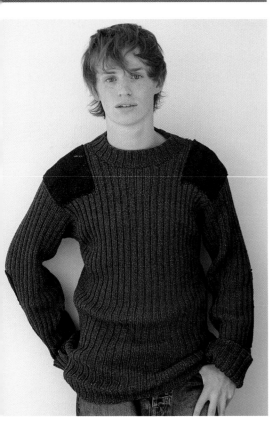

YARN

To fit bust/chest

ladies			mens			
S	M	L	**M**	**L**	**XL**	
86	91	97	**102**	**107**	**112**	cm
34	36	38	**40**	**42**	**44**	in

Rowan Denim

A Memphis 229

16	17	18	**20**	**21**	**22**	x50gm

B Nashville 225

2	2	2	**2**	**2**	**2**	x50gm

NEEDLES

1 pair 3¼ mm (no 10) (US 3) needles
1 pair 3¾ mm (no 9) (US 5) needles
1 pair 4mm (no 8) (US 6) needles

TENSION

Before washing: 20 sts and 28 rows to 10 cm measured over stocking stitch using 4mm (US 6) needles.

Tension note: Denim will shrink in length when washed for the first time. Allowances have been made in the pattern for shrinkage (see size diagram for after washing measurements).

Pattern note: The pattern is written for the 3 ladies sizes, followed by the 3 mens sizes in **bold**. Where only one figure appears this applies to all sizes in that group.

BACK

Cast on 100 (106: 110: **116: 120: 126**) sts using 3¾ mm (US 5) needles and yarn A.
Row 1 (RS): K0 (0: 1: 0), P1 (0: 2: **1: 2: 2**), *K2, P2, rep from * to last 3 (2: 0: **3: 1: 0**) sts, K2 (2: 0: **2: 1: 0**), P1 (0: 0: **1: 0: 0**).
Row 2: P0 (0: 1: 0), K1 (0: 2: **1: 2: 2**), *P2, K2, rep from * to last 3 (2: 0: **3: 1: 0**) sts, P2 (2: 0: **2: 1: 0**), K1 (0: 0: **1: 0: 0**).
These 2 rows form rib.
Work in rib for a further 8 rows, ending with a WS row.
Change to 4mm (US 6) needles.
Cont in rib until back measures 48 (**50.5**) cm, ending with a WS row.
Shape armholes
Keeping rib correct, cast off 8 sts at beg of next 2 rows. 84 (90: 94: **100: 104: 110**) sts.
Cont straight until armhole measures 13.5 (15: 16: **15.5: 16.5: 17.5**) cm, ending with a WS row.
Next row (RS): Rib 2, P18 (20: 22: **24: 26: 28**), rib to last 20 (22: 24: **26: 28: 30**) sts, P to last 2 sts, rib 2.
Next row: Rib 2, K18 (20: 22: **24: 26: 28**), rib to last 20 (22: 24: **26: 28: 30**) sts, K to last 2 sts, rib 2.
Last 2 rows form patt.
Cont in patt until armhole measures 25 (26.5: 27.5: **29: 30: 31**) cm, ending with a WS row.

Shape shoulders and back neck

Cast off 8 (9: 9: **10: 11: 11**) sts at beg of next 2 rows. 68 (72: 76: **80: 82: 88**) sts.
Next row (RS): Cast off 8 (9: 9: **10: 11: 11**) sts, patt until there are 12 (12: 14: **14: 14: 16**) sts on right needle and turn, leave rem sts on a holder.
Work each side of neck separately.
Cast off 4 sts at beg of next row.
Cast off rem 8 (8: 10: **10: 10: 12**) sts.
With RS facing, rejoin yarn to rem sts, cast off centre 28 (30: 30: **32: 32: 34**) sts, patt to end.
Complete to match first side, reverse shapings.

FRONT

Work as given for back until 22 (**22: 24: 24**) rows less have been worked than on back to start of shoulder shaping, ending with a WS row.
Shape neck
Next row (RS): Patt 34 (36: 38: **40: 43: 45**) sts and turn, leaving rem sts on a holder.
Work each side of neck separately.
Dec 1 st at neck edge of next 5 rows, then on foll 4 (**4: 5: 5**) alt rows, then on foll 4th row. 24 (26: 28: **30: 32: 34**) sts.
Work 4 rows, ending with a WS row.
Shape shoulder
Cast off 8 (9: 9: **10: 11: 11**) sts at beg of next and foll alt row.
Work 1 row.
Cast off rem 8 (8: 10: **10: 10: 12**) sts.
With RS facing, rejoin yarn to rem sts, cast off centre 16 (18: 18: **20: 18: 20**) sts, patt to end.
Complete to match first side, reverse shapings.

SLEEVES

Cast on 60 (62: 64: **64: 66: 66**) sts using 3¾ mm (US 5) needles and yarn A.
Row 1 (RS): K1 (0: 0: 0), P2 (0: 1: **1: 2: 2**), *K2, P2, rep from * to last 1 (2: 3: **3: 0: 0**) sts, K1 (2: 2: **2: 0: 0**), P0 (0: 1: **1: 0: 0**).
Row 2: P1 (0: 0: 0), K2 (0: 1: **1: 2: 2**), *P2, K2, rep from * to last 1 (2: 3: **3: 0: 0**) sts, P1 (2: 2: **2: 0: 0**), K0 (0: 1: **1: 0: 0**).
These 2 rows form rib.
Work in rib for a further 8 rows, end with a WS row.
Change to 4mm (US 6) needles.

Cont in rib, shaping sides by inc 1 st at each end of next and every foll 10th (**10th: 10th: 8th**) row until there are 70 (72: 74: **74: 76: 80**) sts, taking inc sts into rib.

Work 9 (**9: 9: 1**) rows, ending with a WS row.

Left sleeve only

Next row (RS): (Inc in first st) 1 (**1: 1: 0**) times, rib 9 (10: 11: **11: 12: 15**), P22, rib to last 1 (**1: 1: 0**) st, (inc in last st) 1 (**1: 1: 0**) times. 72 (74: 76: **76: 78: 80**) sts.

Next row: Rib 39 (40: 41: **41: 42: 43**), K22, rib to end.

Last 2 rows form patt and cont sleeve shaping.

Right sleeve only

Next row (RS): (Inc in first st) 1 (**1: 1: 0**) times, rib 37 (38: 39: **39: 40: 43**), P22, rib to last 1 (**1: 1: 0**) st, (inc in last st) 1 (**1: 1: 0**) times. 72 (74: 76: **76: 78: 80**) sts.

Next row: Rib 11 (12: 13: **13: 14: 15**), K22, rib to end.

Last 2 rows form patt and cont sleeve shaping.

Both sleeves

Cont in patt as now set, shaping sides by inc 1 st at each end of 9th (**9th: 7th: 5th**) and every foll 10th (10th: 8th: 8th) row to 82 (84: 86: **80: 92: 96**) sts, then on every foll - (**8th: -: -**) row until there are - (**-: -: 90: -: -**) sts. Work 7 (**3: 7: 1**) rows, ending with a WS row. Now working all sts in rib, inc 1 st at each end of 3rd (**5th: next: 7th**) and every foll 10th (8th) row to 88 (88: 90: **102: 106: 106**) sts, then on every foll 8th (-: -: 6th) row until there are 90 (94: 98: **-: -: 110**) sts.

Cont straight until sleeve measures 59 (61: 63.5: **66: 67: 68.5**) cm, ending with a WS row. Cast off in rib.

MAKING UP

PRESS as described on the information page. Join right shoulder seam using back stitch, or mattress stitch if preferred.

Neckband

With RS facing, using 3¼ mm (US 3) needles and yarn A, pick up and knit 21 (**21: 24: 24**) sts down left side of neck, 16 (18: 18: 20: 18: 20) sts from front, 21 (**21: 24: 24**) sts up right side of neck, then 36 (38: 38: **40: 40: 42**) sts from back. 94 (98: 98: **102: 106: 110**) sts.

Row 1 (WS): P2, *K2, P2, rep from * to end.

Row 2: K2, *P2, K2, rep from * to end.

Rep last 2 rows 7 times more.

Cast off in rib.

Elbow patches (make 2)

Cast on 22 sts using 4mm (US 6) needles and yarn B.

Row 1 (RS): Knit.

Row 2: K1, P20, K1.

Rep last 2 rows 28 (**31**) times more. Cast off.

Shoulder patches (make 2)

Cast on 18 (20: 22: **24: 26: 28**) sts using 4mm (US 6) needles and yarn B.

Row 1 (RS): Knit.

Row 2: K1, P20, K1.

These 2 rows form patt.

Cont in patt until patch measures 11.5 (**13.5**) cm, ending with a WS row.

Shape shoulder

Row 1 (RS): K5 (6: 7: **7: 8: 9**), wrap next st (by slipping next st to right needle, taking yarn to opposite side of work between needles and then slipping same st back onto left needle - on foll rows, work loop and wrapped st together) and turn.

Row 2: P to last st, K1.

Row 3: K10 (12: 13: **14: 16: 17**), wrap next st and turn.

Row 4: As row 2.

Row 5: K15 (17: 19: **21: 23: 27**), wrap next st and turn.

Row 6: As row 2.

Rows 7 and 8: As rows 3 and 4.

Rows 9 and 10: As rows 1 and 2.

Cont in patt until shorter edge of patch measures 23 (**27**) cm, ending with a WS row. Cast off.

Machine wash all pieces before completing sewing together.

See information page for finishing instructions, setting in sleeves using the square set-in method.

Sew patches onto RS to cover rev st st areas.

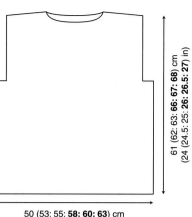

61 (62: 63: **66: 67: 68**) cm (24 (24.5: 25: **26: 26.5: 27**) in)

50 (53: 55: **58: 60: 63**) cm (19.5 (21: 21.5: **23: 23.5: 25**) in)

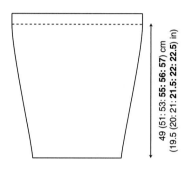

49 (51: 53: **55: 56: 57**) cm (19.5 (20: 21: **21.5: 22: 22.5**) in)

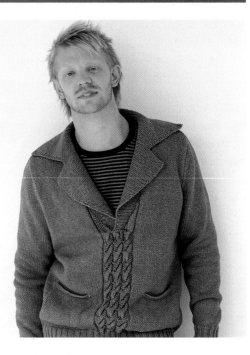

Denver
MARTIN STOREY

YARN

To fit bust/chest

	ladies		mens			
S	M	L	**M**	**L**	**XL**	
86	91	97	**102**	**107**	**112**	cm
34	36	38	**40**	**42**	**44**	in

Rowan Denim

| 16 | 17 | 18 | **20** | **21** | **22** | x50gm |

(photographed in Tennessee 231)

NEEDLES

1 pair 3¼ mm (no 10) (US 3) needles
1 pair 4mm (no 8) (US 6) needles
Cable needle

TENSION

Before washing: 20 sts and 28 rows to
10 cm measured over stocking stitch using
4mm (US 6) needles.

Tension note: Denim will shrink in length
when washed for the first time.
Allowances have been made in the pattern
for shrinkage (see size diagram for after
washing measurements).

Pattern note: The pattern is written for the 3
ladies sizes, followed by the 3 mens sizes in
bold. Where only one figure appears this
applies to all sizes in that group.

SPECIAL ABBREVIATIONS

Cr8R = Cross 8 right Slip next 4 sts onto
cable needle and leave at back of work, (K1,
P1) twice, then K4 from cable needle.
C8B = Cable 8 back Slip next 4 sts onto
cable needle and leave at back of work, K4,
then (K1, P1) twice from cable needle.

BACK

Cast on 104 (110: 114: **120: 124: 130**) sts
using 3¼ mm (US 3) needles.
Row 1 (RS): K0 (0: 1: 0), P1 (0: 2: **1: 2: 2**),
*K2, P2, rep from * to last 3 (2: 0: **3: 1: 0**) sts,
K2 (2: 0: **2: 1: 0**), P1 (0: 0: **1: 0: 0**).
Row 2: P0 (0: 1: 0), K1 (0: 2: **1: 2: 2**), *P2,
K2, rep from * to last 3 (2: 0: **3: 1: 0**) sts, P2
(2: 0: **2: 1: 0**), K1 (0: 0: **1: 0: 0**).
These 2 rows form rib.
Work in rib for a further 20 rows, ending with
a WS row.
Change to 4mm (US 6) needles.
Beg with a K row, cont in st st until back
measures 53 (**55**) cm, ending with a WS row.
Shape armholes
Cast off 3 (4: 5: **6: 7: 8**) sts at beg of next
2 rows. 98 (102: 104: **108: 110: 114**) sts.
Dec 1 st at each end of next 5 rows, then on
foll 2 (3: 3: **4: 4: 5**) alt rows, then on every foll
4th row until 80 (82: 84: **86: 88: 90**) sts rem.
Cont straight until armhole measures
24 (25: 26.5: **27.5: 29: 30**) cm, ending
with a WS row.
Shape shoulders and back neck
Cast off 8 sts at beg of next 2 rows.
64 (66: 68: **70: 72: 74**) sts.

Next row (RS): Cast off 8 sts, K until there
are 11 (11: 12: **12: 13: 13**) sts on right needle
and turn, leaving rem sts on a holder.
Work each side of neck separately.
Cast off 4 sts at beg of next row.
Cast off rem 7 (7: 8: **8: 9: 9**) sts.
With RS facing, rejoin yarn to rem sts, cast off
centre 26 (28: 28: **30: 30: 32**) sts, K to end.
Complete to match first side, reverse shapings.

POCKET LININGS (make 2)

Cast on 26 (**30**) sts using 4mm (US 6) needles.
Beg with a K row, work in st st for 44 (**50**)
rows, ending with a WS row.
Break yarn and leave sts on a holder.

FRONT

Cast on 104 (110: 114: **120: 124: 130**) sts
using 3¼ mm (US 3) needles.
Work in rib as for back for 21 rows, ending
with a RS row.
Row 22 (WS): Rib 44 (47: 49: **52: 54: 57**),
(M1, rib 1, M1, rib 2) 5 times, M1, rib 1, M1,
rib to end.
116 (122: 126: **132: 136: 142**) sts.
Change to 4mm (US 6) needles.
Row 1 (RS): K42 (45: 47: **50: 52: 55**), P2,
(K5, P1, K1, P3) 3 times, K to end.
Row 2: P42 (45: 47: **50: 52: 55**), *K2, (P1,
K1) twice, P4, rep from * twice more, K2, P
to end.
Rows 3 and 4: As rows 1 and 2.
Row 5: K42 (45: 47: **50: 52: 55**), P2, (Cr8R,
P2) 3 times, K to end.
Row 6: P42 (45: 47: **50: 52: 55**), (K2, P5, K1,
P1, K1) 3 times, K2, P to end.
Row 7: K42 (45: 47: **50: 52: 55**), P2, *(K1,
P1) twice, K4, P2, rep from * twice more, K
to end.
Rows 8 to 13: As rows 6 and 7, 3 times.
Row 14: As row 6.
Row 15: K42 (45: 47: **50: 52: 55**), P2, (C8B,
P2) 3 times, K to end.
Row 16: As row 2.
Rows 17 to 20: As rows 1 and 2, twice.
These 20 rows form patt.

Work in patt for a further 24 (**30**) rows, ending with a WS row.

Place pockets

Next row (RS): K8 (11: 13: **12: 14: 17**), slip next 26 (**30**) sts onto a holder and, in their place, K across 26 (**30**) sts of first pocket lining, patt 48 sts, slip next 26 (**30**) sts onto a holder and, in their place, K across 26 (**30**) sts of second pocket lining, K to end.

Cont straight until 18 rows less have been worked than on back to beg of armhole shaping, ending with a WS row.

Divide for neck

Next row (RS): Patt 52 (55: 57: **60: 62: 65**) sts and turn, leaving rem sts on a holder.

Work each side of neck separately.

Work 1 row.

Dec 1 st at neck edge of next and every foll 4th row until 48 (51: 53: **56: 58: 61**) sts rem.

Work 3 rows, ending with a WS row.

Shape armholes

Cast off 3 (4: 5: **6: 7: 8**) sts at beg and dec 1 st at end of next rows. 44 (46: 47: **49: 50: 52**) sts.

Work 1 row.

Dec 1 st at armhole edge of next 5 rows, then on foll 2 (3: 3: **4: 4: 5**) alt rows, then on 2 foll 4th rows and at same time dec 1 st at neck edge of 3rd and every foll 4th row. 31 (31: 32: **33: 34: 34**) sts.

Dec 1 st at neck edge of 2nd (4th: 4th: **2nd: 2nd: 4th**) and every foll 4th (4th: 6th: **4th: 6th: 6t**h) row to 29 (28: 24: **31: 25: 25**) sts, then on every foll 6th (6th: -: **6th: -: -**) row until 23 (23: -: **24: -: -**) sts rem.

Cont straight until front matches back to start of shoulder shaping, ending with a WS row.

Shape shoulder

Cast off 8 sts at beg of next and foll alt row.

Work 1 row.

Cast off rem 7 (7: 8: **8: 9: 9**) sts.

With RS facing, rejoin yarn to rem sts, P2, (K2tog) 4 times, P2 and slip these 8 sts onto a holder, patt to end. 52 (55: 57: **60: 62: 65**) sts.

Complete to match first side, reverse shapings.

SLEEVES (both alike)

Cast on 48 (50: 52: **52: 54: 54**) sts using 3¼ mm (US 3) needles.

Row 1 (RS): K1 (0: 1: **1: 0: 0**), P2, *K2, P2, rep from * to last 1 (0: 1: **1: 0: 0**) sts, K1 (0: 1: **1: 0: 0**).

Row 2: P1 (0: 1: **1: 0: 0**), K2, *P2, K2, rep from * to last 1 (0: 1: **1: 0: 0**) sts, P1 (0: 1: **1: 0: 0**).

These 2 rows form rib.

Work in rib for a further 20 rows, ending with a WS row.

Change to 4mm (US 6) needles.

Beg with a K row, cont in st st, shaping sides by inc 1 st at each end of next and every foll 10th (**8th**) row to 58 (66: 72: **62: 70: 88**) sts, then on every foll 12th (**10th**) row until there are 70 (74: 78: **82: 86: 90**) sts.

Cont straight until sleeve measures 53 (55: 57.5: **60: 61: 62.5**) cm, ending with a WS row.

Shape top

Cast off 3 (4: 5: **6: 7: 8**) sts at beg of next 2 rows. 64 (66: 68: **70: 72: 74**) sts.

Dec 1 st at each end of next 5 rows, then on foll 3 (4) alt rows, then on every foll 4th row until 36 (38: 40: **40: 42: 44**) sts rem.

Work 1 row, ending with a WS row.

Dec 1 st at each end of next and foll 0 (1: 2: **2: 3: 4**) alt rows, then on foll 7 rows, ending with a WS row.

Cast off rem 20 sts.

MAKING UP

PRESS as described on the information page.

Join shoulder seams using back stitch, or mattress stitch if preferred.

Mark points along neck slopes 7 cm down from shoulder seams.

Left rever

Slip 8 sts from front holder onto 3¼ mm (US 3) needles and rejoin yarn with RS facing.

Row 1 (RS): Sl 1, K to end.

Row 2: As row 1.

These 2 rows form patt.

Work 4 rows.

****Next row:** Sl 1, inc in next st, K to last 3 sts, inc in next st, K2.

Rep last 6 rows 13 times more. 36 sts.**

Cont straight until rever, when slightly stretched, fits up left neck slope to marker, sewing in place as you go along and ending at inner attached edge.

Next row (RS of body, WS of rever):

Sl 1, K to last 14 sts, cast off rem 14 sts. 22 sts.

Rejoin yarn with RS of rever facing, sl 1, inc in next st, K to end. 23 sts.

Work 3 rows.

Next row: Sl 1, inc in next st, K to end.

Rep last 4 rows 6 times more. 30 sts.

Work a further 2 rows.

Break yarn and leave sts on a holder.

Right rever

Cast on 8 sts using 3¼ mm (US 3) needles.

Row 1 (RS): Knit.

Row 2: Sl 1, K to end.

Row 3: As row 2.

Last 2 rows form patt.

Work 3 rows.

Work as for left rever from ** to **.

Cont straight until rever, when slightly stretched, fits up right neck slope to marker, sewing in place as you go along and ending at outer free edge.

Next row (RS of body, WS of rever): Cast off 14 sts, K to end. 22 sts.

Next row: Sl 1, K to last 3 sts, inc in next st, K2. 23 sts.

Work 3 rows.

Rep last 4 rows 6 times more, then first of these rows again. 30 sts.

Work a further 2 rows.

Do NOT break yarn.

Collar

Next row (RS of body): K 30 sts of right rever, then with RS facing pick up and knit 34 (36: 36: **38: 38: 40**) sts from back neck, then K 30 sts of left rever. 94 (96: 96: **98: 98: 100**) sts.

Next row: Sl 1, inc in next st, K to last 3 sts, inc in next st, K2. 96 (98: 98: **100: 100: 102**) sts.

Work 3 rows.

Next row: Sl 1, inc in next st, K to last 28 sts and turn.

Next row: Sl 1, K to last 29 sts and turn.

Next row: Sl 1, K to last 32 sts and turn.

Next row: Sl 1, K to last 33 sts and turn.

Next row: Sl 1, K to last 36 sts and turn.

Next row: Sl 1, K to last 37 sts and turn.

Next row: Sl 1, K to last 3 sts, inc in next st, K2.
98 (100: 100: **102: 102: 104**) sts.

Work 3 rows across all sts.

Next row: Sl 1, inc in next st, K to last 3 sts, inc in next st, K2.

Work 3 rows.

Rep last 4 rows until collar measures 11 cm at centre back neck.

Cast off.

Pocket tops (both alike)

Slip 26 (**30**) sts from pocket holder onto 3¼ mm (US 3) needles and rejoin yarn with RS facing.

Work in garter st for 5 rows.

Cast off knitwise (on WS).

Machine wash all pieces before completing sewing together.

See information page for finishing instructions, setting in sleeves using the set-in method and sewing cast-on edge of right rever in place behind left rever.

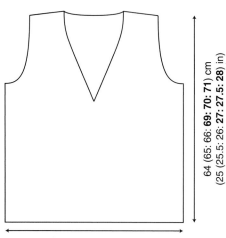

64 (65: 66: **69: 70: 71**) cm
(25 (25.5: 26: **27: 27.5: 28**) in)

52 (55: 57: **60: 62: 65**) cm
(20.5 (21.5: 22.5: **23.5: 24.5: 25.5**) in)

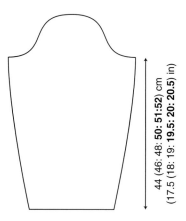

44 (46: 48: **50: 51:52**) cm
(17.5 (18: 19: **19.5: 20: 20.5**) in)

Paris

KIM HARGREAVES

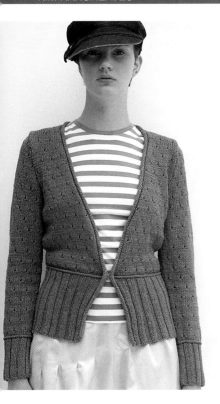

YARN

	XS	S	M	L	XL	
To fit bust	81	86	91	97	102	cm
	32	34	36	38	40	in

Rowan Denim

| | 11 | 12 | 12 | 13 | 14 | x50gm |

(photographed in Tennessee 231)

NEEDLES

1 pair 3¾ mm (no 9) (US 5) needles
1 pair 4mm (no 8) (US 6) needles
3¾ mm (no 9) (US 5) circular needle

EXTRAS - Hook and eye fastener

TENSION

Before washing: 20 sts and 28 rows to
10 cm measured over stocking stitch using
4mm (US 6) needles.

Tension note: Denim will shrink in length
when washed for the first time. Allowances
have been made in the pattern for shrinkage
(see size diagram for after washing
measurements).

BACK

Lower section

Cast on 86 (92: 96: 102: 106) sts using 3¼ mm
(US 5) needles.

Row 1 (RS): P1 (0: 1: 0: 1), K3 (2: 3: 2: 3),
(P2, K3) 0 (1: 1: 2: 2) times, (P4, K3) twice,
P2, (K3, P4) twice, (K3, P2) 3 times, (K3, P4)
twice, K3, P2, (K3, P4) twice, (K3, P2) 0 (1:
1: 2: 2) times, K3 (2: 3: 2: 3), P1 (0: 1: 0: 1).

Row 2: K1 (0: 1: 0: 1), P3 (2: 3: 2: 3), (K2,
P3) 0 (1: 1: 2: 2) times, (K4, P3) twice, K2,
(P3, K4) twice, (P3, K2) 3 times, (P3, K4)
twice, P3, K2, (P3, K4) twice, (P3, K2) 0 (1:
1: 2: 2) times, P3 (2: 3: 2: 3), K1 (0: 1: 0: 1).
These 2 rows form rib.

Work in rib for a further 8 rows, ending
with a WS row.

Change to 4mm (US 6) needles.

Work 10 rows, ending with a WS row.

Row 21 (RS): Rib 6 (9: 11: 14: 16), P2tog,
K3, P2tog, rib 12, P2tog, K3, P2tog, rib 22,
P2tog, K3, P2tog, rib 12, P2tog, K3, P2tog,
rib to end.

78 (84: 88: 94: 98) sts.

Keeping sts correct as now set, work a
further 17 rows, ending with a WS row.

Row 39 (RS): Rib 5 (8: 10: 13: 15), P2tog,
K3, P2tog, rib 10, P2tog, K3, P2tog, rib 20,
P2tog, K3, P2tog, rib 10, P2tog, K3, P2tog,
rib to end. 70 (76: 80: 86: 90) sts.

Work a further 13 rows, end with a WS row.

Cast off in rib.

Upper section

With WS facing (so that ridge is formed on
RS of work) and using 4 mm (US 6) needles,
pick up and knit 71 (77: 81: 87: 91) sts
across cast-off edge of lower section.

Patt as folls:

Row 1 (RS): Knit.

Row 2 and every foll alt row: Purl.

Row 3: K4 (1: 3: 0: 2), *K2tog, yfwd, K4, rep
from * to last 7 (4: 6: 3: 5) sts, K2tog, yfwd,
K5 (2: 4: 1: 3).

Row 5: K2, M1, K to last 2 sts, M1, K2.
73 (79: 83: 89: 93) sts.

Rows 7 and 9: Knit.

Row 11: K2, M1, K0 (3: 5: 2: 4), *K2tog,
yfwd, K4, rep from * to last 5 (8: 10: 7: 9) sts,
K2tog, yfwd, K1 (4: 6: 3: 5), M1, K2.
75 (81: 85: 91: 95) sts.

Rows 13 and 15: Knit.

Row 16: Purl.

These 16 rows form patt and start side
seam shaping.

Working all increases as set by rows 5
and 11, cont in patt, shaping side seams
by inc 1 st at each end of next and every
foll 6th row until there are 87 (93: 97:
103: 107) sts,

taking inc sts into patt.

Work 11 (15: 15: 19: 19) rows, ending
with a WS row. (Work should measure
39 (40.5: 40.5: 42: 42) cm from cast-on
edge of lower section.)

Shape armholes

Keeping patt correct, cast off 3 (4: 4: 5: 5) sts
at beg of next 2 rows.

81 (85: 89: 93: 97) sts.

Dec 1 st at each end of next 5 (5: 7: 7: 9) rows,
then on foll 2 (3: 2: 3: 2) alt rows.

67 (69: 71: 73: 75) sts.

Cont straight until armhole measures 24 (24:
25: 25: 26.5) cm, ending with a WS row.

Shape shoulders and back neck

Cast off 6 (6: 6: 6: 7) sts at beg of next 2 rows.
55 (57: 59: 61: 61) sts.

Next row (RS): Cast off 6 (6: 6: 6: 7) sts,
patt until there are 10 (10: 11: 11: 10) sts
on right needle and turn, leaving rem sts
on a holder.

Work each side of neck separately.

Cast off 4 sts at beg of next row.

Cast off rem 6 (6: 7: 7: 6) sts.

With RS facing, rejoin yarn to rem sts, cast
off centre 23 (25: 25: 27: 27) sts, patt to end.

Complete to match first side, reverse shapings.

LEFT FRONT

Lower section

Cast on 44 (47: 49: 52: 54) sts using 3¼ mm (US 5) needles.

Row 1 (RS): P1 (0: 1: 0: 1), K3 (2: 3: 2: 3), (P2, K3) 0 (1: 1: 2: 2) times, (P4, K3) twice, P2, (K3, P4) twice, (K3, P2) twice.

Row 2: (K2, P3) twice, (K4, P3) twice, K2, (P3, K4) twice, (P3, K2) 0 (1: 1: 2: 2) times, P3 (2: 3: 2: 3), K1 (0: 1: 0: 1).

These 2 rows form rib.

Work in rib for a further 8 rows, ending with a WS row.

Change to 4mm (US 6) needles.

Work 10 rows, ending with a WS row.

Row 21 (RS): Rib 6 (9: 11: 14: 16), P2tog, K3, P2tog, rib 12, P2tog, K3, P2tog, rib to end. 40 (43: 45: 48: 50) sts.

Keeping sts correct as now set, work a further 17 rows, ending with a WS row.

Row 39 (RS): Rib 5 (8: 10: 13: 15), P2tog, K3, P2tog, rib 10, P2tog, K3, P2tog, rib to end. 36 (39: 41: 44: 46) sts.

Work a further 13 rows, ending with a WS row.

Cast off in rib.

Upper section

With WS facing (so that ridge is formed on RS of work) and using 4 mm (US 6) needles, pick up and knit 36 (39: 41: 44: 46) sts across cast-off edge of lower section.

Patt as folls:

Row 1 (RS): Knit.

Row 2 and every foll alt row: Purl.

Row 3: K4 (1: 3: 0: 2), *K2tog, yfwd, K4, rep from * to last 2 sts, K2.

Row 5: K2, M1, K to end. 37 (40: 42: 45: 47) sts.

Rows 7 and 9: Knit.

Row 11: K2, M1, K0 (3: 5: 2: 4), *K2tog, yfwd, K4, rep from * to last 5 sts, K2tog, yfwd, K3. 38 (41: 43: 46: 48) sts.

Rows 13 and 15: Knit.

Row 16: Purl.

These 16 rows form patt and start side seam shaping.

Working all increases as set by rows 5 and 11, cont in patt, shaping side seams by inc 1 st at each end of next and every foll 6th row until there are 41 (45: 47: 50: 52) sts, taking inc sts into patt.

Work 3 (1: 1: 5: 5) rows, end with a WS row.

Shape front slope

Keeping patt correct, work 14 (26: 24: 26: 26) rows, inc 1 st at side seam edge of 3rd (5th: 5th: next: next) and foll 6th row and at same time dec 1 st at front slope edge of next and every foll 4th row.

39 (40: 43: 45: 47) sts.

XS size only

Inc 1 st at side seam edge of next row.

Work 3 rows.

Dec 1 st at front slope edge of next and foll 6th row.

38 sts.

All sizes

Work 1 (0: 2: 0: 0) rows, ending with a WS row. (Left Front should now match back to beg of armhole shaping.)

Shape armhole

Keeping patt correct, cast off 3 (4: 4: 5: 5) sts at beg and dec 0 (0: 1: 0: 0) st at end of next row.

35 (36: 38: 40: 42) sts.

Work 1 row.

Dec 1 st at armhole edge of next 5 (5: 7: 7: 9) rows, then on foll 2 (3: 2: 3: 2) alt rows and at same time dec 1 st at front slope edge of 3rd (3rd: 5th: next: 3rd) and foll 6th (6th: 6th: 4th: 6th) row, then on foll 0 (0: 0: 6th: 0) row.

26 (26: 27: 27: 29) sts.

Dec 1 st at front slope edge only on 6th (4th: 6th: 4th: 2nd) and every foll 6th row until 18 (18: 19: 19: 20) sts rem.

Cont straight until left front matches back to start of shoulder shaping, ending with a WS row.

Shape shoulders and back neck

Cast off 6 (6: 6: 6: 7) sts at beg of next and foll alt row.

Work 1 row.

Cast off rem 6 (6: 7: 7: 6) sts.

RIGHT FRONT

Lower section

Cast on 44 (47: 49: 52: 54) sts using 3¾ mm (US 5) needles.

Row 1 (RS): (P2, K3) twice, (P4, K3) twice, P2, (K3, P4) twice, (K3, P2) 0 (1: 1: 2: 2) times, K3 (2: 3: 2: 3), P1 (0: 1: 0: 1).

Row 2: K1 (0: 1: 0: 1), P3 (2: 3: 2: 3), (K2, P3) 0 (1: 1: 2: 2) times, (K4, P3) twice, K2, (P3, K4) twice, (P3, K2) twice.

These 2 rows form rib.

Work in rib for a further 8 rows, ending with a WS row.

Change to 4mm (US 6) needles.

Work 10 rows, ending with a WS row.

Row 21 (RS): Rib 12, P2tog, K3, P2tog, rib 12, P2tog, K3, P2tog, rib to end. 40 (43: 45: 48: 50) sts.

Keeping sts correct as now set, work a further 17 rows, ending with a WS row.

Row 39 (RS): Rib 11, P2tog, K3, P2tog, rib 10, P2tog, K3, P2tog, rib to end. 36 (39: 41: 44: 46) sts.

Work a further 13 rows, ending with a WS row.

Cast off in rib.

Upper section

With WS facing (so that ridge is formed on RS of work) and using 4 mm (US 6) needles, pick up and knit 36 (39: 41: 44: 46) sts across cast-off edge of lower section.

Patt as folls:

Row 1 (RS): Knit.

Row 2 and every foll alt row: Purl.

Row 3: K5, *K2tog, yfwd, K4, rep from * to last 7 (4: 6: 3: 5) sts, K2tog, yfwd, K5 (2: 4: 1: 3).

Row 5: K to last 2 sts, M1, K2. 37 (40: 42: 45: 47) sts.

Rows 7 and 9: Knit.

Row 11: K2, *K2tog, yfwd, K4, rep from * to last 5 (8: 10: 7: 9) sts, K2tog, yfwd, K1 (4: 6: 3: 5), M1, K2. 38 (41: 43: 46: 48) sts.

Rows 13 and 15: Knit.

Row 16: Purl.

These 16 rows form patt and start side seam shaping.

Complete to match left front, reverse shapings.

SLEEVES (both alike)

Lower section

Cast on 48 (48: 50: 52: 52) sts using 3¼ mm (US 5) needles.

Row 1 (RS): P0 (0: 1: 2: 2), *K3, P2, rep from * to last 3 (3: 4: 5: 5) sts, K3, P0 (0: 1: 2: 2).

Row 2: K0 (0: 1: 2: 2), *P3, K2, rep from * to last 3 (3: 4: 5: 5) sts, P3, K0 (0: 1: 2: 2).

These 2 rows form rib.

Work in rib for a further 8 rows, ending with a WS row.

Change to 4mm (US 6) needles.

Work a further 22 rows, ending with a WS row. Cast off in rib.

Upper section

With WS facing (so that ridge is formed on RS of work) and using 4 mm (US 6) needles, pick up and knit 49 (49: 51: 53: 53) sts across cast-off edge of lower section.

Patt as folls:

Row 1 (RS): Knit.

Row 2 and every foll alt row: Purl.

Row 3: K5 (5: 0: 1: 1), *K2tog, yfwd, K4, rep from * to last 8 (8: 3: 4: 4) sts, K2tog, yfwd, K6 (6: 1: 2: 2).

Row 5: Knit.

Row 7: K2, M1, K to last 2 sts, M1, K2. 51 (51: 53: 55: 55) sts.

Row 9: Knit.

Row 11: K3 (3: 4: 5: 5), *K2tog, yfwd, K4, rep from * to last 0 (0: 1: 2: 2) sts, K0 (0: 1: 2: 2).

Rows 13 and 15: Knit.

Row 16: Purl.

These 16 rows form patt and start sleeve shaping.

Working all increases as set by row 7, cont in patt, shaping sides by inc 1 st at each end

of 5th (3rd: 3rd: 3rd: 3rd) and every foll 14th (12th: 12th: 12th: 12th) row to 59 (63: 69: 71: 61) sts, then on every foll 12th (10th: - : -: 10th) row until there are 65 (67: -: -: 73) sts, taking inc sts into patt.

Cont straight until sleeve measures 51.5 (51.5: 53: 53: 53) cm from cast-on edge of lower section, ending with a WS row.

Shape top

Keeping patt correct, cast off 3 (4: 4: 5: 5) sts at beg of next 2 rows.

59 (59: 61: 61: 63) sts.

Dec 1 st at each end of next 3 rows, then on foll 2 alt rows, then on every foll 4th row until 35 (35: 37: 37: 39) sts rem.

Work 1 row, ending with a WS row.

Dec 1 st at each end of next and every foll alt row to 31 sts, then on foll 5 rows, ending with a WS row.

Cast off rem 21 sts.

MAKING UP

PRESS as described on the information page.

Join shoulder seams using back stitch, or mattress stitch if preferred.

Front band

With RS facing and using 3¾ mm (US 5) circular needle, starting at right front cast-on edge, pick up and knit 55 (**56:** 56: **59:** 59) sts up right front opening edge to start of front slope shaping, 61 (**61:** 63: **63:** 66) sts up right front slope to shoulder, 31 (**33:** 33: **35:** 35) sts from back, 61 (**61:** 63: **63:** 66) sts down left front slope to start of front slope shaping, then 55 (**56:** 56: **59:** 59) sts down left front opening edge to cast-on edge. 263 (**267:** 271: **279:** 285) sts.

Beg with a P row, work in st st for 6 rows. Cast off.

Machine wash all pieces before completing sewing together.

See information page for finishing instructions, setting in sleeves using the set-in method.

Attach hook and eye to reverse of front bands, level with ridge formed between front sections.

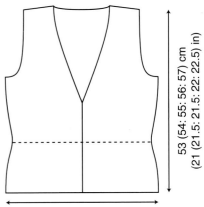

53 (54: 55: 56: 57) cm
(21 (21.5: 21.5: 22: 22.5) in)

43.5 (46.5: 48.5: 51.5: 53.5) cm
(17 (18.5: 19: 20.5: 21) in)

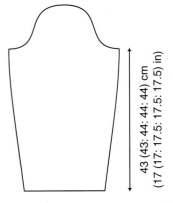

43 (43: 44: 44: 44) cm
(17 (17: 17.5: 17.5: 17.5) in)

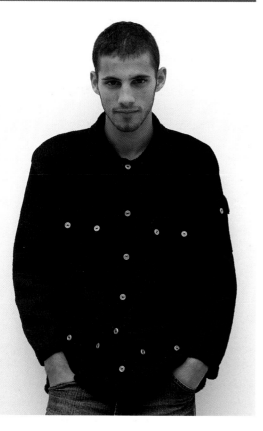

Colorado

MARTIN STOREY

YARN

To fit bust/chest

	ladies		mens			
S	M	L	**M**	**L**	**XL**	
86	91	97	**102**	**107**	**112**	cm
34	36	38	**40**	**42**	**44**	in

Rowan Denim

| 19 | 20 | 21 | **23** | **24** | **25** | x50gm |

(photographed in Nashville 225)

NEEDLES

1 pair 3¼mm (no 10) (US 3) needles
1 pair 4mm (no 8) (US 6) needles

BUTTONS - 17 x 75324

TENSION

Before washing: 20 sts and 28 rows to
10 cm measured over stocking stitch using
4mm (US 6) needles.

Tension note: Denim will shrink in length
when washed for the first time. Allowances
have been made in the pattern for shrinkage
(see size diagram for after washing
measurements).

Pattern note: The pattern is written for the 3
ladies sizes, followed by the 3 mens sizes in
bold. Where only one figure appears this
applies to all sizes in that group.

BACK

Cast on 111 (117: 121: **127: 131: 137**) sts
using 3¼mm (US 3) needles.
Row 1 (RS): K1, *P1, K1, rep from * to end.
Row 2: As row 1.
These 2 rows form moss st.
Work in moss st for a further 10 rows, ending
with a WS row.
Change to 4mm (US 6) needles.
Row 1 (RS): Knit.
Row 2: P32 (34: 35: **37: 38: 40**), K2,
P43 (45: 47: **49: 51: 53**), K2, P to end.
These 2 rows form patt.
Cont in patt until back measures 56.5 cm,
ending with a WS row.
Shape armholes
Keeping patt correct, cast off 6 sts at beg of
next 2 rows.
99 (105: 109: **115: 119: 125**) sts.
Dec 1 st at each end of next and foll 5 alt rows.
87 (93: 97: **103: 107: 113**) sts.
Work 3 rows, ending with a WS row.
Work in garter st for 4 rows.
Beg with a K row, cont in st st until armhole
measures 25 (26.5: 27.5: **29: 30: 31**) cm,
ending with a WS row.
Shape shoulders and back neck
Cast off 9 (10: 11: **11: 12: 13**) sts at beg of
next 2 rows. 69
(73: 75: **81: 83: 87**) sts.

Next row (RS): Cast off 9 (10: 11: **11: 12: 13**) sts,
K until there are 14 (**16**) sts on right needle
and turn, leaving rem sts on a holder.
Work each side of neck separately.
Cast off 4 sts at beg of next row.
Cast off rem 10 (**12**) sts.
With RS facing, rejoin yarn to rem sts, cast off
centre 23 (25: 25: **27: 27: 29**) sts, K to end.
Complete to match first side, reverse shapings.

LOWER POCKET FLAPS (make 2)

Cast on 31 (**33**) sts using 3¼mm (US 3)
needles.
**Work in garter st for 3 rows, end with a RS row.
Change to 4mm (US 6) needles.
Row 4 (WS): K2, P to last 2 sts, K2.
Row 5: K4, K2tog, yfwd, K to last 6 sts, yfwd,
K2tog, K4.
Row 6: As row 4.
Row 7: Knit.
Rep rows 6 and 7, 5 times more, then
row 6 again.
Break yarn and leave sts on a holder.

UPPER POCKET FLAPS (make 2)

Cast on 27 (**29**) sts using 3¼mm
(US 3) needles.
Complete as for lower pocket flaps from **.

LEFT FRONT

Cast on 64 (67: 69: **72: 74: 77**) sts using
3¼mm (US 3) needles.
Row 1 (RS): *K1, P1, rep from * to last 0 (1:
1: **0: 0: 1**) st, K0 (1: 1: **0: 0: 1**).
Row 2: K0 (1: 1: **0: 0: 1**), *P1, K1, rep from *
to end.
These 2 rows form moss st.
Mens sizes only
Work in moss st for a further 2 rows, ending
with a WS row.
Row 5 (buttonhole row) (RS): Moss st to
last 5 sts, work 2 tog, yrn (to make a
buttonhole), moss st 3 sts.
All sizes
Work in moss st for a further 9 (**6**) rows,
ending with a RS row.

Row 12 (WS): Moss st 9 sts and slip these sts onto a holder, M1, moss st to end.

56 (59: 61: **64: 66: 69**) sts.

Change to 4mm (US 6) needles.

Place lower pocket

Next row (RS): K19 (22: 24: **25: 27: 30**) and slip these sts onto a holder, K31 (**33**) and turn, leaving rem 6 sts on a second holder.

Work on this set of 31 (**33**) sts only for lower pocket as folls:

Beg with a P row, work in st st for 66 rows, ending with a RS row.

Work in garter st for 3 rows.

Cast off knitwise (on RS).

Rejoin yarn to 6 sts left on second holder and K to end.

Next row (WS): P6, turn and cast on 31 (**33**) sts, turn and P across 19 (22: 24: **25: 27: 30**) sts left on first holder.

56 (59: 61: **64: 66: 69**) sts.

Beg with a K row, work in st st for 68 rows, ending with a WS row.

Place lower pocket flap

Next row (RS): K19 (22: 24: **25: 27: 30**), holding WS of lower pocket flap against RS of left front K tog first st of lower pocket flap with next st of left front, K tog rem 30 (**32**) sts of lower pocket flap with next 30 (**32**) sts of left front in same way, K6.

Next row (WS): P6, K2, P27 (**29**), K2, P to end.

Next row: Knit.

Last 2 rows form patt.

Cont in patt until left front matches back to beg of armhole shaping, ending with a WS row.

Shape armhole

Keeping patt correct, cast off 6 sts at beg of next row.

50 (53: 55: **58: 60: 63**) sts.

Work 1 row.

Dec 1 st at armhole edge of next and foll 5 alt rows.

44 (47: 49: **52: 54: 57**) sts.

Work 3 rows, ending with a WS row.

Work in garter st for 4 rows.

Place upper pocket flap

Next row (RS): K9 (12: 14: **15: 17: 20**), holding WS of upper pocket flap against RS of left front K tog first st of upper pocket flap with next st of left front, K tog rem 26 (**28**) sts of upper pocket flap with next 26 (**28**) sts of left front in same way, K8.

Beg with a P row, cont in st st until 19 (**19: 21: 21**) rows less have been worked than on back to start of shoulder shaping, ending with a RS row.

Shape neck

Cast off 3 (4: 4: **5: 4: 5**) sts at beg of next row, then 5 sts at beg of foll alt row.

36 (38: 40: **42: 45: 47**) sts.

Dec 1 st at neck edge of next 4 rows, then on foll 2 (**2: 3: 3**) alt rows, then on every foll 4th row until 28 (30: 32: **34: 36: 38**) sts rem, ending with a WS row.

Shape shoulder

Cast off 9 (10: 11: **11: 12: 13**) sts at beg of next and foll alt row.

Work 1 row.

Cast off rem 10 (**12**) sts.

RIGHT FRONT

Cast on 64 (67: 69: **72: 74: 77**) sts using 3¼ mm (US 3) needles.

Row 1 (RS): K0 (1: 1: **0: 0: 1**), *P1, K1, rep from * to end.

Row 2: *K1, P1, rep from * to last 0 (1: 1: **0: 0: 1**) st, K0 (1: 1: **0: 0: 1**).

These 2 rows form moss st.

Ladies sizes only

Work in moss st for a further 2 rows, ending with a WS row.

Row 5 (buttonhole row) (RS): Moss st 3 sts, yrn (to make a buttonhole), work 2 tog, moss st to end.

All sizes

Work in moss st for a further 6 (**9**) rows, ending with a RS row.

Row 12 (WS): Moss st to last 9 sts, M1 and turn, leaving rem 9 sts on a holder.

56 (59: 61: **64: 66: 69**) sts.

Change to 4mm (US 6) needles.

Place lower pocket

Next row (RS): K6 and slip these sts onto a holder, K31 (**33**) and turn, leaving rem 19 (22: 24: **25: 27: 30**) sts on a second holder.

Work on this set of 31 (**33**) sts only for lower pocket as folls:

Beg with a P row, work in st st for 66 rows, ending with a RS row.

Work in garter st for 3 rows.

Cast off knitwise (on RS).

Rejoin yarn to 19 (22: 24: **25: 27: 30**) sts left on second holder and K to end.

Next row (WS): P19 (22: 24: **25: 27: 30**), turn and cast on 31 (**33**) sts, turn and P across 6 sts left on first holder.

56 (59: 61: **64: 66: 69**) sts.

Beg with a K row, work in st st for 68 rows, ending with a WS row.

Place lower pocket flap

Next row (RS): K6, holding WS of lower pocket flap against RS of right front K tog first st of lower pocket flap with next st of right front, K tog rem 30 (**32**) sts of lower pocket flap with next 30 (**32**) sts of right front in same way, K19 (22: 24: **25: 27: 30**).

Next row (WS): P19 (22: 24: **25: 27: 30**), K2, P27 (**29**), K2, P to end.

Next row: Knit.

Last 2 rows form patt.

Cont in patt until right front matches back to beg of armhole shaping, ending with a RS row.

Shape armhole

Keeping patt correct, cast off 6 sts at beg of next row.

50 (53: 55: **58: 60: 63**) sts.

Dec 1 st at armhole edge of next and foll 5 alt rows. 44 (47: 49: **52: 54: 57**) sts.

Work 3 rows, ending with a WS row.

Work in garter st for 4 rows.

Place upper pocket flap

Next row (RS): K8, holding WS of upper pocket flap against RS of right front K tog first st of upper pocket flap with next st of right front, K tog rem 26 (**28**) sts of upper pocket flap with next 26 (**28**) sts of right front in same way, K9 (12: 14: **15: 17: 20**).

Beg with a P row, cont in st st and complete to match left front, reversing shapings.

SLEEVE POCKET FLAP

Cast on 21 sts using 3¼ mm (US 3) needles.

Work in garter st for 3 rows, ending with a RS row.

Change to 4mm (US 6) needles.

Row 4 (WS): K2, P to last 2 sts, K2.

Row 5: K4, K2tog, yfwd, K to last 6 sts, yfwd, K2tog, K4.

Row 6: As row 4.

Row 7: Knit.

Rep rows 6 and 7, 4 times more, then row 6 again.

Break yarn and leave sts on a holder.

LEFT SLEEVE

Cast on 63 (65: 67: **67: 69: 69**) sts using 3¼ mm (US 3) needles.

Work in moss st as for back for 12 rows, ending with a WS row.

Change to 4mm (US 6) needles.

Row 1 (RS): Inc in first st, K to last st, inc in last st.

65 (67: 69: **69: 71: 71**) sts.

Row 2: P22 (23: 24: **24: 25: 25**), K2, P17, K2, P to end.

These 2 rows form patt and start sleeve shaping.

Cont in patt, shaping sides by inc 1 st at each end of 11th (11th: 9th: **9th: 9th: 7th**) and every foll 12th (10th: 10th: **10th: 10th: 8th**) row to 73 (83: 87: **77: 75: 95**) sts, then on every foll 10th (-: -: **8th: 8th: -**) row until there are 79 (-: -: **89: 93: -**) sts.

Work 5 (**5: 1: 5**) rows, ending with a WS row.

Place pocket

Next row (RS): K29 (31: 33: **34: 36: 37**) and slip these sts onto a holder, K21 and turn, leaving rem 29 (31: 33: **34: 36: 37**) sts on a second holder.

Work on this set of 21 sts for pocket as folls:

Next row (WS): Knit.

Beg with a K row, work in st st for 41 rows, ending with a RS row.

Work in garter st for 3 rows.

Cast off knitwise (on RS).

Rejoin yarn to 29 (31: 33: **34: 36: 37**) sts left on second holder and K to end.

Next row (WS): P29 (31: 33: **34: 36: 37**), turn and cast on 21 sts, turn and P across 29 (31: 33: **34: 36: 37**) sts left on first holder. 79 (83: 87: **89: 93: 95**) sts.

Next row (RS): (Inc in first st) 0 (**1**) times, K to last 0 (**1**) st, (inc in last st) 0 (**1**) times. 79 (83: 87: **91: 95: 97**) sts.

Next row: P29 (31: 33: **35: 37: 38**), K2, P17, K2, P to end.

Last 2 rows form patt and cont sleeve shaping.

Cont in patt, shaping sides by inc 1 st at each end of next (**next: 5th: 7th**) and every foll 10th (**8th: 8th: 6th**) row until there are 87 (91: 91: **99: 103: 107**) sts, then on every foll - (-: -: **8th: -**) row until there are - (-: **95: -**) sts.

Work 11 rows, ending with a WS row.

Place pocket flap

Next row (RS): K33 (35: 37: **39: 41: 43**), holding WS of sleeve pocket flap against RS of sleeve K tog first st of sleeve pocket flap with next st of sleeve, K tog rem 20 sts of sleeve pocket flap with next 20 sts of sleeve in same way, K33 (35: 37: **39: 41: 43**).

Next row (WS): P33 (35: 37: **39: 41: 43**), K2, P17, K2, P to end.

Last row sets position of patt.

(Sleeve should measure 51.5 (53: 54: **55: 56.5: 58**) cm.)

Shape top

Keeping patt correct, cast off 6 sts at beg of next 2 rows.

75 (79: 83: **87: 91: 95**) sts.

Dec 1 st at each end of next and foll 5 alt rows, then on foll row, ending with a WS row.

Cast off rem 61 (65: 69: **73: 77: 81**) sts.

RIGHT SLEEVE

Cast on 63 (65: 67: **67: 69: 69**) sts using 3¼ mm (US 3) needles.

Work in moss st as for back for 12 rows, ending with a WS row.

Change to 4mm (US 6) needles.

Row 1 (RS): Inc in first st, K to last st, inc in last st. 65 (67: 69: **69: 71: 71**) sts.

Row 2: P22 (23: 24: **24: 25: 25**), K2, P17, K2, P to end.

These 2 rows form patt and start sleeve shaping.

Cont in patt, shaping sides by inc 1 st at each end of 11th (11th: 9th: **9th: 9th: 7th**) and every foll 12th (10th: 10th: **10th: 10th: 8th**) row to 73 (91: 91: **77: 75: 99**) sts, then on every foll 10th (-: 8th: **8th: 8th: 6th**) row until there are 87 (-: 95: **99: 103: 107**) sts.

Work 13 rows, ending with a WS row.

(Sleeve should measure 51.5 (53: 54: **55: 56.5: 58**) cm.)

Shape top

Keeping patt correct, cast off 6 sts at beg of next 2 rows. 75 (79: 83: **87: 91: 95**) sts.

Dec 1 st at each end of next and foll 5 alt rows, then on foll row, ending with a WS row.

Cast off rem 61 (65: 69: **73: 77: 81**) sts.

MAKING UP

PRESS as described on the information page.

Join shoulder seams using back stitch, or mattress stitch if preferred.

Ladies sizes only

Button band

Slip 9 sts from left front holder onto 3¼ mm (US 3) needles and rejoin yarn with RS facing.

Cont in moss st as set until button band, when slightly stretched, fits up left front opening edge to neck shaping, ending with a WS row.

Break yarn and leave sts on a holder.

Slip stitch band in place.

Mark positions for 7 buttons on this band - first to come level with buttonhole already worked in right front, last to come just above neck shaping and rem 5 buttons evenly spaced between.

Buttonhole band

Slip 9 sts from right front holder onto 3¼ mm (US 3) needles and rejoin yarn with WS facing.

Cont in moss st as set until buttonhole band,

when slightly stretched, fits up right front opening edge to neck shaping, ending with a WS row and with the addition of a further 5 buttonholes to correspond with positions marked for buttons worked as folls:

Buttonhole row (RS): Moss st 3 sts, yrn (to make a buttonhole), work 2 tog, moss st 4 sts. When band is complete, do NOT break yarn. Slip stitch band in place.

Mens sizes only

Button band

Slip 9 sts from right front holder onto 3¼ mm (US 3) needles and rejoin yarn with WS facing. Cont in moss st as set until button band, when slightly stretched, fits up right front opening edge to neck shaping, ending with a WS row.

Do NOT break yarn but set this ball of yarn to one side and leave sts on a holder. Slip stitch band in place.

Mark positions for 7 buttons on this band - first to come level with buttonhole already worked in left front, last to come just above neck shaping and rem 5 buttons evenly spaced between.

Buttonhole band

Slip 9 sts from left front holder onto 3¼ mm (US 3) needles and rejoin yarn with RS facing. Cont in moss st as set until buttonhole band, when slightly stretched, fits up left front opening edge to neck shaping, ending with a WS row and with the addition of a further 5 buttonholes to correspond with positions marked for buttons worked as folls:

Buttonhole row (RS): Moss st 4 sts, work 2 tog, yrn (to make a buttonhole), moss st 3 sts. When band is complete, break yarn and leave sts on a holder.
Slip stitch band in place.

All sizes

Collar

With RS facing and using 3¼ mm (US 3) needles, moss st 9 sts of right front band, pick up and knit 23 (**23: 25: 25**) sts up right side of neck, 31 (33: 33: **35: 35: 37**) sts from back, 23 (**23: 25: 25**) sts down left side of neck, then moss st 9 sts of left front band. 95 (97: 97: **99: 103: 105**) sts.

Work in moss st as set by front bands for 1 row, ending with a WS row.

Ladies sizes only

Next row (RS): Moss st 3 sts, yrn (to make 7th buttonhole), work 2 tog, moss st to end.

Mens sizes only

Next row (RS): Moss st to last 5 sts, work 2 tog, yrn (to make 7th buttonhole), moss st 3 sts.

All sizes

Work in moss st for a further 4 rows. Cast off 4 sts at beg of next 2 rows. 87 (89: 89: **91: 95: 97**) sts.
Cont in moss st until collar measures 14 cm from pick-up row.
Cast off in moss st.

Machine wash all pieces before completing sewing together.

See information page for finishing instructions, setting in sleeves using the shallow set-in method. Fold lower pockets up onto fronts and stitch in place. Fold sleeve pocket up onto sleeve and stitch in place. Slip stitch cast-on edges in place behind pockets.

Sew on buttons to correspond with buttonholes in pocket flaps.

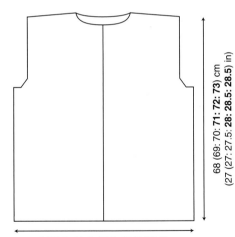

55.5 (58.5: 60.5: **63.5: 65.5: 68.5**) cm
(22 (23: 24: **25: 26: 27**) in)

68 (69: 70: **71: 72: 73**) cm
(27 (27: 27.5: **28: 28.5: 28.5**) in)

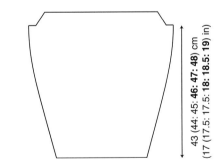

43 (44: 45: **46: 47: 48**) cm
(17 (17.5: 17.5: **18: 18.5: 19**) in)

Nova

KIM HARGREAVES

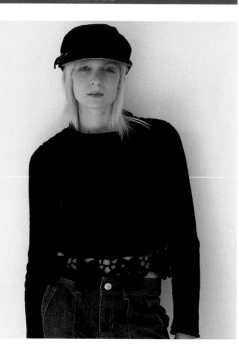

YARN

	XS	S	M	L	XL	
To fit bust	81	86	91	97	102	cm
	32	34	36	38	40	in

Rowan Denim

	10	11	11	12	13	x50gm

(photographed in Nashville 225)

NEEDLES

1 pair 3³/₄ mm (no 9) (US 5) needles
1 pair 4mm (no 8) (US 6) needles
3.50mm (no 9) (US E4) crochet hook

TENSION

Before washing: 20 sts and 28 rows to
10 cm measured over stocking stitch using
4mm (US 6) needles.

Tension note: Denim will shrink in length
when washed for the first time. Allowances
have been made in the pattern for
shrinkage (see size diagram for after
washing measurements).

CROCHET ABBREVIATIONS

ch = chain; ss = slip stitch; dc = double cro-
chet; htr = half treble; tr = treble; dtr = double
treble; sp(s) = space(s).

BASIC MOTIF

Using 3.50mm (US E4) crochet hook,
make 6 ch and join with a ss to form a ring.
Round 1 (RS): 1 ch (does NOT count as st),
*1 dc into ring, 3 ch, rep from * 10 times
more, 1 ch, 1 htr into first dc. 12 ch sps.
Round 2: 1 ch (does NOT count as st), 1 dc
into ch sp partly formed by htr at end of last
round, *3 ch, 1 dc into next ch sp, rep from *
10 times more, 1 ch, 1 htr into first dc.
Round 3: 1 ch (does NOT count as st), 1 dc
into ch sp partly formed by htr at end of last
round, *6 ch, 1 dc into next ch sp, 3 ch, 1 dc
into next ch sp, rep from * 4 times more, 6 ch,
1 dc into next ch sp, 1 ch, 1 htr into first dc.
Round 4: 1 ch (does NOT count as st), 1 dc
into ch sp partly formed by htr at end of last
round, *(5 tr, 2 ch and 5 tr) into next ch sp, 1 dc
into next ch sp, rep from * 4 times more,
(5 tr, 2 ch and 5 tr) into next ch sp, ss to first dc.
Fasten off.
Motif is a 6-pointed star shape, with a 2 ch sp
at the end of each point. Motifs are made and
joined to each other and lower edge of completed
garment whilst working round 4 by replacing
the "2 ch" at end of relevant points with "1 ch, ss
to relevant ch sp or marked point".

BACK

Cast on 88 (94: 98: 104: 108) sts using 4mm
(US 6) needles.
Row 1 (RS): K1 (0: 0: 1: 0), P2 (0: 2: 2: 1),
*K2, P2, rep from * to last 1 (2: 0: 1: 3) sts,
K1 (2: 0: 1: 2), P0 (0: 0: 0: 1).
Row 2: P1 (0: 0: 1: 0), K2 (0: 2: 2: 1), *P2,
K2, rep from * to last 1 (2: 0: 1: 3) sts,
P1 (2: 0: 1: 2), K0 (0: 0: 0: 1).

These 2 rows form rib.
Cont in rib, shaping side seams by inc 1 st
at each end of 9th and foll 20th row, taking
inc sts into rib.
92 (98: 102: 108: 112) sts.
Cont straight until back measures 18 (19: 19:
20.5: 20.5) cm, ending with a WS row.
Shape armholes
Keeping rib correct, cast off 3 (4: 4: 5: 5) sts
at beg of next 2 rows. 86 (90: 94: 98: 102) sts.
Next row (RS): P2, K2, P1, P2tog, rib to last
7 sts, P2tog tbl, P1, K2, P2.
Next row: K2, P2, K1, K2tog tbl, rib to last 7
sts, K2tog, K1, P2, K2.
Rep last 2 rows 0 (0: 1: 1: 2) times more.
82 (86: 86: 90: 90) sts.
Next row (RS): P2, K2, P1, P2tog, rib to last
7 sts, P2tog tbl, P1, K2, P2.
Next row: K2, P2, K2, rib to last 6 sts, K2, P2, K2.
Rep last 2 rows 5 times more.
70 (74: 74: 78: 78) sts.
Cont straight until armhole measures 24 (24:
25: 25: 26.5) cm, ending with a WS row.
Shape shoulders and back neck
Cast off 5 (6: 6: 6: 6) sts at beg of next 2 rows.
60 (62: 62: 66: 66) sts.
Next row (RS): Cast off 5 (6: 6: 6: 6) sts, rib
until there are 10 (9: 9: 10: 10) sts on right
needle and turn, leaving rem sts on a holder.
Work each side of neck separately.
Cast off 4 sts at beg of next row.
Cast off rem 6 (5: 5: 6: 6) sts.
With RS facing, rejoin yarn to rem sts, cast
off centre 30 (32: 32: 34: 34) sts, rib to end.
Complete to match first side, reverse shapings.

FRONT

Work as given for back until 16 (16: 16: 18: 18)
rows less have been worked than on back to
start of shoulder shaping, ending with a WS row.
Shape neck
Next row (RS): Rib 25 (26: 26: 28: 28) and
turn, leaving rem sts on a holder.
Work each side of neck separately.
Dec 1 st at neck edge of next 6 rows, then on foll
3 (3: 3: 4: 4) alt rows. 16 (17: 17: 18: 18) sts.

Work 3 rows, ending with a WS row.

Shape shoulder

Cast off 5 (6: 6: 6: 6) sts at beg of next and foll alt row.

Work 1 row.

Cast off rem 6 (5: 5: 6: 6) sts.

With RS facing, rejoin yarn to rem sts, cast off centre 20 (22: 22: 22: 22) sts, rib to end. Complete to match first side, reverse shapings.

SLEEVES (both alike)

Cast on 50 (50: 52: 54: 54) sts using 3¼ mm (US 5) needles.

Beg with a K row, work in st st for 6 rows, ending with a WS row.

Change to 4mm (US 6) needles.

Row 1 (RS): K0 (0: 1: 0: 0), P2, *K2, P2, rep from * to last 0 (0: 1: 0: 0) sts, K0 (0: 1: 0: 0).

Row 2: P0 (0: 1: 0: 0), K2, *P2, K2, rep from * to last 0 (0: 1: 0: 0) sts, P0 (0: 1: 0: 0).

These 2 rows form rib.

Cont in rib, shaping sides by inc 1 st at each end of 9th and every foll 18th (16th: 16th: 16th: 14th) row to 58 (64: 62: 64: 66) sts, then on every foll 20th (18th: 18th: 18th: 16th) row until there are 64 (66: 68: 70: 72) sts, taking inc sts into rib.

Cont straight until sleeve measures 50.5 (50.5: 51.5: 51.5: 51.5) cm, end with a WS row.

Shape top

Keeping rib correct, cast off 3 (4: 4: 5: 5) sts at beg of next 2 rows. 58 (58: 60: 60: 62) sts.

Working all decreases in same way as armhole decreases, dec 1 st at each end of next 3 rows, then on foll 2 alt rows, then on every foll 4th row until 34 (34: 36: 36: 38) sts rem.

Work 1 row, ending with a WS row.

Dec 1 st at each end of next and every foll alt row to 28 sts, then on foll 3 rows, end with a WS row.

Cast off rem 22 sts.

MAKING UP

PRESS as described on the information page.

Join right shoulder seam using back stitch, or mattress stitch if preferred.

Neckband

With RS facing and using 3¾ mm (US 5) needles, pick up and knit 16 (16: 16: 18: 18) sts down left side of neck, 20 (22: 22: 22: 22) sts from front, 16 (16: 16: 18: 18) sts up right side of neck, then 38 (40: 40: 42: 42) sts from back. 90 (94: 94: 100: 100) sts.

Beg with a P row, work in st st for 13 rows.

Cast off.

Join side seams.

Crochet edging

With RS facing and using 3.50mm (US E4) crochet hook, rejoin yarn at base of one side seam and work 1 round of dc evenly around entire cast-on edge, working 1 dc into each cast-on st and ending with ss to first dc.

Next round (RS): 4 ch, miss dc at base of 4 ch and next dc, *1 tr into next dc, 1 ch, miss 1 dc, rep from * to end, ss to 3rd of 4 ch at beg of round.

Next round: 1 ch (does NOT count as st), 1 dc into each tr and ch sp to end, ss to first dc. Fasten off.

Motif border

Mark 8 (8: 9: 9: 10) evenly spaced points around lower edge of crochet edging - these points will correspond to each motif of border and should be approx 11 cm apart. Now mark a further 2 points inside each of these sections 3 cm in from previous marked points - these points are where motifs are attached.

Make and join 8 (8: 9: 9: 10) basic motifs, joining them whilst working round 4 as folls: join motifs to each other at opposite points of the star shape, leaving 2 points free at upper and lower edges, and join the 2 upper free points to crochet edging at appropriate marked points. All motifs are now joined at 4 of 6 of their points, leaving 2 points free around lower edge. Now fill in triangular gap between pairs of motifs and crochet edging as folls:

With RS facing and using 3.50mm (US E4) crochet hook, rejoin yarn to lower edge of crochet edging one third of the way along this side of the triangle, 3 ch, 1 tr into central tr along side of first point of nearest motif, 1 ch, 1 dtr into 3rd tr along side of next point of same motif, 1 ch, 1 dtr into 3rd tr along side of next point of next motif, 1 ch, 1 tr into 3rd tr along side of next point of this second motif, 3 ch, ss to crochet edging midway between attached point of this second motif and where yarn was rejoined. Fasten off.

Fill in all triangular gaps in this way.

Machine wash all pieces before completing sewing together.

See information page for finishing instructions, setting in sleeves using the set-in method.

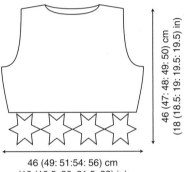
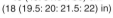
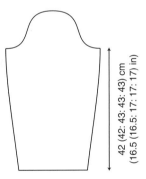

46 (47: 48: 49: 50) cm
(18 (18.5: 19: 19.5: 19.5) in)

46 (49: 51:54: 56) cm
(18 (19.5: 20: 21.5: 22) in)

42 (42: 43: 43: 43) cm
(16.5 (16.5: 17: 17: 17) in)

Polo

LOUISA HARDING

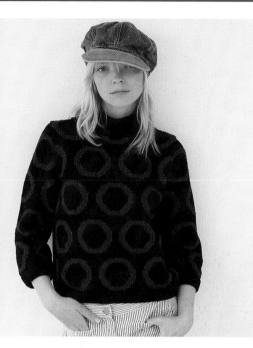

YARN

	XS	S	M	L	XL	
To fit bust	81	86	91	97	102	cm
	32	34	36	38	40	in

Rowan Denim

A	Nashville 225						
		10	10	11	11	12	x50gm
B	Memphis 229						
		3	4	4	4	4	x50gm

NEEDLES

1 pair 3¼ mm (no 10) (US 3) needles
1 pair 4mm (no 8) (US 6) needles

TENSION

Before washing: 20 sts and 28 rows to
10 cm measured over stocking stitch using
4mm (US 6) needles.

Tension note: Denim will shrink in length
when washed for the first time. Allowances
have been made in the pattern for shrinkage
(see size diagram for after washing
measurements).

BACK

Cast on 96 (102: 106: 112: 116) sts using
3¼ mm (US 3) needles and yarn A.

Rows 1 and 2: Knit.

Rows 3 and 4: Purl.

These 4 rows form ridge patt.

Work in ridge patt for a further 12 rows,
ending with a WS row.

Change to 4mm (US 6) needles.

Using the **intarsia** technique as described on
the information page, starting and ending
rows as indicated and repeating the 64 row
repeat throughout, cont in patt from chart,
which is worked entirely in st st beg with a
K row, as folls:

Cont straight until work measures 36 (37: 37:
38.5: 38.5) cm, ending with a WS row.

Shape armholes

Keeping patt correct, cast off 4 (5: 5: 6: 6) sts at beg
of next 2 rows, then 3 sts at beg of foll 2 rows.
82 (86: 90: 94: 98) sts.

Dec 1 st at each end of next 3 (3: 5: 5: 7) rows,
then on foll 1 (2: 1: 2: 1) alt rows, then on every
foll 4th row until 70 (72: 74: 76: 78) sts rem.
Cont straight until armhole measures 24 (24:
25: 25: 26.5) cm, ending with a WS row.

Shape shoulders and back neck

Cast off 6 (6: 6: 6: 7) sts at beg of next 2 rows.
58 (60: 62: 64: 64) sts.

Next row (RS): Cast off 6 (6: 6: 6: 7) sts, patt
until there are 10 (10: 11: 11: 10) sts on right
needle and turn, leave rem sts on a holder.

Work each side of neck separately.

Cast off 4 sts at beg of next row.

Cast off rem 6 (6: 7: 7: 6) sts.

With RS facing, rejoin yarns to rem sts,
cast off centre 26 (28: 28: 30: 30) sts,
patt to end.

Complete to match first side, reverse
shapings.

FRONT

Work as given for back until 16 (16: 16: 18: 18) rows
less have been worked than on back to start
of shoulder shaping, end with a WS row.

Shape neck

Next row (RS): Patt 28 (28: 29: 30: 31) sts
and turn, leaving rem sts on a holder.

Work each side of neck separately.

Cast off 4 sts at beg of next row.

24 (24: 25: 26: 27) sts.

Dec 1 st at neck edge of next 3 rows, then on
foll 2 (2: 2: 3: 3) alt rows, then on foll 4th row.

18 (18: 19: 19: 20) sts.

Work 3 rows, ending with a WS row.

Shape shoulder

Cast off 6 (6: 6: 6: 7) sts at beg of next and
foll alt row.

Work 1 row.

Cast off rem 6 (6: 7: 7: 6) sts.

With RS facing, rejoin yarns to rem sts, cast off

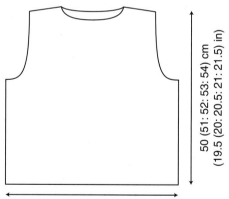

50 (51: 52: 53: 54) cm
(19.5 (20: 20.5: 21: 21.5) in)

48 (51: 53: 56: 58) cm
(19 (20: 21: 22: 23) in)

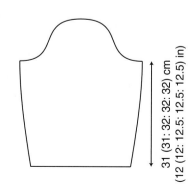

31 (31: 32: 32: 32) cm
(12 (12: 12.5: 12.5: 12.5) in)

centre 14 (16: 16: 16: 16) sts, patt to end.

Complete to match first side, reversing shapings.

SLEEVES (both alike)

Cast on 60 (60: 62: 64: 64) sts using 3¼ mm
(US 3) needles and yarn A.

Work in ridge patt as for back for 16 rows,
ending with a WS row.

Change to 4mm (US 6) needles.

Starting and ending rows as indicated,
cont in patt from chart, shaping sides by
inc 1 st at each end of 3rd and every foll
18th (14th: 14th: 14th: 12th) row to 70 (70: 68:
70: 74) sts, then on every foll - (16th: 16th: 16th:
14th) row until there are - (72: 74:
76: 78) sts, taking inc sts into patt.

Cont straight until sleeve measures 37 (37:
38.5: 38.5: 38.5) cm, ending with a WS row.

Shape top

Keeping patt correct, cast off 4 (5: 5:
6: 6) sts at beg of next 2 rows, then 3 sts at
beg of foll 2 rows.

56 (56: 58: 58: 60) sts.

Dec 1 st at each end of next 3 rows, then on
foll alt row, then on every foll 4th row until
36 (36: 38: 38: 40) sts rem.

Work 1 row, ending with a WS row.

Dec 1 st at each end of next and every foll alt row to
30 sts, then on foll row, end with a WS row. 28 sts.

Cast off 3 sts at beg of next 4 rows.

Cast off rem 16 sts.

MAKING UP

PRESS as described on the information page.

Join right shoulder seam using back stitch, or
mattress stitch if preferred.

Neckband

With RS facing, using 3¼ mm (US 3)
needles and yarn A, pick up and knit 20 (20:
20: 22: 22) sts down left side of neck, 14
(16:16: 16: 16) sts from front, 20 (20: 20: 22:
22) sts up right side of neck, then 34 (36: 36:
38: 38) sts from back. 88 (92: 92: 98: 98) sts.

Beg with row 2, work in ridge patt as for back
for 10 cm, ending with row 3.

Cast off knitwise (on WS).

Machine wash all pieces before completing
sewing together.

See information page for finishing
instructions, setting in sleeves using the
set-in method.

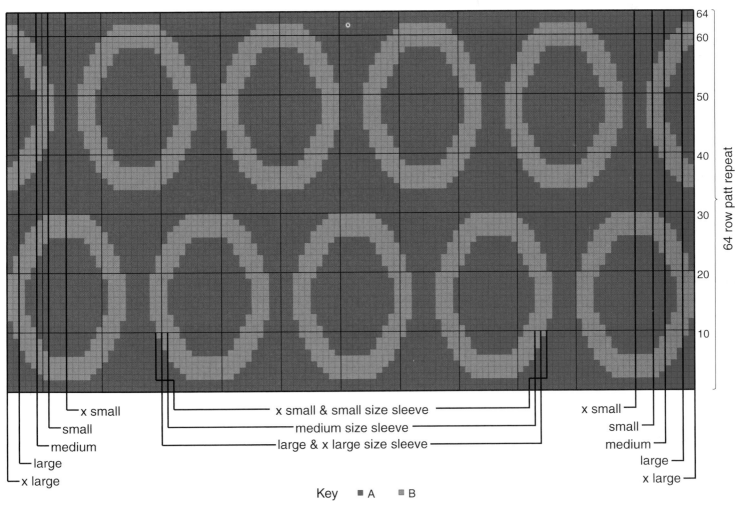

Key ■ A ■ B

Pulse
CAROL MELDRUM

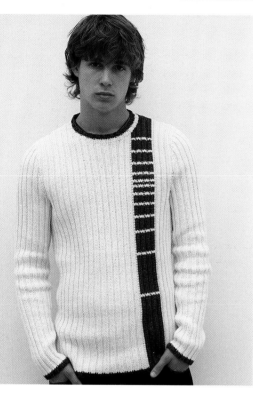

YARN

To fit bust/chest

ladies			mens			
S	M	L	**M**	**L**	**XL**	
86	91	97	**102**	**107**	**112**	cm
34	36	38	**40**	**42**	**44**	in

Rowan Denim

A Ecru 324

14	15	16	**17**	**18**	**19**	x50gm

B Memphis 229

2	2	2	**2**	**3**	**3**	x50gm

NEEDLES

1 pair 3¼ mm (no 10) (US 3) needles
1 pair 4mm (no 8) (US 6) needles

TENSION

Before washing: 20 sts and 28 rows to 10 cm measured over stocking stitch using 4mm (US 6) needles.

Tension note: Denim will shrink in length when washed for the first time. Allowances have been made in the pattern for shrinkage (see size diagram for after washing measurements).

Pattern note: The pattern is written for the 3 ladies sizes, followed by the 3 mens sizes in **bold**. Where only one figure appears this applies to all sizes in that group.

STRIPE BAND (14 sts)

Working in rib as set, use colours as folls:
Rows 1 to 66: Using yarn B.
Rows 67 and 68: Using yarn A.
Rows 69 to 100: Using yarn B.
Rows 101 and 102: Using yarn A.
Rows 103 to 118: Using yarn B.
Rows 119 and 120: Using yarn A.
Rows 121 to 130: Using yarn B.
Rows 131 and 132: Using yarn A.
Rows 133 to 140: Using yarn B.
Rows 141 and 142: Using yarn A.
Rows 143 to 148: Using yarn B.
Rows 149 and 150: Using yarn A.
Rows 151 to 154: Using yarn B.
Rows 155 and 156: Using yarn A.
Rows 157 and 158: Using yarn B.
Rows 159 and 160: Using yarn A.
Rows 161 to 164: Using yarn B.
Rows 165 and 166: Using yarn A.
Rows 167 to 172: Using yarn B.
Rows 173 and 174: Using yarn A.
Rows 175 to 182: Using yarn B.
Rows 183 and 184: Using yarn A.
Rows 185 to 193: Using yarn B.
Rows 194 and 195: Using yarn A.
Rows 196 and onwards: Using yarn B.
These rows form stripe band.

BACK

Cast on 98 (104: 110: **116: 122: 128**) sts using 3¼ mm (US 3) needles and yarn B.
Row 1 (RS): K0 (1: 0: **0: 0: 1**), P0 (2: 2: **1: 0: 2**), *K2, P2, rep from * to last 2 (1: 0: **3: 2: 1**) sts, K2 (1: 0: **2: 2: 1**), P0 (**1: 0: 0**).

Row 2: P0 (1: 0: **0: 0: 1**), K0 (2: 2: **1: 0: 2**), *P2, K2, rep from * to last 2 (1: 0: **3: 2: 1**) sts, P2 (1: 0: **2: 2: 1**), K0 (**1: 0: 0**).
These 2 rows form rib.
Using yarn B, work in rib for a further 2 rows, ending with a WS row.
Join in yarn A.
Using the **intarsia** technique as described on the info page, place stripe band as folls:
Row 5 (RS): Using yarn A rib 64 (67: 70: **73: 76: 79**), work next 14 sts as row 1 of stripe band, using yarn A rib to end.
Row 6: Using yarn A rib 20 (23: 26: **29: 32: 35**), work next 14 sts as row 2 of stripe band, using yarn A rib to end.
These 2 rows set the sts - all sts worked in rib with vertical stripe band near left side seam.
**Keeping rib and stripe band correct throughout, cont as folls:
Work a further 4 rows, ending with a WS row.
Change to 4mm (US 6) needles.
Cont straight until back measures 51.5 cm, ending with a WS row.
Shape armholes
Keeping patt correct, cast off 2 (3: 4: **5: 6: 7**) sts at beg of next 2 rows.
94 (98: 102: **106: 110: 114**) sts.
Dec 1 st at each end of next 3 (3: 5: **5: 7: 7**) rows, then on foll 2 (3: 2: **3: 2: 3**) alt rows.
84 (86: 88: **90: 92: 94**) sts.
Cont straight until armhole measures 24 (25: 26.5: **27.5: 29: 30**) cm, ending with a WS row.
Shape shoulders and back neck
Cast off 8 (**8: 9: 9**) sts at beg of next 2 rows.
68 (70: 72: **74: 74: 76**) sts.
Next row (RS): Cast off 8 (**8: 9: 9**) sts, rib until there are 12 (12: 13: **13: 12: 12**) sts on right needle and turn, leaving rem sts on a holder.
Work each side of neck separately.
Cast off 4 sts at beg of next row.
Cast off rem 8 (8: 9: **9: 8: 8**) sts.
With RS facing, rejoin appropriate yarn to rem sts, cast off centre 28 (30: 30: **32: 32: 34**) sts, rib to end.
Complete to match first side, reverse shapings.

FRONT

Cast on 98 (104: 110: **116: 122: 128**) sts using 3¼ mm (US 3) needles and yarn B. Work in rib as for back for 4 rows, ending with a WS row.

Join in yarn A.

Using the intarsia technique as described on the information page, place stripe band as folls:

Row 5 (RS): Using yarn A rib 20 (23: 26: **29: 32: 35**), work next 14 sts as row 1 of stripe band, using yarn A rib to end.

Row 6: Using yarn A rib 64 (67: 70: **73: 76: 79**), work next 14 sts as row 2 of stripe band, using yarn A rib to end.

These 2 rows set the sts - all sts worked in rib with vertical stripe band near left side seam.

Keeping rib and stripe band correct throughout, work as for back from ** until 24 (**24: 26: 26**) rows less have been worked than on back to start of shoulder shaping, ending with a WS row.

Shape neck

Next row (RS): Rib 36 (36: 37: **37: 39: 39**) and turn, leaving rem sts on a holder.

Work each side of neck separately.

Dec 1 st at neck edge of next 7 rows, then on foll 4 (**4: 5: 5**) alt rows, then on foll 4th row. 24 (24: 25: **25: 26: 26**) sts.

Work 4 rows, ending with a WS row.

Shape shoulder

Cast off 8 (8: 9: 9) sts at beg of next and foll alt row.

Work 1 row.

Cast off rem 8 (8: 9: **9: 8: 8**) sts.

With RS facing, rejoin appropriate yarn to rem sts, cast off centre 12 (14: 14: **16: 14: 16**) sts, rib to end.

Complete to match first side, reverse shapings.

SLEEVES (both alike)

Cast on 52 (54: 56: **56: 58: 58**) sts using 3¼ mm (US 3) needles and yarn B.

Row 1 (RS): K1 (0: 1: **1: 0: 0**), *P2, K2, rep from * to last 3 (2: 3: **3: 2: 2**) sts, P2, K1 (0: 1: **1: 0: 0**).

Row 2: P1 (0: 1: **1: 0: 0**), *K2, P2, rep from * to last 3 (2: 3: **3: 2: 2**) sts, K2, P1 (0: 1: **1: 0: 0**).

These 2 rows form rib.

Using yarn B, work in rib for a further 2 rows, ending with a WS row.

Break off yarn B and join in yarn A.

Cont in rib for a further 6 rows, ending with a WS row.

Change to 4mm (US 6) needles.

Cont in rib, shaping sides by inc 1 st at each end of next and every foll 16th (16th: 14th: **12th: 12th: 10th**) row to 66 (58: 68: **72: 68: 80**) sts, then on every foll 14th (14th: 12th: **10th: 10th: 8th**) row until there are 70 (74: 78: **82: 86: 90**) sts, taking inc sts into rib.

Cont straight until sleeve measures 53 (54: 55: **56.5: 57.5: 59**) cm, ending with a WS row.

Shape top

Keeping rib correct, cast off 2 (3: 4: **5: 6: 7**) sts at beg of next 2 rows.

66 (68: 70: **72: 74: 76**) sts.

Dec 1 st at each end of next 5 rows, then on foll 2 (**3**) alt rows, then on every foll 4th row until 40 (42: 44: **44: 46: 48**) sts rem.

Work 3 rows, ending with a WS row.

Dec 1 st at each end of next and foll 0 (1: 2: **2: 3: 4**) alt rows, then on foll 5 rows, ending with a WS row.

Cast off rem 28 sts.

MAKING UP

PRESS as described on the information page.

Join right shoulder seam using back stitch, or mattress stitch if preferred.

Neckband

With RS facing, using 3¼ mm (US 3) needles and yarn A, pick up and knit 23 (22: 22: **21: 22: 25**) sts down left side of neck, 12 (14: 14: **16: 14: 16**) sts from front, 23 (22: 22: **21: 22: 25**) sts up right side of neck, then 36 (**40: 40: 40**) sts from back.

94 (98: 98: **98: 98: 106**) sts.

Row 1 (WS): P2, *K2, P2, rep from * to end.

Row 2: K2, *P2, K2, rep from * to end.

These 2 rows form rib.

Work in rib for a further 2 rows, ending with a RS row.

Break off yarn A and join in yarn B.

Work in rib for a further 4 rows.

Cast off in rib.

Machine wash all pieces before completing sewing together.

See information page for finishing instructions, setting in sleeves using the set-in method.

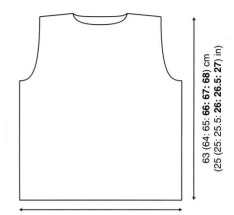

49 (52: 55: **58: 61: 64**) cm
(19.5 (20.5: 21.5: **23: 24: 25**) in)

63 (64: 65: **66: 67: 68**) cm
(25 (25: 25.5: **26: 26.5: 27**) in)

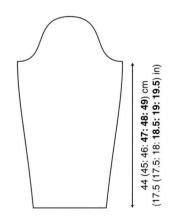

44 (45: 46: **47: 48: 49**) cm
(17.5 (17.5: 18: **18.5: 19: 19.5**) in)

★

Bret
KIM HARGREAVES

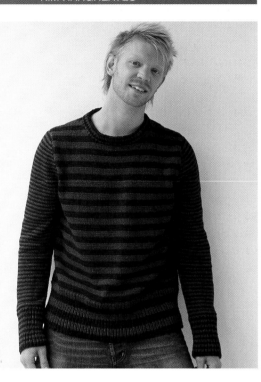

YARN

To fit bust/chest

	ladies		mens			
S	M	L	**M**	**L**	**XL**	
86	91	97	**102**	**107**	**112**	cm
34	36	38	**40**	**42**	**44**	in

Rowan Denim

A Nashville 225

| 11 | 12 | 13 | **13** | **14** | **15** | x 50gm |

B Memphis 229

| 9 | 10 | 10 | **11** | **11** | **12** | x 50gm |

NEEDLES

1 pair 4mm (no 8) (US 6) needles

TENSION

Before washing: 20 sts and 28 rows to 10 cm measured over stocking stitch using 4mm (US 6) needles.

Tension note: Denim will shrink in length when washed for the first time. Allowances have been made in the pattern for shrinkage (see size diagram for after washing measurements).

Pattern note: The pattern is written for the 3 ladies sizes, followed by the 3 mens sizes in **bold**. Where only one figure appears this applies to all sizes in that group.

BACK

Cast on 93 (99: 103: **109: 113: 119**) sts using 4mm (US 6) needles and yarn A **DOUBLE**.
Row 1 (RS): K1, *P1, K1, rep from * to end.
Row 2: P1, *K1, P1, rep from * to end.
These 2 rows form rib.
Work in rib using yarn A **DOUBLE** for a further 2 rows, ending with a WS row.
Join in yarn B **DOUBLE**.
Using yarn B **DOUBLE**, work in rib for 6 rows.
Using yarn A **DOUBLE**, work in rib for 6 rows.
Rep last 12 rows once more.
Using yarn B **DOUBLE**, work in rib for a further 5 rows, ending with a RS row.
Next row (WS): Using yarn B **DOUBLE**, purl.
Break off one strand each of yarn A and yarn B and cont using one strand of each colour **only**.
Beg with a K row, cont in striped st st as folls:
Using yarn A, work 6 rows, inc 1 st at each end of 3rd of these rows. 95 (101: 105: **111: 115: 121**) sts.
Using yarn B, work 6 rows.
These 12 rows form striped st st and start side seam shaping.
Cont as set, inc 1 st at each end of 11th and every foll 20th row until there are 101 (107: 111: **117: 121: 127**) sts.
Cont straight until back measures 36 cm from top of ribbing, ending with a WS row.
Shape armholes
Keeping stripes correct, cast off 2 (3: 4: **5: 6: 7**) sts at beg of next 2 rows.
97 (101: 103: **107: 109: 113**) sts.
Dec 1 st at each end of next 5 rows, then on foll 3 (4: 4: **5: 5: 6**) alt rows.
81 (83: 85: **87: 89: 91**) sts.

Cont straight until armhole measures 24 (25: 26.5: **28: 29: 30**) cm, ending with a WS row.
Shape shoulders and back neck
Cast off 7 (7: 8: **8**) sts at beg of next 2 rows.
67 (69: 69: **71: 73: 75**) sts.
Next row (RS): Cast off 7 (7: 8: **8**) sts, K until there are 12 (12: 11: **11: 12: 12**) sts on right needle and turn, leaving rem sts on a holder.
Work each side of neck separately.
Cast off 4 sts at beg of next row.
Cast off rem 8 (8: 7: **7: 8: 8**) sts.
With RS facing, rejoin appropriate yarn to rem sts, cast off centre 29 (31: 31: **33: 33: 35**) sts, K to end.
Complete to match first side, reverse shapings.

FRONT

Work as given for back until 20 (**20: 22: 22**) rows less have been worked than on back to start of shoulder shaping, ending with a WS row.
Shape neck
Next row (RS): K32 (32: 33: **33: 35: 35**) and turn, leaving rem sts on holder.
Work each side of neck separately.
Dec 1 st at neck edge of next 6 rows, then on foll 4 (**4: 5: 5**) alt rows. 22 (22: 23: **23: 24: 24**) sts.
Work 5 rows, ending with a WS row.
Shape shoulder
Cast off 7 (7: 8: **8**) sts at beg of next and foll alt row.
Work 1 row.
Cast off rem 8 (8: 7: **7: 8: 8**) sts.
With RS facing, rejoin appropriate yarn to rem sts, cast off centre 17 (19: 19: **21: 19: 21**) sts, K to end.
Complete to match first side, reverse shapings.

SLEEVES (both alike)

Cast on 49 (51: 53: **53: 55: 55**) sts using 4mm (US 6) needles and yarn A **DOUBLE**.
Using yarn A **DOUBLE**, work in rib as for back for 2 rows.
Join in yarn B **DOUBLE**.
Using yarn B **DOUBLE**, work in rib for 2 rows.
Rep last 4 rows 6 times more.
Using yarn A **DOUBLE**, work in rib for a further 2 rows.

Using yarn B **DOUBLE**, work in rib for 1 row more, ending with a RS row.

Next row (WS): Using yarn B **DOUBLE**, purl. Break off one strand each of yarn A and yarn B and cont using one strand of each colour **only**. Beg with a K row, cont in striped st st as folls: Using yarn A, work 2 rows, inc 1 st at each end of first of these rows.

51 (53: 55: **55: 57: 57**) sts.

Using yarn B, work 2 rows.

These 4 rows form striped st st and start sleeve shaping.

Cont in striped st st, shaping sides by inc 1 st at each end of 7th (7th: 5th: **5th: 3rd: 3rd**) and every foll 12th (10th: 10th: 8th) row to 55 (65: 73: **73: 81: 77**) sts, then on every foll 14th (14th: -: **12th: -: 10th**) row until there are 65 (69: -: **77: -: 85**) sts.

Cont straight until sleeve measures 38.5 (41: 43: **45.5: 47: 48**) cm from top of ribbing,

ending with a WS row.

Shape top

Keeping stripes correct, cast off 2 (3: 4: **5: 6: 7**) sts at beg of next 2 rows.

61 (63: 65: **67: 69: 71**) sts.

Dec 1 st at each end of next 3 rows, then on foll 2 (3) alt rows, then on every foll 4th row until 33 (35: 37: **37: 39: 41**) sts rem.

Work 1 row, ending with a WS row.

Dec 1 st at each end of next and foll 0 (1: 2: **2: 3: 4**) alt rows, then on foll 3 rows, ending with a WS row.

Cast off rem 25 sts.

MAKING UP

PRESS as described on the information page. Join right shoulder seam using back stitch, or mattress stitch if preferred.

Neckband

With RS facing, using 4 mm (US 6) needles

and yarn B DOUBLE, pick up and knit 20 (**20: 22: 22**) sts down left side of neck, 17 (19: 19: **21: 19: 21**) sts from front, 20 (**20: 22: 22**) sts up right side of neck, then 36 (38: 38: **40: 40: 42**) sts from back.

93 (97: 97: **101: 103: 107**) sts.

Using yarn B DOUBLE, work in rib as for back for 1 row.

Join in yarn A **DOUBLE**.

Using yarn A **DOUBLE**, work in rib for 2 rows.

Using yarn B **DOUBLE**, work in rib for 2 rows.

Using yarn A **DOUBLE**, work in rib for a further 1 row, ending with a RS row.

Using yarn A **DOUBLE**, cast off in rib.

Machine wash all pieces before completing sewing together.

See information page for finishing instructions, setting in sleeves using the set-in method.

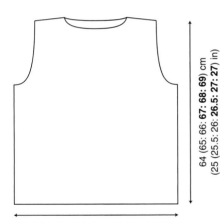

64 (65: 66: **67: 68: 69**) cm
(25 (25.5: 26: **26.5: 27: 27**) in)

50.5 (53.5: 55.5: **58.5: 60.5: 63.5**) cm
(20 (21: 22: **23: 24: 25**) in)

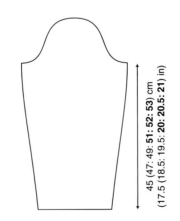

45 (47: 49: **51: 52: 53**) cm
(17.5 (18.5: 19.5: **20: 20.5: 21**) in)

Saccer

★ ★

CAROL MELDRUM

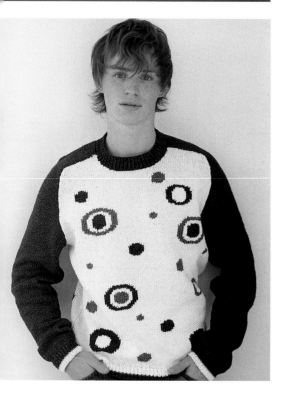

YARN

To fit bust/chest

	ladies			mens		
S	M	L	**M**	**L**	**XL**	
86	91	97	**102**	**107**	**112**	cm
34	36	38	**40**	**42**	**44**	in

Rowan Denim

A Ecru 324

8	9	9	10	10	11	x50gm

B Memphis 229

7	8	8	9	9	10	x50gm

C Tennessee 231

1	1	1	1	1	1	x50gm

NEEDLES

1 pair 3¼ mm (no 10) (US 3) needles
1 pair 4mm (no 8) (US 6) needles

TENSION

Before washing: 20 sts and 28 rows to
10 cm measured over stocking stitch using
4mm (US 6) needles.

Tension note: Denim will shrink in length
when washed for the first time. Allowances
have been made in the pattern for shrinkage
(see size diagram for after washing
measurements).

Pattern note: The pattern is written for the 3
ladies sizes, followed by the 3 mens sizes in
bold. Where only one figure appears this
applies to all sizes in that group.

BACK

Cast on 99 (105: 109: **115: 119: 125**) sts
using 3¼ mm (US 3) needles and yarn B.
Row 1 (RS): K1, *P1, K1, rep from * to end.
Row 2: P1, *K1, P1, rep from * to end.
These 2 rows form rib.
Work in rib for a further 2 rows, ending with a
WS row.
Break off yarn B and join in yarn A.
Work in rib for a further 8 rows, inc 1 st at
end of last row and ending with a WS row.
100 (106: 110: **116: 120: 126**) sts.
Change to 4mm (US 6) needles.
Using the **intarsia** technique as described on
the information page and starting and ending
rows as indicated, cont in patt from chart,
which is worked entirely in st st beg with a K
row, as folls:
Cont straight until chart row 120 has been
completed, ending with a WS row.
(Back should measure 47 cm.)
Shape armholes
Keeping patt correct, cast off 4 (**5: 6: 6**) sts at
beg of next 2 rows.
92 (96: 98: **104: 108: 114**) sts.**
Dec 1 st at each end of next and foll 2 (3: 2:
4: 5: 7) alt rows, then on foll 4th row,
then on every foll 6th row until 72 (74: 76: **78:
80: 82**) sts rem.
Work 3 rows, ending with a WS row.

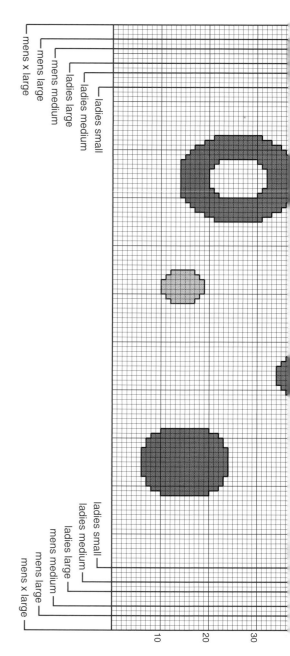

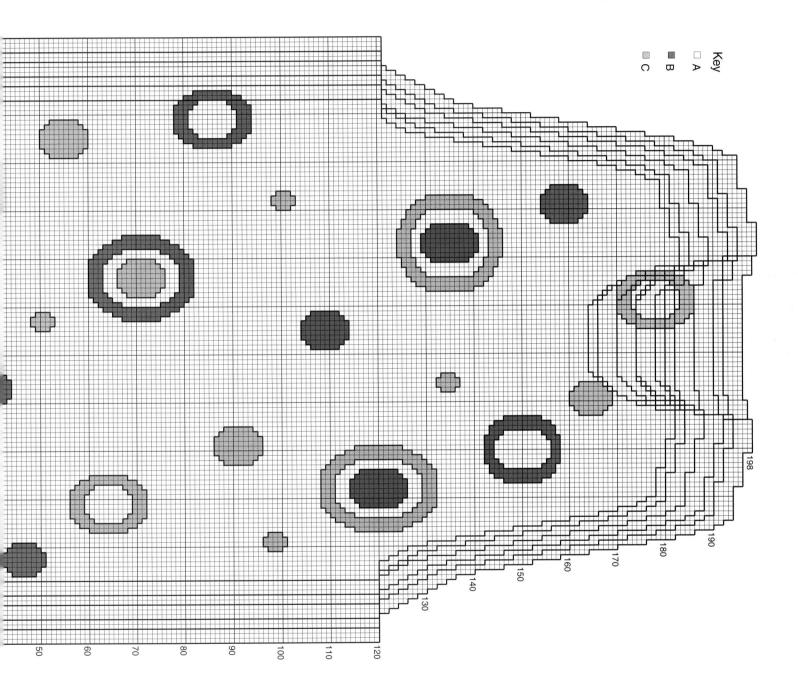

Dec 1 st at each end of next and foll 4th row, then on foll alt row.

66 (68: 70: **72: 74: 76**) sts.

Work 1 row, ending after chart row 178 (180: 184: **188: 190: 194**) and with a WS row.

Shape saddle shoulders and back neck

Cast off 6 (**6: 7: 7**) sts at beg of next 2 rows.

54 (56: 56: **58: 60: 62**) sts.

Next row (RS): Cast off 6 (**6: 7: 7**) sts, patt until there are 11 (11: 10: **10: 11: 11**) sts on right needle and turn, leaving rem sts on a holder.

Work each side of neck separately.

Cast off 4 sts at beg of next row.

Cast off rem 7 (7: 6: **6: 7: 7**) sts.

With RS facing, rejoin yarns to rem sts, cast off centre 20 (22: 22: **24: 24: 26**) sts, patt to end.

Complete to match first side, reverse shapings.

FRONT

Work as given for back to **.

Dec 1 st at each end of next and foll 2 (3: 2: **4: 5: 7**) alt rows, then on foll 4th row, then on every foll 6th row until 74 (76: 78: **80: 82: 84**) sts rem. (Note: Do NOT work part motif at neck edge.)Work 3 (**3: 1: 1**) rows, ending after chart row 164 (166: 170: **174: 174: 178**) and with a WS row.

Shape neck

Next row (RS): Patt 30 (30: 31: **31: 33: 33**) sts and turn, leaving rem sts on a holder.

Work each side of neck separately.

Dec 1 st at neck edge of next 4 rows, then on foll 2 (**2: 3: 3**) alt rows and at same time dec 1 st at armhole edge of 2nd (**2nd: 4th: 4th**) and foll 4th row.

22 (22: 23: **23: 24: 24**) sts.

Work 1 row, ending with a WS row.

Dec 1 st at armhole edge of next and foll alt row and at same time dec 1 st at neck edge of 3rd row.

19 (19: 20: **20: 21: 21**) sts.

Work 1 row, ending after chart row 178 (180: 184: **188: 190: 194**) and with a WS row.

Shape shoulder

Cast off 6 (**6: 7: 7**) sts at beg of next and foll alt row.

Work 1 row.

Cast off rem 7 (7: 6: **6: 7: 7**) sts.

With RS facing, rejoin yarns to rem sts, cast off centre 14 (16: 16: **18: 16: 18**) sts, patt to end.

Complete to match first side, reverse shapings.

SLEEVES (both alike)

Cast on 51 (53: 55: **55: 57: 57**) sts using 3¼ mm (US 3) needles and yarn A.

Work in rib as for back for 4 rows.

Break off yarn A and join in yarn B.

Work in rib for a further 8 rows, inc 1 st at end of last row and ending with a WS row.

52 (54: 56: **56: 58: 58**) sts.

Change to 4mm (US 6) needles.

Beg with a K row, cont in st st, shaping sides by inc 1 st at each end of 3rd and every foll 16th (14th: 14th: **12th: 12th: 10th**) row to 62 (74: 72: **78: 74: 86**) sts, then on every foll 14th (-: 12th: **10th: 10th: 8th**) row until there are 70 (-: 78: **82: 86: 90**) sts.

Cont straight until sleeve measures 53 (55: 57.5: **60: 61: 62.5**) cm, ending with a WS row.

Shape top

Cast off 4 (**5: 6: 6**) sts at beg of next 2 rows.

62 (64: 66: **70: 74: 78**) sts.

Dec 1 st at each end of next and foll 14 (15: 15: **18: 21: 23**) alt rows, then on every foll 4th row until 24 sts rem.

Work 3 rows, ending with a WS row.

Shape saddle strap

Place markers at both ends of last row.

Dec 1 st at each end of next and foll 4th row, then on every foll 8th row until 14 sts rem.

Cont straight until work measures 11.5 (11.5: 12: 12: **12.5: 12.5**) cm from markers, ending with a WS row.

Cast off.

MAKING UP

PRESS as described on the information page.

Matching sleeve markers to beg of shoulder cast-off edges, join both front and right back saddle shoulder seams using back stitch, or mattress stitch if preferred.

Neckband

With RS facing, using 3¼ mm (US 3) needles and yarn B, pick up and knit 12 sts from left sleeve, 14 (**14: 16: 16**) sts down left side of neck, 14 (16: 16: **18: 16: 18**) sts from front, 14 (**14: 16: 16**) sts up right side of neck, 12 sts from right sleeve, then 29 (31: 31: **33: 33: 35**) sts from back. 95 (99: 99: **103: 105: 109**) sts.

Work in rib as for back for 12 rows.

Cast off in rib.

Machine wash all pieces before completing sewing together.

Join left back saddle shoulder and neckband seam. Sew rem sections of sleeves into armholes, matching cast-off edges at underarm. See information page for finishing instructions.

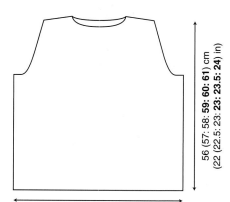

56 (57: 58: **59: 60: 61**) cm
(22 (22.5: 23: **23: 23.5: 24**) in)

50 (53: 55: **58: 60: 63**) cm
(19.5 (21: 21.5: **23: 23.5: 25**) in)

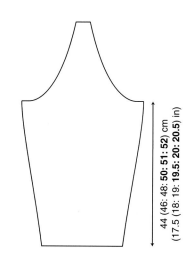

44 (46: 48: **50: 51: 52**) cm
(17.5 (18: 19: **19.5: 20: 20.5**) in)

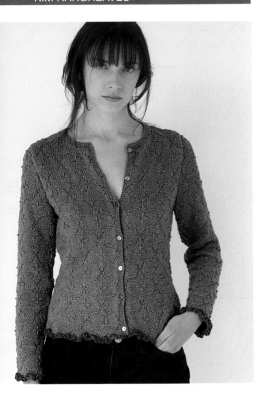

Saffy

KIM HARGREAVES

YARN

	XS	S	M	L	XL	
To fit bust	81	86	91	97	102	cm
	32	34	36	38	40	in

Rowan Denim

A Tennessee 231

	12	13	14	15	15	x50gm

B Memphis 229

	2	2	2	2	2	x50gm

NEEDLES

1 pair 3¼ mm (no 10) (US 3) needles
1 pair 4mm (no 8) (US 6) needles

BUTTONS - 7 x 75320

TENSION

Before washing: 20 sts and 28 rows to
10 cm measured over stocking stitch using
4mm (US 6) needles.

Tension note: Denim will shrink in length
when washed for the first time. Allowances
have been made in the pattern for shrinkage
(see size diagram for after washing
measurements).

BACK

Cast on 337 (361: 377: 401: 417) sts using
3¼ mm (US 3) needles and yarn B.
Break off yarn B and join in yarn A.
Row 1 (RS): K1, *K2, lift 2nd st on right
needle over first st and off needle, rep from *
to end.
169 (181: 189: 201: 209) sts.
Row 2: P1, *P2tog, rep from * to end.
85 (91: 95: 101: 105) sts.
Change to 4mm (US 6) needles.
Beg with a K row, work in st st for 2 rows,
ending with RS facing for next row.
Starting and ending rows as indicated and
repeating the 26 row repeat throughout, cont
in patt from chart as folls:
Work 16 (18: 18: 20: 20) rows, ending with a
WS row.
Dec 1 st at each end of next and foll 6th row,
then on every foll 4th row until 73 (79: 83: 89:
93) sts rem.
Work 9 rows, ending with a WS row.
Inc 1 st at each end of next and every foll 8th
row until there are 85 (91: 95: 101: 105) sts,
taking inc sts into patt.
Cont straight until back measures 39.5 (41:
41: 42: 42) cm, ending with a WS row.
Shape armholes
Keeping patt correct, cast off 3 (4: 4: 5: 5) sts
at beg of next 2 rows.
79 (83: 87: 91: 95) sts.
Dec 1 st at each end of next 3 (3: 5: 5: 7)
rows, then on foll 4 (5: 4: 5: 4) alt rows.
65 (67: 69: 71: 73) sts.
Cont straight until armhole measures
24 (24: 25: 25: 26.5) cm, ending with
a WS row.
Shape shoulders and back neck
Cast off 6 (6: 6: 6: 7) sts at beg of next 2 rows.
53 (55: 57: 59: 59) sts.

Next row (RS): Cast off 6 (6: 6: 6: 7) sts,
patt until there are 10 (10: 11: 11: 10) sts
on right needle and turn, leaving rem sts
on a holder.
Work each side of neck separately.
Cast off 4 sts at beg of next row.
Cast off rem 6 (6: 7: 7: 6) sts.
With RS facing, rejoin yarn to rem sts, cast
off centre 21 (23: 23: 25: 25) sts, patt to end.
Complete to match first side, reverse shapings.

LEFT FRONT

Cast on 169 (181: 189: 201: 209) sts using
3¼ mm (US 3) needles and yarn B.
Break off yarn B and join in yarn A.
Row 1 (RS): K1, *K2, lift 2nd st on right needle
over first st and off needle, rep from * to end.
85 (91: 95: 101: 105) sts.
Row 2: P1, *P2tog, rep from * to end.
43 (46: 48: 51: 53) sts.
Change to 4mm (US 6) needles.
Beg with a K row, work in st st for 2 rows,
ending with RS facing for next row.
Starting and ending rows as indicated, cont
in patt from chart as folls:
Work 16 (18: 18: 20: 20) rows, ending with a
WS row.
Dec 1 st at beg of next and foll 6th row, then on
every foll 4th row until 37 (40: 42: 45: 47) sts rem.
Work 9 rows, ending with a WS row.
Inc 1 st at each end of next and every foll 8th
row until there are 43 (46: 48: 51: 53) sts,
taking inc sts into patt.
Cont straight until left front matches back to beg
of armhole shaping, ending with a WS row.
Shape armhole
Keeping patt correct, cast off 3 (4: 4: 5: 5) sts
at beg of next row.
40 (42: 44: 46: 48) sts.
Work 1 row.
Dec 1 st at armhole edge of next 3 (3: 5:
5: 7) rows, then on foll 4 (5: 4: 5: 4) alt rows.
33 (34: 35: 36: 37) sts.
Cont straight until 21 (21: 21: 23: 23) rows
less have been worked than on back to start
of shoulder shaping, ending with a RS row.

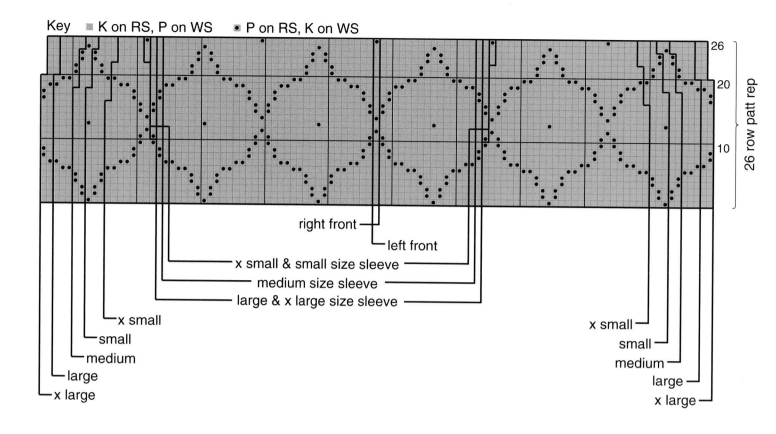

Key ▨ K on RS, P on WS ▪ P on RS, K on WS

26 row patt rep

right front
left front
x small & small size sleeve
medium size sleeve
large & x large size sleeve

x small
small
medium
large
x large

x small
small
medium
large
x large

Shape neck

Keeping patt correct, cast off 6 (7: 7: 7: 7) sts
at beg of next row.

27 (27: 28: 29: 30) sts.

Dec 1 st at neck edge of next 4 rows, then on foll
4 (4: 4: 5: 5) alt rows, then on foll 4th row.

18 (18: 19: 19: 20) sts.

Work 4 rows, ending with a WS row.

Shape shoulder

Cast off 6 (6: 6: 6: 7) sts at beg of next and
foll alt row.

Work 1 row.

Cast off rem 6 (6: 7: 7: 6) sts.

RIGHT FRONT

Work to match left front, reversing shapings.

SLEEVES (both alike)

Cast on 185 (185: 193: 201: 201) sts using
3¼ mm (US 3) needles and yarn B.

Break off yarn B and join in yarn A.

Row 1 (RS): K1, *K2, lift 2nd st on right
needle over first st and off needle, rep
from * to end.

93 (93: 97: 101: 101) sts.

Row 2: P1, *P2tog, rep from * to end.

47 (47: 49: 51: 51) sts.

Change to 4mm (US 6) needles.

Beg with a K row, work in st st for 2 rows,
ending with RS facing for next row.

Starting and ending rows as indicated, cont in
patt from chart, shaping sides by inc 1 st at
each end of 13th (13th: 13th: 13th: 11th)
and every foll 14th (14th: 14th: 14th: 12th) row
to 65 (53: 59: 61: 71) sts, then on
every foll - (12th: 12th: 12th: 10th) row
until there are - (67: 69: 71: 73) sts,
taking inc sts into patt.

Cont straight until sleeve measures
51.5 (51.5: 53: 53: 53) cm, ending with a WS row.

Shape top

Keeping patt correct, cast off 3 (4: 4: 5: 5) sts at
beg of next 2 rows.

59 (59: 61: 61: 63) sts.

Dec 1 st at each end of next 3 rows, then on
foll 2 alt rows, then on every foll 4th row until
35 (35: 37: 37: 39) sts rem.

Work 1 row, ending with a WS row.

Dec 1 st at each end of next and every foll alt row
to 29 sts, then on foll 3 rows, end with a WS row.

Cast off rem 23 sts.

MAKING UP

PRESS as described on the information page.
Join both shoulder seams using back stitch,
or mattress stitch if preferred.

Button band

With RS facing, using 3¼ mm (US 3) needles
and yarn A, pick up and knit 96 (96: 96:
102: 102) sts down left front opening edge,

between neck shaping and cast-on edge.
Work in garter st for 4 rows.
Cast off knitwise (on WS).

Buttonhole band

With RS facing, using 3¼ mm (US 3) needles
and yarn A, pick up and knit 96 (96: 96:
102: 102) sts up right front opening edge,
between cast-on edge and neck shaping.

Row 1 (WS): Knit.

Row 2: K2, *K2tog, (yfwd) twice (to make a
buttonhole - drop extra loop on next row),
K13 (13: 13: 14: 14), rep from * 5 times
more, K2tog, (yfwd) twice, K2.

Work in garter st for a further 2 rows.
Cast off knitwise (on WS).

Neckband

With RS facing, using 3¼ mm (US 3) needles
and yarn A, starting and ending at cast-off
edges of front bands, pick up and knit
27 (28: 28: 31: 31) sts up right side of
neck, 29 (31: 31: 33: 33) sts from back,
then 27 (28: 28: 31: 31) sts down left
side of neck.
83 (87: 87: 95: 95) sts.
Work in garter st for 4 rows.
Cast off knitwise (on WS).

Bullion Stitch

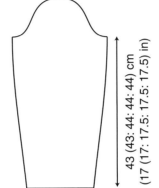

Embroidery

Using yarn A and photograph as a guide,
embroider 4 bullion stitches radiating out from P
st at centre of each diamond shape of pattern.
Machine wash all pieces before completing
sewing together.
See information page for finishing instructions,
setting in sleeves using the set-in method.

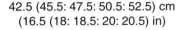

53 (54: 55: 56: 57) cm
(21 (21.5: 21.5: 22: 22.5) in)

42.5 (45.5: 47.5: 50.5: 52.5) cm
(16.5 (18: 18.5: 20: 20.5) in)

43 (43: 44: 44: 44) cm
(17 (17: 17.5: 17.5: 17.5) in)

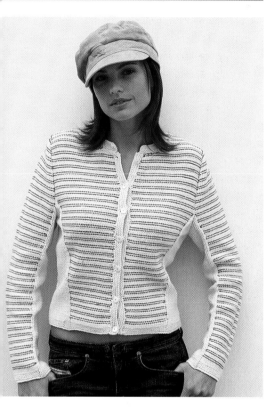

Ticking

KIM HARGREAVES

YARN

	XS	S	M	L	XL	
To fit bust	81	86	91	97	102	cm
	32	34	36	38	40	in

Rowan Denim

A Ecru 324						
	10	11	11	12	13	x50gm
B Tennessee 231						
	2	2	2	2	2	x50gm

NEEDLES

1 pair 3¼ mm (no 10) (US 3) needles
1 pair 4mm (no 8) (US 6) needles
Cable needle

BUTTONS - 7 x 75318

TENSION

Before washing: 20 sts and 28 rows to 10 cm measured over stocking stitch using 4mm (US 6) needles.

Tension note: Denim will shrink in length when washed for the first time. Allowances have been made in the pattern for shrinkage (see size diagram for after washing measurements).

SPECIAL ABBREVIATIONS

Tw3R = Twist 3 right Slip next st onto cable needle and leave at back of work, K2, then P1 from cable needle.

Tw3L = Twist 3 left Slip next 2 sts onto cable needle and leave at front of work, P1, then K2 from cable needle.

BACK

Cast on 73 (79: 83: 89: 93) sts using 3¼ mm (US 3) needles and yarn A.
Row 1 (RS): K13 (15: 16: 18: 19), P1, K2, P1, K to last 17 (19: 20: 22: 23) sts, P1, K2, P1, K to end.
Row 2: K14 (16: 17: 19: 20), P2, K to last 16 (18: 19: 21: 22) sts, P2, K to end.
Rep last 2 rows 3 times more, end with a WS row.
Change to 4mm (US 6) needles.
Row 1 (RS): Using yarn A P14 (16: 17: 19: 20), K2, P to last 16 (18: 19: 21: 22) sts, K2, P to end.
Row 2: Using yarn A K14 (16: 17: 19: 20), P2, K to last 16 (18: 19: 21: 22) sts, P2, K to end.
Row 3: As row 1.
Join in yarn B.
Row 4: Using yarn A K14 (16: 17: 19: 20), P2, using yarn B K to last 16 (18: 19: 21: 22) sts, using yarn A P2, K to end.
Rows 5 to 8: As rows 1 and 2, twice.
Row 9: Using yarn A P14 (16: 17: 19: 20), K2, using yarn B P to last 16 (18: 19: 21: 22) sts, using yarn A K2, P to end.
Row 10: As row 2.
These 10 rows set the sts - centre sts in striped rev st st, side seam sts in rev st st using yarn A and 2 K sts between the rev st st areas.

Cont as set until back measures 8.5 (9.5: 9.5: 11: 11) cm, ending with a RS row.
Place markers after 16th (18th: 19th: 21st: 22nd) st, counting in from both ends of last row.
Next row (WS): Patt to first marker, slip marker onto right needle, M1, patt to second marker, M1, slip marker to right needle, patt to end.
Work 9 rows.
Rep last 10 rows 3 times more.
81 (87: 91: 97: 101) sts.
Next row (WS): Patt to first marker, slip marker onto right needle, M1, patt to second marker, M1, slip marker to right needle, patt to end.
Work 5 rows.
Rep last 6 rows 3 times more, then first of these rows (the inc row) again.
91 (97: 101: 107: 111) sts.
Work a further 2 rows, ending with a WS row.
(Back should measure 32.5 (33.5: 33.5: 35: 35) cm.)
Shape armholes
Keeping patt correct, cast off 4 (5: 5: 6: 6) sts at beg of next 2 rows.
83 (87: 91: 95: 99) sts.
Keeping stripes correct at centre and working all other sts using yarn A, cont as folls:
Row 1 (RS): P2tog, P7 (8: 9: 10: 11), Tw3R, patt to last 12 (13: 14: 15: 16) sts, Tw3L, P to last 2 sts, P2tog.
Row 2: K2tog, K6 (7: 8: 9: 10), P2, patt to last 10 (11: 12: 13: 14) sts, P2, K to last 2 sts, K2tog. 79 (83: 87: 91: 95) sts.
Row 3: P2tog, P5 (6: 7: 8: 9), K2, patt to last 9 (10: 11: 12: 13) sts, K2, P to last 2 sts, P2tog.
Row 4: (K2tog) 0 (0: 1: 1: 1) times, K6 (7: 6: 7: 8), P2, patt to last 8 (9: 10: 11: 12) sts, P2, K to last 0 (0: 2: 2: 2) sts, (K2tog) 0 (0: 1: 1: 1) times.
77 (81: 83: 87: 91) sts.
Row 5: P2tog, P3 (4: 4: 5: 6), Tw3R, patt to last 8 (9: 9: 10: 11) sts, Tw3L, P to last 2 sts, P2tog.

Row 6: (K2tog) 0 (0: 0: 0: 1) times, K4 (5: 5: 6: 5), P2, patt to last 6 (7: 7: 8: 9) sts, P2, K to last 0 (0: 0: 0: 2) sts, (K2tog) 0 (0: 0: 0: 1) times.

Row 7: P2tog, P2 (3: 3: 4: 4), K2, patt to last 6 (7: 7: 8: 8) sts, K2, P to last 2 sts, P2tog. 73 (77: 79: 83: 85) sts.

Row 8: K3 (**4**: 4: **5**: 5), P2, patt to last 5 (6: 6: 7: 7) sts, P2, K to end.

Row 9: P2tog, P0 (1: 1: 2: 2), Tw3R, patt to last 5 (6: 6: 7: 7) sts, Tw3L, P0 (1: 1: 2: 2), P2tog. 71 (75: 77: 81: 83) sts.

Row 10: K1 (2: 2: 3: 3), P2, patt to last 3 (4: 4: 5: 5) sts, P2, K to end.

Row 11: (K2tog) 1 (0: 0: 0: 0) times, (P2tog) 0 (1: 1: 1: 1) times, P0 (0: 0: 1: 1), K1 (2: 2: 2: 2), patt to last 3 (4: 4: 5: 5) sts, K1 (2: 2: 2: 2), P0 (0: 0: 1: 1), (K2tog) 1 (0: 0: 0: 0) times, (P2tog) 0 (1: 1: 1: 1) times. 69 (73: 75: 79: 81) sts.

Row 12: K0 (1: 1: 2: 2), P2, patt to last 2 (3: 3: 4: 4) sts, P2, K0 (1: 1: 2: 2).

XS size only

Row 13: Slip next st onto cable needle and leave at back of work, K1, then P st from cable needle, patt to last 2 sts, slip next st onto cable needle and leave at front of work, P1, then K1 from cable needle.

S and M sizes only

Row 13: Slip first st onto cable needle and leave at back of work, K2tog, then P st from cable needle, patt to last 3 sts, slip next 2 sts onto cable needle and leave at front of work, P1, then K2tog from cable needle. - (71: 73: -: -) sts.

XS, S and M sizes only

Row 14: P1, patt to last st, P1.

L and XL sizes only

Row 13: Slip next 2 sts onto cable needle and leave at back of work, K2, then P2tog from cable needle, patt to last 4 sts, slip next 2 sts onto cable needle and leave at front of work, P2tog, then K2 from cable needle. - (-: -: 77: 79) sts.

Row 14: P2, patt to last 2 sts, P2.

Row 15: K2tog, patt to last 2 sts, K2tog. - (-: -: 75: 77) sts.

Row 16: P1, patt to last st, P1.

All sizes

Now working all sts in striped rev st st, cont straight until armhole measures 25 (25: 26.5: 26.5: 27.5) cm, ending with a WS row.

Shape shoulders and back neck

Cast off 7 sts at beg of next 2 rows. 55 (57: 59: 61: 63) sts.

Next row (RS): Cast off 7 sts, P until there are 10 (10: 11: 11: 12) sts on right needle and turn, leaving rem sts on a holder. Work each side of neck separately. Cast off 4 sts at beg of next row. Cast off rem 6 (6: 7: 7: 8) sts. With RS facing, rejoin appropriate yarn to rem sts, cast off centre 21 (23: 23: 25: 25) sts, P to end. Complete to match first side, reverse shapings.

LEFT FRONT

Cast on 37 (40: 42: 45: 47) sts using 3¼ mm (US 3) needles and yarn A.

Row 1 (RS): K13 (15: 16: 18: 19), P1, K2, P1, K to end.

Row 2: K to last 16 (18: 19: 21: 22) sts, P2, K to end.

Rep last 2 rows 3 times more, end with a WS row. Change to 4mm (US 6) needles.

Row 1 (RS): Using yarn A P14 (16: 17: 19: 20), K2, P to end.

Row 2: Using yarn A K to last 16 (18: 19: 21: 22) sts, P2, K to end.

Row 3: As row 1.

Join in yarn B.

Row 4: Using yarn B K to last 16 (18: 19: 21: 22) sts, using yarn A P2, K to end.

Rows 5 to 8: As rows 1 and 2, twice.

Row 9: Using yarn A P14 (16: 17: 19: 20), K2, using yarn B P to end.

Row 10: As row 2.

These 10 rows set the sts - front opening edge sts in striped rev st st, side seam sts in rev st st using yarn A and 2 K sts between the rev st st areas.

Cont as set until left front measures 8.5 (9.5: 9.5: 11: 11) cm, ending with a RS row.

Place marker after 16th (18th: 19th: 21st: 22nd) st, counting in from end of last row.

Next row (WS): Patt to marker, M1, slip marker onto right needle, patt to end. Work 9 rows. Rep last 10 rows 3 times more. 41 (44: 46: 49: 51) sts.

Next row (WS): Patt to marker, M1, slip marker onto right needle, patt to end. Work 5 rows. Rep last 6 rows 3 times more, then first of these rows (the inc row) again. 46 (49: 51: 54: 56) sts.

Work a further 2 rows, ending with a WS row. (Left front should match back to beg of armhole shaping.)

Shape armhole

Keeping patt correct, cast off 4 (5: 5: 6: 6) sts at beg of next row. 42 (44: 46: 48: 50) sts. Work 1 row.

Keeping stripes correct at centre and working all other sts using yarn A, cont as folls:

Row 1 (RS): P2tog, P7 (8: 9: 10: 11), Tw3R, patt to end.

Row 2: Patt to last 10 (11: 12: 13: 14) sts, P2, K to last 2 sts, K2tog. 40 (42: 44: 46: 48) sts.

Row 3: P2tog, P5 (6: 7: 8: 9), K2, patt to end.

Row 4: Patt to last 8 (9: 10: 11: 12) sts, P2, K to last 0 (0: 2: 2: 2) sts, (K2tog) 0 (0: 1: 1: 1) times. 39 (41: 42: 44: 46) sts.

Row 5: P2tog, P3 (4: 4: 5: 6), Tw3R, patt to end.

Row 6: Patt to last 6 (7: 7: 8: 9) sts, P2, K to last 0 (0: 0: 0: 2) sts, (K2tog) 0 (0: 0: 0: 1) times.

Row 7: P2tog, P2 (3: 3: 4: 4), K2, patt to end. 37 (39: 40: 42: 43) sts.

Row 8: Patt to last 5 (6: 6: 7: 7) sts, P2, K to end.

Row 9: P2tog, P0 (1: 1: 2: 2), Tw3R, patt to end. 36 (38: 39: 41: 42) sts.

Row 10: Patt to last 3 (4: 4: 5: 5) sts, P2, K to end.

Row 11: (K2tog) 1 (0: 0: 0: 0) times, (P2tog) 0 (1: 1: 1: 1) times, P0 (0: 0: 1: 1), K1 (2: 2: 2: 2), patt to end. 35 (37: 38: 40: 41) sts.

Row 12: Patt to last 2 (3: 3: 4: 4) sts, P2, K0 (1: 1: 2: 2).

XS size only

Row 13: Slip next st onto cable needle and leave at back of work, K1, then P st from cable needle, patt to end.

S and M sizes only

Row 13: Slip first st onto cable needle and leave at back of work, K2tog, then P st from cable needle, patt to end. - (36: 37: -: -) sts.

XS, S and M sizes only

Row 14: Patt to last st, P1.

L and XL sizes only

Row 13: Slip next 2 sts onto cable needle and leave at back of work, K2, then P2tog from cable needle, patt to end. - (-: -: 39: 40) sts.

Row 14: Patt to last 2 sts, P2.

Row 15: K2tog, patt to end. - (-: -: 38: 39) sts.

Row 16: Patt to last st, P1.

All sizes

Now working all sts in striped rev st st, cont straight until 19 (19: 19: 21: 21) rows less have been worked than on back to start of shoulder shaping, ending with a RS row.

Shape neck

Keeping stripes correct, cast off 5 (6: 6: 6: 6) sts at beg of next row.

30 (30: 31: 32: 33) sts.

Dec 1 st at neck edge of next 6 rows, then on foll 3 (3: 3: 4: 4) alt rows, then on foll 4th row.

20 (20: 21: 21: 22) sts.

Work 2 rows, ending with a WS row.

Shape shoulder

Cast off 7 sts at beg of next and foll alt row.

Work 1 row.

Cast off rem 6 (6: 7: 7: 8) sts.

RIGHT FRONT

Cast on 37 (40: 42: 45: 47) sts using 3¼ mm (US 3) needles and yarn A.

Row 1 (RS): K to last 17 (19: 20: 22: 23) sts, P1, K2, P1, K to end.

Row 2: K14 (16: 17: 19: 20), P2, K to end.

Rep last 2 rows 3 times more, ending with a WS row.

Change to 4mm (US 6) needles.

Row 1 (RS): Using yarn A P to last 16 (18: 19: 21: 22) sts, K2, P to end.

Row 2: Using yarn A K14 (16: 17: 19: 20), P2, K to end.

Row 3: As row 1.

Join in yarn B.

Row 4: Using yarn A K14 (16: 17: 19: 20), P2, using yarn B K to end.

Rows 5 to 8: As rows 1 and 2, twice.

Row 9: Using yarn B P to last 16 (18: 19: 21: 22) sts, using yarn A K2, P to end.

Row 10: As row 2.

These 10 rows set the sts - front opening edge sts in striped rev st st, side seam sts in rev st st using yarn A and 2 K sts between the rev st st areas.

Cont as set until right front measures 8.5 (9.5: 9.5: 11: 11) cm, end with a RS row. Place marker after 16th (18th: 19th: 21st: 22nd) st, counting in from beg of last row.

Next row (WS): Patt to marker, slip marker to right needle, M1, patt to end.

Work 9 rows.

Rep last 10 rows 3 times more.

41 (44: 46: 49: 51) sts.

Next row (WS): Patt to marker, slip marker to right needle, M1, patt to end.

Work 5 rows.

Rep last 6 rows 3 times more, then first of these rows (the inc row) again.

46 (49: 51: 54: 56) sts.

Work a further 3 rows, ending with a RS row. (Right front should match back to beg of armhole shaping.)

Shape armhole

Keeping patt correct, cast off 4 (5: 5: 6: 6) sts at beg of next row.

42 (44: 46: 48: 50) sts.

Keeping stripes correct at centre and working all other sts using yarn A, cont as folls:

Row 1 (RS): Patt to last 12 (13: 14: 15: 16) sts, Tw3L, P to last 2 sts, P2tog.

Row 2: K2tog, K6 (7: 8: 9: 10), P2, patt to end.

40 (42: 44: 46: 48) sts.

Row 3: Patt to last 9 (10: 11: 12: 13) sts, K2, P to last 2 sts, P2tog.

Row 4: (K2tog) 0 (0: 1: 1: 1) times, K6 (7: 6: 7: 8), P2, patt to end.

39 (41: 42: 44: 46) sts.

Row 5: Patt to last 8 (9: 9: 10: 11) sts, Tw3L, P to last 2 sts, P2tog.

Row 6: (K2tog) 0 (0: 0: 0: 1) times, K4 (5: 5: 6: 5), P2, patt to end.

Row 7: Patt to last 6 (7: 7: 8: 8) sts, K2, P to last 2 sts, P2tog.

37 (39: 40: 42: 43) sts.

Row 8: K3 (4: 4: 5: 5), P2, patt to end.

Row 9: Patt to last 5 (6: 6: 7: 7) sts, Tw3L, P0 (1: 1: 2: 2), P2tog.

36 (38: 39: 41: 42) sts.

Row 10: K1 (2: 2: 3: 3), P2, patt to end.

Row 11: Patt to last 3 (4: 4: 5: 5) sts, K1 (2: 2: 2: 2), P0 (0: 0: 1: 1), (K2tog) 1 (0: 0: 0: 0) times, (P2tog) 0 (1: 1: 1: 1) times.

35 (37: 38: 40: 41) sts.

Row 12: K0 (1: 1: 2: 2), P2, patt to end.

XS size only

Row 13: Patt to last 2 sts, slip next st onto cable needle and leave at front of work, P1, then K1 from cable needle.

S and M sizes only

Row 13: Patt to last 3 sts, slip next 2 sts onto cable needle and leave at front of work, P1, then K2tog from cable needle.

- (36: 37: -: -) sts.

XS, S and M sizes only

Row 14: P1, patt to end.

L and XL sizes only

Row 13: Patt to last 4 sts, slip next 2 sts onto cable needle and leave at front of work, P2tog, then K2 from cable needle.

- (-: -: 39: 40) sts.

Row 14: P2, patt to end.

Row 15: Patt to last 2 sts, K2tog.

- (-: -: 38: 39) sts.

Row 16: P1, patt to end.

All sizes

Now working all sts in striped rev st st, complete to match left front, reversing shapings.

SLEEVES (both alike)

Cast on 51 (51: 53: 55: 55) sts using 3¼ mm (US 3) needles and yarn A.

Row 1 (RS): K8 (8: 9: 10: 10), P1, K2, P1, K to last 12 (12: 13: 14: 14) sts, P1, K2, P1, K to end.

Row 2: K9 (9: 10: 11: 11), P2, K to last 11 (11: 12: 13: 13) sts, P2, K to end.

Rep last 2 rows 3 times more, ending with a WS row.

Change to 4mm (US 6) needles.

Row 1 (RS): Using yarn A P9 (9: 10: 11: 11), K2, P to last 11 (11: 12: 13: 13) sts, K2, P to end.

Row 2: Using yarn A K9 (9: 10: 11: 11), P2, K to last 11 (11: 12: 13: 13) sts, P2, K to end.

Row 3: As row 1.

Join in yarn B.

Row 4: Using yarn A K9 (9: 10: 11: 11), P2, using yarn B K to last 11 (11: 12: 13: 13) sts, using yarn A P2, K to end.

Rows 5 to 8: As rows 1 and 2, twice.

Row 9: Using yarn A P9 (9: 10: 11: 11), K2, using yarn B P to last 11 (11: 12: 13: 13) sts, using yarn A K2, P to end.

Row 10: As row 2.

These 10 rows set the sts - centre sts in striped rev st st, side sts in rev st st using yarn A and 2 K sts between the rev st st areas.

Work 6 rows, ending with a RS row.

Place markers after 11th (11th: 12th: 13th: 13th) st, counting in from both ends of last row.

Next row (WS): Patt to first marker, slip marker onto right needle, M1, patt to second marker, M1, slip marker to right needle, patt to end.

Working all increases as set by last row, inc 1 st at either side of centre section on every foll 16th (14th: 14th: 14th: 12th) row to 59 (61: 65: 67: 73) sts, then on every foll 14th (12th: 12th: 12th: 10th) row until there are 67 (69: 71: 73: 75) sts, taking inc sts into striped rev st st.

Cont straight until sleeve measures 50.5 (50.5: 51.5: 51.5: 51.5) cm, ending with a WS row.

Shape top

Keeping patt correct, cast off 4 (5: 5: 6: 6) sts at beg of next 2 rows.

59 (59: 61: 61: 63) sts.

Dec 1 st at each end of next 3 rows, then on foll 2 alt rows, then on every foll 4th row until 33 (33: 35: 35: 37) sts rem.

Work 1 row, ending with a WS row.

Dec 1 st at each end of next and every foll alt row to 29 sts, then on foll 5 rows, ending with a WS row.

Cast off rem 19 sts.

MAKING UP

PRESS as described on the information page.

Join shoulder seams using back stitch, or mattress stitch if preferred.

Button band

With RS facing, using 3¼ mm (US 3) needles and yarn A, pick up and knit 84 (84: 90: 90: 90) sts evenly down left front opening edge, between neck shaping and cast-on edge.

Work in garter st for 6 rows.

Cast off knitwise (on WS).

Buttonhole band

With RS facing, using 3¼ mm (US 3) needles and yarn A, pick up and knit 84 (84: 90: 90: 90) sts evenly up right front opening edge, between cast-on edge and neck shaping.

Work in garter st for 2 rows.

Row 3 (WS): K2, *K2tog, (yfwd) twice (to make a buttonhole - drop extra loop on next row), K11 (11: 12: 12: 12), rep from * 5 times more, K2tog, (yfwd) twice (to make 7th buttonhole - drop extra loop on next row), K2.

Work in garter st for a further 3 rows.

Cast off knitwise (on WS).

Neckband

With RS facing, using 3¼ mm (US 3) needles and yarn A, starting and ending halfway across top of bands, pick up and knit 25 (26: 26: 28: 28) sts up right side of neck, 29 (31: 31: 33: 33) sts from back, then 25 (26: 26: 28: 28) sts down left side of neck. 79 (83: 83: 89: 89) sts.

Work in garter st for 8 rows.

Cast off knitwise (on WS).

Machine wash all pieces before completing sewing together.

See information page for finishing instructions, setting in sleeves using the set-in method.

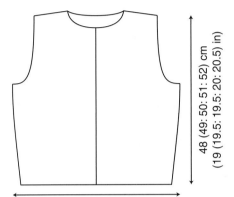

45.5 (48.5: 50.5: 53.5: 55.5) cm (18 (19: 20: 21: 22) in)

48 (49: 50: 51: 52) cm (19 (19.5: 19.5: 20: 20.5) in)

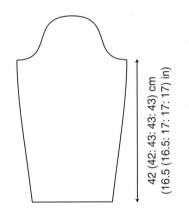

42 (42: 43: 43: 43) cm (16.5 (16.5: 17: 17: 17) in)

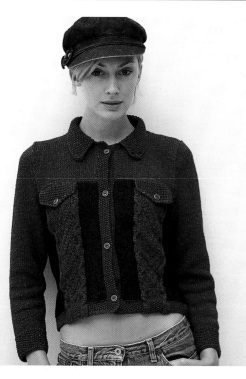

Voyage

KIM HARGREAVES

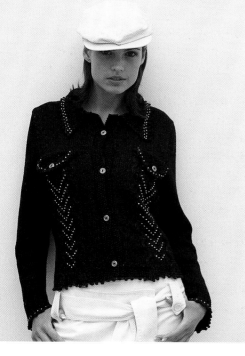

YARN

	XS	S	M	L	XL	
To fit bust	81	86	91	97	102	cm
	32	34	36	38	40	in

Rowan Denim

Two colour version

A Memphis 229

	11	11	12	12	13	x50gm

B Nashville 225

	3	3	3	3	3	x50gm

One colour version

	14	15	16	16	17	x50gm

(photographed in Nashville 225)

NEEDLES

1 pair 3¼ mm (no 10) (US 3) needles
1 pair 4mm (no 8) (US 6) needles
Cable needle

BUTTONS - 10 x 75324

BEADS - One colour version only: Approx 930 (1,050: 1,050: 1,200: 1,200) x J3001008 clear beads

TENSION

Before washing: 20 sts and 28 rows to 10 cm measured over stocking stitch using 4mm (US 6) needles.

Tension note: Denim will shrink in length when washed for the first time. Allowances have been made in the pattern for shrinkage (see size diagram for after washing measurements).

SPECIAL ABBREVIATIONS

C4B = Cable 4 back Slip next 2 sts onto cable needle and leave at back of work, K2, then K2 from cable needle.

C4F = Cable 4 front Slip next 2 sts onto cable needle and leave at front of work, K2, then K2 from cable needle.

Bead 1 = place a bead (on RS row) by bringing yarn to front (RS) of work and slipping bead up next to st just worked, slip next st purlwise from left needle to right needle and take yarn back to back (WS) of work, leaving bead sitting in front of slipped st on RS.

Beading note: Before starting to knit, thread beads onto yarn. To do this, thread a fine sewing needle (one that will easily pass through the beads) with sewing thread. Knot ends of thread and then pass end of yarn through this loop. Thread a bead onto sewing thread and then gently slide it along and onto knitting yarn. Continue in this way until required number of beads are on yarn.

Two colour version

BACK

Cast on 85 (91: 95: 101: 105) sts using 3¼ mm (US 3) needles and yarn A.
Row 1 (RS): K17 (18: 20: 21: 23), P1, K4, P1, K39 (43: 43: 47: 47), P1, K4, P1, K to end.
Row 2: K18 (19: 21: 22: 24), P4, K41 (45: 45: 49: 49), P4, K to end.
Row 3: As row 1.
Row 4: K0 (1: 1: 0: 0) (P1, K1) 9 (9: 10: 11: 12) times, P4, (K1, P1) 20 (22: 22: 24: 24) times, K1, P4, (K1, P1) 9 (9: 10: 11: 12) times, K0 (1: 1: 0: 0).
Row 5: P1 (0: 0: 1: 1), (K1, P1) 8 (9: 10: 10: 11) times, P1, K4, P1, (P1, K1) 19 (21: 21: 23: 23) times, P2, K4, P1, (P1, K1) 8 (9: 10: 10: 11) times, P1 (0: 0: 1: 1).
Rows 6 to 11: As rows 4 and 5, 3 times.
Row 12: As row 4.
Change to 4mm (US 6) needles.
Using the **intarsia** technique as described on the information page, cont as folls:
Next row (RS): Using yarn B, K18 (19: 21: 22: 24), using yarn A C4B, P1, K39 (43: 43: 47: 47), P1, C4F, using yarn B K to end.
Next row: Using yarn B, K18 (19: 21: 22: 24), using yarn A P4, K1, P39 (43: 43: 47: 47), K1, P4, using yarn B K to end.

Now place chart for back as folls:

Row 1 (RS): Using yarn B, P18 (19: 21: 22: 24), using yarn A K4, P1, work next 39 (43: 43: 47: 47) sts as row 1 of chart for back, P1, K4, using yarn B P to end.

Row 2: Using yarn B, K18 (19: 21: 22: 24), using yarn A P4, K1, work next 39 (43: 43: 47: 47) sts as row 2 of chart for back, K1, P4, using yarn B K to end.

Last 2 rows set position of chart for back. Work chart rows 1 to 80 once only and then repeat chart rows 81 to 96 as required, cont as folls:

Row 3: Using yarn B, P18 (19: 21: 22: 24), using yarn A K4, P1, patt 39 (43: 43: 47: 47) sts, P1, K4, using yarn B P to end.

Row 4: Using yarn B, K18 (19: 21: 22: 24), using yarn A P4, K1, patt 39 (43: 43: 47: 47) sts, K1, P4, using yarn B K to end.

Rows 5 and 6: As rows 3 and 4.

Row 7: Using yarn B, P18 (19: 21: 22: 24), using yarn A C4F, P1, patt 39 (43: 43: 47: 47) sts, P1, C4B, using yarn B P to end.

Row 8: As row 4.

Row 9: Using yarn B, P18 (19: 21: 22: 24), using yarn A K4, P1, K1, M1, miss first st of chart, patt 37 (41: 41: 45: 45) sts, M1, miss last st of chart, K1, P1, K4, using yarn B P to end. 87 (93: 97: 103: 107) sts.

Row 10: Using yarn B, K18 (19: 21: 22: 24), using yarn A P4, K1, patt 41 (45: 45: 49: 49) sts, K1, P4, using yarn B K to end.

Row 11: Using yarn B, P18 (19: 21: 22: 24), using yarn A K4, P1, patt 41 (45: 45: 49: 49) sts, P1, K4, using yarn B P to end.

Rows 12 and 13: As rows 10 and 11.

Row 14: As row 10.

Row 15: Using yarn B, P18 (19: 21: 22: 24), using yarn A C4B, P1, patt 41 (45: 45: 49: 49) sts, P1, C4F, using yarn B P to end.

Row 16: As row 10.

Rows 1 to 16 form patt for side sections. Keeping patt correct as now set over all sts, cont as folls:

Work 2 rows, ending with a WS row.

Row 19 (RS): Patt 23 (24: 26: 27: 29) sts, K1, M1, miss first st of chart, patt to last

24 (25: 27: 28: 30) sts, M1, miss last st of chart, K1, patt to end. 89 (95: 99: 105: 109) sts.

Work 9 rows.

Rep last 10 rows 5 times more, then row 19 again. 101 (107: 111: 117: 121) sts.

Cont straight until back measures 35 (36: 36: 37: 37) cm, ending with a WS row.

Shape armholes

Keeping patt correct, cast off 4 (5: 5: 6: 6) sts at beg of next 2 rows. 93 (97: 101: 105: 109) sts.

Dec 1 st at each end of next 7 rows, then on foll alt row. 77 (81: 85: 89: 93) sts.

Break off yarn B and cont using yarn A only.

Next row (WS): K6 (6: 8: 8: 10), (P2tog) twice, patt to last 10 (10: 12: 12: 14) sts, (P2tog) twice, K to end. 73 (77: 81: 85: 89) sts.

Next row: P2tog, P to last 2 sts, P2tog. 71 (75: 79: 83: 87) sts.

Next row: Knit.

Beg with a K row, cont in st st, dec 1 st at each end of next and foll 0 (1: 2: 3: 4) alt rows. 69 (71: 73: 75: 77) sts.

Cont straight until armhole measures 24 (24: 25: 25: 26.5) cm, ending with a WS row.

Shape shoulders and back neck

Cast off 7 sts at beg of next 2 rows. 55 (57: 59: 61: 63) sts.

Next row (RS): Cast off 7 sts, K until there are 10 (10: 11: 11: 12) sts on right needle and turn, leaving rem sts on a holder.

Work each side of neck separately.

Cast off 4 sts at beg of next row.

Cast off rem 6 (6: 7: 7: 8) sts.

With RS facing, rejoin yarn to rem sts, cast off centre 21 (23: 23: 25: 25) sts, K to end.

Complete to match first side, reverse shapings.

LEFT FRONT

Cast on 51 (54: 56: 59: 61) sts using 3¼mm (US 3) needles and yarn A.

Row 1 (RS): K17 (18: 20: 21: 23), P1, K4, P1, K5 (7: 7: 9: 9), P1, K4, P1, K to end.

Row 2: K18, P4, K7 (9: 9: 11: 11), P4, K to end.

Row 3: As row 1.

Row 4: (P1, K1) 9 times, P4, (K1, P1) 3 (4: 4: 5: 5) times, K1, P4, (K1, P1) 9 (9: 10: 11: 12) times, K0 (1: 1: 0: 0).

Row 5: P1 (**0**: 0: 1: 1), (K1, P1) 8 (9: 10: 10: 11) times, P1, K4, P1, (P1, K1) 2 (3: 3: 4: 4) times, P2, K4, P1, (P1, K1) 8 times, P1.

Rows 6 to 11: As rows 4 and 5, 3 times.

Row 12: (P1, K1) 4 times and slip these 8 sts onto a holder, M1, (P1, K1) 5 times, P4, (K1, P1) 3 (4: 4: 5: 5) times, K1, P4, (K1, P1) 9 (9: 10: 11: 12) times, K0 (1: 1: 0: 0). 44 (47: 49: 52: 54) sts.

Change to 4mm (US 6) needles.

Using the **intarsia** technique as described on the information page, cont as folls:

Next row (RS): Using yarn B, K18 (19: 21: 22: 24), using yarn A C4B, P1, K5 (7: 7: 9: 9), P1, C4F, using yarn B K to end.

Next row: Using yarn B, K11, using yarn A P4, K1, P5 (7: 7: 9: 9), K1, P4, using yarn B K to end.

Now place chart for front as folls:

Row 1 (RS): Using yarn B, P18 (19: 21: 22: 24), using yarn A K4, P1, work next 5 (7: 7: 9: 9) sts as row 1 of chart for front, P1, K4, using yarn B P to end.

Row 2: Using yarn B, K11, using yarn A P4, K1, work next 5 (7: 7: 9: 9) sts as row 2 of chart for front, K1, P4, using yarn B K to end.

Last 2 rows set position of chart for front. Working chart rows 1 to 64 once only and then repeating chart rows 65 to 80 as required, cont as folls:

Row 3: Using yarn B, P18 (19: 21: 22: 24), using yarn A K4, P1, patt 5 (7: 7: 9: 9) sts, P1, K4, using yarn B P to end.

Row 4: Using yarn B, K11, using yarn A P4, K1, patt 5 (7: 7: 9: 9) sts, K1, P4, using yarn B K to end.

Rows 5 and 6: As rows 3 and 4.

Row 7: Using yarn B, P18 (19: 21: 22: 24), using yarn A C4F, P1, patt 5 (7: 7: 9: 9) sts, P1, C4B, using yarn B P to end.

Row 8: As row 4.

Rows 9 to 14: As rows 3 and 4, 3 times.

Row 15: Using yarn B, P18 (19: 21: 22: 24), using yarn A C4B, P1, K1, M1, miss first st of chart, patt 3 (5: 5: 7: 7) sts, M1, miss last st of chart, K1, P1, C4F, using yarn B P to end. 46 (49: 51: 54: 56) sts.

Row 16: Using yarn B, K11, using yarn A P4, K1, patt 7 (9: 9: 11: 11) sts, K1, P4, using yarn B K to end.

Rows 1 to 16 form patt for side sections.

Keeping patt correct as now set over all sts, cont as folls:

Work 14 rows, ending with a WS row.

Row 31 (RS): Patt 23 (24: 26: 27: 29) sts, K1, M1, miss first st of chart, patt to last 17 sts, M1, miss last st of chart, K1, patt to end. 48 (51: 53: 56: 58) sts.

Work 15 rows.

Rep last 16 rows once more, then row 31 again. 52 (55: 57: 60: 62) sts.

Cont straight until left front matches back to beg of armhole shaping, ending with a WS row.

Shape armhole

Keeping patt correct, cast off 4 (5: 5: 6: 6) sts at beg of next row.

48 (50: 52: 54: 56) sts.

Work 1 row.

Dec 1 st at armhole edge of next 7 rows, then on foll alt row. 40 (42: 44: 46: 48) sts.

Break off yarn B and cont using yarn A only.

Next row (WS): K11, (P2tog) twice, patt to last 10 (10: 12: 12: 14) sts, (P2tog) twice, K to end.

36 (38: 40: 42: 44) sts.

Next row: P2tog, P to end.

35 (37: 39: 41: 43) sts.

Next row: Knit.

****Beg with a K row, cont in st st, dec 1 st at armhole edge of next and foll 0 (1: 2: 3: 4) alt rows. 34 (35: 36: 37: 38) sts.

Cont straight until 19 (19: 19: 21: 21) rows less have been worked than on back to start of shoulder shaping, ending with a RS row.

Shape neck

Cast off 6 (7: 7: 7: 7) sts at beg of next row. 28 (28: 29: 30: 31) sts.

Dec 1 st at neck edge of next 4 rows, then on foll 3 (3: 3: 4: 4) alt rows, then on foll 4th row. 20 (20: 21: 21: 22) sts.

Work 4 rows, ending with a WS row.

Shape shoulder

Cast off 7 sts at beg of next and foll alt row.

Work 1 row.

Cast off rem 6 (6: 7: 7: 8) sts.

RIGHT FRONT

Cast on 51 (54: 56: 59: 61) sts using 3¼ mm (US 3) needles and yarn A.

Row 1 (RS): K17, P1, K4, P1, K5 (7: 7: 9: 9), P1, K4, P1, K to end.

Row 2: K18 (19: 21: 22: 24), P4, K7 (9: 9: 11: 11), P4, K to end.

Row 3: As row 1.

Row 4: K0 (1: 1: 0: 0) (P1, K1) 9 (9: 10: 11: 12) times, P4, (K1, P1) 3 (4: 4: 5: 5) times, K1, P4, (K1, P1) 9 times.

Row 5: (P1, K1) 8 times, P2, K4, P1, (P1, K1) 2 (3: 3: 4: 4) times, P2, K4, P1, (P1, K1) 8 (9: 10: 10: 11) times, P1 (0: 0: 1: 1).

Rows 6 to 11: As rows 4 and 5, 3 times.

Row 12: K0 (1: 1: 0: 0) (P1, K1) 9 (9: 10: 11: 12) times, P4, (K1, P1) 3 (4: 4: 5: 5) times, K1, P4, (K1, P1) 5 times, M1 and turn, leaving rem 8 sts on a holder.

44 (47: 49: 52: 54) sts.

Change to 4mm (US 6) needles.

Using the **intarsia** technique as described on the information page, cont as folls:

Next row (RS): Using yarn B, K11, using yarn A C4B, P1, K5 (7: 7: 9: 9), P1, C4F, using yarn B K to end.

Next row: Using yarn B, K18 (19: 21: 22: 24), using yarn A P4, K1, P5 (7: 7: 9: 9), K1, P4, using yarn B K to end.

Now place chart for front as folls:

Row 1 (RS): Using yarn B, P11, using yarn A K4, P1, work next 5 (7: 7: 9: 9) sts as row 1 of chart for front, P1, K4, using yarn B P to end.

Row 2: Using yarn B, K18 (19: 21: 22: 24), using yarn A P4, K1, work next 5 (7: 7: 9: 9) sts as row 2 of chart for front, K1, P4, using yarn B K to end.

Last 2 rows set position of chart for front. Working chart rows 1 to 64 once only and then repeating chart rows 65 to 80 as required, cont as folls:

Row 3: Using yarn B, P11, using yarn A K4, P1, patt 5 (7: 7: 9: 9) sts, P1, K4, using yarn B P to end.

Row 4: Using yarn B, K18 (19: 21: 22: 24), using yarn A P4, K1, patt 5 (7: 7: 9: 9) sts, K1, P4, using yarn B K to end.

Rows 5 and 6: As rows 3 and 4.

Row 7: Using yarn B, P11, using yarn A C4F, P1, patt 5 (7: 7: 9: 9) sts, P1, C4B, using yarn B P to end.

Row 8: As row 4.

Rows 9 to 14: As rows 3 and 4, 3 times.

Row 15: Using yarn B, P11, using yarn A C4B, P1, K1, M1, miss first st of chart, patt 3 (5: 5: 7: 7) sts, M1, miss last st of chart, K1, P1, C4F, using yarn B P to end. 46 (49: 51: 54: 56) sts.

Row 16: Using yarn B, K18 (19: 21: 22: 24), using yarn A P4, K1, patt 7 (9: 9: 11: 11) sts, K1, P4, using yarn B K to end.

Rows 1 to 16 form patt for side sections.

Keeping patt correct as now set over all sts, cont as folls:

Work 14 rows, ending with a WS row.

Row 31 (RS): Patt 16 sts, K1, M1, miss first st of chart, patt to last 24 (25: 27: 28: 30) sts, M1, miss last st of chart, K1, patt to end. 48 (51: 53: 56: 58) sts.

Work 15 rows.

Rep last 16 rows once more, then row 31 again. 52 (55: 57: 60: 62) sts.

Cont straight until right front matches back to beg of armhole shaping, ending with a RS row.

Shape armhole

Keeping patt correct, cast off 4 (5: 5: 6: 6) sts at beg of next row. 48 (50: 52: 54: 56) sts.

Dec 1 st at armhole edge of next 7 rows, then on foll alt row. 40 (42: 44: 46: 48) sts.

Break off yarn B and cont using yarn A only.

Next row (WS): K6 (6: 8: 8: 10), (P2tog) twice, patt to last 15 sts, (P2tog) twice, K to end. 36 (38: 40: 42: 44) sts.

Front

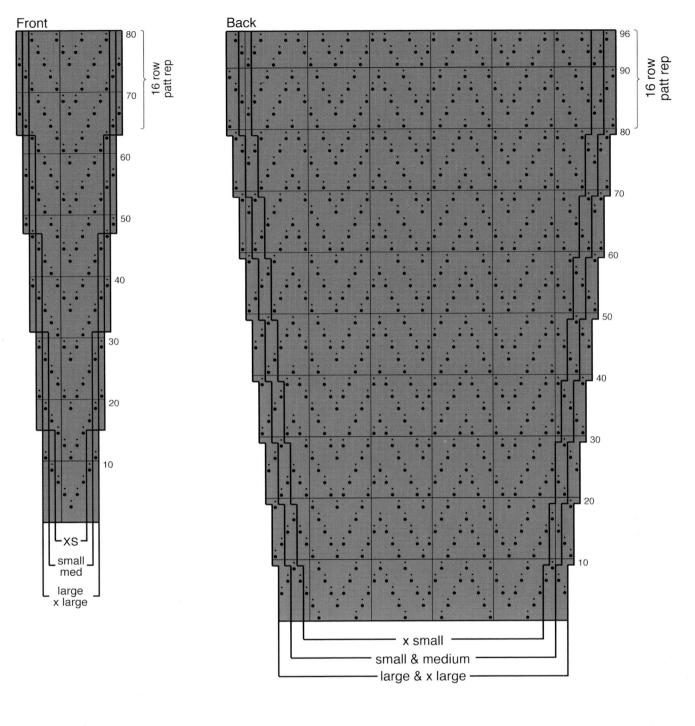

16 row
patt rep

Back

16 row
patt rep

XS

small
med

large
x large

x small

small & medium

large & x large

Key for Two colour version

K on RS, P on WS

P on RS, K on WS

P on RS, K on WS

Key for One colour version

K on RS, P on WS

K on RS, P on WS

bead 1

Next row: P to last 2 sts, P2tog.
35 (37: 39: 41: 43) sts.
Next row: Knit.
Complete to match left front from **,
reversing shapings.

LEFT SLEEVE
Cuff
Cast on 56 (56: 58: 60: 60) sts using 3¼ mm
(US 3) needles and yarn A.
Rows 1 to 3: Knit.
Row 4 (WS): *K1, P1, rep from * to end.
Row 5: *P1, K1, rep from * to end.
Last 2 rows form moss st.
Work in moss st for a further 3 rows, ending
with a WS row.
Row 9 (RS): Moss st 2 sts, cast off 2 sts
(to make a buttonhole - cast on 2 sts over these
cast-off sts on next row), moss st to end.
Work in moss st for a further 13 rows, ending
with a WS row.
Row 23: As row 9.
Work in moss st for 1 more row, end with a WS row.
Change to 4mm (US 6) needles.
Shape front sleeve
Next row (RS): Moss st 5 sts, K32 (32: 33:
34: 34) and turn, leaving rem sts on a holder.
Work each side of sleeve separately.
Next row: P to last 5 sts, moss st 5 sts.
Last 2 rows set the sts - sleeve opening
edge 5 sts in moss st with rem sts in st st.
Next row: Patt to last 2 sts, M1, K2.
Working all increases as set by last row,
inc 1 st at end of foll 14th (14th: 14th:
14th: 12th) row.
39 (39: 40: 41: 41) sts.
Work a further 3 (3: 3: 3: 5) rows, ending with
a WS row.
Break yarn and leave sts on a second holder.
Shape back sleeve
With RS facing, rejoin yarn to 19 (19: 20:
21: 21) sts left on first holder and cont as folls:
Next row (RS): K to last 5 sts, moss st 5 sts.
Next row: Moss st 5 sts, P to end.
Last 2 rows set the sts - sleeve opening
edge 5 sts in moss st with rem sts in st st.

Next row: K2, M1, patt to end.
Working all increases as set by last row,
inc 1 st at beg of foll 14th (14th: 14th:
14th: 12th) row.
21 (21: 22: 23: 23) sts.
Work a further 2 (2: 2: 2: 4) rows, ending with
a RS row.
Cast off 5 sts at beg of next row.
16 (16: 17: 18: 18) sts.
Join sections
Next row (RS): K16 (16: 17: 18: 18), then
with RS facing K across 39 (39: 40: 41: 41) sts
left on second holder.
55 (55: 57: 59: 59) sts.
**Beg with a P row and working all
increases as set, cont in st st, shaping
sides by inc 1 st at each end of 10th (8th:
10th: 10th: 6th) and every foll 14th (12th:
14th: 14th: 12th) row to 67 (69: 61: 63: 69)
sts, then on every foll - (-: 12th: 12th: 10th)
row until there
are - (-: 71: 73: 75) sts.
Cont straight until sleeve measures 49 (49:
50.5: 50.5: 50.5) cm, ending with a WS row.
Shape top
Cast off 4 (5: 5: 6: 6) sts at beg of next 2 rows.
59 (59: 61: 61: 63) sts.
Dec 1 st at each end of next 3 rows, then on
foll 2 alt rows, then on every foll 4th row until
33 (33: 35: 35: 37) sts rem.
Work 1 row, ending with a WS row.
Dec 1 st at each end of next and every foll alt
row to 29 sts, then on foll 3 rows, ending with
a WS row.
Cast off rem 23 sts.

RIGHT SLEEVE
Cuff
Cast on 56 (56: 58: 60: 60) sts using 3¼ mm
(US 3) needles and yarn A.
Rows 1 to 3: Knit.
Row 4 (WS): *P1, K1, rep from * to end.
Row 5: *K1, P1, rep from * to end.
Last 2 rows form moss st.
Work in moss st for a further 3 rows, ending
with a WS row.

Row 9 (RS): Moss st to last 4 sts, cast off 2 sts
(to make a buttonhole - cast on 2 sts over
these cast-off sts on next row), moss st 1 st.
Work in moss st for a further 13 rows, ending
with a WS row.
Row 23: As row 9.
Work in moss st for 1 more row, end with a WS row.
Change to 4mm (US 6) needles.
Shape back sleeve
Next row (RS): Moss st 5 sts, K14 (14: 15:
16: 16) and turn, leaving rem sts on a holder.
Work each side of sleeve separately.
Next row: P to last 5 sts, moss st 5 sts.
Last 2 rows set the sts - sleeve opening edge
5 sts in moss st with rem sts in st st.
Next row: Patt to last 2 sts, M1, K2.
Working all increases as set by last row, inc 1 st
at end of foll 14th (14th: 14th: 14th: 12th) row. 21
(21: 22: 23: 23) sts.
Work a further 2 (2: 2: 2: 4) rows, ending with
a RS row.
Next row (WS): P to last 5 sts, cast off rem 5 sts.
Break yarn and leave rem 16 (16: 17: 18: 18) sts
on a second holder.
Shape front sleeve
With RS facing, rejoin yarn to 37 (37: 38:
39: 39) sts left on first holder and cont as folls:
Next row (RS): K to last 5 sts, moss st 5 sts.
Next row: Moss st 5 sts, P to end.
Last 2 rows set the sts - sleeve opening edge
5 sts in moss st with rem sts in st st.
Next row: K2, M1, patt to end.
Working all increases as set by last row, inc 1 st
at beg of foll 14th (14th: 14th: 14th: 12th) row.
39 (39: 40: 41: 41) sts.
Work a further 3 (3: 3: 3: 5) rows, end with a RS row.
Join sections
Next row (RS): K39 (39: 40: 41: 41), then with
RS facing K across 16 (16: 17: 18: 18) sts left on
second holder. 55 (55: 57: 59: 59) sts.
Complete to match left sleeve from **.

MAKING UP
PRESS as described on the information page.
Join both shoulder seams using back stitch,
or mattress stitch if preferred.

Button band

Slip 8 sts from left front holder onto 3¼ mm (US 3) needles and rejoin yarn A with RS facing.

Cont in moss st as set until button band, when slightly stretched, fits up left front opening edge to neck shaping, ending with a WS row.

Cast off in moss st.

Slip stitch band in place.

Mark positions for 4 buttons on this band - first to come 4 cm up from cast-on edge, last to come 3.5 cm below neck shaping and rem 2 buttons evenly spaced between.

Buttonhole band

Slip 8 sts from right front holder onto 3¼ mm (US 3) needles and rejoin yarn A with WS facing.

Cont in moss st as set until buttonhole band, when slightly stretched, fits up right front opening edge to neck shaping, ending with a WS row and with the addition of 4 buttonholes to correspond with positions marked for buttons worked as folls:

Buttonhole row (RS): Moss st 2 sts, cast off 2 sts (to make a buttonhole - cast on 2 sts over these cast-off sts on next row), moss st to end.

When band in complete, cast off in moss st.

Slip stitch band in place.

Collar

Cast on 83 (87: 87: 95: 95) sts using 3¼ mm (US 3) needles and yarn A.

Row 1 (RS): K1, *P1, K1, rep from * to end.

Row 2: As row 1.

These 2 rows form moss st.

Row 3: Moss st 2 sts, inc twice in next st, moss st to last 3 sts, inc twice in next st, moss st 2 sts. 87 (91: 91: 99: 99) sts.

Work in moss st for 5 rows.

Rep last 6 rows 3 times more, then row 3 again. 103 (107: 107: 115: 115) sts.

Work in moss st for a further 3 rows.

Cast off in moss st.

Pocket flaps (make 2)

Cast on 25 sts using 3¼ mm (US 3) needles and yarn A.

Work in moss st as given for collar for 14 rows, ending with a WS row.

Dec 1 st at each end of next 11 rows. 3 sts.

Next row (WS): K1, K2tog, psso and fasten off.

Machine wash all pieces before completing sewing together.

See information page for finishing instructions, setting in sleeves using the set-in method. Sew cast-on edge of collar to neck edge, positioning ends of collar halfway across top of bands. Sew cast-on edge of pocket flaps onto fronts as in photograph. Attach a button to each pocket flap to secure flaps to fronts. Sew cast-off edge of sleeve back section in place on WS.

One colour version

BACK

Using 3¼ mm (US 3) needles work picot cast-on as folls: cast on 4 (4: 3: 3: 5) sts, cast off 2 sts, slip st on right needle back onto left needle - 2 (2: 1: 1: 3) sts cast on, *cast on 5 sts, cast off 2 sts, slip st on right needle back onto left needle (3 extra sts cast on), rep from * until there are 83 (89: 94: 100: 102) sts on left needle, cast on 2 (2: 1: 1: 3) sts. 85 (91: 95: 101: 105) sts.

Using same colour throughout, complete as given for back of two colour version.

LEFT FRONT

Using 3¼ mm (US 3) needles work picot cast-on as folls: cast on 5 (5: 3: 3: 4) sts, cast off 2 sts, slip st on right needle back onto left needle - 3 (3: 1: 1: 2) sts cast on, *cast on 5 sts, cast off 2 sts, slip st on right needle back onto left needle (3 extra sts cast on), rep from * until there are 48 (51: 55: 58: 59) sts on left needle, cast on 3 (3: 1: 1: 2) sts. 51 (54: 56: 59: 61) sts.

Using same colour throughout, complete as given for left front of two colour version.

RIGHT FRONT

Using 3¼ mm (US 3) needles work picot cast-on as folls: cast on 5 (5: 3: 3: 4) sts, cast off 2 sts, slip st on right needle back onto left needle - 3 (3: 1: 1: 2) sts cast on, *cast on 5 sts, cast off 2 sts, slip st on right needle back onto left needle (3 extra sts cast on), rep from * until there are 48 (51: 55: 58: 59) sts on left needle, cast on 3 (3: 1: 1: 2) sts. 51 (54: 56: 59: 61) sts.

Using same colour throughout, complete as given for right front of two colour version.

LEFT SLEEVE

Cuff

Using 3¼ mm (US 3) needles work picot cast-on as folls: cast on 3 (3: 4: 5: 5) sts, cast off 2 sts, slip st on right needle back onto left needle - 1 (1: 2: 3: 3) sts cast on, *cast on 5 sts, cast off 2 sts, slip st on right needle back onto left needle (3 extra sts cast on), rep from * until there are 55 (55: 56: 57: 57) sts on left needle, cast on 1 (1: 2: 3: 3) sts. 56 (56: 58: 60: 60) sts.

Row 1 and 2: Knit.

Row 3 (RS): K2, *bead 1, K1, rep from * to end.

Complete as given for left sleeve of two colour version from row 4.

RIGHT SLEEVE

Cuff

Using 3¼ mm (US 3) needles work picot cast-on as folls: cast on 3 (3: 4: 5: 5) sts, cast off 2 sts, slip st on right needle back onto left needle - 1 (1: 2: 3: 3) sts cast on, *cast on 5 sts, cast off 2 sts, slip st on right needle back onto left needle (3 extra sts cast on), rep from * until there are 55 (55: 56: 57: 57) sts on left needle, cast on 1 (1: 2: 3: 3) sts. 56 (56: 58: 60: 60) sts.

Row 1 and 2: Knit.

Row 3 (RS): *K1, bead 1, rep from * to last 2 sts, K2.

Complete as given for right sleeve of two colour version from row 4.

MAKING UP

PRESS as described on the information page.

Join both shoulder seams using back stitch, or mattress stitch if preferred.

Button and buttonhole bands

Work as given for button and buttonhole bands of two colour version.

Collar

Using 3¼ mm (US 3) needles work picot cast-on as folls: cast on 3 (5: 5: 3: 3) sts, cast off 2 sts, slip st on right needle back onto left needle - 1 (3: 3: 1: 1) sts cast on, *cast on 5 sts, cast off 2 sts, slip st on right needle back onto left needle (3 extra sts cast on), rep from * until there are 100 (102: 102: 112: 112) sts on left needle, cast on 1 (3: 3: 1: 1) sts.
101 (105: 105: 113: 113) sts.

Row 1 and 2: Knit.

Row 3 (RS): *K1, bead 1, rep from * to last st, K1.

Row 4: K2tog, *P1, K1, rep from * to last 3 sts, P1, K2tog. 99 (103: 103: 111: 111) sts.

Row 5: As row 3.

Row 6: K1, *P1, K1, rep from * to end.
Last row sets position of moss st.
Keeping moss st correct as now set, dec 1 st

at each end of next and every foll 3rd row until 83 (87: 87: 95: 95) sts rem.
Work in moss st for a further 2 rows.
Cast off in moss st.

Pocket flaps (make 2)

Using 3¼ mm (US 3) needles work picot cast-on as folls: cast on 3 sts, cast off 2 sts, slip st on right needle back onto left needle - 1 st cast on, *cast on 5 sts, cast off 2 sts, slip st on right needle back onto left needle (3 extra sts cast on), rep from * until there are 34 sts on left needle, cast on 1 st. 35 sts.

Row 1 and 2: Knit.

Row 3 (RS): *K1, bead 1, rep from * to last st, K1.

Row 4: Cast off 12 sts (one st on right needle), (P1, K1) 5 times, cast off rem 12 sts. 11 sts.

With RS facing, rejoin yarn to centre 11 sts

and, keeping moss st correct as set by last row, cont as folls:
Inc 1 st at each end of next 3 rows, then on foll alt row. 19 sts.
Work in moss st for a further 13 rows.
Cast off in moss st.
Machine wash all pieces before completing sewing together.
See information page for finishing instructions, setting in sleeves using the set-in method.
Sew cast-off edge of collar to neck edge, positioning ends of collar halfway across top of bands. Slip stitch cast-off edge of picot cast-on strips to shaped row-end edges of pocket flaps, then sew cast-off edges of pocket flaps onto fronts as in photograph. Attach a button to each pocket flap to secure flaps to fronts. Sew cast-off edge of sleeve back section in place on WS.

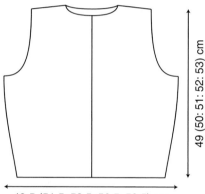

49 (50: 51: 52: 53) cm
(19.5 (19.5: 20: 20.5: 21) in)

48.5 (51.5: 53.5: 56.5: 58.5) cm
(19 (20.5: 21: 22: 23) in)

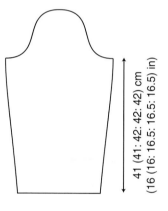

41 (41: 42: 42: 42) cm
(16 (16: 16.5: 16.5: 16.5) in)

Wallflower

LOUISA HARDING

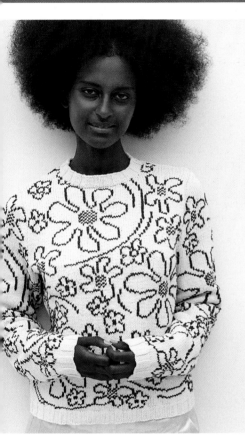

YARN

	XS	S	M	L	XL	
To fit bust	81	86	91	97	102	cm
	32	34	36	38	40	in

Rowan Denim

A Ecru 324						
	11	12	13	13	14	x50gm
B Memphis 229						
	5	5	6	6	6	x50gm

NEEDLES

1 pair 3¼ mm (no 10) (US 3) needles
1 pair 4mm (no 8) (US 6) needles

TENSION

Before washing: 20 sts and 28 rows to
10 cm measured over stocking stitch using
4mm (US 6) needles.

Tension note: Denim will shrink in length
when washed for the first time. Allowances
have been made in the pattern for shrinkage
(see size diagram for after washing
measurements).

BACK

Cast on 93 (99: 105: 111: 117) sts using
3¼ mm (US 3) needles and yarn A.
Row 1 (RS): K3, *P3, K3, rep from * to end.
Row 2: P3, *K3, P3, rep from * to end.
These 2 rows form rib.

XS and S sizes only

Work in rib for a further 7 rows, ending with a
RS row.
Row 10 (WS): rib 15 (16: -: -: -), M1, *rib 31 (33: -:
-: -), M1, rep from * once more, rib to end.

M and L sizes only

Work in rib for a further 8 rows, inc 1 st at
end of last row and ending with a WS row.

XL size only

Work in rib for a further 8 rows, dec 1 st at
end of last row and ending with a WS row.

All sizes

96 (102: 106: 112: 116) sts.
Change to 4mm (US 6) needles.
Using the **intarsia** technique as described on
the information page, and starting and ending
rows as indicated, cont in patt from chart,
which is worked entirely in st st beg with a K
row, as folls:
Cont straight until chart row 90 (94: 94:
98: 98) has been completed, ending with a
WS row.

Shape armholes

Keeping patt correct, cast off 3 (4: 4: 5: 5) sts
at beg of next 2 rows, then 3 sts at beg of foll
2 rows.
84 (88: 92: 96: 100) sts.
Dec 1 st at each end of next 3 (3: 5: 5: 7) rows,
then on foll 1 (2: 1: 2: 1) alt rows, then on foll
4th row.
74 (76: 78: 80: 82) sts.
Cont straight until chart row 158 (162: 164:
168: 172) has been completed, ending with a
WS row.

Shape shoulders and back neck

Cast off 7 sts at beg of next 2 rows.
60 (62: 64: 66: 68) sts.
Next row (RS): Cast off 7 sts, patt until there
are 10 (10: 11: 11: 12) sts on right needle
and turn, leaving rem sts on a holder.
Work each side of neck separately.
Cast off 4 sts at beg of next row.
Cast off rem 6 (6: 7: 7: 8) sts.
With RS facing, rejoin yarns to rem sts, cast
off centre 26 (28: 28: 30: 30) sts, patt to end.
Complete to match first side, reverse shapings.

FRONT

Work as given for back until chart row
144 (148: 150: 152: 156) has been
completed, ending with a WS row.

Shape neck

Next row (RS): Patt 30 (30: 31: 32: 33) sts
and turn, leaving rem sts on a holder.
Work each side of neck separately.
Cast off 4 sts at beg of next row.
26 (26: 27: 28: 29) sts.
Dec 1 st at neck edge of next 4 rows, then on
foll 2 (2: 2: 3: 3) alt rows.
20 (20: 21: 21: 22) sts.
Work 4 rows, ending with a WS row.

Shape shoulder

Cast off 7 sts at beg of next and foll alt row.
Work 1 row.
Cast off rem 6 (6: 7: 7: 8) sts.
With RS facing, rejoin yarns to rem sts, cast
off centre 14 (16: 16: 16: 16) sts, patt to end.
Complete to match first side, reverse shapings.

SLEEVES (both alike)

Cast on 51 (51: 53: 55: 55) sts using 3¼ mm
(US 3) needles and yarn A.
Row 1 (RS): P0 (0: 1: 2: 2), K3, *P3, K3, rep
from * to last 0 (0: 1: 2: 2) sts, P0 (0: 1: 2: 2).
Row 2: K0 (0: 1: 2: 2), P3, *K3, P3, rep from
* to last 0 (0: 1: 2: 2) sts, K0 (0: 1: 2: 2).
These 2 rows form rib.
Work in rib for a further 8 rows, inc 1 st at
end of last row and ending with a WS row.
52 (52: 54: 56: 56) sts.

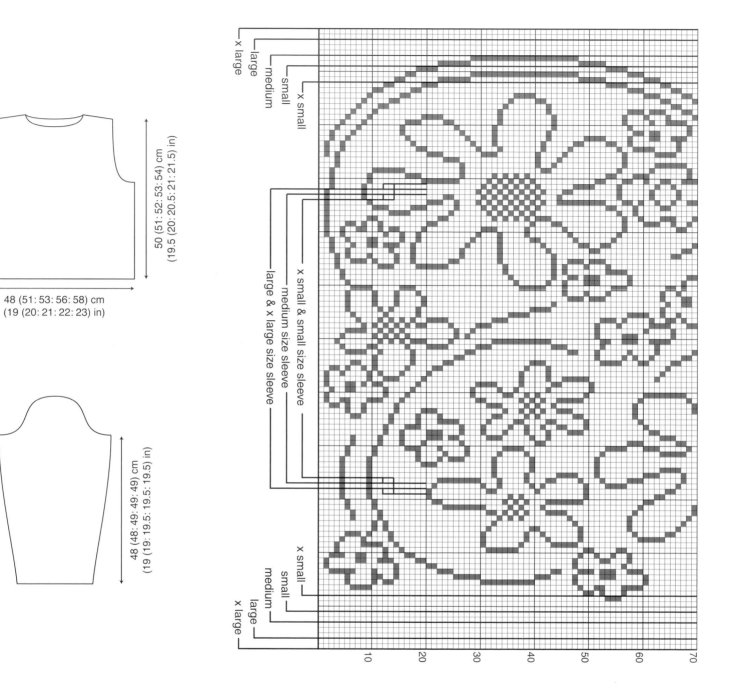

Change to 4mm (US 6) needles.

Starting and ending rows as indicated, cont in patt from chart, shaping sides by inc 1 st at each end of 15th (13th: 15th: 15th: 13th) and every foll 14th (14th: 14th: 14th: 12th) row to 58 (72: 72: 74: 68) sts, then on every foll 16th (-: 16th: 16th: 14th) row until there are 70 (-: 74: 76: 78) sts, taking inc sts into patt.

Cont straight until chart row 152 (152: 156: 156: 156) has been completed, ending with a WS row.

Shape top

Keeping patt correct, cast off 3 (4: 4: 5: 5) sts at beg of next 2 rows, then 3 sts at beg of foll 2 rows.

58 (58: 60: 60: 62) sts.

Dec 1 st at each end of next 3 rows, then on foll 2 alt rows, then on every foll 4th row until 38 (38: 40: 40: 42) sts rem.

Work 1 row, ending with a WS row.

Dec 1 st at each end of next and every foll alt row to 30 sts, then on foll row, ending with a WS row.

28 sts.

120

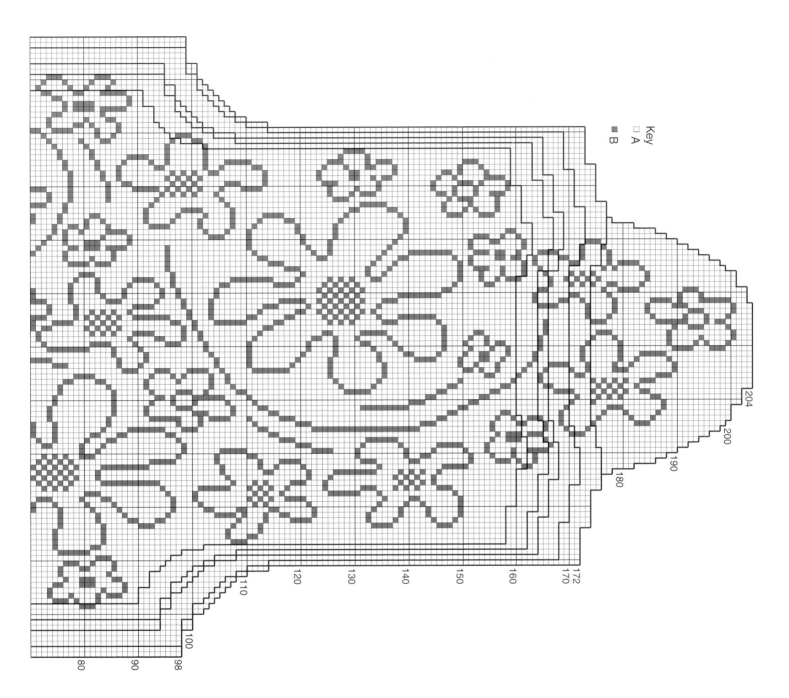

Key
□ A
■ B

Cast off 3 sts at beg of next 4 rows.

Cast off rem 16 sts.

MAKING UP

PRESS as described on the
information page.

Join right shoulder seam using back stitch,
or mattress stitch if preferred.

Neckband

With RS facing, using 3¼ mm (US 3)
needles and yarn A, pick up and knit 19 (19:
19: 21: 21) sts down left side of neck,
15 (19: 19: 19: 19) sts from front,
19 (19: 19: 21: 21) sts up right side of
neck, then 34 (36: 36: 38: 38) sts from back.
87 (93: 93: 99: 99) sts.

Beg with row 2, work in rib as for back for
9 rows.

Cast off in rib.

Machine wash all pieces before completing
sewing together.

See information page for finishing
instructions, setting in sleeves using the
set-in method.

Slouch

KIM HARGREAVES

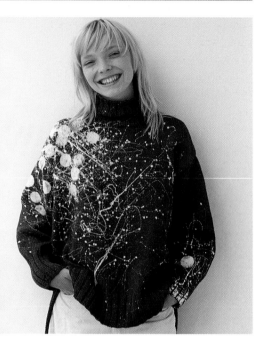

YARN

	XS	S	M	L	XL	
To fit bust	81	86	91	97	102	cm
	32	34	36	38	40	in

Rowan Denim

	17	18	19	20	21	x50gm

(photographed in Memphis 229)

NEEDLES

1 pair 3¾ mm (no 9) (US 5) needles
1 pair 4mm (no 8) (US 6) needles

EXTRAS - Bleach (to create optional splash effect)

TENSION

Before washing: 20 sts and 28 rows to 10 cm measured over stocking stitch using 4mm (US 6) needles.

Tension note: Denim will shrink in length when washed for the first time. Allowances have been made in the pattern for shrinkage (see size diagram for after washing measurements).

BACK

Cast on 127 (132: 137: 142: 147) sts using 3¾ mm (US 5) needles.
Row 1 (RS): P2, *K3, P2, rep from * to end.
Row 2: K2, *P3, K2, rep from * to end.
These 2 rows form rib.
Work in rib for a further 48 rows, dec 1 (0: 1: 0: 1) st at end of last row and end with a WS row.
126 (132: 136: 142: 146) sts.
Change to 4mm (US 6) needles.
Beg with a K row, cont in st st until back measures 48.5 (49.5: 49.5: 51: 51) cm, ending with a WS row.

Shape armholes

Cast off 4 sts at beg of next 2 rows.
118 (124: 128: 134: 138) sts.
Next row (RS): K2, K3tog, K to last 5 sts, K3tog tbl, K2.
Work 1 row.
Rep last 2 rows twice more.
106 (112: 116: 122: 126) sts.
Cont straight until armhole measures 30 (30: 31: 31: 32.5) cm, ending with a WS row.

Shape shoulders and back neck

Cast off 11 (12: 13: 13: 14) sts at beg of next 2 rows. 84 (88: 90: 96: 98) sts.
Next row (RS): Cast off 11 (12: 13: 13: 14) sts, K until there are 16 (16: 16: 18: 18) sts on right needle and turn, leaving rem sts on a holder.
Work each side of neck separately.
Cast off 4 sts at beg of next row.
Cast off rem 12 (12: 12: 14: 14) sts.
With RS facing, rejoin yarn to rem sts, cast off centre 30 (32: 32: 34: 34) sts, K to end.
Complete to match first side, reversing shapings.

FRONT

Cast on 127 (132: 137: 142: 147) sts using 3¾ mm (US 5) needles.
Work in rib as for back for 32 rows,

dec 1 (0: 1: 0: 1) st at end of last row and end with a WS row.
126 (132: 136: 142: 146) sts.
Change to 4mm (US 6) needles.
Beg with a K row, cont in st st until front measures 42 (43: 43: 44.5: 44.5) cm, ending with a WS row. (Note: Back rib is longer than front rib but length of st st sections above rib is the same.)
Cont as for back from start of armhole shaping until 12 (12: 12: 14: 14) rows less have been worked than on back to start of shoulder shaping, ending with a WS row.

Shape neck

Next row (RS): K42 (44: 46: 49: 51) and turn, leaving rem sts on a holder.
Work each side of neck separately.
Dec 1 st at neck edge of next 6 rows, then on foll 2 (2: 2: 3: 3) alt rows.
34 (36: 38: 40: 42) sts.
Work 1 row, ending with a WS row.

Shape shoulder

Cast off 11 (12: 13: 13: 14) sts at beg of next and foll alt row.
Work 1 row.
Cast off rem 12 (12: 12: 14: 14) sts.
With RS facing, rejoin yarn to rem sts, cast off centre 22 (24: 24: 24: 24) sts, K to end.
Complete to match first side, reversing shapings.

SLEEVES (both alike)

Cast on 72 (72: 74: 76: 76) sts using 3¾ mm (US 5) needles.
Row 1 (RS): K0 (0: 1: 2: 2), P2, *K3, P2, rep from * to last 0 (0: 1: 2: 2) sts, K0 (0: 1: 2: 2).
Row 2: P0 (0: 1: 2: 2), K2, *P3, K2, rep from * to last 0 (0: 1: 2: 2) sts, P0 (0: 1: 2: 2).
These 2 rows form rib.
Work in rib for a further 30 rows, ending with a WS row.
Change to 4mm (US 6) needles.
Beg with a K row, work in st st for 2 rows.
Next row (RS): K2, M1, K to last 2 sts, M1, K2.
Working all increases as set by last row, cont in st st, shaping sides by inc 1 st at each end of every foll 8th row to 90 (90: 88: 96: 84) sts,

then on every foll 6th row until there are
100 (100: 104: 104: 108) sts.
Cont straight until sleeve measures
50.5 (50.5: 51.5: 51.5: 51.5) cm, ending
with a WS row.

Shape top

Cast off 4 sts at beg of next 2 rows.
92 (92: 96: 96: 100) sts.
Work 2 rows.
Next row (RS): K2, K3tog, K to last 5 sts,
K3tog tbl, K2.
Work 1 row.
Rep last 4 rows twice more.
Cast off rem 80 (80: 84: 84: 88) sts.

MAKING UP

PRESS as described on the information page.
Join right shoulder seam using back stitch,
or mattress stitch if preferred.

Neckband

With RS facing and using 3³/₄ mm (US 5) needles,
pick up and knit 16 (16: 16: 18: 18) sts down left
side of neck, 22 (24: 24: 24: 24) sts from front,
16 (16: 16: 18: 18) sts up right side of neck,
then 38 (41: 41: 42: 42) sts from back.
92 (97: 97: 102: 102) sts.
Beg with row 2, work in rib as for back
for 33 rows.
Cast off in rib.
Machine wash all pieces before completing
sewing together.
See information page for finishing instructions,
setting in sleeves using the shallow set-in
method and leaving side seams open along
sides of ribbing.

Decoration (optional)

Once garment has been washed for first time
and sewn up, decorate using bleach as folls:

Roll up old newspapers and slip inside
sleeves and inside body - this will stop bleach
soaking through to other side of
garment. Cut vegetable (such as carrot) in
half and pour a little bleach into a saucer.
Dip cut end of vegetable into bleach, then
press cut edge onto garment to form faded
spots. Carefully splash and drip bleach
over required areas around faded spots.
(Note: as bleach will remove colour from
virtually everything it comes into contact
with, protect your clothes and the surface
you are working on) Once bleach has
removed dye and you are happy with
finished effect, immediately wash garment
again to remove bleach residue.
(Remember to wash it on its own as the
bleach that remains in the garment will fade
anything else washed with it)

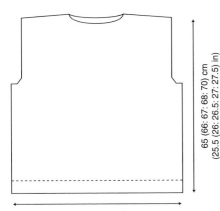

65 (66: 67: 68: 70) cm
(25.5 (26: 26.5: 27: 27.5) in)

63 (66: 68: 71: 73) cm
(25 (26: 27: 28: 28.5) in)

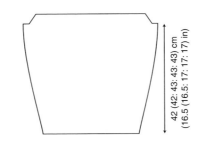

42 (42: 43: 43: 43) cm
(16.5 (16.5: 17: 17: 17) in)

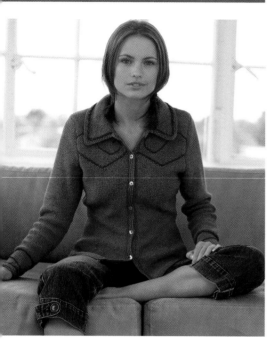

Dolly

KIM HARGREAVES

YARN

	XS	S	M	L	XL	
To fit bust	81	86	91	97	102	cm
	32	34	36	38	40	in

Rowan Denim

A Tennessee 231

	11	12	13	14	14	x50gm

B Memphis 229

	1	1	1	1	1	x50gm

NEEDLES

1 pair 3¼ mm (no 10) (US 3) needles
1 pair 3¾ mm (no 9) (US 5) needles
1 pair 4mm (no 8) (US 6) needles

BUTTONS - 12 x 75320

TENSION

Before washing: 20 sts and 28 rows to
10 cm measured over stocking stitch using
4mm (US 6) needles.

Tension note: Denim will shrink in length
when washed for the first time. Allowances
have been made in the pattern for shrinkage
(see size diagram for after washing
measurements).

BACK

Cast on 85 (91: 95: 101: 105) sts using
3¾ mm (US 5) needles and yarn A.
Work in garter st for 6 rows, end with a WS row.
Change to 4mm (US 6) needles.

Shape hem as folls:

Row 1 (RS): P54 (60: 64: 70: 74), wrap
next st (by slipping next st from left needle to
right needle, taking yarn to opposite side of
work between needles and slipping same st
back onto left needle), turn.

Row 2: K27 (33: 37: 43: 47), wrap next st
and turn.

Row 3: P31 (37: 41: 47: 51), wrap next st
and turn.

Row 4: K35 (41: 45: 51: 55), wrap next st
and turn.

Row 5: P39 (45: 49: 55: 59), wrap next st and
turn.

Row 6: K42 (48: 52: 58: 62), wrap next st
and turn.

Row 7: P45 (51: 55: 61: 65), wrap next st and
turn.

Row 8: K48 (54: 58: 64: 68), wrap next st and
turn.

Row 9: P51 (57: 61: 67: 71), wrap next st and
turn.

Cont in this way, working an extra 3 sts on
every row before wrapping next st and
turning, until the foll row has been worked:

Row 15: P69 (75: 79: 85: 89), wrap next st
and turn.

Now working an extra 2 sts on every row
before wrapping next st and turning, cont in
this way until the foll row has been worked:

Row 22: K83 (89: 93: 99: 103), wrap next st
and turn.

Beg with a P row, work in rev st st across all
sts for 10 (12: 12: 14: 14) rows, ending with a
WS row.

Shape darts

Place markers on 22nd (24th: 26th:
28th: 30th) st in from both ends of last row.

Next row (RS): P2, P2tog, P to within 1 st of
first marked st, P3tog, P to within 1 st of
second marked st, P3tog tbl, P to last 4 sts,
P2tog tbl, P2.

79 (85: 89: 95: 99) sts.

Work 5 rows.

Rep last 6 rows once more, and then the first
of these rows again.

67 (73: 77: 83: 87) sts.

Work 15 rows, ending with a WS row.

Next row (RS): P2, M1, (P to marked st, M1, P
marked st, M1) twice, P to last 2 sts, M1, P2.

Work 13 rows.

Rep last 14 rows once more, and then the
first of these rows again.

85 (91: 95: 101: 105) sts.

Cont straight until back measures 42 (43: 43:
44.5: 44.5) cm **at centre**, ending with
a WS row.

Shape armholes

Cast off 3 (4: 4: 5: 5) sts at beg of next 2 rows.

79 (83: 87: 91: 95) sts.

Dec 1 st at each end of next 3 (3: 5: 5: 6)
rows, then on foll 1 (1: 0: 0: 0) alt rows.

71 (75: 77: 81: 83) sts.

Work 1 (1: 1: 1: 0) row, end with a WS row.

Starting and ending rows as indicated, now
work from chart for back as folls:

Dec 1 st at each end of next and foll 2 (3: 3:
4: 4) alt rows. 65 (67: 69: 71: 73) sts.

Cont straight until all 40 rows of chart have
been completed, ending with a WS row.

Beg with a K row, cont in st st until armhole
measures 24 (24: 25: 25: 26.5) cm, ending
with a WS row.

Shape shoulders and back neck

Cast off 6 (6: 6: 6: 7) sts at beg of next 2 rows.

53 (55: 57: 59: 59) sts.

Next row (RS): Cast off 6 (6: 6: 6: 7) sts, K until there are 10 (10: 11: 11: 10) sts on right needle and turn, leaving rem sts on a holder.

Work each side of neck separately.

Cast off 4 sts at beg of next row.

Cast off rem 6 (6: 7: 7: 6) sts.

With RS facing, rejoin yarn to rem sts, cast off centre 21 (23: 23: 25: 25) sts, K to end. Complete to match first side, reverse shapings.

LEFT FRONT

Cast on 42 (45: 47: 50: 52) sts using 3¾ mm (US 5) needles and yarn A.

Work in garter st for 6 rows, end with a WS row.

Change to 4mm (US 6) needles.

Shape hem as folls:

Row 1 (RS): Purl.

Row 2: K11 (14: 16: 19: 21), wrap next st and turn.

Row 3: Purl.

Row 4: K15 (18: 20: 23: 25), wrap next st and turn.

Row 5: Purl.

Row 6: K19 (22: 24: 27: 29), wrap next st and turn.

Row 7: Purl.

Row 8: K22 (25: 27: 30: 32), wrap next st and turn.

Row 9: Purl.

Cont in this way, working an extra 3 sts on every alt row before wrapping next st and turning, until the foll row has been worked:

Row 16: K34 (37: 39: 42: 44), wrap next st and turn.

Now working an extra 2 sts on every alt row before wrapping next st and turning, cont in this way until the foll row has been worked:

Row 22: K40 (43: 45: 48: 50), wrap next st and turn.

Row 23: Purl.

Beg with a K row, work in rev st st across all sts for 9 (11: 11: 13: 13) rows, ending with a WS row.

Shape darts

Place marker on 22nd (24th: 26th: 28th: 30th) st in from end of last row.

Next row (RS): P2, P2tog, P to within 1 st of marked st, P3tog, P to end.

39 (42: 44: 47: 49) sts.

Work 5 rows.

Rep last 6 rows once more, and then the first of these rows again. 33 (36: 38: 41: 43) sts.

Work 15 rows, ending with a WS row.

Next row (RS): P2, M1, P to marked st, M1, P marked st, M1, P to end.

Work 13 rows.

Rep last 14 rows once more, and then the first of these rows again.

42 (45: 47: 50: 52) sts.

Cont straight until left front matches back to beg of armhole shaping, end with a WS row.

Shape armhole

Cast off 3 (4: 4: 5: 5) sts at beg of next row.

39 (41: 43: 45: 47) sts.

Work 1 row.

Dec 1 st at armhole edge of next 3 (3: 5: 5: 6) rows, then on foll 1 (1: 0: 0: 0) alt rows.

35 (37: 38: 40: 41) sts.

Work 1 (1: 1: 1: 0) row, end with a WS row. Starting and ending rows as indicated, now work from chart for left front as folls:

Dec 1 st at armhole edge of next and foll 2 (3: 3: 4: 4) alt rows.

32 (33: 34: 35: 36) sts.

Cont straight until all 22 rows of chart have been completed, ending with a WS row.

Beg with a K row, cont in st st until 19 (19: 19: 21: 21) rows less have been worked than on back to start of shoulder shaping, ending with a RS row.

Shape neck

Cast off 3 (4: 4: 4: 4) sts at beg of next row.

29 (29: 30: 31: 32) sts.

Dec 1 st at neck edge of next 6 rows, then on foll 5 (5: 5: 6: 6) alt rows.

18 (18: 19: 19: 20) sts.

Work 2 rows, ending with a WS row.

Shape shoulder

Cast off 6 (6: 6: 6: 7) sts at beg of next and foll alt row.

Work 1 row.

Cast off rem 6 (6: 7: 7: 6) sts.

RIGHT FRONT

Cast on 42 (45: 47: 50: 52) sts using 3¾ mm (US 5) needles and yarn A.

Work in garter st for 6 rows, end with a WS row.

Change to 4mm (US 6) needles.

Shape hem as folls:

Row 1 (RS): P11 (14: 16: 19: 21), wrap next st and turn.

Row 2: Knit.

Row 3: P15 (18: 20: 23: 25), wrap next st and turn.

Row 4: Knit.

Row 5: P19 (22: 24: 27: 29), wrap next st and turn.

Row 6: Knit.

Row 7: P22 (25: 27: 30: 32), wrap next st and turn.

Row 8: Knit.

Row 9: P25 (28: 30: 33: 35), wrap next st and turn.

Cont in this way, working an extra 3 sts on every row before wrapping next st and turning, until the foll row has been worked:

Row 15: P34 (37: 39: 42: 44), wrap next st and turn.

Now working an extra 2 sts on every row before wrapping next st and turning, cont in this way until the foll row has been worked:

Row 21: K40 (43: 45: 48: 50), wrap next st and turn.

Row 22: Purl.

Beg with a P row, work in rev st st across all sts for 10 (12: 12: 14: 14) rows, ending with a WS row.

Shape darts

Place marker on 22nd (24th: 26th: 28th: 30th) st in from beg of last row.

Next row (RS): P to within 1 st of marked st, P3tog tbl, P to last 4 sts, P2tog tbl, P2.

39 (42: 44: 47: 49) sts.

Work 5 rows.

Rep last 6 rows once more, and then the first of these rows again.

33 (36: 38: 41: 43) sts.

Work 15 rows, ending with a WS row.

Next row (RS): P to marked st, M1, P

marked st, M1, P to last 2 sts, M1, P2.

Work 13 rows.

Rep last 14 rows once more, and then the first of these rows again.

42 (45: 47: 50: 52) sts.

Cont straight until right front matches back to beg of armhole shaping, end with a RS row.

Shape armhole

Cast off 3 (4: 4: 5: 5) sts at beg of next row.

39 (41: 43: 45: 47) sts.

Dec 1 st at armhole edge of next 3 (3: 5: 5: 6) rows, then on foll 1 (1: 0: 0: 0) alt rows.

35 (37: 38: 40: 41) sts.

Work 1 (1: 1: 1: 0) row, end with a WS row.

Starting and ending rows as indicated, now work from chart for right front as folls:

Dec 1 st at armhole edge of next and foll 2 (3: 3: 4: 4) alt rows.

32 (33: 34: 35: 36) sts.

Cont straight until all 22 rows of chart have been completed, ending with a WS row.

Beg with a K row, cont in st st and complete to match left front, reversing shapings.

LEFT SLEEVE

Cuff

Cast on 53 (53: 55: 57: 57) sts using 3¾ mm (US 5) needles and yarn A.

Work in garter st for 8 rows, end with a WS row.

Row 9 (RS): Knit.

Row 10: K4, P to last 4 sts, K4.

Rows 9 and 10 form patt.

Row 11 (RS): K2, K2tog, (yfwd) twice (to make a buttonhole - drop extra loop on next row), K to end.

Work in patt for a further 11 rows, ending with a WS row.

Rep last 12 rows once more.

Change to 4mm (US 6) needles.

Shape front sleeve

Next row (RS): K2, K2tog, (yfwd) twice (to make 3rd buttonhole - drop extra loop on next row), P31 (31: 32: 33: 33) and turn, leaving rem sts on a holder.

Work each side of sleeve separately.

Next row: Knit.

Last 2 rows set the sts - sleeve opening edge 4 sts in garter st with rem sts in rev st st.

Next row (RS): Patt to last 2 sts, M1, P2.

Working all increases as set by last row, inc 0 (1: 1: 1: 1) st at end of foll 12th row.

36 (37: 38: 39: 39) sts.

Work a further 1 row, ending with a WS row.

Break yarn and leave sts on a second holder.

Shape back sleeve

With RS facing, rejoin yarn to 18 (18: 19: 20: 20) sts left on first holder and cont as folls:

Next row (RS): P to last 4 sts, K4.

Next row: Knit.

Last 2 rows set the sts - sleeve opening edge 4 sts in garter st with rem sts in rev st st.

Next row (RS): P2, M1, patt to end.

Working all increases as set by last row, inc 0 (1: 1: 1: 1) st at beg of foll 12th row, ending with a RS row.

19 (20: 21: 22: 22) sts.

Cast off 4 sts at beg of next row.

15 (16: 17: 18: 18) sts.

Join sections

Next row (RS): (P2, M1) 1 (0: 0: 0: 0) times, P13 (16: 17: 18: 18), then with RS facing P across first (all: all: all: all) 35 (37: 38: 39: 39) sts left on second holder, (M1, P2) 1 (0: 0: 0: 0) times.

53 (53: 55: 57: 57) sts.

**Beg with a K row and working all increases as set, cont in rev st st, shaping sides by inc 1 st at each end of 14th (10th: 10th: 10th: 10th) and every foll 14th (12th: 12th: 12th: 10th) row to 59 (63: 67: 69: 73) sts, then on every foll 12th (10th: 10th: 10th: -) row until there are 65 (67: 69: 71: -) sts.

Cont straight until sleeve measures 50.5 (50.5: 51.5: 51.5: 51.5) cm, ending with a WS row.

Shape top

Cast off 3 (4: 4: 5: 5) sts at beg of next 2 rows.

59 (59: 61: 61: 63) sts.

Dec 1 st at each end of next 3 rows, then on foll 2 alt rows, then on every foll 4th row until 35 (35: 37: 37: 39) sts rem.

Work 1 row, ending with a WS row.

Dec 1 st at each end of next and every foll alt

row to 29 sts, then on foll 3 rows, ending with a WS row.

Cast off rem 23 sts.

RIGHT SLEEVE

Cuff

Cast on 53 (53: 55: 57: 57) sts using 3¾ mm (US 5) needles and yarn A.

Work as given for cuff of left sleeve to end of row 10, ending with a WS row.

Row 11 (RS): K to last 4 sts, (yfwd) twice (to make a buttonhole - drop extra loop on next row), K2tog, K2.

Work in patt for a further 11 rows, ending with a WS row.

Rep last 12 rows once more.

Change to 4mm (US 6) needles.

Shape back sleeve

Next row (RS): K4, P14 (14: 15: 16: 16) and turn, leaving rem sts on a holder.

Work each side of sleeve separately.

Next row: Knit.

Last 2 rows set the sts - sleeve opening edge 4 sts in garter st with rem sts in rev st st.

Next row (RS): Patt to last 2 sts, M1, P2.

Working all increases as set by last row, inc 0 (1: 1: 1: 1) st at end of foll 12th row, ending with a RS row. 19 (20: 21: 22: 22) sts.

Next row (WS): K to last 4 sts, cast off rem 4 sts.

Break yarn and leave rem 15 (16: 17: 18: 18) sts on a second holder.

Shape front sleeve

With RS facing, rejoin yarn to 35 (35: 36: 37: 37) sts left on first holder and cont as folls:

Next row (RS): P to last 4 sts, K4.

Next row: Knit.

Last 2 rows set the sts - sleeve opening edge 4 sts in garter st with rem sts in rev st st.

Next row (RS): P2, M1, patt to end.

Working all increases as set by last row, inc 0 (1: 1: 1: 1) st at beg of foll 12th row.

36 (37: 38: 39: 39) sts.

Work a further 1 row, ending with a RS row.

Join sections

Next row (RS): (P2, M1) 1 (0: 0: 0: 0) times, P34 (37: 38: 39: 39), then with RS facing P

across first (all: all: all: all) 13 (16: 17: 18: 18) sts left on second holder, (M1, P2) 1 (0: 0: 0: 0) times.

53 (53: 55: 57: 57) sts.

Complete to match left sleeve from **.

MAKING UP

PRESS as described on the information page.

Join shoulder seams using back stitch, or mattress stitch if preferred.

Button band

With RS facing, using 3¼ mm (US 3) needles and yarn A, pick up and knit 99 (101: 103: 104: 106) sts down left front opening edge, between neck shaping and cast-on edge.

Work in garter st for 4 rows.

Cast off knitwise (on WS).

Buttonhole band

With RS facing, using 3¼ mm (US 3) needles and yarn A, pick up and knit 99 (101: 103: 104: 106) sts up right front opening edge, between cast-on edge and neck shaping.

Row 1 (WS): Knit.

Row 2: K19 (21: 23: 18: 20), *K2tog, (yfwd) twice (to make a buttonhole - drop extra loop on next row), K13 (13: 13: 14: 14), rep from * 5 times more, K2tog, (yfwd) twice, K3.

Work in garter st for a further 2 rows.

Cast off knitwise (on WS).

Collar

Cast on 93 (97: 97: 103: 103) sts using 3¼ mm (US 3) needles and yarn A.

Row 1 (RS): Knit.

Row 2: K3, P to last 3 sts, K3.

These 2 rows set the sts - centre sts in st st with 3 sts in garter st at each side.

Keeping sts correct as now set, cont as folls:

Row 3 (RS): K4, M1, K to last 4 sts, M1, K4.

Work 3 rows.

Rep last 4 rows 6 times more, and then row 3 again.

109 (113: 113: 119: 119) sts.

Work in garter st for 4 rows.

Cast off knitwise (on WS).

Machine wash all pieces before completing sewing together.

See information page for finishing instructions, setting in sleeves using the set-in method. Sew cast-off edge of back sleeve in place behind front sleeve. Sew cast-on edge of collar to neck edge, positioning ends of collar halfway across top of bands. Using photo as a guide and using yarn B, outline cuffs, collar and yoke "seams" by oversewing along edges twice (once in each direction to form closed cross stitches). Following embroidery diagrams, embroider swirls onto cuffs and yokes in stem stitch using yarn B.

French Knot

Sleeves

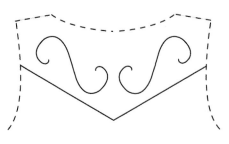

Back

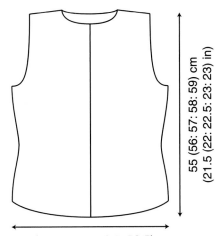
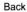

42.5 (45.5: 47.5: 50.5: 52.5) cm
(16.5 (18: 18.5: 20: 20.5) in)

55 (56: 57: 58: 59) cm
(21.5 (22: 22.5: 23: 23) in)

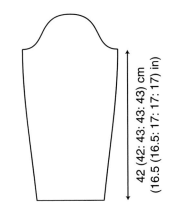

42 (42: 43: 43: 43) cm
(16.5 (16.5: 17: 17: 17) in)

Fronts

Vintage
KIM HARGREAVES

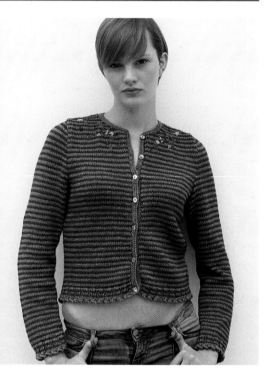

YARN

	XS	S	M	L	XL	
To fit bust	81	86	91	97	102	cm
	32	34	36	38	40	in

Rowan Denim

A Tennessee 231

	7	7	7	8	8	x50gm

B Memphis 229

	6	6	6	6	7	x50gm

NEEDLES

1 pair 3¼ mm (no 10) (US 3) needles
1 pair 4mm (no 8) (US 6) needles

BUTTONS - 7 x 75320

EMBROIDERY THREADS - Oddments of
apricot, dark magenta, brick red, blood red,
burgundy, light green and olive green.

TENSION

Before washing: 20 sts and 28 rows to
10 cm measured over stocking stitch using
4mm (US 6) needles.

Tension note: Denim will shrink in length
when washed for the first time. Allowances
have been made in the pattern for shrinkage
(see size diagram for after washing
measurements).

BACK

Cast on 147 (159: 171: 183: 189) sts using
3¼ mm (US 3) needles and yarn A.
Row 1 (RS): K3, *cast off 3 sts, K until there
are 3 sts on right needle after cast-off, rep
from * to end.
75 (81: 87: 93: 96) sts.
XS and S sizes only
Work in garter st for 3 rows, inc 1 st at end of
last row.
M and L sizes only
Work in garter st for 3 rows, dec 1 st at end
of last row.
XL size only
Work in garter st for 3 rows.
All sizes
76 (82: 86: 92: 96) sts.
Join in yarn B.
Row 5 (RS): Using yarn B, P1 (0: 0: 1: 0), K2
(2: 0: 2: 1), *P2, K2, rep from * to
last 1 (0: 2: 1: 3) sts, P1 (0: 2: 1: 2),
K0 (0: 0: 0: 1).
Row 6: Using yarn B, K1 (0: 0: 1: 0),
P2 (2: 0: 2: 1), *K2, P2, rep from * to last
1 (0: 2: 1: 3) sts, K1 (0: 2: 1: 2), P0 (0: 0: 0: 1).
Rows 7 and 8: As rows 5 and 6 but using
yarn A.
Rows 9 to 12: As rows 5 to 8.
Change to 4mm (US 6) needles.
Beg with a K row, work in striped st st as folls:
Using yarn B, work 2 rows.
Using yarn A, work 2 rows.
These 4 rows form striped st st.
Keeping stripes correct throughout, work a
further 4 rows.

Next row (RS): K2, M1, K to last 2 sts,
M1, K2.
Working all increases as set by last row, inc
1 st at each end of every foll 14th row until
there are 86 (92: 96: 102: 106) sts.
Cont straight until back measures 32.5 (33.5:
33.5: 35: 35) cm, ending with a WS row.
Shape armholes
Keeping stripes correct, cast off 5 (6: 6: 7: 7) sts
at beg of next 2 rows.
76 (80: 84: 88: 92) sts.
Dec 1 st at each end of next 3 (3: 5: 5: 7)
rows, then on foll 2 (3: 2: 3: 2) alt rows.
66 (68: 70: 72: 74) sts.
Cont straight until armhole measures 24 (24:
25: 25: 26.5) cm, ending with a WS row.
Shape shoulders and back neck
Cast off 6 (6: 7: 7: 7) sts at beg of next
2 rows. 54 (56: 56: 58: 60) sts.
Next row (RS): Cast off 6 (6: 7: 7: 7) sts, K
until there are 11 (11: 10: 10: 11) sts on right
needle and turn, leaving rem sts on a holder.
Work each side of neck separately.
Cast off 4 sts at beg of next row.
Cast off rem 7 (7: 6: 6: 7) sts.
With RS facing, rejoin appropriate yarn to
rem sts, cast off centre 20 (22: 22: 24: 24) sts,
K to end.
Complete to match first side, reverse shapings.

LEFT FRONT

Cast on 75 (81: 81: 87: 93) sts using 3¼ mm
(US 3) needles and yarn A.
Row 1 (RS): K3, *cast off 3 sts, K until there
are 3 sts on right needle after cast-off, rep
from * to end. 39 (42: 42: 45: 48) sts.
XS and S sizes only
Work in garter st for 3 rows, dec 1 st at end
of last row.
M and L sizes only
Work in garter st for 3 rows, inc 1 st at end
of last row.
XL size only
Work in garter st for 3 rows.
All sizes
38 (41: 43: 46: 48) sts.

Join in yarn B.**

Row 5 (RS): Using yarn B, P1 (0: 0: 1: 0), K2 (2: 0: 2: 1), *P2, K2, rep from * to last 3 sts, P2, K1.

Row 6: Using yarn B, P1, *K2, P2, rep from * to last 1 (0: 2: 1: 3) sts, K1 (0: 2: 1: 2), P0 (0: 0: 0: 1).

Rows 7 and 8: As rows 5 and 6 but use yarn A.

Rows 9 to 12: As rows 5 to 8.

Change to 4mm (US 6) needles.

Beg with a K row and 2 rows using yarn B, and working all side seam increases in same way as for back, cont in striped st st as for back, shaping side seam by inc 1 st at beg of 9th and every foll 14th row until there are 43 (46: 48: 51: 53) sts.

Cont straight until left front matches back to beg of armhole shaping, ending with a WS row.

Shape armhole

Keeping stripes correct, cast off 5 (6: 6: 7: 7) sts at beg of next row. 38 (40: 42: 44: 46) sts.

Work 1 row.

Dec 1 st at armhole edge of next 3 (3: 5: 5: 7) rows, then on foll 2 (3: 2: 3: 2) alt rows. 33 (34: 35: 36: 37) sts.

Cont straight until 19 (19: 19: 21: 21) rows less have been worked than on back to start of shoulder shaping, ending with a RS row.

Shape neck

Cast off 5 (6: 6: 6: 6) sts at beg of next row. 28 (28: 29: 30: 31) sts.

Dec 1 st at neck edge of next 4 rows, then on foll 5 (5: 5: 6: 6) alt rows. 19 (19: 20: 20: 21) sts.

Work 4 rows, ending with a WS row.

Shape shoulder

Cast off 6 (6: 7: 7: 7) sts at beg of next and foll alt row.

Work 1 row.

Cast off rem 7 (7: 6: 6: 7) sts.

RIGHT FRONT

Work as for left front to **.

Row 5 (RS): Using yarn B, K1, *P2, K2, rep from * to last 1 (0: 2: 1: 3) sts, P1 (0: 2: 1: 2), K0 (0: 0: 0: 1).

Row 6: Using yarn B, K1 (0: 0: 1: 0), P2 (2: 0: 2: 1), *K2, P2, rep from * to last 3 sts, K2, P1.

Rows 7 and 8: As rows 5 and 6 but using yarn A.

Rows 9 to 12: As rows 5 to 8.

Change to 4mm (US 6) needles.

Beg with a K row and 2 rows using yarn B, and working all side seam increases in same way as for back, cont in striped st st as for back, shaping side seam by inc 1 st at end of 9th and every foll 14th row until there are 43 (46: 48: 51: 53) sts.

Complete to match left front, reversing shapings.

SLEEVES (both alike)

Cast on 93 (93: 99: 99: 99) sts using 3¼ mm (US 3) needles and yarn A.

Row 1 (RS): K3, *cast off 3 sts, K until there are 3 sts on right needle after cast-off, rep from * to end.

48 (48: 51: 51: 51) sts.

XS and S sizes only

Work in garter st for 3 rows.

M size only

Work in garter st for 3 rows, dec 1 st at end of last row.

L and XL sizes only

Work in garter st for 3 rows, inc 1 st at end of last row.

All sizes

48 (48: 50: 52: 52) sts.

Join in yarn B.

Row 5 (RS): Using yarn B, K1 (1: 2: 1: 1), *P2, K2, rep from * to last 3 (3: 4: 3: 3) sts, P2, K1 (1: 2: 1: 1).

Row 6: Using yarn B, P1 (1: 2: 1: 1), *K2, P2, rep from * to last 3 (3: 4: 3: 3) sts, K2, P1 (1: 2: 1: 1).

Rows 7 and 8: As rows 5 and 6 but using yarn A.

Rows 9 to 12: As rows 5 to 8.

Change to 4mm (US 6) needles.

Beg with a K row and 2 rows using yarn B, and working all increases in same way as for side seam increases, cont in striped st st as for back, shaping sides by inc 1 st at each end of 9th and every foll 14th (12th: 12th: 12th: 10th) row to 64 (62: 60: 62: 56) sts, then on every foll 16th (14th: 14th: 14th: 12th) row until there are 66 (68: 70: 72: 74) sts.

Cont straight until sleeve measures 51.5 (51.5: 53: 53: 53) cm, ending with a WS row.

Shape top

Keeping stripes correct, cast off 5 (6: 6: 7: 7) sts at beg of next 2 rows.

56 (56: 58: 58: 60) sts.

Dec 1 st at each end of next 3 rows, then on foll 2 alt rows, then on every foll 4th row until 32 (32: 34: 34: 36) sts rem.

Work 1 row, ending with a WS row.

Dec 1 st at each end of next and every foll alt row to 26 sts, then on foll 3 rows, ending with a WS row.

Cast off rem 20 sts.

MAKING UP

PRESS as described on the information page.

Join both shoulder seams using back stitch, or mattress stitch if preferred.

Button band

With RS facing, using 3¼ mm (US 3) needles and yarn A, pick up and knit 82 (88: 88: 94: 94) sts down left front opening edge, between neck shaping and cast-on edge.

Work in garter st for 4 rows.

Cast off knitwise (on WS).

Buttonhole band

With RS facing, using 3¼ mm (US 3) needles and yarn A, pick up and knit 82 (88: 88: 94: 94) sts up right front opening edge, between cast-on edge and neck shaping.

Row 1 (WS): Knit.

Row 2: K1, *K2tog, (yfwd) twice (to make a buttonhole - drop extra loop on next row), K11 (12: 12: 13: 13), rep from * 5 times more, K2tog, (yfwd) twice, K1.

Work in garter st for a further 2 rows.

Cast off knitwise (on WS).

Neckband

With RS facing, using 3¼ mm (US 3)
needles and yarn A, starting and ending at
cast-off edges of front bands, pick up and knit
23 (24: 24: 27: 27) sts up right side of neck, 28
(30: 30: 32: 32) sts from back, then 23 (24: 24:
27: 27) sts down left side of neck.
74 (78: 78: 86: 86) sts.
Work in garter st for 4 rows.
Cast off knitwise (on WS).
Machine wash all pieces before completing
sewing together.
See information page for finishing instructions,
setting in sleeves using the set-in method.

French Knot

Embroidery

Using all 6 strands of embroidery thread and
photograph as a guide, embroider flowers and
leaves onto fronts. For flowers, work 5-7
straight stitches radiating out from one point
and, for some flowers, a french knot as the
flower centre. For leaves, work 3 straight
stitches radiating out from one point, making
centre stitch longer than side stitches.

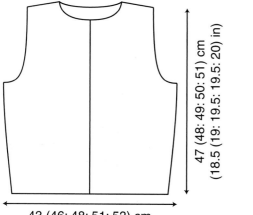

47 (48: 49: 50: 51) cm
(18.5 (19: 19.5: 19.5: 20) in)

43 (46: 48: 51: 53) cm
(17 (18: 19: 20: 21) in)

43 (43: 44: 44: 44) cm
(17 (17: 17.5: 17.5: 17.5) in)

Louise

ERIKA KNIGHT

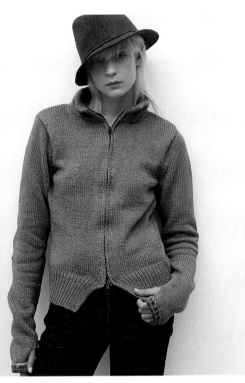

YARN

	XS	S	M	L	XL	
To fit bust	81	86	91	97	102	cm
	32	34	36	38	40	in

Rowan Denim

	12	13	14	14	15	x50gm

(photographed in Tennessee 231)

NEEDLES

1 pair 3¼ mm (no 10) (US 3) needles
1 pair 4mm (no 8) (US 6) needles

ZIP - Open-ended zip to fit

EXTRAS - Scraps cut from old denim jeans

TENSION

Before washing: 20 sts and 28 rows to
10 cm measured over stocking stitch using
4mm (US 6) needles.

Tension note: Denim will shrink in length
when washed for the first time. Allowances
have been made in the pattern for shrinkage
(see size diagram for after washing
measurements).

Pattern note: As row end edges of fronts form
actual finished edges of garment it is important
these edges are kept neat. Therefore all new
balls of yarn should be joined in at side seam
or armhole edges of rows.

BACK

Cast on 83 (89: 93: 99: 103) sts using
3¼ mm (US 3) needles.
Row 1 (RS): K1, *P1, K1, rep from * to end.
Row 2: P1, *K1, P1, rep from * to end.
These 2 rows form rib.
Work in rib for a further 26 rows, dec 1 st at
end of last row and ending with a WS row.
82 (88: 92: 98: 102) sts.
Change to 4mm (US 6) needles.
Beg with a K row, cont in st st as folls:
Work 2 rows, ending with a WS row.
Next row (RS): K2, K2tog, K to last 4 sts,
K2tog tbl, K2.
Working all decreases as set by last row, dec
1 st at each end of every foll 4th row until
72 (78: 82: 88: 92) sts rem.
Work 9 rows, ending with a WS row.
Next row (RS): K2, M1, K to last 2 sts, M1, K2.
Working all increases as set by last row, inc 1
st at each end of every foll 8th row until there
are 82 (88: 92: 98: 102) sts.
Cont straight until back measures 36 (37: 37:
38.5: 38.5) cm, ending with a WS row.
Shape armholes
Cast off 3 sts at beg of next 2 rows.
76 (82: 86: 92: 96) sts.
Working all armhole decreases in same way
as side seam decreases, dec 1 st at each
end of next and foll 1 (2: 2: 3: 3) alt rows.
72 (76: 80: 84: 88) sts.
Cont straight until armhole measures 23 (23:
24: 24: 25) cm, ending with a WS row.
Shape shoulders and back neck

Cast off 5 (6: 6: 7: 7) sts at beg of next 2 rows.
62 (64: 68: 70: 74) sts.
Next row (RS): Cast off 5 (6: 6: 7: 7) sts, K
until there are 10 (9: 11: 10: 12) sts on right
needle and turn, leaving rem sts on a holder.
Work each side of neck separately.
Cast off 4 sts at beg of next row.
Cast off rem 6 (5: 7: 6: 8) sts.
With RS facing, rejoin yarn to rem sts, cast
off centre 32 (34: 34: 36: 36) sts, K to end.
Complete to match first side, reverse shapings.

LEFT FRONT

Cast on 41 (45: 47: 49: 51) sts using 3¼ mm
(US 3) needles.
Work in rib as given for back for 28 rows, dec
0 (1: 1: 0: 0) st at end of last row and ending
with a WS row.
41 (44: 46: 49: 51) sts.
Change to 4mm (US 6) needles.
Next row (RS): K to last 2 sts, P1, K1.
Next row: P1, K1, P to end.
These 2 rows form patt.
Keeping patt correct, cont as folls:
Next row (RS): K2, K2tog, patt to end.
Working all decreases as set by last row, dec
1 st at beg of every foll 4th row until 36 (39:
41: 44: 46) sts rem.
Work 9 rows, ending with a WS row.
Next row (RS): K2, M1, patt to end.
Working all increases as set by last row, inc
1 st at beg of every foll 8th row until there are
41 (44: 46: 49: 51) sts.
Cont straight until left front matches back to
beg of armhole shaping, end with a WS row.
Shape armhole
Cast off 3 sts at beg of next row.
38 (41: 43: 46: 48) sts.
Work 1 row.
Working all armhole decreases in same way
as side seam decreases, dec 1 st at armhole
edge of next and foll 1 (2: 2: 3: 3) alt rows. 36
(38: 40: 42: 44) sts.
Cont straight until 15 (15: 15: 17: 17) rows
less have been worked than on back to start
of shoulder shaping, ending with a RS row.

Shape neck

Next row (WS): Patt 12 (13: 13: 13: 13) sts and slip these sts onto a holder, patt to end. 24 (25: 27: 29: 31) sts.

Dec 1 st at neck edge of next 6 rows, then on foll 1 (1: 1: 2: 2) alt rows, then on foll 4th row. 16 (17: 19: 20: 22) sts.

Work 2 rows, ending with a WS row.

Shape shoulder

Cast off 5 (6: 6: 7: 7) sts at beg of next and foll alt row.

Work 1 row.

Cast off rem 6 (5: 7: 6: 8) sts.

RIGHT FRONT

Cast on 41 (45: 47: 49: 51) sts using 3¼ mm (US 3) needles.

Work in rib as given for back for 28 rows, dec 0 (1: 1: 0: 0) st at beg of last row and ending with a WS row.

41 (44: 46: 49: 51) sts.

Change to 4mm (US 6) needles.

Next row (RS): K1, P1, K to end.

Next row: P to last 2 sts, K1, P1.

These 2 rows form patt.

Keeping patt correct, cont as folls:

Next row (RS): Patt to last 4 sts, K2tog tbl, K2.

Working all decreases as set by last row, dec 1 st at end of every foll 4th row until 36 (39: 41: 44: 46) sts rem.

Complete to match left front, reversing shapings.

SLEEVES

Cast on 46 (46: 48: 50: 50) sts using 4mm (US 6) needles.

Row 1 (RS): *K1, P1, rep from * to end.

Row 2: As row 1.

Beg with a K row, work in st st for 8 rows, ending with a WS row.

Shape thumb opening

Right sleeve only

Next row (RS): K11 (11: 12: 13: 13) and slip these sts onto a holder, cast off 2 sts, K to end. 33 (33: 34: 35: 35) sts.

Work 5 rows, ending with a WS row.

Next row (RS): K to last 2 sts, M1, K2. 34 (34: 35: 36: 36) sts.

Work a further 3 rows, ending with a WS row. Break yarn and leave these sts on a second holder.

With WS facing, rejoin yarn to 11 (11: 12: 13: 13) sts left on first holder and work 5 rows, ending with a WS row.

Next row (RS): K2, M1, K to end. 12 (12: 13: 14: 14) sts.

Work a further 3 rows, ending with a WS row.

Next row (RS): K12 (12: 13: 14: 14), turn and cast on 2 sts, turn and K across 34 (34: 35: 36: 36) sts left on second holder. 48 (48: 50: 52: 52) sts.

Left sleeve only

Next row (RS): K33 (33: 34: 35: 35) and slip these sts onto a holder, cast off 2 sts, K to end. 11 (11: 12: 13: 13) sts.

Work 5 rows, ending with a WS row.

Next row (RS): K to last 2 sts, M1, K2. 12 (12: 13: 14: 14) sts.

Work a further 3 rows, ending with a WS row. Break yarn and leave these sts on a second holder.

With WS facing, rejoin yarn to 33 (33: 34: 35: 35) sts left on first holder and work 5 rows, ending with a WS row.

Next row (RS): K2, M1, K to end. 34 (34: 35: 36: 36) sts.

Work a further 3 rows, ending with a WS row.

Next row (RS): K34 (34: 35: 36: 36), turn and cast on 2 sts, turn and K across 12 (12: 13: 14: 14) sts left on second holder. 48 (48: 50: 52: 52) sts.

Both sleeves

Work 15 (15: 13: 15: 11) rows, end with a WS row.

Next row (RS): K2, M1, K to last 2 sts, M1, K2.

Working all increases as set by last row, cont in st st, shaping sides by inc 1 st at each end of every foll 18th (18th: 16th: 18th: 14th) row to 52 (52: 62: 60: 72) sts, then on every foll 16th (16th: 14th: 16th: 12th) row until there are 66 (66: 70: 70: 74) sts.

Cont straight until sleeve measures 63.5 (63.5: 65: 65: 65) cm, ending with a WS row.

Shape top

Cast off 3 sts at beg of next 2 rows. 60 (60: 64: 64: 68) sts.

Working all decreases in same way as side seam and armhole decreases, dec 1 st at each end of next and foll 4 (4: 5: 5: 6) alt rows, then on every foll 4th row until 30 (30: 32: 32: 34) sts rem.

Work 3 rows, ending with a WS row.

Cast off.

MAKING UP

PRESS as described on the information page. Join both shoulder seams using back stitch, or mattress stitch if preferred.

Collar

With RS facing and using 4 mm (US 6) needles, slip 12 (13: 13: 13: 13) sts from right front holder onto right needle, rejoin yarn and pick up and knit 18 (18: 18: 20: 20) sts up right side of neck, 39 (41: 41: 43: 43) sts from back, and 18 (18: 18: 20: 20) sts down left side of neck, then patt across 12 (13: 13: 13: 13) sts from left front holder.

99 (103: 103: 109: 109) sts.

Row 1 (WS): P1, K1, P to last 2 sts, K1, P1.

Row 2: K1, P1, K to last 2 sts, P1, K1.

Rep last 2 rows until collar measures 9.5 cm, ending with a WS row.

Change to 3¼ mm (US 3) needles.

Next row (RS): K1, *P1, K1, rep from * to end.

Next row: P1, *K1, P1, rep from * to end.

Rep last 2 rows until collar measures 19 cm from pick-up row.

Using a 4 mm (US 6) needle, cast off in rib. Machine wash all pieces before completing sewing together.

See information page for finishing instructions, setting in sleeves using the set-in method.

Insert zip, placing top of zip 7.5 cm up from collar pick-up row and lower edge of zip level with top of ribbing. Fold collar in half to inside and stitch in place.

For elbow patches, cut a piece from old jeans approx 15 cm square. Fold raw edges to WS around all 4 edges.

Using photograph as a guide, position elbow patches onto sleeves and stitch in place. For cuff trim, cut strips from hem edge of jeans and use these to bind cast-on edge of sleeves. Cut belt loop off jeans and attach to centre back neck, just below collar.

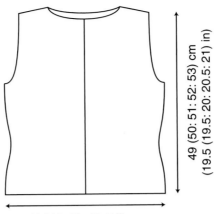

49 (50: 51: 52: 53) cm
(19.5 (19.5: 20: 20.5: 21) in)

41 (44: 46: 49: 51) cm
(16 (17.5: 18: 19.5: 20) in)

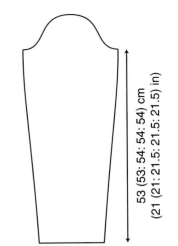

53 (53: 54: 54: 54) cm
(21 (21: 21.5: 21.5: 21.5) in)

Thelma
ERIKA KNIGHT

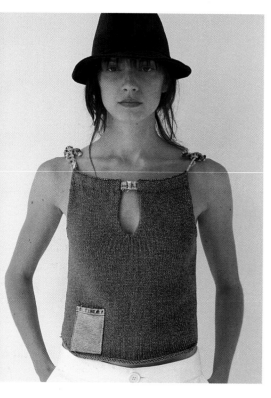

YARN

	XS	S	M	L	XL	
To fit bust	81	86	91	97	102	cm
	32	34	36	38	40	in

Rowan Denim

| | 6 | 6 | 7 | 8 | 8 | x50gm |

(photographed in Tennessee 231)

NEEDLES

1 pair 3¼ mm (no 9) (US 5) needles
1 pair 4mm (no 8) (US 6) needles

EXTRAS - Scraps cut from old denim jeans

TENSION

Before washing: 20 sts and 28 rows to 10 cm measured over stocking stitch using 4mm (US 6) needles.

Tension note: Denim will shrink in length when washed for the first time. Allowances have been made in the pattern for shrinkage (see size diagram for after washing measurements).

BACK

Cast on 42 (48: 52: 58: 62) sts using 4mm (US 6) needles.
Row 1 (RS): K2, M1, K to last 2 sts, M1, K2.
Row 2: P2, M1P, P to last st, M1P, P2.
Rep these 2 rows 7 times more.
74 (80: 84: 90: 94) sts.
Beg with a K row, cont in st st until back measures 27.5 (29: 29: 30: 30) cm, ending with a WS row.
Shape armholes
Cast off 2 (3: 3: 4: 4) sts at beg of next 2 rows.
70 (74: 78: 82: 86) sts.**
Next row (RS): K2, K2tog, K to last 4 sts, K2tog tbl, K2.
Working all decreases as set by last row, dec 1 st at each end of 2nd and foll 0 (1: 2: 3: 4) alt rows, then on foll 6th row, then on every foll 8th row until 60 (62: 64: 66: 68) sts rem.
Cont straight until armhole measures 19 (19: 20.5: 20.5: 21.5) cm, ending with a WS row.
Change to 3¼ mm (US 5) needles.
Next row (RS): Purl (to form fold line).
Beg with a P row, work in st st for a further 7 rows.
Cast off.

FRONT

Work as for back to **.
Working all armhole decreases as for back, dec 1 st at each end of next and foll 1 (2: 2: 2: 2) alt rows. 66 (68: 72: 76: 80) sts.
Work 3 (1: 1: 1: 1) rows, end with a WS row.
Divide for front opening
Next row (RS): (K2, K2tog) 0 (0: 1: 1: 1) times, K33 (34: 32: 34: 36) and turn, leaving rem sts on a holder.
Work each side of neck separately.
Dec 1 st at armhole edge of 2nd (4th: 6th: 2nd: 2nd) and 0 (0: 0: 0: 1) alt row, then on every foll

6th row to 30 (31: 32: 33: 34) sts, then on every foll 8th row until 28 (29: 30: 31: 32) sts rem.
Cont straight until armhole measures 16.5 (16.5: 18: 18: 19) cm, ending with a WS row.
Change to 3¾ mm (US 5) needles.
Next row (RS): Purl (to form fold line).
Beg with a P row, work in st st for a further 7 rows.
Cast off.
With RS facing, rejoin yarn to rem sts, K to last 0 (0: 4: 4: 4) sts, (K2tog tbl, K2) 0 (0: 1: 1: 1) times.
Complete to match first side, reverse shapings.

MAKING UP

PRESS as described on the information page.
Machine wash all pieces before sewing together.
Join side seams using back stitch, or mattress stitch if preferred. Across upper edges, fold last 7 rows to inside along fold line rows and stitch in place. For neck tie, cut two 1.5 cm wide stripes of denim (we used the stitched hem edges) approx 40 cm long. Thread one length through back neck casing and other through both front neck casings. Tie ends in knots on shoulders.
For pocket, cut a piece from old jeans approx 10 cm wide and 12 cm deep. Make hem across upper edge (or use hemmed edge of jeans) and turn raw edges to inside along other 3 edges. Using photograph as a guide, position pocket onto front and stitch in place.

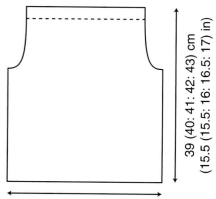

39 (40: 41: 42: 43) cm
(15.5 (15.5: 16: 16.5: 17) in)

37 (40: 42: 45: 47) cm
(14.5 (15.5: 16.5: 17.5: 18.5) in)

Raspy

KIM HARGREAVES

YARN

	XS	S	M	L	XL	
To fit bust	81	86	91	97	102	cm
	32	34	36	38	40	in
Rowan Denim						
	11	12	12	13	14	x50gm

(photographed in Memphis 229)

NEEDLES

1 pair 3¾ mm (no 9) (US 5) needles
1 pair 4mm (no 8) (US 6) needles

TENSION

Before washing: 20 sts and 28 rows to
10 cm measured over stocking stitch using
4mm (US 6) needles.

Tension note: Denim will shrink in length
when washed for the first time. Allowances
have been made in the pattern for shrinkage
(see size diagram for after washing
measurements).

BACK and FRONT (both alike)

Cast on 90 (96: 100: 106: 110) sts using
3¾ mm (US 5) needles.
Row 1 (RS): K to last 19 (22: 24: 27: 29) sts,
yfwd and mark this st, K6, yfwd and mark
this st, K to end.
(Note: marked sts are those that will be
dropped later to form laddered effect and do
NOT count as sts.)
Beg with a P row, work in st st for 7 rows,
ending with a WS row.
Change to 4mm (US 6) needles.
Row 9: K to last marked st, drop this
marked st and unravel down to cast-on
edge, K to end.
Work 1 row.
Row 11: K14 (17: 19: 22: 24), yfwd and mark
this st, K to end.
Work 3 rows.
Row 15: K to second marked st, drop
this marked st and unravel down to
cast-on edge.
Work 7 rows.
Row 23: K22 (25: 27: 30: 32), yfwd and mark
this st, K to last 27 (30: 32: 35: 37) sts, yfwd
and mark this st, K to end.
Work 3 rows.
Row 27: K to first marked st, drop this marked
st and unravel down to row 11, K to end.
Work 3 rows.
Row 31: K to first marked st, drop this marked
st and unravel down to row 23, K to end.
Work 7 rows.
Row 39: K2, K2tog tbl, K to marked st, drop
marked st and unravel down to row 23, K to
last 4 sts, K2tog, K2.
88 (94: 98: 104: 108) sts.
Working all side seam decreases as set by
last row, dec 1 st at each end of every foll 6th
row until 78 (84: 88: 94: 98) sts rem.

Work 11 rows, ending with a WS row.
Next row (RS): K2, M1, K to last 2 sts, M1, K2.
Working all side seam increases as set by
last row, inc 1 st at each end of next and
every foll 6th row until there are 88 (94: 98:
104: 108) sts.
Work 5 rows.
Next row (RS): K2, M1, K14 (17: 19:
22: 24), yfwd and mark this st, K to last
2 sts, M1, K2.
90 (96: 100: 106: 110) sts.
Work 9 rows.
Next row: K to marked st, drop marked st
and unravel down to yfwd, K to end.
Work a further 3 (5: 5: 7: 7) rows, ending
with a WS row.
Shape raglan armholes
Cast off 6 sts at beg of next 2 rows.
78 (84: 88: 94: 98) sts.
Working all raglan armhole decreases 2 sts
in from ends of rows in same way as for side
seam decreases, dec 1 st at each end of
next and foll 5 (8: 11: 14: 15) alt rows, then
on every foll 4th (4th: 4th: -: -) row until
60 (62: 62: 64: 66) sts rem.
Work 1 row, ending with a WS row.
Next row (RS): (K2, K2tog tbl) 0 (0: 0: 0: 1)
times, K to last 18 (19: 19: 20: 21) sts, yfwd
and mark this st, K to last 0 (0: 0: 0: 4) sts,
(K2tog, K2) 0 (0: 0: 0: 1) times.
60 (62: 62: 64: 64) sts.
Work 5 rows, dec 1 st at each end of 2nd of
these rows.
58 (60: 60: 62: 62) sts.
Next row: K2, K2tog tbl, K to 5 sts beyond
marked st, yfwd and mark this st, K to last
4 sts, K2tog, K2.
56 (58: 58: 60: 60) sts.
Work 1 row.
Next row: K to first marked st, drop this st
and unravel down to yfwd, K to end.
Work 3 rows, dec 1 st at each end of 2nd of
these rows.
54 (56: 56: 58: 58) sts.
Next row: K19 (20: 20: 21: 21), yfwd and
mark this st, K to end.

Work 3 rows, dec 1 st at each end of 2nd of these rows.

52 (54: 54: 56: 56) sts.

Next row: K to 4 sts beyond first marked st, yfwd and mark this st, K to last marked st, drop this marked st and unravel down to yfwd, K to end.

Work 5 rows, dec 1 st at each end of 2nd of these rows.

50 (52: 52: 54: 54) sts.

Next row: K2, K2tog tbl, K to 6 sts before first marked st, yfwd and mark this st, K to last 4 sts, K2tog, K2.

48 (50: 50: 52: 52) sts.

Work 1 row.

Next row: K to 4 sts beyond 3rd marked st, yfwd and mark this st, K to end.

Work 1 row.

Dec 1 st at each end of next and every foll 4th row until 42 (44: 44: 46: 46) sts rem, then on foll alt row.

40 (42: 42: 44: 44) sts.

Work 1 row, ending with a WS row.

Cast off, dropping marked sts down to relevant yfwd.

SLEEVES (both alike)

Cast on 50 (50: 52: 54: 54) sts using 3¾ mm (US 5) needles.

Row 1 (RS): K26 (26: 27: 28: 28), yfwd and mark this st, K4, yfwd and mark this st, K5, yfwd and mark this st, K to end.

(Note: marked sts are those that will be dropped later to form laddered effect and do NOT count as sts.)

Beg with a P row, work in st st for 3 rows, ending with a WS row.

Row 5: K to first marked st, drop this marked st and unravel down to cast-on edge, K to end.

Work 3 rows.

Change to 4mm (US 6) needles.

Work a further 2 rows.

Row 11: K to last marked st, drop this marked st and unravel down to cast-on edge, K to end.

Work 3 rows.

Row 15: K to marked st, drop this marked st and unravel down to cast-on edge.

Work 5 rows, ending with a WS row.

Row 21 (RS): K2, M1, K13 (13: 14: 15: 15), yfwd and mark this st, K to last 2 sts, M1, K1.

52 (52: 54: 56: 56) sts.

Working all increases as set by last row, cont as folls:

Work 11 rows.

Row 33 (RS): (K2, M1) 0 (0: 0: 0: 1) times, K to marked st, drop marked st and unravel down to row 21, K to last 0 (0: 0: 0: 2) sts, (M1, K2) 0 (0: 0: 0: 1) times.

52 (52: 54: 56: 58) sts.

Inc 1 st at each end of 2nd (2nd: 2nd: 2nd: 12th) and every foll 14th (14th: 14th: 14th: 12th) row to 58 (56: 60: 62: 64) sts, then on foll 0 (12th: 0: 0: 0) row.

58 (58: 60: 62: 64) sts.

Work 7 (9: 7: 7: 1) row, ending with a WS row.

Next row: K24 (24: 25: 26: 27), yfwd and mark this st, K to end.

Work 5 rows, inc 1 st at each end of - (2nd: -: -: -) of these rows. 58 (60: 60: 62: 64) sts.

Next row: (K2, M1) 1 (0: 1: 1: 0) times, K to 10 sts before marked st, yfwd and mark this st, K to last 2 (0: 2: 2: 0) sts, (M1, K2) 1 (0: 1: 1: 0) times.

60 (60: 62: 64: 64) sts.

Work 3 rows.

Next row: (K2, M1) 0 (0: 0: 0: 1) times, K to second marked st, drop this marked st and unravel down to yfwd, K to last 0 (0: 0: 0: 2) sts, (M1, K2) 0 (0: 0: 0: 1) times.

60 (60: 62: 64: 66) sts.

Work 3 rows.

Next row: (K2, M1) 0 (1: 0: 0: 0) times, K to marked st, drop this marked st and unravel down to yfwd, K to last 0 (2: 0: 0: 0) sts, (M1, K2) 0 (1: 0: 0: 0) times.

60 (62: 62: 64: 66) sts.

Inc 1 st at each end of 6th (12th: 4th:

4th: 8th) and every foll 14th (12th: 12th: 12th: 12th) row to 68 (70: 72: 74: 72) sts, then on every foll - (-: -: -: 10th) row to - (-: -: -: 76) sts.

Work 9 rows.

Next row (RS): K45 (46: 47: 48: 49), yfwd and mark this st, K to end.

Work 5 rows, ending with a WS row.

Shape raglan

Cast off 6 sts at beg of next 2 rows.

56 (58: 60: 62: 64) sts.

Working all raglan decreases in same way as body raglan decreases, dec 1 st at each end of next and foll alt row.

52 (54: 56: 58: 60) sts.

Work 1 row.

Next row (RS): K2, K2tog tbl, K to marked st, drop marked st and unravel down to yfwd, K to last 4 sts, K2tog, K2.

50 (52: 54: 56: 58) sts.

Dec 1 st at each end of 2nd and every foll alt row to 40 sts, then on every foll 4th row until 26 sts rem.

Work 3 rows.

Next row: K2, K2tog tbl, K11, yfwd and mark this st, K7, K2tog, K2.

24 sts.

Work 3 rows.

Next row: K2, K2tog tbl, K6, yfwd and mark this st, K to last 4 sts, K2tog, K2.

22 sts.

Dec 1 st at each end of 4th and foll 4th row, then on foll alt row.

16 sts.

Work 1 row, ending with a WS row.

Cast off, dropping marked sts down to relevant yfwd.

MAKING UP

PRESS as described on the information page.

With wrong sides together, join raglan seams using back stitch, or mattress stitch if preferred, to create ridge on RS.

Machine wash all pieces before completing sewing together.

See information page for finishing instructions.

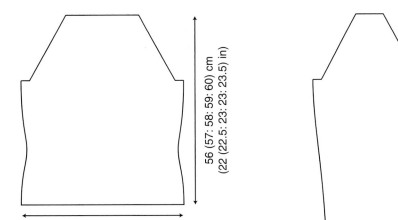

45 (48: 50: 53: 55) cm
(17.5 (19: 19.5: 21: 21.5) in)

56 (57: 58: 59: 60) cm
(22 (22.5: 23: 23: 23.5) in)

44 (44: 45: 45: 45) cm (17.5 in)

Picot

LEAH SUTTON

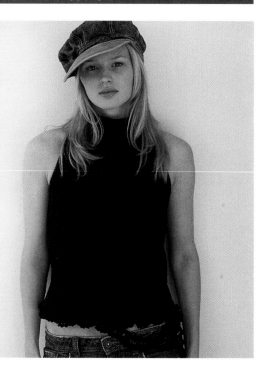

YARN

	XS	S	M	L	XL	
To fit bust	81	86	91	97	102	cm
	32	34	36	38	40	in

Rowan Denim

| | 6 | 6 | 7 | 8 | 8 | x50gm |

(photographed in Nashville 225)

NEEDLES

1 pair 3¹/₄ mm (no 10) (US 3) needles
1 pair 4 mm (no 8) (US 6) needles

TENSION

Before washing: 20 sts and 28 rows to 10 cm measured over stocking stitch using 4mm (US 6) needles.

Tension note: Denim will shrink in length when washed for the first time. Allowances have been made in the pattern for shrinkage (see size diagram for after washing measurements).

BACK and FRONT (both alike)

Using 3¹/₄ mm (US 3) needles, work picot cast-on as folls: cast on 3 sts, cast off 2 sts (one st remains on right needle), slip st now on right needle back onto left needle, *cast on a further 3 sts, cast off 2 sts and slip st on right needle back onto left needle - one extra st on left needle, rep from * until there are 69 (75: 79: 85: 89) sts on left needle, cast on 1 more st.
70 (76: 80: 86: 90) sts.
Change to 4mm (US 6) needles.
Beg with a K row, work in st st for 6 rows, ending with a WS row.
Next row (RS): K2, K2tog, K to last 4 sts, K2tog tbl, K2.
Working all decreases as set by last row, dec 1 st at each end of every foll 6th row until 64 (70: 74: 80: 84) sts rem.
Work 7 (9: 9: 11: 11) rows, ending with a WS row.
Next row (RS): K2, M1, K to last 2 sts, M1, K2.
Working all increases as set by last row, inc 1 st at each end of every foll 10th row until there are 78 (84: 88: 94: 98) sts.
Cont straight until back measures 33.5 (35: 35: 36: 36) cm, ending with a WS row.

Shape armholes

Cast off 4 (6: 6: 8: 8) sts at beg of next 2 rows.
70 (72: 76: 78: 82) sts.
Next row (RS): K2, K3tog, K to last 5 sts, K3tog tbl, K2.
Working all decreases as set by last row, dec 2 sts at each end of 2nd and foll 0 (0: 1: 1: 2) alt rows, then on foll 4th row, then on foll 8th row, then on foll 10th row, then on every foll 12th row until 42 (44: 44: 46: 46) sts rem.
Cont straight until armhole measures 21.5 (21.5: 23: 23: 24) cm, ending with a WS row.
Cast off.

MAKING UP

PRESS as described on the information page.

Collar

With RS facing and using 4 mm (US 6) needles, pick up and knit 42 (44: 44: 46: 46) sts from front, then 42 (44: 44: 46: 46) sts from back.
84 (88: 88: 92: 92) sts.
Beg with a P row, work in st st for 3 rows.
Row 4 (RS): *K2, K2tog, K34 (36: 36: 38: 38), K2tog tbl, K2, rep from * once more.
80 (84: 84: 88: 88) sts.
Work 5 rows.
Row 10 (RS): *K2, K2tog, K32 (34: 34: 36: 36), K2tog tbl, K2, rep from * once more.
76 (80: 80: 84: 84) sts.
Work 3 rows, ending with a WS row.
Work picot cast-off as folls: Cast off 2 sts, slip st on right needle back onto left needle, *cast on 2 sts, cast off 3 sts, slip st on right needle back onto left needle, rep from * until all sts have been cast off.
Join collar seam using back stitch, or mattress stitch if preferred.

Armhole borders (both alike)

With RS facing and using 3¹/₄ mm (US 3) needles, pick up and knit 84 (88: 92: 96: 100) sts evenly around armhole edge.
Cast off knitwise (on WS).

Lower trim

Cast on 100 sts using 4mm (US 6) needles.
Work picot cast-off as for collar.
Machine wash all pieces before completing sewing together.
Join side and armhole border seams.
Using photograph as a guide, attach one end of trim to base of left side seam.
Measure roughly one third of the way along the trim and attach this point to centre of lower edge of front, ensuring trim forms a loop below lower edge.
Now attach centre point of remaining length of trim strip to inside of hem edge near side seam, again ensuring trim forms a loop below hem edge.

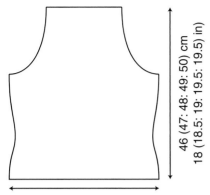

46 (47: 48: 49: 50) cm
18 (18.5: 19: 19.5: 19.5) in)

39 (42: 44: 47: 49) cm
(15.5 (16.5: 17.5: 18.5: 19.5) in)

ROWAN overseas distributors

AUSTRALIA
Australian Country Spinners
314 Albert Street,
Brunswick
Victoria 3056.
Tel: (03) 9380 3888

BELGIUM
Pavan
Meerlaanstraat 73
B9860 Balegem (Oosterzele)
Tel: (32) 9 221 8594

CANADA
Diamond Yarn
9697 St Laurent,
Montreal
Quebec H3L 2N1
Tel: (514) 388 6188
www.diamondyarns.com

Diamond Yarn (Toronto)
155 Martin Ross,
Unit 3
Toronto,
Ontario M3J 2L9
Tel: (416) 736 6111
www.diamondyarns.com

DENMARK
Individual stockists -
please contact Rowan for details

FRANCE
Elle Tricot
8 Rue dua Coq
67000 Strasbourg
Tel: (33) 3 88 23 03 13
www.elletricote.com

GERMANY
Wolle & Design
Wolfshovener Strasse 76
52428 Julich-Stetternich
Tel : (49) 2461 54735.
www.wolleundesign.de

HOLLAND
de Afstap
Oude Leliestraat 12
1015 AW Amsterdam
Tel : (31) 20 6231445

HONG KONG
East Unity Co Ltd
Unit B2
7/F, Block B
Kailey Industrial Centre
12 Fung Yip Street
Chai Wan
Tel : (852) 2869 7110.

ICELAND
Storkurinn
Kjorgardi
Laugavegi 59
Reykjavik
Tel: (354) 551 82 58

JAPAN
Puppy Co Ltd
TOC Building
7-22-17 Nishigotanda
Shinagwa-Ku
Tokyo
Tel : (81) 3 3494 2435

NEW ZEALAND
Individual stockists -
please contact Rowan for details

NORWAY
Paa Pinne
Tennisun 3D
0777 OSLO
Tel: (47) 909 62 818
www.paapinne.no

SWEDEN
Wincent
Norrtulsgaten 65
11345 Stockholm
Tel: (46) 8 673 70 60

U.S.A.
Rowan USA
4 Townsend West
Suite 8
Nashua
New Hampshire 03063
Tel: (1 603) 886 5041/5043

For details of U.K. stockists or any other information concerning this book please contact:

R O W A N

Rowan Yarns, Green Lane Mill, Holmfirth, West Yorkshire HD9 2DX
Tel: +44 (0)1484 681881 Fax: +44 (0)1484 687920
Email: denimpeople@knitrowan.com www.knitrowan.com

information page

KNITTING WITH ROWAN DENIM, NASHVILLE AND BLACK

Because the dye is only a surface dye, during knitting the colour will come off onto your hands. This will wash off very easily but it is advisable to protect your clothing or wear something dark. Occasionally, because of the unconventional dyeing process, shading may occur which is not visible until after the first wash. To help maintain a more even colour we suggest the following; knit until approximately one third of the first ball remains, join in the second ball and work 2 rows, change back to the first ball and work 2 rows. Taking the yarn up the side of the work, continue working 2 rows from each ball alternately, until first ball is finished. Continue until approximately one third of second ball remains, then join in the next ball and continue as before.

TENSION

Obtaining the correct tension is perhaps the single factor which can make the difference between a successful garment and a disastrous one. It controls both the shape and size of an article, so any variation, can distort the finished look of the garment. We recommend that you knit a square in pattern and/or stocking stitch of perhaps 5 more stitches and rows than those given in the tension note. Place finished square on a flat surface and mark out the central 10cm square. If you have too many stitches to 10cm try again using thicker needles, if you have too few stitches to 10cm try again using finer needles.

SIZING AND SIZE DIAGRAM NOTE

The instructions are given for the smallest size. Where they vary, work the figures in brackets for the larger sizes. One set of figures refers to all sizes. Included with every pattern in this magazine is a 'size diagram', the purpose of which is to enable you to accurately achieve a perfect fitting garment without the need for worry during knitting. The size diagram shows the finished width of the garment at the under-arm point, total length and sleeve length.

FINISHING INSTRUCTIONS

After working for hours knitting a garment, it seems a great pity that many garments are spoiled because such little care is taken in the pressing and finishing process.

PRESSING

Darn in all ends neatly along the selvage edge or a colour join, as appropriate. Block out each piece of knitting using pins and gently press each piece, omitting the ribs, using a warm iron over a damp cloth. Tip: Take special care to press the edges, as this will make sewing up both easier and neater.

STITCHING

When stitching the pieces together, remember to match areas of colour and texture very carefully where they meet. Use a seam stitch such as back stitch or mattress stitch for all main knitting seams, and join all ribs and neckband with a flat seam unless otherwise stated.

CONSTRUCTION

Having completed the pattern instructions, join left shoulder and neckband seams as detailed above. Sew the top of the sleeve to the body of the garment using the method detailed in the pattern, referring to the appropriate guide:

Square set-in sleeves: Set sleeve head into armhole, the straight sides at top of sleeve to form a neat right-angle to cast-off sts at armhole on back and front.

Shallow set-in sleeves: Join cast-off sts at beg of armhole shaping to cast-off sts at start of sleeve- head shaping. Sew sleeve head into armhole, easing in shapings.

Set-in sleeves: Set in sleeve, easing sleeve head into armhole.

Join side and sleeve seams
Slip stitch pocket edgings and linings into place. Sew on buttons to correspond with buttonholes. After sewing up, press seams and hems. Ribbed welts and neckbands and any areas of garter stitch should not be pressed.

ABBREVIATIONS

K	knit
P	purl
st (s)	stitch(es)
inc	increas(e)(ing)
dec	decreas(e)(ing)
stst	stocking stitch (1 row K, 1 row P)
garter st	garter stitch (K every row)
beg	begin(ning)
foll	following
rem	remain(ing)
rev	revers(e)(ing)
rep	repeat
alt	alternate
cont	continue
patt	pattern
tog	together
mm	millimetres
cm	centimetres
in (s)	inch(es)
RS	right side
WS	wrong side
sl1	slip one stitch
psso	pass slipped stitch over
p2sso	pass 2 slipped stitches over
tbl	through back of loop
M1	make one stitch by picking up horizontal loop before next stitch and knitting into back of it
yfwd	yarn forward
yrn	yarn round needle
yon	yarn over needle
cn	cable needle

EXPERIENCE RATINGS

= Easy, straight forward knitting

= Suitable for average knitter